Collaboration in Italian Renaissance Art

# COLLABORATION IN ITALIAN RENAISSANCE ART

EDITED BY

WENDY STEDMAN SHEARD AND JOHN T. PAOLETTI

NEW HAVEN AND LONDON    YALE UNIVERSITY PRESS    1978

*Publication of this book was made possible in part by the friends of*
*Charles Seymour, Jr., in the Russell Trust Association*

*Designed by Thos. Whitridge and set in Trump Mediaeval type. Printed in the*
*United States of America by The Murray Printing Company, Westford, Mass.*

*Published in Great Britain, Europe, Africa, and Asia (except Japan) by Yale*
*University Press, Ltd., London. Distributed in Latin America by Kaiman &*
*Polon, Inc., New York City; in Australia and New Zealand by Book & Film*
*Services, Artarmon, N.S.W., Australia; and in Japan by Harper & Row,*
*Publishers, Tokyo Office.*

Library of Congress Cataloging in Publication Data
*Main entry under title:*

*Collaboration in Italian Renaissance art.*

*Includes index.*
*1. Art, Renaissance–Italy–Addresses, essays, lectures. 2. Art,*
*Italian–Addresses, essays, lectures. 3. Group work in art–Italy–Addresses,*
*essays, lectures. I. Sheard, Wendy Stedman. II. Paoletti, John T.*
N6915.C64      709'.45      77-91068      ISBN 0-300-02175-5

IN MEMORIAM
CHARLES SEYMOUR, JR.

# Contents

## Milan

## Venice and the Veneto

# Illustrations

*Illustrations are located at the end of their respective chapters.*

# Preface

*WENDY STEDMAN SHEARD*

RENAISSANCE ART seen as a series of dramatic rivalries between passionate egotists is one aspect of art history's inheritance from Vasari. Charles Seymour often used to explore with students the ironies of this view, as he sought to disentangle the threads of evidence from the pattern of romance. Since the writing of history itself is an art requiring variety and liveliness, Vasari's topos, which underlies, for example, his treatment of the lives of Andrea del Castagno and Domenico Veneziano, provided history with a ready-made artists' psychology. This book of essays by colleagues, friends, and pupils of Charles Seymour reflects a very different attitude.

The theme originally proposed by John Paoletti and John Spencer was "collaboration or competition among Renaissance artists." Almost as though the conscious intention had been to provide contrast to Vasari's emphasis on rivalry in artists' interactions, *all* the contributions accentuate collaborative activities. By and large, these essays reflect the clearer insight which emerges as archival research focuses attention away from the individual and onto patterns of group functioning. How a harmonious and reasonably profitable system of workshop organization fostered collaboration and, indeed, often served to discourage undue competitiveness, is more generally understood.

The inspiration of Charles Seymour's teaching and work shows itself in innumerable ways. One that immediately comes to mind is the emphasis in most of these essays on particular phases or aspects of the art-making process itself. To isolate the variables—social, individual, mental, material, and technical—and refashion them in a historical reconstruction that does not deny the element of creativity in scholarship—this is a valued part of Charles Seymour's legacy to us. Within the general framework of examining collaboration, a wide range of approaches and styles is evident here. As Charles Seymour believed, a single, doctrinaire approach applied universally to problems of art history no longer serves its best interests. Rather, the scholar must be able to fit the methods to the demands of the particular problem being examined: archival study, connoisseurship, typology, iconology, and formal and structural analysis were among the tools to which his students were exposed.

Collaboration among artists took many forms. The most straightforward arose when two artists worked on the same object or contributed to a single project. Studying polychromed sculpture immediately puts one in touch with numerous products of artists' collaborations. Ulrich Middeldorf's account of Florentine painted reliefs reveals the continuity of painting and sculpture while examining the phenomena of waves of fashion which encouraged widespread manufacture of a type that nevertheless lasted only a few years. The art of sculpture also, of course, applies to the frames that were an integral part of the works themselves—Madonna and Child reliefs in terracotta, stucco, and marble. Middeldorf directs attention to the problems clustering around these works and suggests a number of solutions. Enzo Carli has written about two large heraldic tablets he attributes to Neroccio de' Landi. They are painted stuccos whose original coloring has been obscured by later repainting and uses alien to their original function as a record of the rectorate of Salimbene di Cristofano Capacci at the hospital of Santa Maria della Scala in Siena. Neroccio's pride in his mastery of both sculpture and painting underlines the close relationship of the two arts in the Quattrocento, with which Middeldorf and Carli are both concerned.

The relation between teacher and pupil was likewise susceptible to many variations. A pupil's including his master's architectural drawings in his professional portfolio, as was the case with Giovanni Vincenzo Casale and Montorsoli that George Kubler outlines, surely bears a relation to workshop practices whereby collections of drawings recording ideas and solutions—ranging from standard composition or building types to variations on decorative motifs—sometimes numbered in the hundreds. Already in the first decade of the Cinquecento the disposition of a great workshop's drawings on the death of a master had become a matter of note. Even in Vasari's lifetime, the value of such drawings, it was realized, extended far beyond their practical utility, prized though that was. Kubler's discovery of new sixteenth-century Italian drawings for architecture and decoration that had found their way to Madrid is thus obviously an exciting one. This find has provided significant new knowledge of Montorsoli's career, especially his work procedures and his synthesis of Michelangelesque details with more traditional architectural modes.

A top-ranking master with a large shop inevitably attracted highly competent assistants. Often, from the Dugento onward, he was confronted with the phenomenon of the youthful apprentice as budding genius. James Stubblebine's essay offers us an unusual glimpse into a situation in which two artists of widely differing abilities, the Master of Tabernacle 35 and Simone Martini, collaborated on a triptych from the shop of Duccio. John Spencer's essay treats of Filarete's bronze doors for St. Peter's. The problems posed by the collaboration of a major artist with several assistants whose

individual styles are difficult or impossible to distinguish are tackled with the benefit of Spencer's close study of these doors after the extensive cleaning of 1962 revealed much about the variety and extent of the chasing. An examination of Filarete's whereabouts in relation to the events unfolding in the arena of papal-imperial relations alluded to in the doors' iconography permits Spencer to make new observations on the chronology of this important papal commission—notably, that it began slowly and accelerated markedly after 1440. The considerable expansion of Filarete's staff required to carry out the immense labor of chasing these reliefs toward the end of the campaign must be considered a key element in the establishment of bronze technology in the context of Quattrocento sculpture in Rome.

Rome is also the setting for André Chastel's look at a kind of collaboration frequently encountered in papal and state art. This is collaboration with art of the past. Lorenzetto's statue of Saint Peter was done in a deliberately archaizing style in the early 1530s, to allow it to agree stylistically, as well as iconographically, with the Saint Paul by Paolo Romano of two generations earlier, which had been rescued from storage by Pope Clement VII as part of a program of reaffirmation of papal legitimacy.

The Morelli-Berenson idea of connoisseurship conceived as a comparative visual method where analogies of detail (the typical method of forming an ear or a hand, for example) and of technique (the characteristic brush-stroke shape seen as an artist's 'handwriting'), were relied upon exclusively. What Berenson—perhaps naïvely—called the "science" of connoisseurship is no longer so mechanical. Stubblebine, addressing a question of attribution, makes use not only of the standard tools in the connoisseur's detective kit but also of contextual considerations: what is the tabernacle's relationship to the paradigm scene in the *Maestà?* Do its groupings and modeling techniques bespeak a generative mind or an imitative one? The qualities of the style and working methods of a principal Duccio assistant, previously cloaked in the obscurity typically reserved for Master X or Y in a top artist's firm, are thus deduced.

Another essential feature of Charles Seymour's approach has been analysis of context or program, perhaps in reaction to the formalist tendencies art history acquired by osmosis from art criticism early in our century. A closer look at its Venetian context allows Paul Watson to challenge the traditionally assumed rivalry with Michelangelo of Titian's *Danae.* Instead, a ripening in the painter's mind of a figural motif experienced decades earlier is revealed as the determining factor. In another reevaluation of context, Chastel's discussion of Saints Peter and Paul shows how seemingly conservative, traditional imagery can, at a particular historical moment, assume a tone of defiance.

The effort, now being made more and more frequently, to understand how a compositional idea develops in an artist's mind over time, shown

here in both David Brown's and Paul Watson's studies, benefits from certain controls. Among these, awareness of factors such as medium and program, including as many circumstances as are recoverable of the patron's intentions, are especially important. Douglas Lewis's publication of Antonio Lombardo's *Peace Establishing her Reign: An Allegory of the Victory of Ravenna,* a unique bronze relief that is closely related to a series of marbles originating from the court of Alfonso d'Este, exemplifies the fruitful results sometimes obtainable when a patron sets or pervasively influences a program that can be deduced from reviewing the historical-political circumstances surrounding the art work. In the case of the *Allegory,* neither a purely formal nor a single-mindedly iconographic approach used in isolation could have yielded such satisfactory results.

Collaboration between a great master and assistants or associates, though common, has often presented obstacles to penetrating beneath the surface of the bare documented facts. Such is the case with Agostino di Duccio's work for the *Opera del Duomo* in Florence in the mid-1460s. John Paoletti evaluates documented payments to Agostino in postulating a background for Michelangelo's *David*, carved from a block that Agostino had quarried and begun, and relates it more specifically than previous opinion has done to Donatello's bronze *David* in the Bargello.

Another problem of this sort is approached, though with different tactics, by David Brown. Analysis of Leonardo's collaboration with Ambrogio de Predis on the *Madonna of the Rocks* is complicated by the existence of two versions, one in Paris, the other in London. Brown shows how Leonardo, in the London picture, followed a logic of refinement that sought increased abstract beauty and greater psychological self-containment. The curve of the angel's shoulder was simplified and enhanced through dramatic use of highlights. A process of sharpened definition and concentration tightened up the looser, more generalized construction of the figure as seen in the Louvre version. Drawing in new ways upon largely neglected visual evidence, Brown dates the inception of the London *Madonna of the Rocks* to the mid-1490s and establishes its authenticity as a record of Leonardo's thought on the relevant formal and esthetic issues.

Similarly, I have studied a greater and lesser master at work on the Widener *Orpheus.* This small painting, which was never completely finished, nevertheless bears a frequently noticed yet unanalyzed stamp of significance in the ferment of change that characterized Venetian art at the turn of the century (1490s). By locating the composition in a type sequence and exploring the picture's tight integration of visual means, psychological effects, and intellectual structure, I argue that Giorgione authored its conceptual and pictorial inventions, leaving their execution largely to a collaborator during a time when both belonged to Giovanni Bellini's shop.

The process of collaboration between artist and patron has received increasing attention in recent years. Edmund Pillsbury recounts how Cosimo I de' Medici delayed completion of Vasari's resystematized staircase in the Palazzo Vecchio out of concern lest he be perceived as too rapidly changing the revered civic structure into a grandiose ducal residence. The preoccupation with political "image" divorced from the substance of actions, which distinctly sharpened as the Cinquecento wore on, played a crucial role in the history of the Palazzo Vecchio, one of the world's best-known buildings. Pillsbury publishes for the first time the documents recording payments to stonemasons in three well-defined building campaigns, which reveal that, contrary to widely held opinion, the new staircase system was not completely finished before 1570.

A collaboration between architect and theoretician in influencing contemporary responses to architecture is the subject of George Hersey's investigation of a hitherto unnoticed aspect of Marsilio Ficino's thought: the Neoplatonic philosopher's use of architectural imagery as a metaphor for the cosmos. How late Quattrocento contemporaries might have been persuaded that viewing a building in perspective could lead the observer to a state of contemplation is an aspect of Renaissance architectural theory and its effects on perception that is particularly suggestive.

Art theory is, of course, a crucial part of art's ambient that Charles Seymour encouraged students to investigate. David Summers, in his examination of the relationship between Michelangelo's *David* and Renaissance physiognomic theory, shows how the statue reflects recently revived ancient ideas. The concept of physiognomy according to which outward form and animating spirit must be shown visually as being harmoniously reciprocal would naturally have exerted compelling force in the mind of a young artist nurtured in the intellectual ferment that was Marsilio Ficino's Florence.

This book, as originally conceived by John Paoletti and John Spencer, was to have been a sixty-fifth birthday offering. Charles Seymour's untimely death transforms the occasion from one of celebration to one of commemoration. The fourteen contributors here express their affection and gratitude, together with the profound respect they share, toward the memory of an inimitable friend, colleague, and teacher. The very diversity of their approaches to art will stand as a memorial to the energetic creativity and individualism of expression that his teaching and example encouraged.

*Stony Creek, Conn.*                                      W.S.S.
*June 1977*

# Acknowledgments

LIKE THE WORKS OF ART DISCUSSED in these essays on the varieties of artistic practice during the Italian Renaissance, this book represents a collaboration of efforts on the part of many individuals and organizations. In addition to the contributors who responded so generously to the editors' demands, specific individuals were of enormous help in seeing this book to publication.

John Spencer of the National Endowment for the Arts and Sumner McKnight Crosby of Yale University were encouraging and supportive of the project at the beginning and the end stages respectively, particularly in the areas of procuring generous subventions toward publication. Miss Mary Davis of the Samuel H. Kress Foundation provided the initial grant for publication and editorial work that took the book through the very difficult middle stages of preparation; to her especially and to the Kress Foundation we are most grateful. The Russell Trust Association generously supported the final editorial stages of the book. Anne Coffin Hanson and David Alan Brown were active in their efforts to insure proper publication of the volume and are owed a special word of thanks. Janet Smith gave unstintingly of her time to secure difficult-to-obtain photographs in Florence for this book; in an area in which Charles Seymour himself was especially meticulous, we owe a particular debt to her.

At a very tentative moment in the history of this book, Judy Metro of the Yale University Press intervened on our behalf and subsequently guided us, with precision and patience, through the myriad details that accompany the publishing process. She has our warmest gratitude.

Finally, Charlotte Seymour has borne our numerous inquiries with patient and unfailing helpfulness; she was kindest and most supportive at a time when she had every reason to have been impatient. Had Charles Seymour lived to see this book published he would have agreed that in no small measure it is her book as well as his.

Wendy Stedman Sheard
John T. Paoletti

*Siena*

# 1. The Boston Ducciesque Tabernacle, A Collaboration

*James H. Stubblebine*

THE BOSTON MUSEUM OF FINE ARTS has in its collection one of the finest Ducciesque paintings in America, a tabernacle with the *Crucifixion* and saints (fig. 1.1).[1] It is in an excellent state of preservation for the most part, gleaming with gold and vibrant colors. The study of the work is as interesting as the work is beautiful. This is so because the tabernacle reveals the sort of collaboration that went on in Duccio's shop and this, in turn, reveals to us something about workshop arrangements in the early fourteenth century.

The tabernacle has as its central image a *Crucifixion*, while the shutters contain images of Saint Nicholas of Bari on the left and Saint Gregory on the right. When the tabernacle is closed, we find that the exterior is decorated with a dense but delicate pattern of white lines curving and looping over a pale, purplish-rose background (fig. 1.3). This surface is decorated with small geometric shapes of gold, red, and black which imitate leather strapwork.

The Boston tabernacle has been discussed by relatively few critics, mainly because for a long time it was hidden away at the J. P. Morgan estate at Aldenham, Hertfordshire, England.[2] Since it came to the Boston Museum in 1945, however, interest in the painting has quickened, but no two critics exactly agree on how to attribute it.

In the older literature the picture was given to Duccio himself by Douglas (1908) and Cecchi (1938).[3] Van Marle (1924) and Weigelt (1911), however, considered it to be shopwork.[4] Edgell's publications on the tabernacle after it came to Boston diverted criticism in a fundamentally different direction.[5] He believed that while the center was by Duccio, the wings were by the young Simone Martini; in this he was followed only by Coletti.[6] Other critics have, more or less vehemently, denied Simone's participation in the work.[7] Generally, the more recent criticism—Brandi (1951), Garrison (1949), Carli (1952), Arb (1959)—has been very hesitant

to grant even the central panel to Duccio himself, preferring to attribute it to his shop.[8]

There has been equal disagreement about the date of the tabernacle. Edgell, attributing the *Crucifixion* to Duccio, thought it was, so to speak, a still somewhat naïve rehearsal for the scene Duccio would later depict on the *Maestà* of 1311 (fig. 1.5); he therefore dated the Boston tabernacle between 1304 and 1307. Carli, on the other hand, believing the work to be by Duccio's shop, dated the tabernacle after 1311, since he considered the *Crucifixion* to be based on that of the *Maestà*. In short, both the attribution and the dating of the Boston tabernacle have for the most part been determined according to how close to or remote from the Cathedral *Maestà* it was thought to be.

Certainly the *Crucifixion* on the *Maestà* had considerable popularity, as can be judged by the number of copies of it made by various pupils of Duccio.[9] Of these, the Boston scene is by far the closest imitation. We should, however, be all the warier of attributing the Boston *Crucifixion* to the master on that account; Duccio is hardly likely, as Edgell claimed, to have first painted the composition in this small tabernacle and then to have imitated it in so precise and even servile a manner in such a major work as the Cathedral *Maestà*. Indeed, far from being a "rehearsal," the Boston Crucifixion scene is more like a simplification and reduction of the Maestà scene. The number of figures in the groups to either side of the cross is about half those of the Maestà scene, and the angels at the top are less than half of those on the Cathedral altarpiece. A sure sign of the process of simplification is to be observed in the way in which the artist of the Boston tabernacle has given up the mellifluous interplay of the hands of the Virgin and Saint John the Evangelist seen on the *Maestà* (figs. 1.6 and 1.7). Altogether, the Boston *Crucifixion* is a typical example of the reduction and reinterpretation of the prototype it purports to mimic.

The central panel of the Boston tabernacle is the part which has sometimes been thought to be the most Ducciesque;[10] but even here, as I have said, critics have had their doubts. And these doubts are based upon certain sound observations with which I would agree. Carli, for example, finds certain figures unpersuasive and the whole a slightly mannered but cold reelaboration of the Maestà scene. Arb has noted that the colors in the Boston *Crucifixion* differ from Duccio's treatment, being more sensuous and being laid on in a system of dominant hues with small, contrasting accents, in contradistinction to Duccio's large areas of competing colors.[11] The irony is that Arb used the Passion scenes on the back of the *Maestà* as examples of typical works of Duccio but, as we have tried to show elsewhere, we believe that the only parts of the *Maestà* Duccio painted himself are the main front panel and the front predella. Various

parts of the *Maestà* back appear to have been painted by a number of Duccio's assistants, among them the Lorenzetti brothers and Simone Martini. Consequently, the back of the *Maestà* cannot be used to gauge Duccio's style.[12]

It must be said, though, that Arb is the only writer to analyze the Boston painting on such points of style, and to do so perceptively. When we examine the Boston *Crucifixion* that way, we discover an optical or painterly approach in which forms are defined in terms of light, shade, and color patches. This is seen especially in the highlights and intervening shadows of the faces on the left, with their closely repeated accents on lips and noses. The same style is apparent in the loose brushwork of the beards in the group on the right. This mode of painting heightens the suggestion of "insistent fervor" and "intense presence" Arb finds so characteristic of the figures in the Boston *Crucifixion* (fig. 1.6). The very same elements are present in the Maestà *Crucifixion* (fig. 1.7) and the scenes following it, as I have pointed out in my analysis of the various hands at work on the back of the *Maestà*. The clearest examples, perhaps, are the *Deposition* and the *Entombment*, where the fervent expressions and the surprisingly loose and painterly style in which the faces are painted convinced even Weigelt that an assistant had painted these scenes.[13]

I propose that the same artist who executed this particular group of scenes on the back of the *Maestà* was also responsible for the Crucifixion scene on the Boston tabernacle. He was a faithful and careful imitator of Duccio, whom we have named the Tabernacle 35 Master after a work of his in the Siena gallery which reveals his identifying characteristics.[14]

When we look to see who among Duccio's assistants might have executed the figures in the shutters (fig. 1.1), we have to agree with Edgell that they are by the young Simone Martini. This attribution has not gained wide acceptance; wary of taking great names in vain, scholars are usually reluctant to see the hand of a leading artist in the work of someone from a preceding generation. In this case, however, critics have been overcautious in rejecting Edgell's thesis. The two figures from the Boston tabernacle have much in common with the figures in Simone's Pisa polyptych of 1320 (fig. 1.8): the narrow eyes, the thin lips pressed firmly together, the light on the protuberant cheekbones. Above all, these faces are, like those in the polyptych, elegantly aloof. The draperies on the two saints are also Simonesque: fully Gothic in their V-shaped cascades, they resemble the draperies we find in Simone's *St. Louis* of 1317 in Naples and those of the Madonna in his 1315 *Maestà* (a figure apparently repainted in 1321). The draperies are, in fact, quite different from what we find on the front predella of the *Maestà* by Duccio himself, where soft fabrics, gently lighted, fall in irregular folds, hugging the

bodies beneath. Like all of Simone's draperies, those in the Boston shutters have a rich variety of decorative hems, brocadings, and patterns covering a good deal of the surfaces. Except for those on the large figures accompanying the Virgin on the front of the *Maestà*, the draperies in paintings by Duccio himself are uniformly simple, decorated only with a thin, gold hemline.

It is interesting that Paccagnini, in denying these wings to Simone, said that they must date soon after 1320 since they are full of "riflessi simoniani."[15] I would say, on the contrary, that these two saints are earlier than the Pisa polyptych since they reveal Simone's personal style evolving away from the Ducciesque. They reflect, in fact, the same moment of his development as the parts of Duccio's *Maestà* which we attribute to Simone—that is, the Pilate episodes and the *Via Crucis*. The assistants at work alongside Duccio on the *Maestà* kept closely to the master's face and figure style; yet in several instances Simone broke from that stricture and revealed something of his personal style. One obvious example is to be found in the *Christ in a White Robe before Pilate*. There, Christ's lips and eyes are narrow, the cheekbones high, the expression taut. The similarities to the figures of the Pisa polyptych need no further demonstration.

Edgell observed that the papal hat of Saint Gregory in the Boston tabernacle is woven or plaited from ribbons or leather strips and that this unusual design is also used on the hat of Saint Gregory in both the frame medallion of Simone's Palazzo Pubblico *Maestà* and in his 1320 Pisa polyptych; a variant is seen in the plaited hat of Boniface VIII in the predella scene from his Saint Louis panel in Naples.[16] This type of ornamentation does not, to my knowledge, appear elsewhere in early Sienese painting and consequently appears to be a Simonesque element; it helps to confirm Simone's connection with this panel.

It certainly would have been a curious arrangement if the Tabernacle 35 Master, a relatively minor painter, had been assigned the centerpiece of this work while the more talented Simone only got to do the wings. But as a matter of fact, closer examination reveals that the *Crucifixion* is not stylistically uniform and that the hand of Simone can also be found there. The figure of Christ (fig. 1.10) is conceptually at variance with the groups to either side of it. This is best understood if we compare the figure with the one on the Cathedral *Maestà* (fig. 1.9). In the Boston *Crucifixion* the figure is more gaunt and has thinner features; the whole figure is lighter, more elegant, and more spiritual. It is, in fact, very close to the crucified figure in the little panel in Antwerp, which Simone painted around 1320 (fig. 1.11).[17]

The style of the Christ figure lies, in fact, somewhere between Duccio and Simone. It has evolved beyond the Ducciesque formula seen on

the Cathedral *Maestà* and on the *Cross* from his shop (no. 36 in the Siena gallery),[18] and yet it has not quite reached Simone's fully developed formula exemplified by the Antwerp *Crucifixion*. The figure leans a little farther away from the cross than in the Ducciesque examples—a posture even more pronounced in the Antwerp scene. Compared to the figure on the *Maestà* and the no. 36 *Cross*, Christ's body in the Boston tabernacle has fewer demarcations, such as the ribs and the network of horizontal and vertical lines in the abdominal area. Indeed, the parts of the body flow together very smoothly, as is true also of the Christ figure in the Antwerp panel. Even the arms and legs of the Boston figure are thinner and more stretched out than those of our two Ducciesque examples. The head, somewhat Ducciesque still, especially in the dark, fluffy hair, has the elegant, narrow features we associate with Simone's work. The nose with its thin highlight again recalls Simone's *Crucifixion* in Antwerp.

From all of the foregoing, it emerges that the two artists, both of them assistants to Duccio, collaborated in the execution of the Boston tabernacle. It would appear, furthermore, that they were not exactly equals but that Simone was superior in status. He took for himself the execution of the important central figure of Christ as well as the full-length saints on the wings. The Tabernacle 35 Master was assigned the crowds and the angels of the *Crucifixion* as well as the small figures of the gable. This latter painter was a born follower. The panels he executed on the Cathedral *Maestà*—the *Crucifixion* through the *Noli me tangere*—are the only ones on the back of the altarpiece for which I believe Duccio supplied full designs and in which he probably supervised the assistant closely. In the painting of the Boston tabernacle this same assistant no doubt accepted his role unhesitatingly.

Thus, Master Duccio seems not to have been involved in the production of the Boston tabernacle, not even in drawing up the design—a simple enough matter of copying and appropriately simplifying the Maestà *Crucifixion*. This would not be the only time that Duccio handed over a commission to one or more assistants and that some of them acted as lieutenants in his shop. For example, Segna di Buonaventura was, no doubt, of higher rank than the average assistant in Duccio's shop, serving as a sort of right-hand man to the master around the time that the *Maestà* was underway, although he probably left the shop soon after the completion of that great altarpiece. During his stay, I believe Segna executed the polyptych no. 28 in the Siena gallery, a work that may once have borne Duccio's name and the date 1310.[19] There, as in his signed polyptych (no. 40 in the Siena Pinacoteca), we find those hard, enameled forms and the darker mood that are hallmarks of Segna's art.

It may, then, have been Simone Martini who assumed this position of first lieutenant to Duccio for the short duration of his stay in the shop.

He had already participated in the project on the Cathedral *Maestà*, executing himself the scenes of Christ before Pilate. It was during this time, presumably, that he undertook work on the Boston tabernacle.

I believe Simone was also in charge of the execution of the fine tabernacle in the National Gallery in London (fig. 1.2). Previously, no one has ever questioned Duccio's authorship. Nevertheless, the cool, distant glance of the Virgin, the dry, crisp handling of the forms, and the somewhat hard shaping of the features differentiates this *Madonna* from those more securely attributed to Duccio himself, such as the Perugia and Stoclet Madonnas. The difference is less one of quality than it is of artistic intent and the individual artist's mode of expression. The Simonesque qualities of the saints in the shutters of the London tabernacle are more immediately apparent, especially in the fine, thin features and the dark, brooding glances, all of which draw these figures close to those in the Pisa polyptych of 1320 (fig. 1.8).

It seems relevant that the London and Boston tabernacles have not only the same shapes but also identical dimensions.[20] They also share the same decoration and coloring on the exterior (figs. 1.3 and 1.4): looping white lines on a purplish-pink background, as well as geometric forms imitating strapwork.

One curiosity about the London tabernacle is that Simone relied on a formula for the Madonna image which Duccio had first created in the Stoclet *Madonna* back in the 1290s—a faraway glance on the Virgin's face and a diminutive scale for the Christ Child. Even so, Simone must have worked on the London tabernacle at about the same time as the Boston one, that is, between about 1310 and 1313 or so; soon after the latter date he became established in his own right.

Undoubtedly, in these two works Simone was following a tabernacle formula already established by Duccio. That this Ducciesque formula goes back at least to the 1290s is demonstrated by the tabernacle in Krakow by a follower of Guido da Siena, which not only has the central gable and the inscribed arch but a good many other Ducciesque elements as well.[21] Presumably, the formula was used with a fair amount of frequency in Duccio's shop, since this sort of small tabernacle, so well suited to small altars and private devotions, would have been in great demand; it is, then, only a coincidence that the two Ducciesque ones which have survived were done under Simone's lieutenancy.[22]

Moreover, the fact that the Boston and London tabernacles are of identical shape, size, and exterior decoration—thus suggesting a standardization of procedures—need not come as a total surprise. Because so few works from the thirteenth and fourteenth centuries have come down to us, we have wrongly become accustomed to elevating each surviving work to a very special status. Yet there was obviously a more practical approach

to production within the workshops, including such basic areas as the carpentry of forms. And again, because the survivals from the period are so few, our knowledge is inevitably limited. Still, there is the example of the two pairs of reliquary shutters made in Siena in the second half of the Dugento; even though they are separated by about fifteen years and one is by the master while the other is from his shop, they nevertheless have identical shapes and measurements.[23] In short, there seems to have been a logical approach to the standardization of forms and measurements, just as there was a logical division in the labors of production. Painting was not merely an art, it was also a well-run business.

Apparently, the working procedures in the shop of such a painter as Duccio, though more complex than we used to believe, need not remain forever fathomless. With this exploration of the modus operandi employed in the Boston tabernacle, we may begin to feel a little less deficient in our knowledge of such matters.

# NOTES

1. Museum number 45.880. The central panel measures 24″ by 15½″, the wings 17¾″ by 7½″.

2. Where it was seen by Langton Douglas. (Crowe and Cavalcaselle, *A New History of Painting in Italy* ed. Douglas [London, 1908], 3: 19–20 n.). The picture was seen by Gustaf Friedrich Waagen in the W. Young Ottley Collection, London, in 1837 (*Kunstwerke und Künstler in England und Paris* [Berlin, 1837], 1: 395).

3. Emilio Cecchi, *Trecentisti senesi* 2d. ed. (Milan, 1948), pp. 55, 174, 204.

4. Raimond van Marle, *The Development of the Italian Schools of Painting* (The Hague, 1924), 2: 98 n.; Curt Weigelt, *Duccio di Buoninsegna* (Leipzig, 1911), p. 261.

5. George Edgell, "A Crucifixion by Duccio with Wings by Simone Martini," *Burlington Magazine* 88 (1946): 107–12; idem, "An Important Triptych of the Sienese Trecento," *Bulletin of the Museum of Fine Arts* 44 (June 1946): 35–41.

6. Who was at the time attributing the altarpiece in the Cathedral of Massa Marittima to Simone (Luigi Coletti, "The Early Works of Simone Martini," *Art Quarterly* 12 [1949]: 291–308).

7. Giovanni Paccagnini, *Simone Martini* (Milan, 1955), pp. 98–99.

8. Cesare Brandi, *Duccio* (Florence, 1951), pp. 147–48, n. 29; Edward Garrison, *Italian Romanesque Panel Painting* (Florence, 1949), no. 350; Enzo Carli, *Duccio* (Milan-Florence, 1952), unpaginated, next to last page of text; Renée Arb, "A Reappraisal of the Boston Museum's Duccio," *Art Bulletin* 41 (1959): 191–98.

9. One example is the scene on a diptych by the Monte Oliveto Master in the Robert Lehman Collection at the Metropolitan Museum, New York (Lionello Venturi, *Italian Paintings in America* [New York, 1933], vol. 1, pl. 20).

10. See, for example, Evelyn Sandberg-Vavalà, *Sienese Studies, the Development of the School of Painting of Siena* (Florence, 1953), p. 91, n. 2.

11. Arb, "Boston Museum's Duccio," p. 198.

12. James Stubblebine, "Duccio and his Collaborators on the Cathedral *Maestà*," *Art Bulletin* 55 (1973): 185–204.

13. Weigelt, *Duccio,*, p. 257.

14. Brandi, *Duccio*, figs. 110, 111. See also Stubblebine, "Duccio and his Collaborators," pp. 203–04 and fig. 31.

15. Paccagnini, *Simone Martini*, p. 99.

16. Ibid., figs. 7, 26, 11.

17. For discussions of the dating of the Antwerp *Crucifixion*, see Paccagnini, *Simone Martini*, pp. 110–21, and Stubblebine, "Duccio's *Maestà* of 1302 for the Chapel of the Nove," *Art Quarterly*, 35 (1972): 267, n. 53.

18. Van Marle, *Italian Schools*, vol. 2, fig. 58.

19. Stubblebine, "The Role of Segna di Buonaventura in the Shop of Duccio," *Pantheon* 30 (1972): 272–82.

20. H. 24⅛″ by W. 15⅜″ (Boston: H. 24″ by W. 15½″).

21. Stubblebine, *Guido da Siena* (Princeton, 1964) pp. 101–02.

22. Another tabernacle formula, that used for the slightly larger work no. 35 in the Siena gallery, has a rectangular shape to the central panel; a number of examples of this type have been gathered by Garrison (*Italian Romanesque Panel Painting*, pp. 124–25).

23. Stubblebine, *Guido da Siena*, figs. 1 and 35, and pp. 22–23, 70–71.

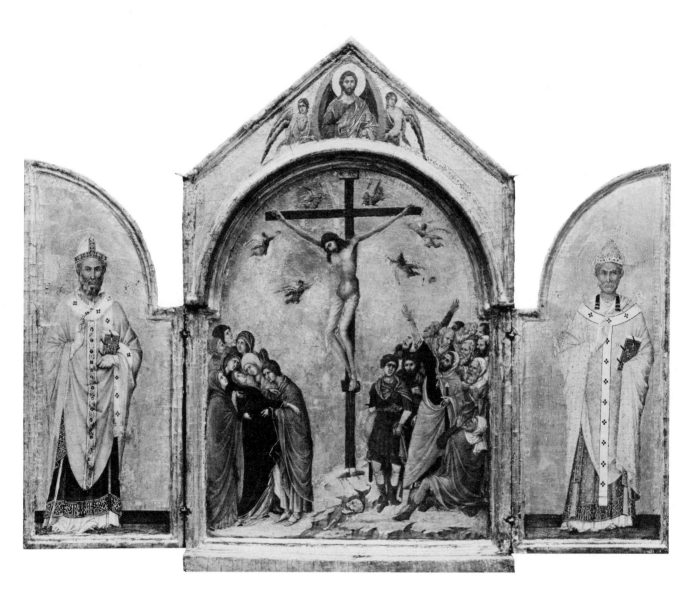

1.1 Shop of Duccio, *Crucifixion with Saints Nicholas of Bari and Gregory*. Museum of Fine Arts, Boston, Grant Walker and Charles Potter Kling Fund.

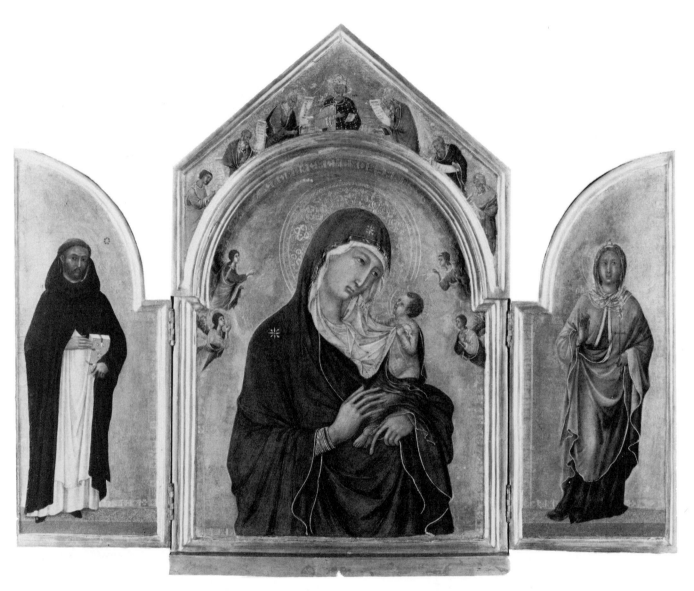

1.2 Shop of Duccio, *Madonna and Child with Saints Dominic and Aurea*. National Gallery, London.

1.3 *Crucifixion with Saints Nicholas of Bari and Gregory,* with shutters closed.

1.4 *Madonna and Child with Saints Dominic and Aurea*, with shutters closed.

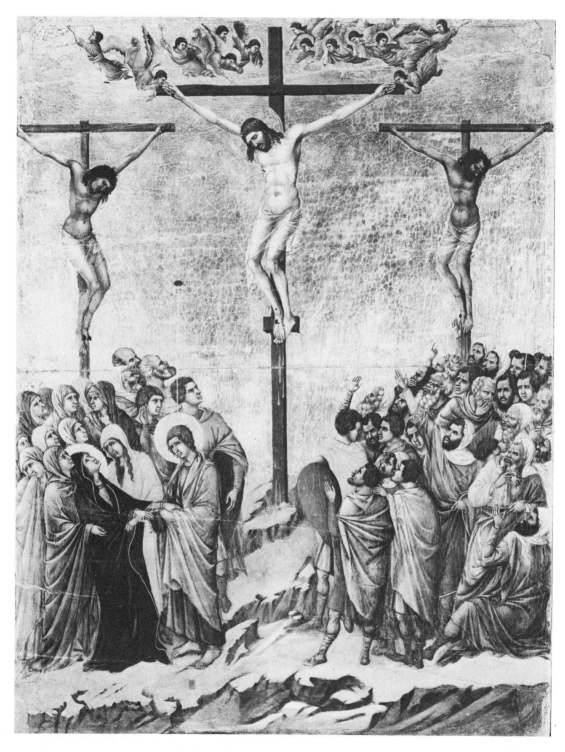

1.5 Duccio and shop, *Crucifixion from the Maestà*. Opera del Duomo, Siena.

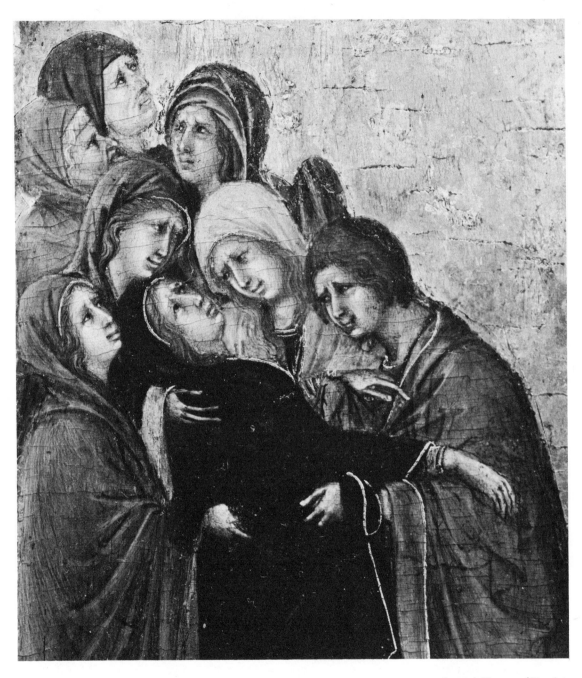

1.6 Detail of figure 1.1, central panel.

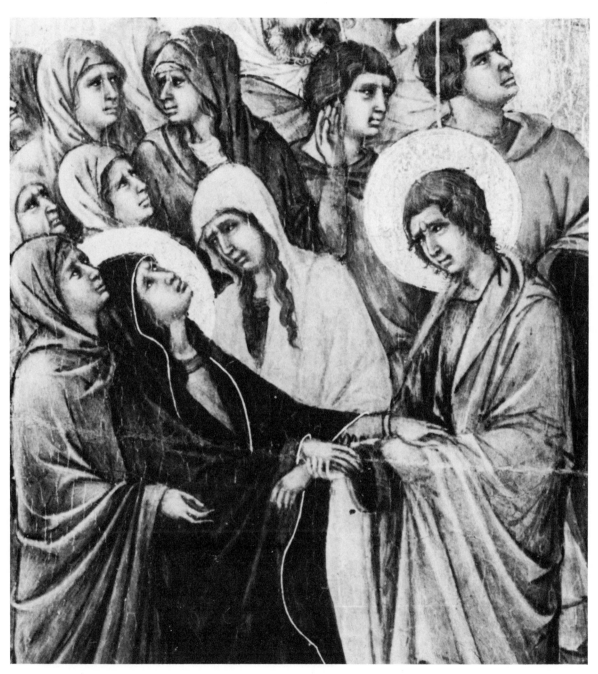

1.7 Detail of figure 1.5.

1.8 Simone Martini, *Saints Agnes and Amborse*, detail of polyptych. Museo Nazionale, Pisa.

1.9  Detail of figure 1.5.

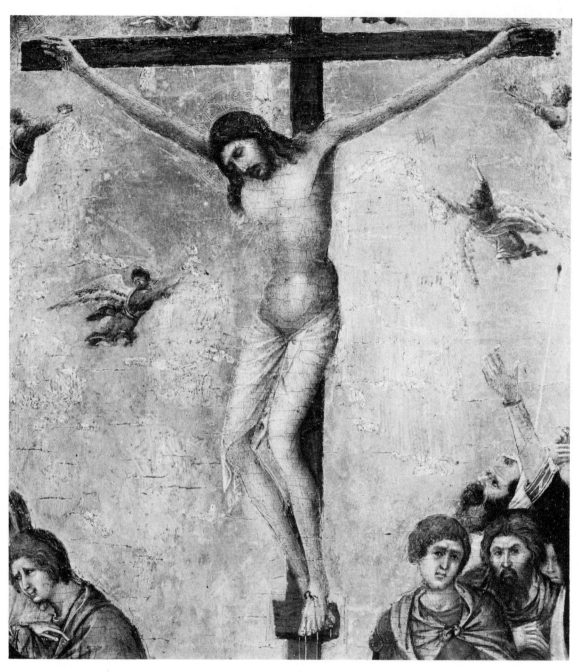

1.10 Detail of figure 1.1.

1.11  Simone Martini, detail of Crucifixion. Royal Museum of Fine Arts, Antwerp.

# 2. Two Stucco Reliefs by Neroccio di Bartolomeo

*ENZO CARLI*

THIS BRIEF DISCUSSION tackles the difficult problem of attributing and establishing the original setting for two unusual works (figs. 2.1–4) published here for the first time.[1] I have found nothing similar to them, at least in Sienese art. They are two large panels or boards—each 225 cm. high and 118 cm. wide—decorated in stucco relief, that hang on the interior side of the portal which constituted the main entrance to the room called the "Pellegrinaio" of the Hospital of Santa Maria della Scala in Siena. I do not exclude the possibility that this precise place was their original setting, recalling the festoons in carved and painted wood which even now are placed around doors on the façades of certain churches on the occasion of the exposition of the Blessed Sacrament, for the observance of the "Forty Hours' Devotion," or on other religious holidays. Such festoons, after all, serve to embellish a large space not used for worship, and they lack religious elements or symbols.

I don't believe, moreover, that these reliefs formed part of some catafalque or funeral display, even though they are painted black. This rather slapdash of paint, in addition to exaggerating the modeling, hides their original blue color and its gilding—slight traces are visible through the paint—and gives the relief panels a funereal aspect. This is in contrast to their figural repertory, which lacks any reference to death: it is, rather, quite cheerfully decorative and heraldic.

These large panels, though symmetrical, are not identical. In one of them (fig. 2.2), the ropes supporting the tassels and bunches of fruit held by the little angels and also secured at the upper corners where the festoons are attached, are much longer than in the other. The coats-of-arms, too, are different; but since almost all of the parts carved in relief in both the panels correspond *ad unguem*, one can gather that they were made from molds.

As one can see from the photographs (figs. 2.1 and 2.2), each panel contains two pairs of winged putti. The upper pair, standing on two small

pedestals, holds the long ribbons or cords connected at the top to an over-hanging pair of festoons of fruits and flowers. The lower pair, standing beneath two full volutes, flanks a coat-of-arms which in one of the panels (fig. 2.1) is that of the Hospital of Santa Maria della Scala (a ladder surmounted by a small cross—fig. 2.3) while in the other (fig. 2.2) is the well-known coat-of-arms of the Capacci family, represented by the head ("capaccio" [pig-head]) of a wild boar.*

The Capacci coat-of-arms permits us to draw the conclusion that the two panels were commissioned by Messer Salimbene di Cristofano Capacci, who was twice rector of the hospital. He was first elected on February 15, 1479, after six months during which the institution had remained without a rector and was run by the *camerlingo* Fra' Giovanni di Martino because of a brief but severe plague during which, according to Fecini's account, about sixty people died in Siena each day. A decree of the Balìa of July 8, 1480, dismissed Capacci from office and exiled him along with a brother, Andrea, to Camerino, for having sided with the Reformers, who had been defeated by the Noveschi and the Popolari. On February 1, 1483, however, he was reinstated in the position, which he held until his death on November 3, 1497.

During his second and much longer rectorship, Salimbene Capacci who, born in 1433, had held various public offices (he was, among other things, one of the four ambassadors sent from Siena to render obedience to Innocent VIII in 1484), succeeded in bringing to a successful conclusion many important negotiations on behalf of the hospital. These included the placement of the hospitals of Acquapendente and Viterbo under its rule and the incorporation of the property of the Hospital of Castel della Pieve. But it does not appear that he took any initiatives of an artistic sort,[2] unless it was the rather peculiar stipulation contained in his will, where he asks that his heirs, one of which was the hospital (to which he left even that part of his income not yet collected, amounting to at least 2,500 florins) "faciant fieri eorum sumptibus tres immagines stature hominis ad similitudinem, cum pallio longo et bireto ad usum ipsius testatoris, et illas ponant videlicet, unam penes Numptiatam Hospitalis, et aliam alla Madonna della Fonte et unam alla Madonna di Camollia." Hence we know that Capacci wanted three statues of himself wearing the long robe and beret in which he was accustomed to be seen—apparently the uniform of a rector of the hospital—in three different locations. We can further suppose that, to the generosity which

---

*Translator's note:* The term *capaccio,* literally, a "large, bald head," has through usage come to mean a stubborn, pig-headed person. Hence the pun—the Capacci arms represented by a pig's head—to which Carli alludes.

characterized him and earned him most honorable funeral rites, he added the desire to leave a memorial to himself. His wish that one of the two hospital panels carry his coat-of-arms corresponds to what is expressed in the will.

As far as the authorship of the panels is concerned, one thinks immediately of the two very agreeable putti holding up a coat-of-arms that surmounts the marble sepulchre of Tommaso Piccolomini del Testa, Bishop of Pienza and Montalcino, in the Duomo of Siena (fig. 2.5). The bishop died in 1483 and the sepulchre, commissioned by his brothers Angelo and Giovanni on March 10, 1484, from Vito di Marco and Lucillo di maestro Marco, came to be assigned on February 4, 1485, because of the death of Vito and the departure from Siena of Lucillo, to "maestro Neroccio di Bartolomeo di Neroccio, maestro scultore" who contracted to complete the work in six months and who signed it OPUS NEROCII PIC-TORIS."[3] Neroccio signed his name in such a way in order to underscore his double capacity as sculptor and painter, just as his teacher Maestro Lorenzo di Pietro, called "Vecchietta," called himself a sculptor when he signed his pictorial masterpiece, the altarpiece of the *Assumption* in the Pienza Duomo, and called himself a painter on the base of the wooden statue of *San Bernardino* which was in Narni and is now in the Bargello in Florence!

It is superfluous to underline the great resemblance between the three pairs of putti—the two pairs on each of the stucco panels and the pair on the Piccolomini monument—even though the first two are in relief, are winged (and are therefore little angels or Cupids), and are made of stucco whose modeling is obscured by overpainting, while the third is made of marble carved in the round. The putti of the panels are a bit more slender, but the body structure is the same; the little eyes appear finely incised in all three, and the arrangement of the hair in short, curved locks which expose part of the temples is similar. Although putti and cupids were among the most widespread motifs of the ornamental repertory of the Renaissance, the most famous examples of them in Siena to which Neroccio could have turned for inspiration for his panel putti— and especially for the two uppermost pairs under the festoons—are the bronze ones of Donatello which crown the tabernacle of the baptismal font in San Giovanni.

The other motifs of the panels, even if they do not have an exact counterpart in Neroccio's work, completely fall within his decorative taste. The two volutes above the coats-of-arms echo, with greater exuberance, those of the capitals on the pilasters of the Piccolomini monument (compare fig. 2.3 with fig. 2.6). The festoons of fruit and flowers with fluttering ribbons, another common motif, adopted with great sobriety and subtle elegance in the architrave of the Piccolomini monument (fig.

2.6), find instead a more precise precedent in those painted high on the wall between the two beams in the church of the Annunziata alla Scala—some remains of which have been recovered—during a campaign of enlargement begun in 1466.

Since I do not doubt that the two panels were executed in Neroccio's workshop during one of Messer Salimbene Capacci's rectorships, it remains to be seen what, if any, relations the artist had with the hospital. Various documents to this effect exist, documents that refer, however, to the period in which Capacci, having already been removed from office, had been succeeded in his role as rector by one of the Noveschi, Messer Cino di Checco Cinughi. The first document, in fact, is dated October 23, 1480, and is a credit of four *ducati larghi gravi* for an unspecified service. On November 14 and 18 of the same year, there follow items relative to the purchase by Neroccio of a house on the hospital piazza, on the side near the bishop's residence where Vecchietta had had his shop, and mention of an altar-panel in relief left unfinished by Vecchietta, which was due to go to Lucca, "overo in quello di Lucha" (or to the zone called Lucca) and which cost him 36 florins, of which half had to be paid immediately and the rest after eighteen months.[4] This debt of 18 florins to the hospital figures, in fact, in the *Denunzie dei Beni* of 1481, after which there is no longer any record of Neroccio in the hospital registers. But one cannot say that because of the absence of his name the artist did not work for the hospital after that date. The silence of the documents in this case can be explained by the fact that, if the two panels, as is probable, were a gift made by Capacci to that institution during his second, long rectorship, their payment would have had to have been made directly by the patron and for this reason was not an item for registration.[5]

Translated from the Italian by Emily Procaccini.

# NOTES

1. Not even the brief but accurate guide of the *RR. Spedali Riuniti di S. Maria della Scala* (Milan: Alfieri & Lacroix, ca. 1913, probably compiled by G. De Nicola) mentions it.

2. For reference to these facts and other information, see Luciano Banchi, *I Rettori dello Spedale di S. Maria della Scala di Siena* (Bologna, 1877), pp. 132–35 and 139–43.

3. See the pertinent documents, republished and collated with the originals, in Gertrude Coor, *Neroccio de' Landi 1447–1500* (Princeton: Princeton University Press, 1961), pp. 147–49.

4. For this panel, damaged in some areas, which is now in the National Museum of the Villa Guinigi in Lucca, see Enzo Carli, "Vecchietta e Neroccio a Siena e in 'quel di Lucca,' " *Critica d'arte* 1 (1954): 336–54, and then in *Museo Nazionale di Villa Guinigi* (catalogue; Lucca: Ente provinciale per il turismo, 1968), pp. 158–60.

5. The practice of making bas-reliefs in stucco, and even in papier-mâché, from molds in Neroccio's workshop is evidenced by the *Madonna and Child* in polychrome stucco in the Museo d'Arte Sacra in Grosseto, duplicated by those of the Bardini Museum in Florence (stucco), of the Berlin Museum (papier-mâché) destroyed in the last war, and one in the Princeton Museum (papier-mâché), for which see Enzo Carli, *Arte Senese nella Maremma grossetana* (Grosseto: Associazione "Pro Loco," 1964), p. 43 and fig. 38. I am not familiar with the similar composition, a copy of a relief by the artist, in polychromed wood, formerly in the Perkins collection in Assisi, listed by Coor *Neroccio*, p. 161. Other stucco reliefs by Neroccio or his workshop are in the Chicago Art Institute (Coor, p. 164) and in a shrine in Via Paglaresi, Siena (Coor, p. 188).

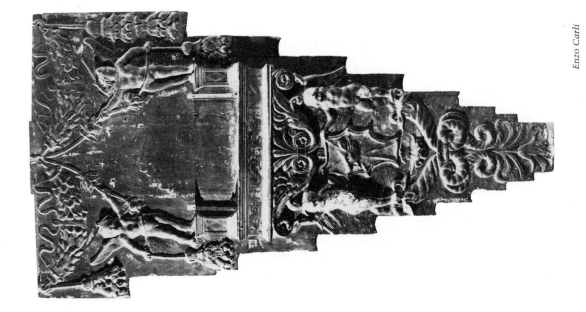

2.1 Neroccio di Bartolomeo, stucco relief. Ospedale di Santa Maria della Scala, Siena.

2.2 Neroccio di Bartolomeo, stucco relief. Ospedale di Santa Maria della Scala, Siena.

2.4 Detail of figure 2.1.

2.3 Detail of figure 2.1.

2.6 Neroccio di Bartoloemo, detail of Tomb of Bishop Tommaso Piccolomini del Testa.

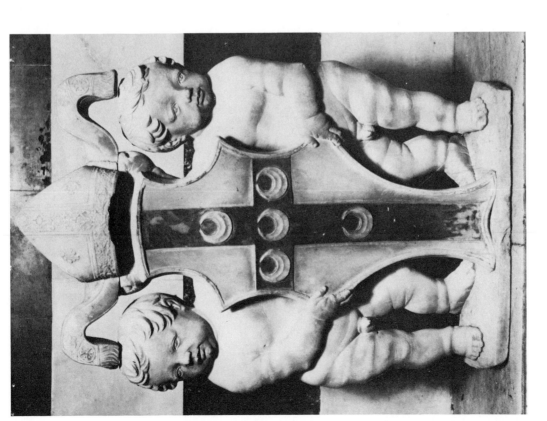

2.5 Neroccio di Bartolomeo, detail of Tomb of Bishop Tommaso Piccolomini del Testa, Siena, Cathedral.

# Rome

# 3. Filarete's Bronze Doors at St. Peter's

## A Cooperative Project with Complications of Chronology and Technique

*JOHN R. SPENCER*

THE CENTRAL DOORS OF ST. PETER'S BASILICA were one of the major collaborative sculptural projects of the first half of the fifteenth century in Rome. They are also one of the five sets of bronze doors executed during the fifteenth century in all of Italy. The project was extremely important, for Pope Eugene IV apparently saw in it the possibility of restoring the central Porta Argentea of the Constantinian basilica to its original splendor and thus of expressing the return of the papacy to Rome. The revised program went even further to celebrate the primacy of the papacy in matters both temporal and spiritual by the insertion of *istorie* depicting the pope's dealings with emperors and the union of Latin and Eastern churchs.

The nature of the project imposed unique requirements not found in other collaborative projects in Rome either in stone sculpture or in architecture. There were stone carvers and masons in sufficient numbers to carry out most of these projects. The doors of St. Peter's, however, required a bronze foundry capable of making very large relief castings, executing a large number of casts, cleaning and chasing these castings, and finally assembling the whole as a set of bronze doors.[1] There were few foundries anywhere in Italy equal to such an immense task.

Antonio di Pietro Averlino, better known by the soubriquet of Filarete that he has acquired in the literature, was placed in charge of the project. He must have been associated with the casting of the bronze tomb-slab of Martin V, since he alone in the 1430s seems to have been capable of casting a relief of that size. It may even be that he was brought to Rome by Donatello and Michelozzo as their foundryman, since it is highly unlikely that Pope Eugene IV would have entrusted a project of

such importance to an untried artist unless he were both present in Rome and allied to a major sculptural shop. Whatever the reasons, Filarete received the commission and, with characteristic optimism, set about the monumental task.

The study of Filarete's doors has been handicapped for centuries by Vasari's condemnation of them and by their condition. Since Vasari is not infallible in matters of taste, an unbiased approach reveals some remarkably fine passages for such an early date, and what may also be an early and conscious archaizing style. Until 1962 it was virtually impossible to see the doors. Lazzaroni and Muñoz's monograph[2] relied on radically foreshortened photographs that often revealed only centuries of corrosion and grime.

With the cleaning of 1962 the doors again emerged;[3] but they have suffered. There are breaks in the frame that may have occurred at the time of the rehanging in 1619.[4] The kneeling Pope Eugene in the Saint Peter panel has received a blow that gives the pope a second pupil and a most reptilian eye. The soft paste enamels are almost completely eroded. In his *Treatise on Architecture,* Filarete implies that the doors were gilded, but there were no traces of gold found in the cleaning.

What did emerge in 1962 was most revealing. The chasing, the repairs, and the impressive size of the castings were clearly visible. After the cleaning, these doors assumed a new importance for our understanding of fifteenth-century bronze sculpture and of collaborative projects. Questions that had seemed of minor concern now became more compelling. A recognition of the exact contribution of each worker in the shop is probably impossible to achieve, but one can now observe the wide variations in their contributions. It is also possible to recognize that the finished work is a collaborative effort, with all the strengths and weaknesses inherent in such a project.

At the same time, it now becomes more important to know the chronology of the project with greater precision. The traditional dates of 1433 to 1445 represent a great deal less time than Ghiberti required for his doors to the Baptistry in Florence. Filarete actually had less than twelve years to devote to the task. He experienced longer delays and greater pressures than his contemporaries and executed much more difficult castings where the chance of failure was great. A closer look at St. Peter's doors may aid our understanding of the project, and certainly it will increase our appreciation of Filarete's achievement, intervening criticism and the effects of time aside.

In the broadest terms, the central doors of St. Peter's basilica were begun around 1433 and completed by 1445. During the cleaning, the date DIE ULTIMO IULII MCCCCXLV emerged in the "signature relief" on the back of the left leaf. The date of August 14, 1445, found in the *Mesti-*

*canza di Paolo di Liello Petrone*,[5] which has generally been accepted as the completion date, can only refer to the hanging of the doors.[6] The date of the commission and the sequence of work are more difficult to determine.

A number of facts point to the year 1433 as the most likely date for the commission, and in all probability it occurred in the early part of that year. As Martinelli points out, 1433 was the only year when Eugene IV could think of art and building.[7] Donatello, Michelozzo, and "Bernardus architector" had all been engaged on papal projects and, according to Vasari's dubious testimony, the first two had been engaged at St. Peter's on decorations for the coronation of Emperor Sigismund.

Filarete makes two references, one visual and one textual, to the coronation of the Holy Roman Emperor. In the treatise he states, "I too have seen some large men, like Niccolò of Parma who was with the Emperor Sigismund when he came to Rome to be crowned in the time of Eugene IV."[8] Although the emperor left Feldkirch on the evening of October 28, 1431, he did not enter Rome until May 28, 1433.[9] He paused in Milan in November of 1431 to be crowned with the Iron Crown at Monza, and wintered in Piacenza. A slow progress through the mountains by way of the La Cisa Pass and Pontremoli brought him to Lucca in July 1432. He crossed the Arno at the castle of Santa Maria in Trebbio (near Pontedera), bypassed Volterra on the west, and entered Siena through the Porta Camollia on July 12, 1432. He remained in Siena until April 25, 1433. After the coronation, he left Rome on August 13, 1433, and passed through Perugia, Urbino, Rimini, Ferrara, Mantua, and Trento, to Basle, where he arrived on October 11, 1433.[10] In brief, Filarete could not have seen this giant, Niccolò of Parma, in Florence; he could only have been seen in Rome, during the emperor's leisurely but cautious avoidance of Florentine territory as he entered Italy, or during his rapid departure.

Filarete's knowledge of the coronation of Emperor Sigismund is so complete that he must have been an eye-witness to it. He has chosen to depict on the doors both the actual coronation and the return of the emperor, accompanied by the pope, to his quarters in Castel Sant'Angelo. Stefano Infessura describes the return in this manner: "Eodem anno (1433) die ultima maii fo incoronato lo imperatore in Santo Pietro da papa Eugenio, et fo lo dì di Pasqua rosata, et gio poi ad Santo Ianni Laterano, et papa Eugenio si li fece compagnia per fino ad piazza Castello, et poi lo papa tornao allo palazzo suo . . . quali stanno scolpiti nella porta di metallo di Santo Pietro a mano dritta quando s'entra."[11]

The relief, actually on the left leaf, depicts the crowned emperor and Pope Eugene (with a punched legend PAPA EUGENIUS IIII near his head) approaching a building upon which hang the papal and Condulmer arms (fig. 3.1). The mounted man is identified by a punched legend as

Antonius de Riddo C. Behind him stands the "giant." It would appear to be a carefully observed event, yet an event that was probably not immediately recorded in sculpture. The legend under Antonio da Rido is an anachronism. He was not made castellan until May 1434 and did not obtain full control of the Castel Sant'Angelo until Baldassare Baroncelli di Offida, commandant of the presidio (lower part), was named senator on January 12, 1435.[12] If, as I shall attempt to demonstrate, this and the three other long, narrow reliefs were not cast until around 1443, it is understandable that Filarete would fail to remember that this man who was so powerful in 1443 was not already castellan in 1433. All evidence points, however, to Filarete's presence in Rome on August 31, 1433. If he had already received the commission for the bronze doors, the scene would have made a strong impression on him. In any case, subsequent events made it difficult if not impossible, for him to begin the work.

The rapidly deteriorating political situation surrounding Pope Eugene IV must have caused delays in the project from the outset. Although a peace treaty was signed by Emperor Sigismund, the pope, Florence, and Venice in 1433, Filippo Visconti ostensibly released his two favorite *condottieri*, Francesco Sforza and Piccinino, to make war on their own account. During 1433, Sforza conquered city after city in the Marches and by March 1434 had taken Todi and entered the Patrimony. The Pope thereupon issued a Bull on March 25, 1434, naming Francesco Sforza *Gonfaloniere della Chiesa* and confirming his holdings.[14]

The situation in Rome deteriorated rapidly. Piccinino arrived at the gates on May 29 in support of antipapal factions. On June 4, the pope fled Rome and the Vatican and Trastevere quarters were sacked. By October of the same year, however, Bishop—and later Cardinal—Giovanni Vitelleschi entered Rome with the help of troops on loan from Francesco Sforza to put down the rebellion. By August 1436 he had effectively crushed the Colonna faction by capturing and demolishing its stronghold in Palestrina. By the spring of 1437 he had also crushed the Savelli and other rebel families. Because of all this activity between early 1434 and early 1438, Rome was no place for an artist with a papal commission. There are, in fact, indications that Filarete left Rome during precisely this period.

In his treatise, Filarete refers to two events datable to this period. One is to a type of suspension bridge built by Francesco Sforza at Todi. The other is to a theft of jewels from a reliquary in the Lateran.[15]

The bridge at Todi can be dated with some precision. In the capitulation document of March 12, 1434,[16] the twenty-eighth item deals with a request that Francesco Sforza should cede 400 florins a year from his income to rebuild "le ponte de cuti," that is, the bridge at Montecuti over the Tiber, which had been begun and one pier set. The bridge would

be to the count's advantage, for he could pass over it quickly to go into the Patrimony or wherever he wished. Sforza stated that he needed more information and would decide later. On October 1 the same request was made in the same form, and on October 9 it was granted.

By October the count needed a bridge to outflank Fortebraccio and to support Vitelleschi's advance on Rome. A temporary bridge, using the existing pier, was made of large ropes or cables and, because it was unusual, it was a great surprise to all who saw it. The troops passed quickly over and defeated Fortebraccio near Camerino.[17] Since a bridge of this sort could only have endured for a short period of time, Filarete must have seen it shortly after its construction. He may have been in Todi seeking work on the portal of San Fortunato or perhaps hoping that he might design a fitting monument to Jacopone da Todi, whose bones had been rediscovered the preceding year. A single reference to a temporary bridge is indeed tenuous documentation for Filarete's absence from Rome, but given the situation in Rome and the ease with which he entered Francesco Sforza's service in Milan, it is not unlikely that he was in Todi, and probably, during the Gonfaloniere's brief residence there between March 1434 and November 1435.

By 1438 Filarete had returned to Rome. His reference in the treatise[18] is quite clear. The theft of the jewels occurred in April of 1438. The three thieves were arrested in August, exposed in a cage in the Campo dei Fiori in early September, and finally executed in the Piazza San Giovanni in Laterano on September 18, 1438.[19] The political situation was much improved. Francesco Sforza had defeated the Visconti forces under Piccinino near Lucca and had transferred his operations into Lombardy. By early 1438 he had concluded an agreement with Visconti which promised him Bianca Maria Visconti as his wife. The pope was in Florence and the council with the Greeks was about to begin. The council in Basle had lost all force, and Vitelleschi's pacification efforts in Rome were so successful that by 1439 the pope was able to begin sending funds to Rome for the repair of the Lateran palace.[20] It was an atmosphere in which Filarete could get back to work.

Despite the new environment in Rome, there are indications that Filarete was again absent from at least June through November of 1439. As the ecumenical council with the Greeks was drawing to a close, Eugene was able to enlarge his concept of the bronze doors. Indicative of the pope's new sense of power are the legends engraved beneath Saints Peter and Paul on either leaf of the doors. Although one of the inscriptions must be dated after 1443, they both indicate the pope's state of mind as early as 1439. Beneath Saint Peter is engraved on the frame; SVNT HAEC EVGENI MONIMENTA ILLVSTRIA QVARTI EXCELSI HAEC ANIMII SVNT MONIMENTAS VIS. On the frame beneath Saint Paul is engraved: VT

GRAECI. ARMENI: AETHIOPES: HIC ASPICE: VT IPSA ROMANAM AMPLEXA EST GENS IACOBINA FIDEM.[21] Clearly the long, narrow panels served both to commemorate high points in Eugene's career and to celebrate his skill as a peacemaker with the emperors of both East and West and with the Eastern churches.

The depiction of the arrival and departure of the Greeks is so vague and general that there is little likelihood that Filarete saw them in Venice. His rendering of some of the more unusual costumes of the Greeks would seem to indicate, rather, that he encountered them in Florence or that he had access to drawings. The agreement between the Greek and Roman churches was signed by July 5, 1439, in Florence. The Armenians arrived before all the Greeks had left, sometime during the summer of 1439. Daily meetings in Santa Maria Novella led to union with the Armenians on November 22.[22] The Armenians had been brought to Italy in Genoese ships, and could have landed at any convenient Genoese port north of Pisa. They left as they arrived without passing through Rome, yet there is an inscription in perfectly correct fifteenth-century Armenian letters engraved on the upper frame of the Martyrdom of Saint Peter. Filarete could only have learned of Saint Gregory the Illuminator, who brought Christianity to the Armenians, and how to write his name in Armenian script from Armenians.[23] Perhaps the pope had called Filarete to Florence to hear a report on progress to date and to set the new expanded program. Filarete could have used the opportunity to meet with and study both the Greeks and the Armenians then in Florence. By 1443 he was again in Rome. One panel conforms to contemporary literary descriptions of the Jacobites' (Syrians') arrival in Rome from Florence in 1443. Their final agreement was not signed until September 30, 1444. When the Maronites and Nestorians signed an agreement on August 7, 1445, the doors were about to be set in place.

In summary, Filarete is clearly documented as having been in Rome in 1433. He probably left the city during the summer of 1434. Some time after October 1434 he was in the vicinity of Todi. By 1438 he was again in Rome, but spent part of the year 1439 in Florence, where he saw both Greeks and Armenians. Work must have reached a fever pitch from 1443 on. On March 7, 1443, Eugene IV left Florence and entered Rome in triumph on the following September 19. All of the long narrow "predella" panels refer to events prior to 1443. Whether the new program was set in Florence in 1439 or after the pope's return to Rome in 1443, it is clear that sections of the frame that had already been cast were broken out, and new long, narrow relief panels were cast to commemorate deeds of Eugene IV and were literally hammered into the new scheme. By July 31, 1445, the doors were completed and by August 14 they were in place.[24]

Although Milanesi[25] and others following him believed that the proj-

ect continued without interruption, the doors themselves provide a number of clues that reinforce the chronology derived from external sources. The color of the bronze varies widely within the total complex, suggesting that the melts were poured at different times. The four largest reliefs are blondest in their tonality. Certainly the pairs were cast from the same bronze, and perhaps all four. The frame is slightly ruddier than the large reliefs and is pretty much all of a piece in tonality. The martyrdom reliefs contain the most copper of all, and a repair on the upper right hand corner of the Martyrdom of Saint Peter is almost pure copper. The four predellae are about the same in tonality, although the Sigismund relief is slightly blonder than the others. At least four different melts can be visually observed; close chemical analysis might reveal even more. Differences in bronze do indicate different dates of pouring, although not necessarily different dates for the preparation of the wax models. In this case there does seem to be fairly close conformity between the stylistic progression in the doors and the different grades of bronze used for the reliefs.

The identification of some of Filarete's helpers on the doors seems also to indicate varying kinds of work mounting to great haste in the final months. Clearly "Varro" and "Iohannes" are seniors in the shop. In the signature relief on the rear of the left leaf, they follow the leader of the dance and, like him, wear the adult berretta. "Pasquino" falls between his elders and the last three who, by their dress and by their actions, must be the garzoni of the shop. If Milanesi and von Tschudi[26] are correct in identifying Varro with Beltrame, then Varro, since he was born in 1420, could not have come to work on the doors much before 1438. Unfortunately, von Tschudi was unable to identify Giovanni with any certainty, but he equates Pasquino with Matteo da Montepulciano and places his birth-date around 1425. Whatever the date he came to work on the doors, it must allow for his complete training in bronze; his later appearance in documents is as a bronze worker on such major projects as the Cappella della Cintola grill in Prato (1461–64). His assumed age, together with that of Varro, would suggest that a shop of six workers and a master was not really necessary until after approximately 1440.

The making of the wax models and their investiture do not require a large shop; the casting, cleaning, and chasing require as many hands as possible. The careful and highly detailed chasing of the four large reliefs (figs. 3.3–7) argues for an unhurried pace early on in the projects. By the time of the predella panels, the shop was under such pressure that a circle and a dot punch were considered adequate to define an eye. In the same way, the upper section of the two stiles of the right leaf were carefully engraved—perhaps to receive silver wire as at San Paolo fuori le mura—down to the level of the relief depicting the departure of the Greeks. When

the frame was broken at this point to receive the new relief, a decision was made not to continue the engraving. Since the engraving is totally lacking on the left leaf, we are provided with another chronological note and further evidence of the great amount of chasing still to be done in the closing years of the project.

The pace of the chasing and the presence of seven different hands make it impossible to identify the collaborative role of any individual shop member. A closer look at details of some of the panels does serve to indicate to what degree the collaborator can alter the intent of the master.

The importance of chasing in fifteenth-century bronze casting cannot be overemphasized. Although the wax may have been meticulously rendered, the bronze that came from the mold must have been the roughest of casts. In his treatise Filarete invariably refers to these doors as "carved." The mark of the chisel, file, and burin are so frequently met with in the reliefs that his statement must be taken almost literally.

The quality of the modeling and chasing in some sections is really quite remarkable. Although the acanthus swags and rosettes of the frame are all crisply modeled, the cluster of acanthus at the base of the left (fig. 3.2) and right leaves of the doors are surely as fine as any executed this early in the fifteenth century. The mermen presenting Filarete's self-portrait medal directly above the cluster of acanthus, or the griffins in a comparable position on the right leaf, indicate a solid knowledge of ancient Roman sculpture and the ability to translate that knowledge into the new idiom. The rapid shift in scale from acanthus to the bird to the story of Mercury and Argus is bothersome to modern eyes. It may also indicate the nature of the collaboration, for the scale on the right leaf is more coherent in the comparable area.

It is in the large panels, however, that Filarete and his shop demonstrate their abilities. The panel with the seated Christ contains the greatest degree of both actual and illusory relief of all the four large panels (fig. 3.3). The massive claw feet of the throne and the heavy leaves and rosettes have actual as well as fictive projection. The treatment of surfaces also heightens the relief. Filarete is clearly not interested in the quasi-perspective space of Ghiberti's second doors or the schiacciato of Donatello. He seeks, rather, a middle way in which the back plane is clearly stated and in which a shallow box of space is created to contain the figure or figures. Occasionally they emerge from this box. It is a way of conceiving the relief that he could have learned from the reliefs of Michelozzo's Aragazzi tomb or from ancient Roman relief. In this respect, he anticipated developments in later fifteenth-century sculpture and must have had an impact, particularly on those sculptors who worked in Rome.

The basis for the old assumption that Filarete was trained in a goldsmith's shop probably rests on the degree and amount of chasing on these

doors. Actually, it is not much different in kind from the boots of Donatello's bronze *David*; it only differs in quantity. A detail of the head of Christ (fig. 3.4) will serve to give some notion of the almost obsessive working of every square centimeter of surface. A fine punch was used to roughen the surface of the background, allowing the Condulmer arms and papal rose to stand out in a pattern that suggests brocade. One set of punches is used for the turned-back lining of the outer robe, another for the undergarments; another punch defines the Cufic lettering of the nimbus. A burin defines the pattern on the sleeve, the fringe of the robe, and hair of face and head. A broader burin or chisel defines fingernails, fold of the finger joints, and crows' feet at the corners of the eyes. The three visible arms of the nimbus were enameled in a dark red, possibly with local application of heat. Similar detailed chasing, but for different effects, can be seen on both the heads of Saints Peter and Paul (figs. 3.5 and 3.6), where enamels are also employed. The great extremes to which the shop was willing to go in defining textures and in creating detail invisible to anyone entering through the doors is perhaps best seen in the *Vas electionis* in the Saint Paul panel (fig. 3.7).

Some of the problems inherent in bronze sculpture and the solutions of Filarete and his shop can perhaps best be seen in the analysis of two details. In the Martyrdom of Saint Paul panel, the Roman emperor is seated in an edicula. The base of the lefthand pilaster contains the head of Nero, which looks much like an impression made from a Roman cameo.[27] Air bubbles trapped in the molten bronze are clearly visible. The marks of a chisel that removed excess bronze are to be seen to the left of the head, as well as of a burin defining the base. File marks can be seen on the molding above. Clearly the casts required many man-hours of work to bring them to their present state.

Failure of the cast presented even graver problems. The upper righthand corner of the Martyrdom of Saint Peter failed in the casting (fig. 3.9.) Modern bronze founders have a technique by which a dam is erected along the line of failure, the failed section is recast and the new molten metal fuses old and new together. Filarete used a somewhat similar technique but the line of juncture is still clearly visible passing alongside the capital of the central pilaster, through the Triumph of Bacchus relief, to the edge of the frame, where hammer and chisel marks still remain. The bronze of the repair has a much higher copper content than the body of the relief. It was easier to carve directly on it, but it was also more subject to damage.[28] Since the relief is placed low on the door and clearly visible, it was necessary to go to some effort to complete the cast. Higher on the doors, where the "predella" panels were let in, new bronze was hammered into place and carved directly. Both the nature of the direct carving and the haste to finish the doors contributed to the low quality of these figures.

The results of haste can be seen most clearly by comparing a section of

the Departure of the Greeks (fig. 3.10) with the Return of the Emperor Sigismund to his Quarters (fig. 3.1) or, for greater contrast, with the head of Christ (fig. 3.4). In the Sigismund panel there is a concern with the musculature and stance of the horses which is lacking in the Departure of the Greeks. The care for differentiating textures in Sigismund becomes simply an overall pattern in the Departure. Clearly, the large panel of Christ must have been cast early when there was still time for intricate and careful chasing. The "predella" panels were not only the last panels cast, they were also the least carefully worked.

The wide variety that exists in the chasing of the doors can best be seen by comparing five medallic profile heads from the frame of the doors.[29] The problem of attempting to differentiate between the various hands involved in the chasing is complicated by the chronology of the doors. Since this is Filarete's first datable work, we have no way of determining what abilities he brought to the task. It is possible that he learned as he went along. It is also possible that some of his assistants improved in the same way. Two of the seemingly earliest heads can be found in the frame on either side of the Virgin Mary (figs. 3.11 and 3.12). Both have the kind of textile background that was abandoned at the base of this large panel. They are quite different in execution of hair, eyes, nose, and mouth. The one on the left (fig. 3.11) makes an attempt to create a shift in plane at the jaw-line, but neither attempts to suggest neck muscles.

The "modern" head from the left stile of the left leaf (fig. 3.13) is different still. It has been called a self-portrait, but it bears no relation to the self-portrait medal let into the frame at the base of the Martyrdom of Saint Paul. The latter medal is signed and dated 1445 and depicts a person so much younger than the head on the frame that the "self-portrait" designation should be discarded. In the "modern" head of the frame, there is at least greater concern with the musculature of the face, which tends also to be true of Filarete's identifiable medals.

Two emperor heads differ from each other and from the other three already illustrated (figs. 3.14 and 3.15). The one from the left stile of the left leaf (fig. 3.14) is imposed on the acanthus curl whereas the others have been contained by it. It shows much greater skill in working the wax and the bronze to model the surfaces. The emperor from the right stile, however, goes even further in the modeling (fig. 3.15). A small repair in the bronze seems to have been used by this sculptor to emphasize the profile of mouth and chin.

Although the position of these five heads on various parts of the frame on both the right and left valves could point to a stylistic development of Filarete over time, it is more likely that they represent the collaboration of various individuals in the shop. The modeling of the frame might have been spread over a period of time, but it is clear that the members of the frame

were all cast at the same time. It is equally clear that the cast was very rough when it emerged from the mold and that it required the kind of carving seen around the Nero head (fig. 3.8). In such circumstances, the skill and the interpretation could serve to explain the differences in quality and execution on various parts of the doors.

In a major bronze collaboration of any century the two problems that have been encountered in this study of the bronze doors of St. Peter's will almost surely emerge. It seems to me essential to know, not only the beginning and ending dates of a project, but also the amount of time actually available for work. Filarete and his shop were certainly interrupted by external causes. They also began the work at a leisurely pace which then quickened under papal pressure. All the members of the shop must have been under great pressure to complete the cleaning and chasing. Each contributed according to his skill and each left his impression on the completed work. In any major bronze project the intent of the master who executed the model is concealed to a greater or lesser degree by the craftsmen who actually wielded the file and the burin. To this extent the bronze doors of St. Peter's are highly instructive for our understanding of collaborative projects, as well as a clear warning against oversimplification.

One unexpected discovery made during the cleaning of the doors of St. Peter's may be suggestive for a better understanding of Renaissance taste. I have already mentioned that at least four different colors of bronze are observable in the doors. When they were stripped of their patina, every repair to the casts made by Filarete became visible. There were bronze strips let into sections of the frame to fill holes, keys to join sections of the frame together, and both round- and square-headed nails to attach the reliefs to the pine core of the doors. The largest reliefs were pocked with small lead plugs to fill the largest air bubbles.

It is highly unlikely that Filarete would have wanted or have been permitted to set up such a coloristic patch-work in such an important position. These doors were to replace the Porta Argentea. They are the doors through which the pope passes on entering or leaving the basilica. They must have received an artificial patina to unify them and to conceal the repairs. Thus, they would have become instant antiques, with all the color and softness of age. It would seem that, in this case at least, artist and patron were concerned with the totality of the work and its overall appearance. They were not above applying a cosmetic patina to achieve that end, and perhaps they were not the first nor the last in Renaissance Italy to make such a decision.

# NOTES

1. The doors include two reliefs (Saints Peter and Paul) each 2.2 meters high by 1.03 wide, two reliefs (Christ and the Virgin) 1.70 by 1.03, and the two Martyrdom reliefs, 1.03 meters square. The reliefs are surrounded by frames which bring the dimensions of each leaf to 6.30 meters by 1.79 or 6.30 by 3.58 for the pair, excluding the seventeenth-century enlargements top and bottom. The oak frame of the doors was probably added in the seventeenth century. The fifteenth-century bronze is attached to pine.

2. Michele Lazzaroni e Antonio Muñoz, *Filarete, scultore e architetto del secolo XV* (Rome, 1908).

3. Through the good offices of the late Luke Hart, I was the recipient of a grant from the Knights of Columbus which permitted me to have photographs made of the doors after the corrosion had been removed and (with a few exceptions) before a new patina was chemically applied. These photographs, made by Foto Vasari, Rome, have recently been released.

4. Tiberii Alfarani, *De Basilicae Vaticanae,* ed. D. Michele Cerrati (Rome, 1914), p. 11, n. 2.

5. Ludovico Muratori, ed., *Rerum italicarum scriptores*, Vol. 24, Col. 1128. "Sabbato a di XIV del mese di Agosto furo poste nella porta principale di Santo Pietro le Porte di metallo." Hereafter cited as R.I.S.

6. In 1962, work on the doors was hurriedly completed so they could be set again in place for the beginning of Holy Week. The same sort of urgency must have been felt by Filarete. July 31 is followed the next day by an annual pontifical mass at San Pietro in Vincoli and by the exhibition of the chains of Saint Peter. August 14 is followed by the Feast of the Assumption on the 15th.

7. Valentino Martelli, "Donatello e Michelozzo a Roma," *Commentari* 8 (1957):178. Eugene IV had been elected on March 3 and enthroned on March 11, 1431. He almost immediately encountered problems both within Rome from the anti-papal factions and outside Rome from the Council of Basel. See Conrad Eugel, *Heirarchia Catholica Medii Aevi sive Summorum Pontificum, S. R. E. Cardinalium, Ecclesiarum Antistitum.* (n.p., 1901), p. 7.

8. *Filarete's Treatise on Architecture,* J. R. Spencer (New Haven: Yale University Press, 1965), p. 7. Hereafter cited as *Filarete.*

9. *Deutsche Reichstagsakten unter Kaiser Sigmund,* sect. 4, ed. Hermann Herre, Vol. 10 (Gotha, 1906). See especially pp. 141–43 and 728.

10. Ibid.,11: 2–7.

11. Stefano Infessura, *Diario della città di Roma,* ed. Oreste Tommasini (Rome, 1890), p. 30.

12. Pio Paschini, *Roma nel Rinascimento, in Storia di Roma* (Bologna, 1940), 11: 132, 137.

13. Ibid, p. 150. He remained in the pay of Pope Nicholas V but gave up the Castel Sant'Angelo in April 1447, (ibid., p. 171). He died in 1475 and is buried in Santa Francesca Romana. His tomb is marked by a large marble relief which derives from the relief on the doors.

14. Pietro Candido Decembrio, *Vita Francisci Sfortiae, in R. I. S.* ed. Muratori, Carduci, et al. (Bologna, 1935) 20: 645. The reconfirmation, signed in Florence on November 29, 1434, is preserved in Archivio di Stato, Milan (hereafter cited as ASM), Archivio sforzesco 20 (Conte Francesco Sforza, Carteggio generale), fasc. 21.

15. *Filarete,* pp. 168 and 178 respectively.

16. ASM, Archivio sforzesco 20 (Conte Francesco Sforza, Carteggio generale), fasc. 18.

17. Ambrosiana, Milan. Class Z Sup 226, manuscript of Corij, *Patria Historia,* vol 3, *sub anno* 1434. Similar events are narrated by Giovanni Simonetta in his *Historia de rebis gestis Francisci Sfortiae, in R. I. S.,* Vol. 21, col. 237.

18. *Filarete*, p. 178.

19. Infessura, Diario, pp. 36 ff., and Paolo di Liello Petrone, *R. I. S.*, col. 1120.

20. Paschini, *Roma nel Rinasimento*, p. 157.

21. See also J. M. Haskinson, "The Crucifixion of St. Peter: A Fifteenth-Century Topographical Problem" *Journal of the Warburg and Courtauld Institutes* 32 (1969): 135–61; especially p. 156 and appendix 2.

22. Joseph Gill, S. J. *Eugene IV, Pope of Christian Union*, (Westminster, Md., 1961), pp. 134–35.

23. The accuracy of the inscription has been verified for me by members of the Armenian College in Rome and by Sirarpie der Nessesian *in litteris* as being fifteenth-century as well.

24. Further evidence of Filarete's presence in Rome in 1445 can be derived from the treatise *Filarete*, p. 7, where he refers to a second giant. The date of April 1445 is provided by Paolo di Liello Petrone, *Mesticanza*, col. 1126.

25. Giorgio Vasari, *Vite*, ed., Milanesi 2: 454.

26. Hugo von Tschudi, "Filarete's Mitarbeiter an den Bronzethüren von St. Peter," *Repertorium für Kunstwissenschaft* 7 (1884): 291–94.

27. The reclining figure atop the entablature clearly derives from recumbent antique types and is not unlike those on Ghiberti's second doors. It is much worn from handling. Local legend has it that it represents the son of one of the Sampetrini, who used to follow his father to work high up in old St. Peter's. He also had the habit of sleeping on the entablatures. One day he turned over in his sleep and fell to his death. He is said to be commemorated here, and the Sampetrini are still said to touch the boy for luck.

28. All are of medal size and range from 120 to 140 mm., with an average of 135 mm.

3.1 Filarete, bronze doors, St. Peter's, Rome. Detail showing Emperor Sigismund returning to Castel Sant'Angelo.

3.2 Bronze doors, detail of left leaf, bottom rail.

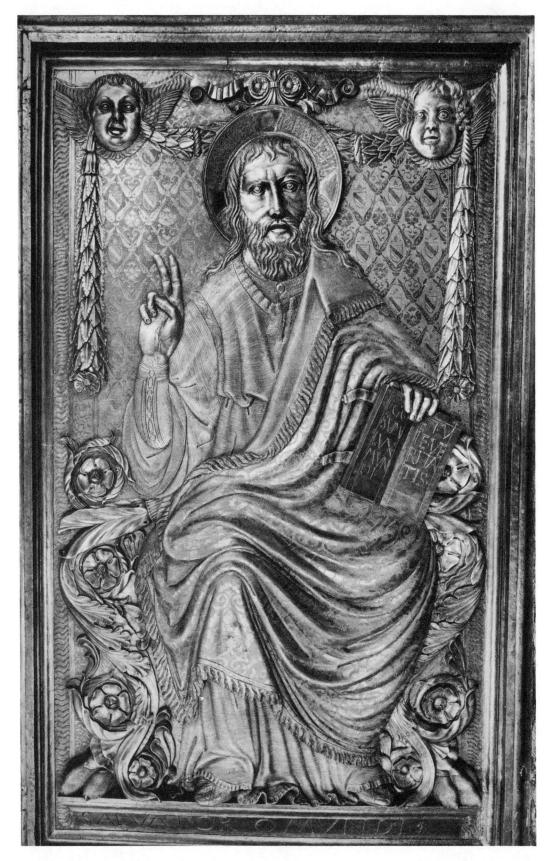

3.3 Bronze doors, detail of left leaf, Salvator Mundi panel.

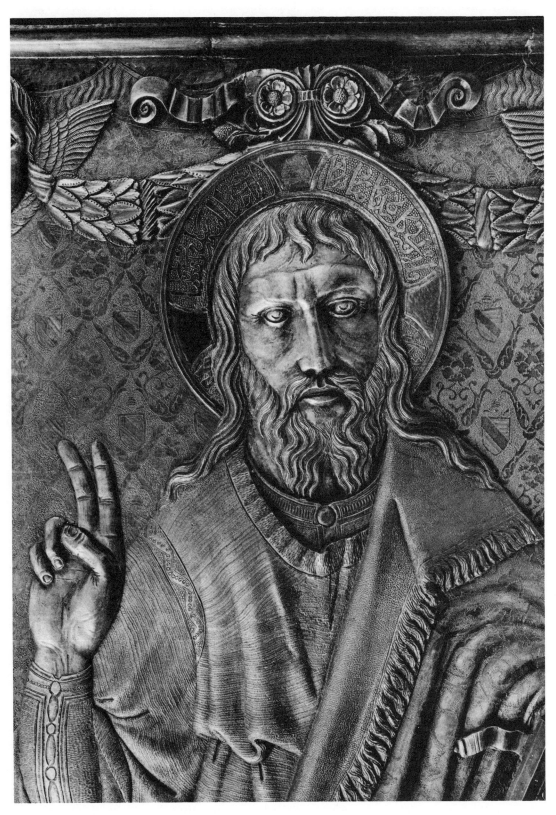

3.4 Detail of figure 3.3.

3.5 Bronze doors, detail of right leaf, head of Saint Peter.

3.6 Bronze doors, detail of left leaf, head of Saint Paul.

3.7 Bronze doors, detail of left leaf, Vas electionis
from Saint Paul panel.

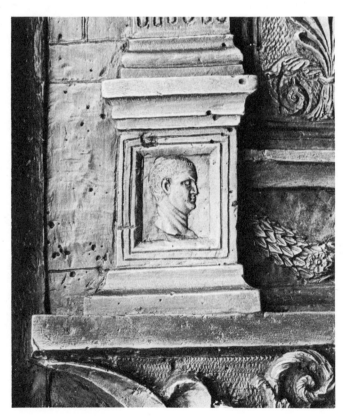

3.8 Bronze doors, detail of left leaf, Nero from Mar-
tyrdom of Saint Paul.

3.9 Bronze doors, detail of right leaf, failed casting in Martyrdom of Saint Peter panel.

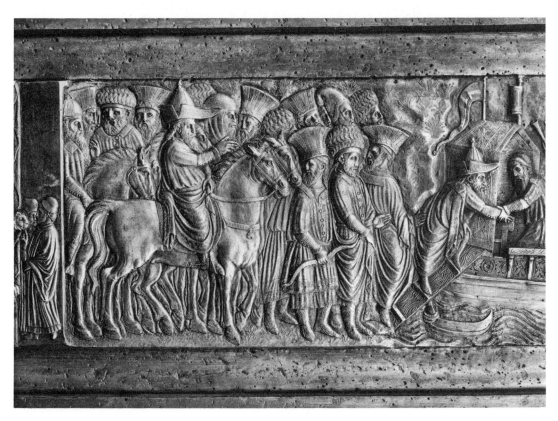

3.10 Bronze doors, detail of right leaf, Departure of the Greeks.

3.11 Bronze doors, detail of right leaf, wreathed
male head, left stile.

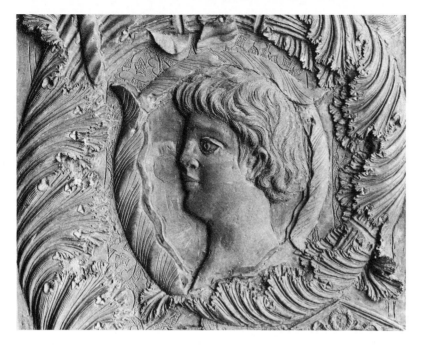

3.12 Bronze doors, detail of right leaf, youthful male head, right stile.

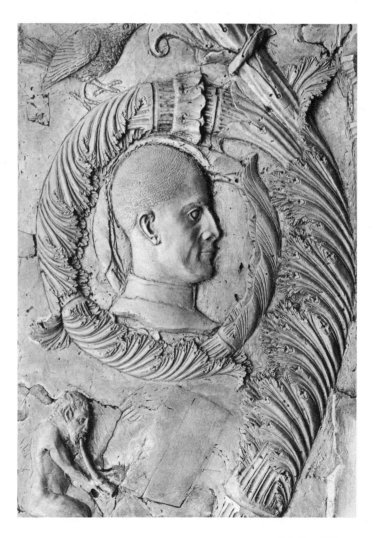

3.13 Bronze doors, detail of left leaf, "modern" head, left stile.

3.14 Bronze doors, detail of left leaf, emperor head, left stile.

3.15 Bronze doors, detail of left leaf, emperor head, right stile.

# 4. Two Roman Statues: Saints Peter and Paul

*ANDRÉ CHASTEL*

A LATE SIXTEENTH-CENTURY FRENCH DRAWING presents a view of the *Ponte Sant'Angelo* seen from upstream, and decorated with statues which anticipate Bernini's famous angels (fig. 4.1). Reminiscent of the décor for the triumphal entrance of Charles V in 1536, was this drawing an original project or a fantasy? No one knows.[1] The six statues atop the buttresses of the major piers are not identifiable, in contrast to the two statues at the head of the bridge: Peter and Paul, the saint with the key and the saint with the sword. These two figures may still be seen there today, but in poses which reverse the gestures indicated in the drawing. Saint Paul holds the sword heavenward, while Saint Peter has let his keys fall beside his cloak (fig. 4.2 and 4.3). This modification of the silhouette, deliberate or not, reveals at least that the statues were correctly identified and their importance understood.

The statues' origin is well known, thanks to Vasari. This presentation of the two founders of the church is a consequence of the Sack of Rome in May 1527. There were at the entrance to the bridge two chapels in commemoration of a tragic event (the drowning of pilgrims during the 1250 jubilee)—a frequent custom in the Middle Ages. They are shown in the fresco that depicts the miraculous appearance of Saint Michael at the Trinita dei Monti, as well as on the oldest maps of Rome, Foresti (1490) and Hartmann Schedel (1493) (fig. 4.4). These chapels were used as shelters by imperial marksmen in May and June of 1527, and they were damaged by the great flood of 1530; so Clement ordered that they be destroyed and replaced by two statues on pedestals. A statue of Saint Paul, which had been executed about 1460 on a Vatican commission but remained unused, was brought to the bridge and paired with a Saint Peter that had been ordered from Lorenzetto (fig. 4.2).[2] I have studied this curious procedure elsewhere,[3] and simply wish to indicate here, in homage to a close departed friend, the interest of the composition conceived

some years after the Sack of Rome, in which the *Castel Sant'Angelo* had played a decisive role.[4] Henceforth, when looking across this bridge from the city side, the mass of the fortress, surmounted by the new Saint Michael entrusted to Bandinelli by Clement VII, would have been framed between the two monumental statues; the whole, regrouped by perspective, would compose a sort of emblematic image of the divine protection of the Holy See.

The two saints Peter and Paul are constantly associated in Christian iconography, as they are in prayers.[5] Their association furnishes one of those binary groupings that are found everywhere, and lends itself easily to all kinds of compositions, painted or sculpted. A little panel by Domenico di Bartolo which is commonly dated at about 1430[6] is a good example of the treatment of the "two fathers" (fig. 4.6). Symmetrical, with the book of doctrine held in the right hand, the sword and the key respectively in the left hand, they frame the Madonna's throne. They appear to be its living pillars; and the position of these two figures on either side of the Child, unusual as it is, has a particularly imposing quality. These saints, who accompany the Madonna in most altar paintings, are witnesses associated with the divinity by devotion. Here they seem to respond to something fundamental: the Prince of the Apostles and the Apostle of the Gentiles encompass by their very presence the primitive history of Christianity. They reveal its divine foundation and its Roman vocation.

In altarpieces in which saints frame the Madonna, the composition takes on a certain solemnity whenever Peter and Paul appear on either side. In the *anconetta* of Lorenzo Monaco in Baltimore (fig. 4.7),[7] the two figures, which resemble living uprights, exchange looks as though neither one wished to yield to the other—a means of underlining their complementary character. This arrangement is so striking that one must wonder if the painter faced with the depiction of the two saints deliberately chose to emphasize them, to separate them, or, in this case, to preoccupy himself with them alone. In liturgical invocations, they precede all other names, and they alone connote the institution of the church. This is why, among the figures traditionally depicted on the panels of dalmatics, they are normally the first, and are often the only ones visible or identifiable since the artist places them at the base of the collar. On the dalmatic worn by Saint Augustine in an altarpiece by Giovanni di Paolo, in New York (fig. 4.8),[8] to cite one example among many, they are presented in this way. The two saints open, as it were, the hagiographic gallery, which appears on liturgical vestments as it does in traditional prayers.

When they are associated with other intercessors, as, for example, on the retable of the Jarves Collection, attributed to the "Pseudo Ambrogio

di Baldese," about 1420, Saints Peter and Paul are, of course, in the two places of honor, closest to the Madonna.[9] No conventions other than those of place and attributes are rigidly observed; features and drapery vary with style. It would be helpful to determine the possible relation of the sculpted Saint Paul of 1460 to painted models, which, as we have seen, were numerous in the second quarter of the Quattrocento. But knowledge of Roman workshops in the middle of the century is not precise enough to permit an answer.

The idea of placing effigies of the two intercessors at the head of the bridge was not an insignificant one. Should we suppose that the very etymology of the title *Pontifex* did not go unnoticed?—that it must have seemed satisfying to erect the figures of the two founding saints of the church at the entrance to the bridge which would henceforth be the most famous of Rome, that used by processions to cross from one bank to the other, and abundantly represented in images of the appearance of Saint Michael on the summit of the imperial mausoleum?[10] In any case, it was natural to evoke the two founders at an intersection where the historical grandeur of Rome and of the ecclesiastical institution of the church was associated with popular, familiar, or tragic memories.[11]

But around 1531 there was yet another, more precise reason to be interested in these two personages. Not only did their presence erase in a way the disaster of 1527, by purifying and transforming the area from which the impious troops had menaced the pope, but it also gave reply to the sarcasm and denunciations of the Lutherans and, more precisely, of the *Landsknechten*, who, as Heemskerck's famous print recalls (fig. 4.5), had challenged the pontiff at the head of the bridge, summoning him to yield to the Reformer.[12]

One might imagine that all these facts, disseminated throughout Christendom with the news of the Sack, were well enough known to everyone to give an appreciable interest to the double image of Peter and Paul. They may even help us to understand why Clement VII, according to Vasari's story, went searching in a Vatican storehouse for the abandoned statue by Paolo Romano. Lorenzetto, moreover, patterned his work after the slightly heavy style of his predecessor and produced a sculpture with a certain archaic attraction, which it is difficult to reconcile with its date of 1531–32 (see fig. 4.2). The resurrection of an old work of sculpture and the wish to restore it to use in some way along with a modern counterpart is very much in accord with the desire to make manifest both the antiquity and the continuity of the Roman institution of the Christian church. It is not the first time that an "archaic" orientation has been given to a work of religious restoration.

The choice of the two founders was also appropriate for another reason: it was important not to leave a monopoly of reference to Peter and

Paul to the Reformers. These two appear constantly in the frontispieces of the innumerable pamphlets and other short works which diffused Lutheran thought so successfully (fig. 4.9). There they represented Christ's doctrine, which the evolution of the church had modified over time. They were, in fact, the major figures to emerge from the great purification and simplification of religion to which the adversaries of Rome adhered.[13] For the Lutherans, the pair signified the will to "return to the sources," which entailed the elimination of the Roman authority. From the pontifical point of view, the erection of these two statues was an implicit rejoinder, in monumental style, to the Reformers' argument expressed in graphics, as well as a reaffirmation, from the doctrinal point of view, that the Roman See was more than ever under the patronage and particular protection of its "founders." These statues thus became an essential feature of the face of Rome "dopo il Sacco."

Translated from the French by Virginia E. Swain.

# NOTES

1. Attributed to Lafrery, ca. 1580. Berlin-Dahlem, Kupferstichkabinett. See Mark S. Weil, *The History and Decoration of the Ponte S. Angelo* (State College, Pa., 1976), fig. 17.

2. Giorgio Vasari, *Vita di Lorenzetto*, ed. Club del Libro (Milan, 1963), 4: 248. The same facts are given by Vasari in his *Vita di Paolo Romano*, 2:488.

3. In the volume devoted to the Sack of Rome, A. W. Mellon Lectures, 1977, at the National Gallery of Art, Washington, D. C.

4. Charles Seymour, Jr., *Sculpture in Italy 1400 to 1500*, The Pelican History of Art (Baltimore, Harmondsworth, 1966) explained how "Paul II had in mind the remodeling of the whole entrance front of St. Peter's with a 'benediction pulpit' similar presumably to that of the Lateran, and also with two colossally scaled figures of St. Peter and St. Paul to flank the monumental steps leading to the atrium." See also note 8, p. 244. But they were never put in place; see Adolfo Venturi, *Storia d'arte italiana*, Vol 6: *La Scultura del Quattrocento* (Milan, 1908), fig. 756/7, and Weil, Ponte S. Angelo, p. vi. The reuse of Saint Paul is explained clearly by both authors; yet they seem—erroneously—unwilling to believe the Vasari story of the destruction of the chapels for "military" reasons. Their existence prior to 1527 is indisputable, and Vasari's is one of the most plausible accounts.

5. Fern Rusk Shapley, *Paintings from the Samuel H. Kress Collection, Italian Schools, XIII–XV centuries* (London, New York, 1966), p.140, fig. 377.

6. Federico Zeri, *Italian Paintings in the Walters Art Gallery*, 2 vols. (Baltimore, 1976), vol. 1, no. 15, pl. 12. The text comments on the attitude of the Child but not on the presence of the two saints.

7. *Madonna and Child with Saints*, Metropolitan Museum, 32.100.76.

8. Yale University Art Gallery, 1871.22. See Charles Seymour, Jr., *Early Italian Paintings in the Yale University Art Gallery* (New Haven, London, 1970), pp. 112–14, with illustration.

9. For example, Beccafumi, predella panel for the retable of Saint Michael, Carnegie Institute, Pittsburgh. Published by Federico Zeri, *Quaderni d'arte* (Bergamo, 1971).

10. M. Borgatti, *Castel Sant'Angelo in Roma* (Rome, 1931), passim.

11. *Historia Discreptionis Urbis Romae* (Paris, 1537), pp. 108 ff. This episode is not mentioned by Judith Hook. *The Sack of Rome, 1527* (London, 1972).

12. For example, *Ein trostlich Predigt* (Basel, 1520). Copy consulted and illustrated in Washington, D. C., Folger Shakespeare Library, Stickelberger collection no. 387 (catalog; Basel, 1977).

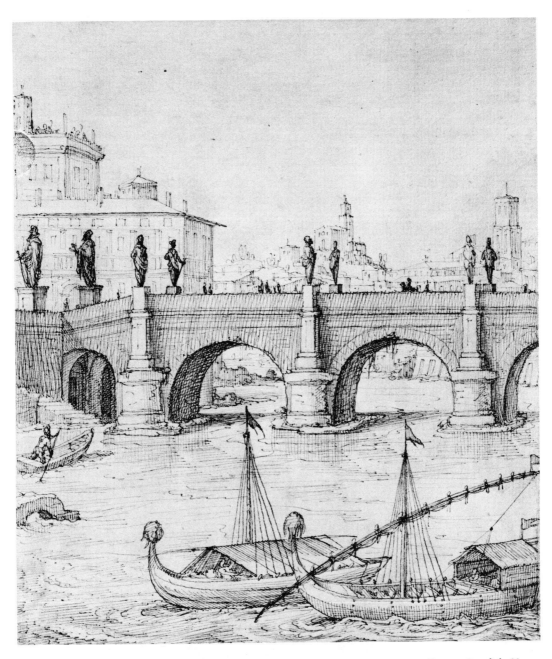

4.1 Attributed to Etienne du Pérac, Ponte Sant'Angelo, Rome. Drawing. Staatliche Museen, Berlin-Dahlem, Department of Prints and Drawings.

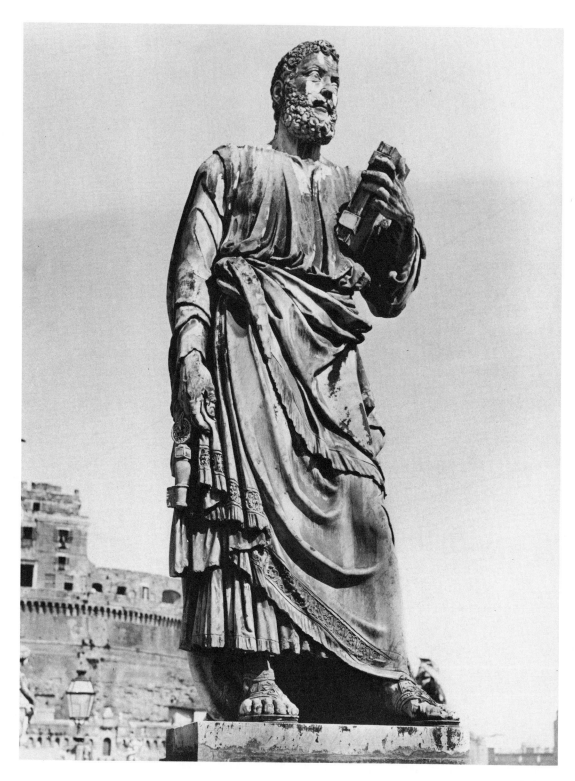

4.2  Lorenzetto, *Saint Peter*. Ponte Sant'Angelo, Rome.

4.3  Paolo Romano, *Saint Paul*. Ponte Sant'Angelo, Rome.

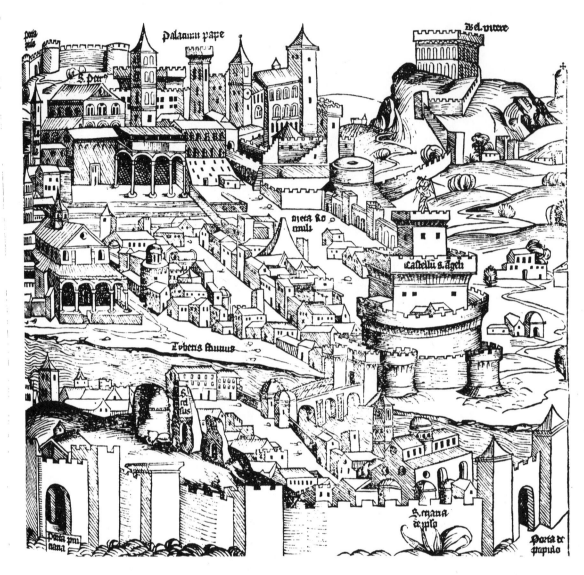

4.4  Hartmann Schedel, detail of the view of Rome.

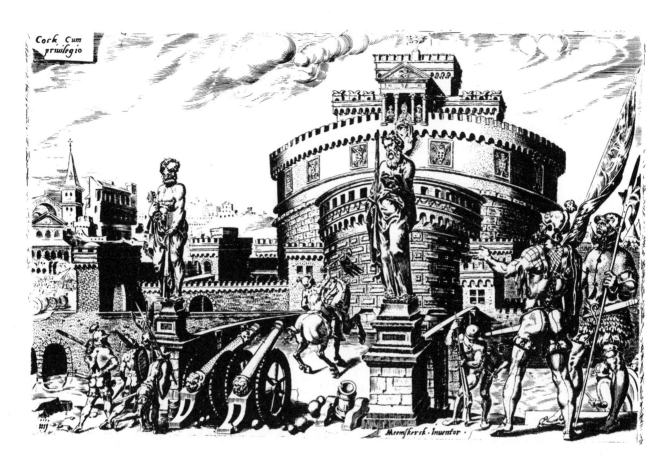

4.5 Dirk Coornhert after Martin van Heemskerck, *Military Triumphs of Charles V, Clement VII, in the Castel Sant'Angelo.* Engraving. Metropolitan Museum of Art, New York, Harris Brisbane Dick Fund, 1928.

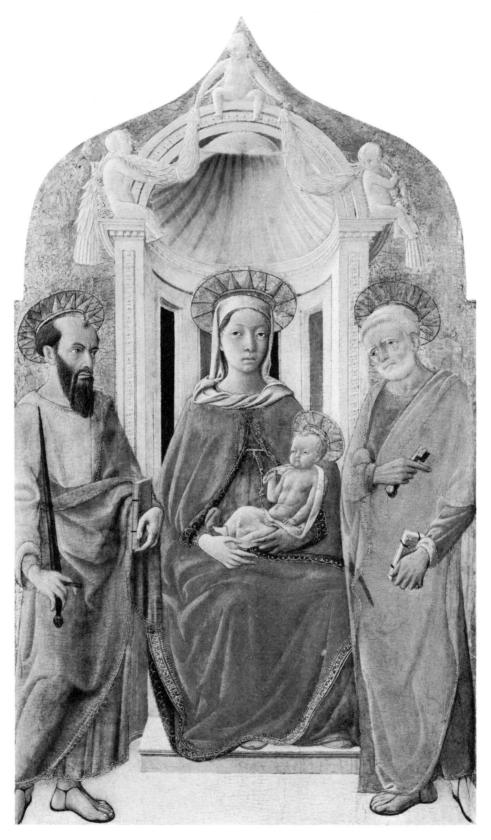

4.6 Domenico di Bartolo, *Madonna and Child Enthroned with Saint Peter and Saint Paul*. The National Gallery of Art, Washington, D.C., The Samuel H. Kress Collection.

4.7 Lorenzo Monaco, *Madonna and Child with Saints and Angels*. Walters Art Gallery, Baltimore.

4.8 Giovanni di Paolo, *Madonna and Child with Saints*, detail of the dalmatic of Saint Augustine. Metropolitan Museum of Art, New York.

# Ein troſtlich pre/
dig von der gnaden got/
tes vnd fryen willen.

Vnd von dem gewalt der ſchlüſſel ſant
Petri. Beſchriben durch D. Mar⸗
tinun Luther.

Gedruckt zů Baſel/ durch Adam Petri.
M. D. XIX.

4.9 Frontispiece of pamphlet *Ein Trostlich Predigt . . .*, Basel, 1520.

*Florence*

# 5. Some Florentine Painted Madonna Reliefs

*Ulrich Middeldorf*

*La scultura e la pittura per il vero sono sorelle, nate di un padre, che è il disegno, in un sol parto et ad un tempo, e non precedono l'una alla altra.*[1]

THE FOLLOWING ESSAY is a small contribution to a vast problem: the relation between painting and sculpture. Artists and writers of the Italian Renaissance discussed it almost ad nauseam. It is of interest to us to verify how their theoretical views were translated into practice.[2]

So much of the polychromy of Renaissance sculpture has been lost or spoilt—by time, by neglect, by prejudice—that it has become difficult to visualize what the sculptures originally looked like. That they were polychromed far into the sixteenth century must be taken for granted, though a systematic study would be useful.[3] Here the special case of the plastic materials, clay, stucco, and cartapesta[4] will be considered. If even marble, which as a material has its own value and beauty, was thought to need at least partial coloring and gilding,[5] how much more would this be the case with these mean and indifferent materials. Of course, the sculpture came first and then the coloring. We shall see, however, that occasionally the painter completely took over, so that reliefs and pictures have become undistinguishable and interchangeable.

Terracotta was a material one did not care to show, and we had better realize that all those terracotta sculptures now stripped of their coloring are far from looking like their original selves.[6] Of course, the della Robbias attended to the polychromy of their sculpture with such perfect technique that it still glories in its old coloring.[7] A famous instance of the collaboration of a sculptor and a painter is the lunette with the *Coronation of the Virgin* over the door of Sant'Egidio in Florence, which was modeled by Dello Delli and painted in 1424 by Bicci di Lorenzo.[8]

Not always was the coloring polychrome. There are cases of gilding—for instance, the tomb of the Beato Pacifico in the Frari in Venice[9]

or the lavabo in the cloister of the Certosa of Pavia, modeled by Amadeo and gilded in 1466 by his brother Protasio.[10] The two busts by Alessandro Vittoria in the National Gallery in Washington still had traces of gilding,[11] which today have disappeared. Two additional works by Alessandro Vittoria can be mentioned, the terracotta busts in the museum of the *Seminario* in Venice, one painted a dull, darkish green to imitate bronze, and one white to imitate marble. Both mimetic practices must have been quite common and can be documented by other examples.

We also have written proof for them. In an inventory of the Medici collection of 1553 ff., we find "una Caritá di terra cotta in color di metallo".[12] In 1444 a certain Giovanni da Roma furnished for the façade of the church of Sant'Antonio in Cremona "quasdam figuras terrecoctas ad fornacem et factas ad modum marmoris".[13] Does this mean that they were painted white? This was certainly the case with the figures on the catafalque for the funeral of Michelangelo[14] and with Benedetto da Maiano's *Madonna dell'Ulivo* in the cathedral of Prato, which is described by Vasari as "di terra, lavorata tanto bene, che così fatta senza altro colore è bella quanto se fusse di marmo".[15] Of course, a terracotta left raw would have clashed badly with the marble relief of a *Pietà* which decorated the altar underneath. How bad it would have looked is demonstrated by some tombs in the cloister of the Santo in Padua made in the form of stone tabernacles which house terracotta busts attributed to Francesco Segala. The busts have lost their coloring, and with it their protection against the weather, and look pretty miserable with their ugly color and corroded surfaces.

Stucco required the same treatment as terracotta, and sculptures fashioned in it were invariably colored.[16] Among the many stuccos and terracottas after Madonna reliefs by Donatello and his followers, there are a few with well-preserved polychromy; as examples may serve a small tabernacle in the Victoria and Albert Museum possibly painted by Paolo Schiavo[17] and one in the art market in Florence (fig. 5.1). In the lunette of the latter the *Man of Sorrows* is painted. Often the Dove of the Holy Ghost is found in this place. The composition of this piece is known in a number of terracottas and stuccos, the best one in the Victoria and Albert Museum.[18] The example there has unfortunately lost its polychromy, while ours is carefully painted and gilt, with the gold heavily tooled. The slightly pedantic richness of its ornamental decoration denotes a special taste which is also found in stuccos and terracottas after other masters. One might call them the "overdecorated" variety and ask to what whims or to what commercial speculation they owe their existence. They even have plastic decorations added[19] and often come in highly elaborate frames.[20]

A phenomenon that should interest the economic historian is the

prodigious production of polychromed Madonna reliefs of a handy size during the fifteenth century in Florence. The appearance of these reliefs is virtually limited to Florence; in Siena there were some; elsewhere none except occasional pieces. The Florentine products must also have been very saleable abroad; they are to be found nearly everywhere in Italy. One might suspect special workshops, perhaps those of some potters, to have turned them out, but there does not seem to be any specific evidence for this. Probably these pieces were the well-paying by-products of the workshops of the great masters, whose terracottas and marbles were used as patterns. At first this production clustered around Ghiberti, though we do not know of a single piece which, with assurance, could be ascribed to him. Then follow the replicas of the Madonnas of Donatello and his school.

The most flourishing phase of the production, however, centered around Desiderio da Settignano, Antonio Rossellino, Domenico Rosselli, Francesco di Simone Ferrucci, the Master of the Marble Madonnas, Benedetto da Maiano, and to a minor extent Verrocchio. Of course, the della Robbias were great contributors, both with their own compositions and those of others which they glazed. What is so puzzling is the sudden outbreak of this fashion, its almost total disappearance after the lapse of a few generations, and its local circumscription. It was followed, lasting into the sixteenth century, by the equally surprising fad of small terracottas in the round by artists like the Master of the Statuettes of Saint John[21] and the slightly later Master of the Unruly Children.[22] We also find the della Robbias in alliance with them.

Neri di Bicci's *ricordanze*[23] give us a lively insight into the activities of a renowned and busy painter of his time, who collaborated with cabinetmakers like Giuliano da Maiano and with woodcarvers like Don Romualdo, abbot of Candeli.[24] Of Neri we learn that:

In 1454 he colors with the blue and gold "una Nostra Donna da chamera di terra cotta".

In 1454 he describes in detail how he painted "una Nostra Donna di gesso (stucco)".

In 1456 he describes in detail how he painted "una Vergine Maria di rilievo grande di gesso" and its tabernacle.

In 1456 he mentions his connection with Desiderio.

In 1461 he paints and gilds a tabernacle for a Madonna in marble by Desiderio.

In 1464 he makes a large tabernacle for a Madonna in stucco by Desiderio.[25]

It is interesting to know that in almost all cases he also had to take care of the gilding and retouching of the frames. These tabernacle frames actually were an integral part of their polychrome reliefs (fig. 5.1), which—alas—have often been lost or hopelessly spoiled. They deserve a special study, particularly as famous artists like Giuliano da Maiano are involved.

To illustrate the above, two almost identical, well-preserved Madonna reliefs may serve: one formerly in a private collection in Germany (fig. 5.2) without a frame; the other, formerly in the collection of E. Volpi,[26] still with its original tabernacle frame. They reproduce a composition by Desiderio[27] and certainly have been colored by Neri di Bicci. The reduction of Desiderio's lively faces and hands to slightly simple-minded schemes betrays Neri's hand and mind. If more proof were needed, there is a picture by him (fig. 5.3)[28] which repeats the composition with some minor variations, and which breathes the same spirit.

A stucco after another composition by Desiderio, which is best known through a marble in Turin,[29] is a particularly attractive example (fig. 5.4).[30] It is reasonably well preserved in its original tabernacle. The polychromy follows the usual scheme: the garment of the Virgin is red, her cloak dark blue. On both sides of the Madonna two full-length adoring angels are painted with complete disregard for scale. The frame has elegant proportions almost worthy of Giuliano da Maiano. Its frieze is decorated with garlands and heads of cherubim; the gable shows the half-figure of the blessing God the Father. A half-effaced inscription in excellent lettering, A V E M A R I A G R A T I A P L E N A, completes the picture. Such were Neri di Bicci's finest productions.

As a rule, the painters who colored such reliefs cannot be identified. There is, however, another exception. A painter known as the Pseudo Pier Francesco Fiorentino,[31] though slightly younger, has many similarities to Neri di Bicci. His output was large and repetitive; his works are schematic and artisanlike. He often depended on the ideas of others, such as Filippo Lippi and Pesellino. For the coloring of Madonna reliefs, he qualified through his meticulous technique and the skill with which he handled decorative details—above all flowers. A stucco in the Currier Gallery of Art in Manchester, New Hampshire (fig. 5.5),[32] which repeats perhaps the most popular Madonna of the century by the young Antonio Rossellino,[33] is certainly colored by him, as comparison with one of his pictures shows (fig. 5.6).[34] That all this was serial production is proved by the fact that there also exists an almost identical piece, in the Musée Jacquemart-André in Paris.[35]

This story comes full circle—with a curious twist, however. Another extremely well-known composition by Antonio Rossellino[36] was copied in a picture, if Berenson was right, by the *real* Pierfrancesco Fiorentino.[37] This fact might have induced Berenson to reconsider his distinction between the real and "pseudo," at least for this picture. Two technical details may illustrate how closely the arts of painting and sculpture are interwoven in these works. The gilding of the haloes and of decorative details like borders is often tooled as in pictures (e.g. fig. 5.1). And often the colors of the garments are not applied evenly, but are graded from

deeper tones in the depths of the folds to lighter ones on the ridges, which enhances the modeling. In a photograph this trick cannot be seen; but its effect does show (fig. 5.4). Which brings us back to the quotation from Vasari that introduced this essay.

# NOTES

1. Giorgio Vasari, *Le vite de' più eccellenti pittori, scultori ed architettori*, ed. Gaetano Milanesi (Florence, 1906), 1: 103 (hereafter cited as Vasari-Milanesi); idem, *Le vite de' più eccellenti pittori, scultori ed architettori, nelle redazioni del 1550 e 1568*, ed. Rosanna Betarini and Paola Barocchi (Florence, 1966–71), 1: 26.

2. The latest contribution to the subject, which discusses its main aspects, is by John Pope-Hennessy, "The interaction of painting and sculpture in Florence in the fifteenth century," *The Journal of the Royal Society of Arts*, 117 (1969): 406–24.

3. I have the suspicion that the statues and reliefs of the campanile of Santa Maria del Fiore originally were painted a bright yellow ochre so as to appear gilded, as are the statues in the background of Botticelli's *Calumny of Apelles*. They are entirely covered by a thin layer of some earth, except for patches where it has flaked off. This could easily be a faded yellow earth. For yellow and gold to be indistinguishable at some distance is a common experience. The problem would be worth a chemical analysis.

4. In these pages stucco and terracotta will not be treated as distinct from each other. Sometimes it is quite difficult to obtain information as to which of the two materials forms the medium of a given piece. The two materials did not differ in the process of production. A squeeze from a mold is taken as easily in one as in the other. Both can be, and were, retouched afterwards. The quality of stucco varies greatly from a soft, crumbly substance to a hard, marblelike one. There are also squeezes in cartapesta and in leather. The latter are quite rare, and the surfaces of those I have seen do not allow any conclusions concerning original coloring.

5. The polychromy of bronzes since antiquity is a special case. Of some interest is the information on the silvering of the faces and hands of Donatello's bronzes in Padua quoted by James H. Beck, *Mitteilungen des Kunsthistorischen Institutes in Florenz* 14 (1969/70): 459, n. 8. Sculpture composed of various materials, e.g. Verrocchio's Medici tomb, is again another matter.

6. Jacob Burckhardt, *Skulptur der Renaissance*, in *Gesamtausgabe* (Stuttgart, Berlin, Leipzig, 1934), 13: 197, states that certain terracottas were left unpainted, without giving reasons. His piece is perhaps the best ever written on Renaissance sculpture, and his views otherwise deserve the closest attention.

7. As another aside it might be added that some later della Robbia products, which try to imitate the variety of color of painting, have faces and hands as well as other areas unglazed. The reason for this was, of course, that these parts were intended to be naturalistically painted. Time and lack of understanding have frequently removed this paint, giving the figures unusually dark complexions.

8. For the literature, see Walter and Elisabeth Paatz, *Die Kirchen von Florenz* (Frankfurt-am-Main, 1940–54), 4: 13, 41; Ulrich Middeldorf, "Dello Delli and *The Man of Sorrows* in the Victoria and Albert Museum," *The Burlington Magazine* 78 (1941): 71–78; and more recently, although not convincing, James H. Beck, "Masaccio's Early Career as a Sculptor," *The Art Bulletin* 53 (1971): 177–95.

9. Pietro Paoletti, *L'architettura e la scultura del rinascimento a Venezia* (Venice, 1893), 1: 185 n., quotes Marino Sanuto.

10. Carlo Magenta, *La Certosa di Pavia* (Milano, 1897), p. 454.

11. Theodor von Frimmel, "Terracottabüsten des Alessandro Vittoria im K.K. Oesterr. Museum f. Kunst u. Industrie," *Mitteilungen des K. K. Oesterreichische Museum für Kunst und Industrie* 11, no. 129 (Vienna, 1896): 188; National Gallery of Art, *Summary Catalogue of European Paintings and Sculpture* (Washington, D. C.), pp. 173–174, nos. A 1666 and A 1667; illustrated in National Gallery of Art, *European Paintings and Sculpture* (Washington, D. C., 1968), p. 153.

12. Eugène Muentz, *Les collections d'antiques formées par les Médicis au XVIᵉ siècle, Mémoires de L'Académie des Inscriptions et Belles-lettres*, vol. 35, pt. 2 (Paris, 1895), p. 59.

13. Alfredo Puerari, *Le tarsie del Platina* (Milan, 1967), pp. 13, 131.

14. Allan Marquand, *Benedetto and Santi Buglioni* (Princeton, 1921), p. 215; Vasari-Milanesi, 7: 298, 303.

15. Vasari-Milanesi, 3: 344.

16. There is, however, a type of stucco which is evenly covered by a thin brown stain. This type mostly reproduces more ambitious reliefs, e.g. parts of the Doors of Paradise or marbles by Benedetto da Maiano. Occasionally they are claimed to be models. They must, however, be later casts, since I have seen some after Giovanni Bologna's Passion reliefs. They are usually very well molded and close to the originals.

17. Philip Pouncey, "A Painted Frame by Paolo Schiavo," *The Burlington Magazine* 88 (1946): 228; John Pope-Hennessy, *Catalogue of Italian Sculpture in the Victoria and Albert Museum* (London, 1964), 1: 83, n. 68.

18. Pope-Hennessy, *Catalogue of Italian Sculpture*, 1: 77, no. 64.

19. They are frequent but are rarely found reproduced. For example, see Allan Marquand, "Antonio Rossellino's Madonna of the Candelabra," *Art in America* 7 (1919): 198–206.

20. For an example (after Rossellino) in the Victoria and Albert Museum, see Pope-Hennessy, 1: 133–34, no. 111.

21. Ibid., pp. 191–96.

22. Frida Schottmüller, *Die Bildwerke in Stein, Holz, Ton und Wachs (Bildwerke des Kaiser Friedrich-Museums: Die italienischen und spanischen Bildwerke der Renaissance und des Barock,* I) (Berlin and Leipzig, 1933), pp. 157–59.

23. These *ricordanze* were unfortunately never completely published; but see Filippo Baldinucci, *Notizie dei professori del disegno . . . per cura di F. Ranalli* (Florence, 1845–47; reprint, 1975); Vasari-Milanesi, 2: 69–90; Giovanni Poggi, "Le Ricordanze di Neri di Bicci (1453–1475)," *Il Vasari* 1 (1927/1928): 317–38, 3 (1930): 133–53, 222–234, 4, (1931): 181–202. Since these pages were written, the complete text of the *ricordanze* has been published. See Neri di Bicci, *Le Ricordanze (10 marzo 1453–24 aprile 1475),* ed. Bruno Santi (Pisa: Edizioni Marlin, 1976).

24. Poggi, "Le Ricordanze di Neri di Bicci (1453–1475)," *Il Vasari,* 3: 227, 231, 4: 189; Vasari-Milanesi, 2: 86, n. 7. He is mentioned in 1456 and 1469. This prolific carver of crucifixes probably is responsible for some of those published by Margrit Lisner, *Holzkruzifixe in Florenz und in der Toskana von der Zeit um 1300 bis zum frühen Cinquecento* (Munich, 1970).

25. Poggi, "Le Ricordanze di Neri di Bicci (1453–1475)," *Il Vasari,* 1: 329, 332–33, 3: 233–34, 4: p. 194; Clarence Kennedy, "Documenti inediti su Desiderio da Settignano e la sua famiglia," *Rivista d'Arte* 12 (1930): 274, 276.

26. New York, *American Art Galleries,* Nov. 21, 1916, n. 710.

27. See Pope-Hennessy, 1: 142–46 no. 117, who discusses the various replicas also in pictures.

28. In the museum of Dijon.

29. Noemi Gabrielli, *Galleria Sabauda. Maestri italiani* (Turin, 1971), p. 261, no. 167. I do not believe it to be a forgery. This is not the place to enter into a discussion, which would have to concern itself with fundamentals of the production of marbles in the Quattrocento. See also Ida Cardellini, *Desiderio da Settignano* (Milan, 1962), pp. 286 ff., where other polychromed specimens are reproduced.

30. I have seen the piece in the art market in Florence.

31. Ulrich Thieme and Felix Becker, *Allgemeines Lexikon der Bildenden Künstler von der Antike bis zur Gegenwart* (Leipzig, 1907–50), 37 (1950): 281.

32. Formerly in the Acquavella Galleries in New York. See W. R. Valentiner, *Catalogue of an Exhibition of Italian Gothic and early Renaissance Sculptures,* Detroit, The Detroit Institute of Arts, 1938, no. 4; Valentiner has identified the Pseudo Pierfrancesco Fiorentino as the author of the coloring of both pieces. I am grateful to David S. Brooke for the photograph.

33. See Pope-Hennessy, 1: 133, no. 111.

34. The picture is in a private collection; the author thanks the owner for permission to publish the photograph.

35. Georges E. Lafenestre, et al., *Le Musée Jacquemart-André* (Paris, 1914), pp. 89–90 and illustration.

36. See Pope-Hennessy, 1: 132–33, no. 110.

37. Bernard Berenson, *Homeless Paintings of the Renaissance* (London, 1969), pp. 177, 318.

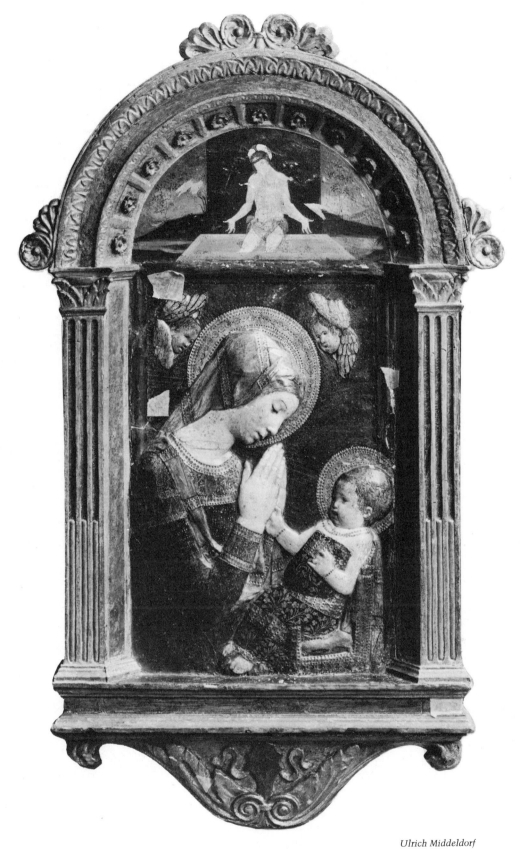

5.1 School of Donatello, *Madonna and Child*. Art market, Florence.

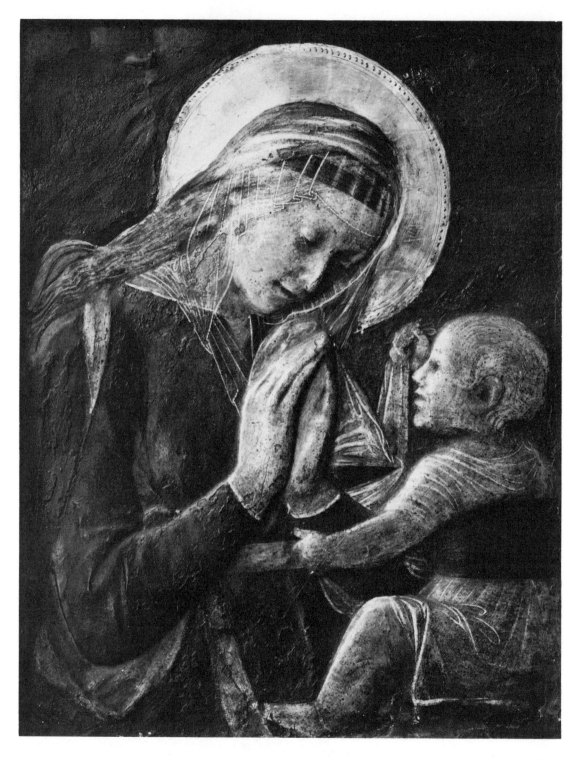

5.2 After Desiderio da Settignano, polychromed by Neri di Bicci, *Madonna and Child*. Formerly in a private collection, Germany.

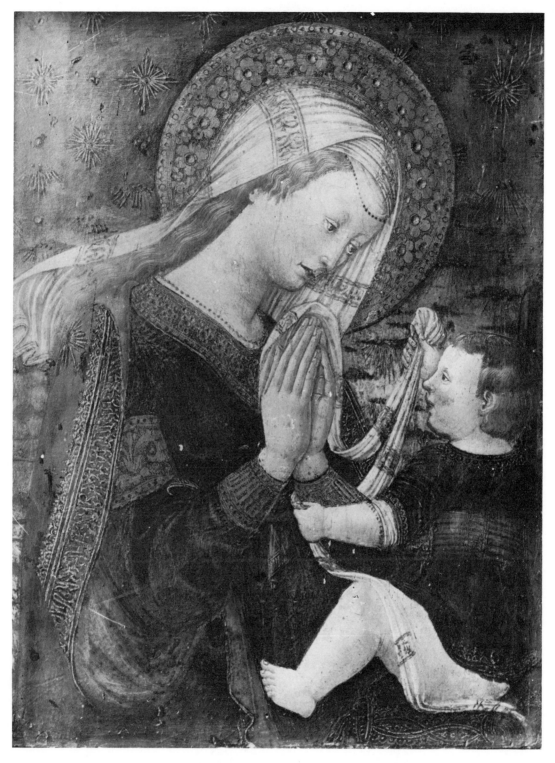

5.3 Neri di Bicci, *Madonna and Child*. Musée des Beaux-Arts, Dijon.

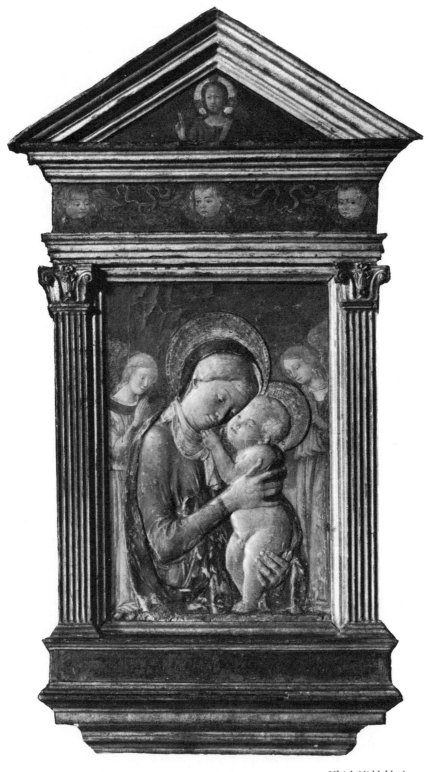

*Ulrich Middeldorf*

5.4 After Desiderio da Settignano, polychromed by Neri di Bicci,
*Madonna and Child*. Art market, Florence.

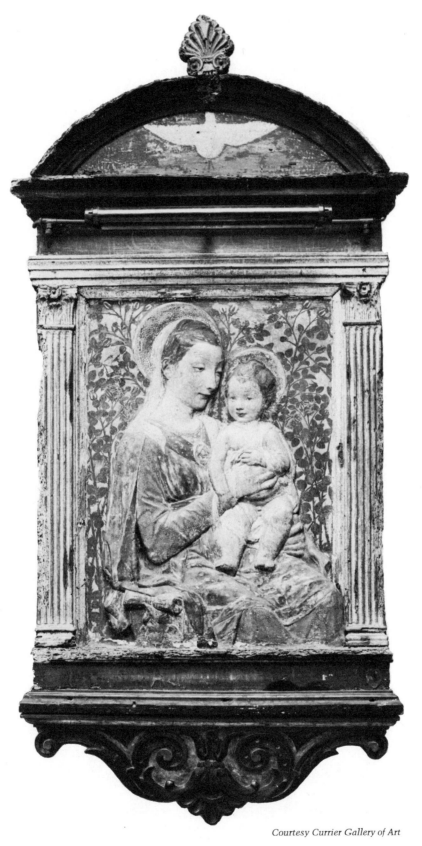

5.5 After Antonio Rossellino, polychromed by the Pseudo Pier Francesco Fiorentino, *Madonna and Child*. The Currier Gallery of Art, Manchester, New Hampshire.

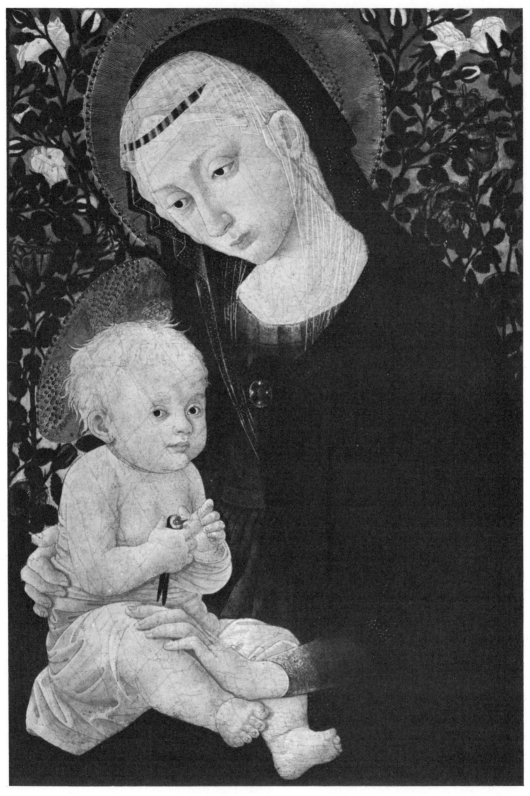

5.6  The Pseudo Pier Francesco Fiorentino, *Madonna and Child*.

# 6. Marsilio Ficino's Cosmic Temple

*GEORGE L. HERSEY*

THIS BOOK deals with joint enterprises among Italian artists of the Renaissance. In this essay I would like to open up the supernatural side of that theme. I have in mind the Neoplatonic notion that there are invisible beings in the cosmos, ultimately directed by God, who assist man in his activities. Some of these creatures are the usual sort of angels, demiurges, or daemons; but others are numbers and geometrical forms. And these mathematical creatures have a direct relation to the fine arts. Sculptors, painters, and architects can have unseen helpers as well as real ones: the labors of visible architects can be lightened through their contact with unseen but sentient models and formulas.

The Quattrocento writer who most completely expressed these ideas for architecture was Marsilio Ficino.

### I

Ficino's thoughts about architecture have been investigated by historians of philosophy and of art,[1] but the full extent of his architectural vision has not, so far as I know, been suggested. Ficino, like Aristotle and many another philosopher, used architecture and the processes of design as vehicles for his ideas. Hence his thought relates to that of Vitruvius, Alberti, and Filarete; but Ficino possessed by far the most projective imagination of the four writers. Indeed, he set his fantastic stamp on a brand of architectural theory that continued through Daniele Barbaro, Lomazzo, and Scamozzi, and which affected the Spaniards Herrera, Juan Bautista de Toledo, and Caramuel Lobkowitz—to name but a few.[2]

Ficino saw the cosmos as a vast temple composed of numerical-geometrical beings. The philosopher's task was to describe that temple.[3] In other words, to paraphrase Vitruvius, the cosmic temple was a signifier— *quod significat*—and the philosopher's description was the temple's signified—*quod significatur*.[4] The signified, in Ficino, involved theoretical geometry. It was in the realm of number and form, not that of words,

that architectural meaning-lay. Thus Ficino describes the author of *De re aedificatoria* as a "Platonic mathematician" rather than calling him an architect.[5]

Another way of "describing" this cosmic temple numerically and geometrically was to build earthly temples modeled after it. These earthly temples, as well as telling us something about the cosmos, were also—for Ficino—models of the human intellect. Designing and erecting them helped men to understand how as humans they themselves were designed and built, and also how God had acted when he created the universe. So earthly architecture, correctly understood, was cosmogonic. This is true because architecture is at once so mathematical and so material. After mathematics itself it is the highest of the sciences.[6] By imposing mathematical form on matter, whose natural state is formlessness, man the architect not only imitates God but struggles against what nowadays we would call the entropy of material creation. In Ficino's terms, one might even define civilization itself as man's making architecture out of chaos.

Ficino's descriptions of the cosmic temple are not simple prose formulas like Vitruvius's descriptions or quod significaturs of Greek temples. Rather, they take the form of a principal Neoplatonic artifact, the affinity table or *scala*. This scala is a grid (in Ficino's text, written out rather than presented graphically) of qualities, things, and numbers that are aligned according to their hermetic kinships with the cosmic temple. Being a grid, an affinity table is in itself to some extent an architectural form; in other words, both signifier and signified are rectangular, compartmented structures. I will give an example presently.

All this differentiates Ficino from the more down-to-earth Alberti. Yet Ficino does build on some of Alberti's ideas—for example, he repeats the notion from Alberti's Book 9 that, in analyzing buildings, one transforms number into geometrical shape and vice versa, thus reducing the building ultimately to the number 1 and its immediate offspring.[7] Ficino goes on to claim that this transformation is above all possible in architecture, for besides being supremely material and supremely mathematical, architecture is the most transformational (*Mercurialis*) of the arts.[8] And Ficino adds a new ingredient to Alberti's transformational process. He posits a specific, ideal, sentient building and a specific ideal observer of the building. Cubical reduction occurs, for Ficino, in perspective and from a viewpoint in space. And it occurs in two different intellectual modes: when we see a façade elevationally we are led to calculation. When we see it retreating in perspective we are led to speculation and contemplation. Hence Ficino's "Platonic mathematician" imagines and surmises as well as calculating. A proper earthly temple, moreover, should be more deep than wide, to express the greater inherent depth of

the act of contemplation. Similarly, says Ficino, the various rectangles derived via simple fractions from the square demonstrate, first, their respective positions in a kinship structure and, second, thus seen, they give rise to parallel sequences of emotions and thoughts in the observer.[9]

Thus does Ficino endow the Platonic mathematics of architecture with philosophical functions. One conceives of the *res aedificatoria* not as a corpus of general principles, as Alberti does, but as a corpus of unseen but specific buildings. It is a body of individual signifiers observed by individual calculating/speculating minds. The process of giving signifieds to the signifiers, meaning to the temples, is affective and speculative. Finally, as Ficino's own commentaries show over and over again, a single mind can produce a complex signified or affinity table that is extendible to the remotest areas. This invisible Platonic mathematician may therefore be set down as one of the Renaissance architect's possible demiurges, just as the living cosmic temple is an unseen but sentient model.

## II

Again following but also modifying Alberti, Ficino says that the most beautiful source of form for architecture is the cube. And like the Pythagoreans, he identifies the cube in its stability with Earth. But for Ficino, Earth is not *simply* a cube. It is a cube pervaded by a sphere. This notion of two mutually pervading forms introduces another Ficinian claim that bears on the fine arts.

As a cube, Earth is one, a unity, a monad or irreducible compositional unit. In its unity it represents "the single work by the one God", just as a building is a single work by one architect. All God's created species and varieties lead back to this single image: "whence whoever would know the ideas of things must find them in the mind of the Architect of the world."[10] For the one God is himself like the one Earth and the number 1. He is the one form from which all other forms proceed. The one God makes many material objects, just as the human architect in his domination of matter can produce many buildings stamped from a single mold. "The cube has six sides and is called a cube or die, and the cube stands for Earth because it has solidity and firmness."[11] Here Ficino is playing the Pythagorean; he may even be echoing Vitruvius.[12] But he develops his notion Neoplatonically: "as a solid [Earth] stands for action, as point stands for essence, line for being, and plane for virtue."[13]

Now we are ready for a Ficinian affinity table. When presented in the modern form, rather than being written out as in Ficino's *Opera omnia*, the *scala* is a uniform grid, façade, or temple which demonstrates by the alignment of its compartments and their contents, first, the relationships

between the Pythagorean tetrad or quaternion 1 2 3 4 (held to be the basis of the cosmos); second, the geometric sequence, point/line/plane/solid;[14] and third, a set of progressive or hierarchical philosophical states:

Ficino's Scala of Earth-as-Cube

| Number | Form | Philosophical State |
|---|---|---|
| 1 | point | essence |
| 2 | line | being |
| 3 | plane | virtue |
| 4 | solid | action |

But the temple of Earth-as-cube contains other compartments. In fact, through the automatic extension of this simple 4:3 lattice, ultimately the species, figures, quantities, magnitudes, and proportions of all [earthly] things are includable in the temple.[15] This again relates it to Vitruvius. Just as Vitruvius, by inserting the phrase "Ionic order" into the formula for a Greek temple, was automatically plugging into his short algorithm the complex circuitry of the rules for these columns and their entablatures, so Ficino's philosophical temple-grid, when it says "essence," automatically entails other grids that are thereby joined to this one.

Indeed, everything on — and in — Earth, can be integrated into scalae and traced back to a single source. The quod significatur of Earth-as-cube is immense. And it, in turn, is part of an even larger grid connecting the animal and sensible worlds, the four quarters of the universe, the four armies of its inhabitants, and the gods of the world — angels, daemons, and individual souls. Within the larger scala, which also includes metals, jewelry, colors, and the like, cube-Earth is the equivalent not only of the solid, of the number 4, and of action, but of the world of sense and the army of individual souls.[16] Cube-Earth can thus be projected outward, through its fellow temples, so as to fill all space and combine all cosmic hierarchies of number, form, beings, and quantities. This greater grid goes beyond the possibilities of two- and even three-dimensional presentation. Ultimately it constitutes an infinitely manifold frame of affinities for the Platonic mathematician as he Pythagorizes on its perspectives and elevations.

So much for Earth-as-cube. Earth's simultaneous spherical nature involves it more directly in heavenly and invisible matters. Earth-sphere is the most indissoluble and capacious of forms. Where Earth-cube had been a principle of action, springing from a motionless base, and has been solid and material, Earth-sphere is the principle of motion as opposed to action, and of space as opposed to solid.[17] And space — volume, interval — in Ficino's scheme of things is as important as line, plane, and solid.

Space is what *allows* action. A spherical/spatial signifier is the work of an "invisible" architect as opposed to a visible one. That is because spheres and space are based on the principle of duality: they derive from even numbers which have zero at their center (when divided into two halves).

But this ease of division gives them an energy not possible to *im*-mobile, stable, cubic numbers. These, when divided, leave a 1 at the center.[18] Furthermore, all these numbers, or number-forms, are personalities or beings, even divinities. They are also male or female, they marry and procreate, and they have various sorts of temperaments and behavior patterns. The cosmic temple and its earthly imitations are not inert material objects. Through their number content and structure they are living things, clusters of beings.

In all this Ficino greatly enlarges the realm of architectural anthropomorphism. And he also makes a crucial distinction between visible and invisible architecture.[19] Out of his elaboration of this distinction, with its concomitants of solid vs. void, stable vs. mobile, cubic vs. spherical buildings or parts of buildings, will come the notion held by later theorists, notably Scamozzi,[20] of two mutually pervading buildings within a given material structure. One is visible, the architecture of solids and action; the other invisible, the architecture of space and motion. With Scamozzi, as with some of his predecessors, invisible columns and compartments count as much as visible ones.

Ficino's concept of architecture, here so briefly set forth, contains or entails a number of arresting notions for the student of Renaissance art. Ficino set architectural description, contemplative or calculatory, on an equal footing with the buildings themselves. Indeed, the art of architectural description is implicitly more important than the art of architectural design: it is the describing of it that gives a building its meaning. By describing the cosmic temple, too, the architect designs an earthly one. Creation and criticism are opposite sides of the same coin. And in either activity God and his demiurges, his sentient formulas and models, are partners in the firm.

# NOTES

1. André Chastel, *Marsile Ficin et l'art* (Geneva/Lille, 1954), with earlier bibliography. Chastel effectively refutes P. O. Kristeller's claim regarding Ficino, that "was dieser führende Denker der Renaissance . . . über die Malerei und Architektur zu sagen weiss, ist erstaunlich wenig." Kristeller, *Die Philosophie des Marsilio Ficino* (Frankfurt, 1972), p. 288.

2. For the notion of the work of art as philosophical model, so to speak, see Erwin Panofsky, *Idea: ein Beitrag zur Begriffsgeschichte der alteren Kunsttheorie* [1924] (Berlin, 1960), pp. 13–16 (Plotinus) and 30 (Ficino). I deal with this Ficinian architectural tradition in my *Pythagorean Palaces: Magic and Architecture in the Italian Renaissance* (Ithaca, N.Y., 1976), esp. pp. 34–40. As a measure of the importance of Pythagorean and Neoplatonic teaching within this tradition, one can cite the large proportion of the books in Juan Bautista de Toledo's personal library (according to one of the inventories in Luis Cerrera Vera, *Libros del arquitecto Juan Bautista de Toledo* [Madrid, 1951] that were devoted to these subjects. Out of a total of 41 books 16 were architectural (including six different Vitruviuses), 13 were miscellaneous, mostly Bibles and prayerbooks, and 12 were all or partly about magic and Pythagorean mathematics.

3. See the commentaries on Plato's *Timaeus* and *Republic*. Marsilio Ficino, *Opera omnia* [1576] (Turin, 1959), 2¹: 1413–85. Ficino mentions architecture — though briefly — in the *Theologia Platonica*, 1¹: 255: "Omnis mens figuram laudat rotundam in rebus statim consideratam, et cur laudet, ignorat. In aedificiis quoque similiter talem, vel quadraturam aedium, vel parietum aequalitatem, lapidumve dispositionem, angulorum oppositionem, fenestrarum figuram atque occursum. Laudat insuper eodem pacto certam quandam sive membrorum humanorum proportionem, sive numerorum vocumque concordiam." And, on p. 275 an opinion important for the art of fenestration: "Sed certe quaerendum est, cur nos offendat si duabus fenestris non supra invicem, sed iuxta invicem locatis, una earum maior, altera minor sit, cum aequales esse potuerint, si vero super invicem fuerint, ambaeque dimidio quamvis impares, non ita offendat illa inaequalitas, et cur non multum curemus quanto sit una earum, aut maior, aut minor, quia duae sunt, in tribus autem sensus ipse videtur expetere ut impares non sint, aut inter maximam et minimam ita sit media, ut tanto praecedat minorem, quanto a maiore praeceditur."

4. Vitruvius, *De architectura* 1.1.3. For this concept, see Silvio Ferri, ed., *Vitruvio (dai libri I–VII)* (Rome, 1960), pp. 34–35 note.

5. Ficino, *Opera Omnia* 2¹: 1464r: "Florentiae vero Baptistam Leonem Albertum ab eisdem disciplinis [scil. mathematicorum] exorsum, opus in architectura pulcherrimum edidisse."

6. Ibid., p. 1267: "Architectura igitur omnisque consimilis, . . . maxime omnium artium ingenio utitur."

7. See my "Alberti's Cubism," in *Studies in Honor of Myron Gilmore* (Florence, 1977), pp. 245–51.

8. Ficino, *Opera Omnia* 2¹: 1267.

9. Ibid.: "Aliter Mathematica industria utitur contemplator, aliter vero practicus: ille equidem unitates, et numeros considerat, per se formaliter existentes: Itaque apud illum Unum, non differt ab uno, binarius vero non discrepat a binario. Hic autem numeros in rebus resque; considerat numeratas. Quapropter apud hanc, hoc unum ab illo uno diversum scilicet lignum magnum a ligno parvo, vel lignum a ferro. Similiter duo exercitus Bovesque duo, ille rursus, quae sit proportionum virtus et proprietas contemplatur; Quae virtus in proportione aequali, vel dupla, vel sesquialtera. Hic autem ultrum aedificii longitudo plura ad latitudinem esse debeat. Alio quoque tendit contemplatoris, alio practici computatio."

10. Ibid., 2¹: 1444: "utpote qui intelligat ideas rerum non inter nubes, ut maledici quidam calumniantur, sed in mundani architecti mente consistere."

11. Ibid., p. 1447.

12. See Vitruvius, 5, Proem, 3, 4.

13. Ficino, *Opera Omnia* 2¹: 1447: "Quatuor apud metaphysicum sunt elementa essentia, esse, virtus et actio. Quatuor apud mathematicum, signum, linea, planum atque profundum. Quatuor apud physicum, seminaria naturae virtus, pullulatio naturalis, et adulta forma atque compositum. Redde vero singula singulis. Essentiae quidem signum atque semen, ipsi vero esse lineam pullulationemque virtuti planum atque formam, actioni profundum atque compositum, et ubique extrema velut solida duobus concilia mediis."

14. For the tetrad, see Thomas L. Heath, *A Manual of Greek Mathematics* (Oxford, 1931), pp. 36–72; S.K. Heninger, Jr., "Some Renaissance Versions of the Pythagorean Tetrad," *Studies in the Renaissance*, 8 (1961): 7–35: and Antonio Farina, ed., *I Versi aurei di Pitagora* (Naples, 1962), p. 40, n. 31.

15. Ficino, *Opera Omnia* 2¹: 1446: "Per numeros quidem intelligi vult ipsas rerum naturalium species formasque substantiales: quas etiam Aristoteles numeris, comparavit. Per mensuras autem certas instrumentalesque figuras, vel magnitudines speciebus certis accommodatas. Per solida denique atque vires significat qualitates, et quae cum motibus penitus protenduntur, et praestant motionibus, actionibusque momentum."

16. Ibid., pp. 1445–47; also pp. 1415–25.

17. Ibid., p. 1444: "Sit autem figura mundi sphaerica, sic enim est maxime uniformis capax, indissipabilis, agilis; atque ita nec aliter potest moles in mole, et sine vacuo collocari, et sine offensione moveri, id est, si non quadrata quadratis, aut circulis, sed orbes orbibus inserantur."

18. For his ideas on personified numbers, Ficino may have depended on Martianus Capella, *De nuptiis Philologiae et Mercurii*, ed. Adolphus Dick (Leipzig, 1925), Book 7 passim (for the number 1 as the "sole creator," see p. 367). See also Maurice de Gandillac, "Astres, anges et génies chez Marsile Ficin," in Eugenio Garin, ed., *Umanesimo e esoterismo* (Padua, 1960), pp. 85–109.

19. For this, see again Martianus Capella, *De nuptiis* pp. 351–53, which discusses "corporeal" vs. "incorporeal" geometry.

20. For example, see the classical villa he "clones" on the basis of an imaginary hypostyle matrix: Vincenzo Scamozzi, *L'idea della architettura universale* [1615] (Ridgewood, N.J., 1964), 1: 266–69.

# 7. The Bargello *David* and Public Sculpture in Fifteenth-Century Florence

*JOHN T. PAOLETTI*

WHEN MICHELANGELO WAS AWARDED the commission for the marble *David* in 1501 (figs. 8.1 and 8.2), the first action he took, according to a secretarial notation hastily scribbled in the margin of the account books, was to strike a "nodum" from the already blocked out chest of the figure. This nodum, rather than being a blemish in the marble or a roughly worked piece of drapery, was undoubtedly a transfer point near the shoulder of the figure. The origins of this transfer point most likely date from Agostino di Duccio's roughing out of the block between 1464–66, after he had been awarded the commission for a giant (*gughante*) in August 1464.[1]

When Michelangelo struck off this nodum on September 9, 1501, with "one or two blows of the hammer" as the document states, he was not merely displaying a personal impetuosity, but, rather, a desire to be free of an earlier model which had been prepared for enlargement by means of transfer points into the colossal scale of the *David*. Whether the original model that provided the basis for these transfer points and the nascent human form in the block still existed in 1501 is debatable; but certainly Agostino di Duccio must have prepared such a model before he was actually awarded the important commission for the statue in 1464.

The documents do, nonetheless, suggest a possible early history for this model even though they do not indicate its ultimate fate. Agostino's work on this project for a colossal—and unnamed—figure for the buttress of the north tribune began as early as April 16, 1463, when he was commissioned to make a giant similar to Donatello's terracotta *Joshua*, which then stood on the tribune buttress. He was promised a salary of 321 lire and told that his work must be completed by the following

August — that is, just four months later. By November the account for this commission was closed when Agostino received his final payment.[2]

Although the commission specifically mentions a giant, nowhere does it indicate the material from which Agostino was to fashion the figure. Both the four-month working period and the size of Agostino's payment indicate that this commission was not for marble sculpture. Perhaps the contract which stipulates that the statue be made "in quella forma e manera" as the terracotta *Joshua*, indicates that Agostino's commission was also for a terracotta statue.[3] Yet in 1412 Donatello's payment for the *Joshua* had been 128 gold florins, more than half again what Agostino received in 1462. This discrepancy is difficult to justify, even arguing on the very tenuous basis of the relative reputations enjoyed by the two artists. Agostino's 1463 project for the cathedral may, in fact, have been a sizable model, rather than a full-scale figure, for the giant that was eventually awarded to him in 1464.

Given the favor with which the Duomo authorities received the model provided by Agostino, we might well ask what happened to it in the years immediately after Agostino was released from his commission for the colossal marble figure in 1466. More importantly, we might ask, as Charles Seymour did, what Agostino's real role was in the commissions of 1463 and 1464, given the fact that he had not until that time carved any free-standing, large-scale sculpture, so far as secure documentary evidence allows us to ascertain.

Seymour suggested that Agostino's role in the commission was really that of assistant to Donatello, who, then in his eighties, was returning to a program with which he had begun his independent career in 1408 with his own marble *David*.[4] According to this view, Donatello and not Agostino would have been responsible for the actual concept behind the 1463–64 commission. Such a supposition explains the Opera's decision to release Agostino from his contract in December 1466, a few days after the death of Donatello, the guiding intellect behind the commission. Whether Agostino and Donatello worked together between 1463 and 1466 may be impossible to say with certainty, yet there is little in the admittedly hazy career of Agostino which could account for his having received such an important commission alone.[5]

What does remain is the fact that Agostino, whether alone or more likely with help, did produce a model which Michelangelo apparently rejected in 1501 when he struck the nodum from the chest of the partially carved block, did quarry a block of marble 9 braccia high in Carrara, and did begin carving on the block which Michelangelo ultimately received and formed into the *David* from 1501–04.

If Michelangelo's own figure was at least partially determined by this already cut block of marble then some echoes of the form of the 1463

model should appear in his *David* completed in 1504, despite his dramatic gesture in 1501. Although there are numerous earlier examples of David figures,[6] only one Quattrocento statue even slightly approximates Michelangelo's hero in the power it exerted over its contemporaries and the fascination it has held for modern historians as well. This statue is the bronze *David* in the Bargello (fig. 7.1), universally accepted as a work by Donatello and now generally dated in the 1430s.[7]

Comparisons of the two figures reveal similarities in pose, deriving from the frequently repeated Hercules type used by Donatello and Nanni di Banco, for example, for their own 1408–09 statues for the cathedral buttress area. Of particular interest, however, are the wide stance of both figures, the supports for the right legs of winged helmet and tree stump respectively, and the frank nudity of each figure. A more telling comparison, however, is the strong frontal pose of the bronze *David* which, like Michelangelo's later figure, is slightly softened by a gentle movement to the left and right. This compositional characteristic has been misinterpreted in the literature, perhaps because the earliest reference to the bronze *David* in 1469, at the time of the wedding of Lorenzo the Magnificent and Clarice Orsini, describes the statue as standing on a pedestal in the center of the courtyard of the Medici Palace, and because the statue continued to exist as a column statue until the mid-sixteenth century.[8] Until the mid-sixteenth century the statue existed as a column statue apparently to be seen in the round. Yet, like Michelangelo's later *David*, the statue is obviously designed to be seen frontally, with perhaps some movement to the left and right — again like Michelangelo's figure.

Yet unlike Donatello's *Judith and Holofernes*, which has no single face or static viewing point, the bronze *David* makes sense only from the front. The sword held in the right hand moves toward the front of the figure, the stone in David's left hand is clearly visible from the front, and even the head of Goliath beneath David's left foot faces more or less toward the front. No compositional element in the statue pushes the viewer's attention around the figure. In fact, the view from the back is not only uninteresting and nondirecting, but even somewhat awkward, especially at the waist and the point where the left leg meets the hip and buttock (fig. 7.2). Even though the erotically suggestive wing that is part of the decoration of Goliath's helmet is more clearly visible from the rear, all of the visual information of the statue is clearly in evidence primarily from the front of the figure.[9] Despite the fact that the statue existed for much of its recorded history as a column statue, and thus visible from all sides, the artist who conceived the work obviously had something else in mind; the form of the statue bears little relationship to its ultimate placement on a column and to subsequent descriptions of it as a figure to be seen in the round.

Other aspects of the bronze *David* also deserve comment. The figure's downward glance indicates that it was designed to be seen from below, which accords with its placement on a column in the Medici Palace and, after 1495, in the Palazzo Vecchio. Yet its size (158 cm.) indicates that the statue as it currently exists, unlike Donatello's lost *Dovizia*, could not have been conceived for any large public space, where it would have been all but invisible. The pervasive sensuality of the figure also calls into question its appropriateness as a civic monument, regardless of the scatological reputation of Florence in the Quattrocento.

The surface of the bronze *David*, for all its sleekness, is misleading in its rounded sensuousness for, far from being a thin membrane stretched over a vibrant human anatomy, the skin of the body is surprisingly chilly, and, in some areas, particularly around the face, the upper chest, and the back, exceedingly dry. In addition, the hard crispness of the folds of flesh at the corners of the eyes, the sharp planar treatment of the nose, the frozen set of the mouth, and the schematic incisions around the neck of the *David* are all contradictory to the otherwise modeled androgynous sleekness of the statue. On the whole, the figure suggests, by the treatment of its surface and by the variant sensibilities of its parts, a cast by an artist different from the creator of the original model.

Although the visual evidence does not necessarily contradict traditional attributions of the bronze *David* to Donatello extending back to the early sixteenth century, it does indicate that a fresh look at the conception and the dating of the statue is in order. The statue itself appears as a classical ephebe figure despite the naturalistic renderings of the softly swelling adolescent body. The fusion of extremes of classicistic and naturalistic representation, while disturbing visually, does nonetheless suggest possibilities for placing the statue in time. No other sculpture created in Florence during the first half of the Quattrocento displays quite the sensibility of the bronze *David*. Even when Donatello himself turned to a blatant antiquarianism in the *Cantoria* in the late 1430s he did not simultaneously attempt the near-palpitating reconstruction of the human figure that lies behind the *David*. Nor does the aesthetic of the *David* compare with other Florentine works of art produced during the first half of the century. Moreover, it is difficult to imagine who would have commissioned such a statue, even were it a response to the expanding tradition of scatological literature of this period.[10]

Not until the *Judith and Holofernes*, added to the Medici collections during the reign of Piero di Cosimo between 1464 and 1469, does Donatello or any other Florentine artist present the male torso in such a sensual manner, even though incipient explorations of such a presentation can be detected in Donatello's last two Campanile prophets. Without making any specific linkages other than of style to the *Judith and Holo-*

*fernes* group, the bronze *David* gives every appearance of participating in Donatello's late concern for sensuously realized surfaces and for an implied movement in the figures which suggests a near-stilled slow motion rather than the robust activities of the figures from the late 1430s.

The meaning of the *David*, usually glossed over in favor of discussion of its perverse attractiveness, must also be investigated in any attempt to clarify the history of the figure. David is, after all, a biblical hero who raises the question of political tyranny, hardly a topic which Cosimo would have chosen as an ornament for his immediate surroundings during the early years of his dominance in Florentine politics. The deliberate Herculean pose emphasizes the idea of the victory of liberty over tyranny which has been, and was to continue to be, a recurrent theme in Florentine artistic imagery.[11] Yet the classicized ephebe of the bronze *David*[12] drains the heroic violence from the tale and essentially domesticates or tames the myth by placing it in the allegorical tradition of the psychomachia, where the particular story and its attendant political implications are translated into a general allegory of virtue overcoming vice. The *David*'s participation in the psychomachia tradition is shared by Donatello's *Judith and Holofernes*. As decorations in the Medici Palace, both the *Judith* and the *David* describe similar messages, although no explicit connections need be made between their commissions.

Yet it should be remembered that Piero di Cosimo added inscriptions to the base of the *Judith* which make explicit reference to rulership and republican values.[13] It is clear from these inscriptions that Piero intended far more than a simple renewal of the psychomachia tradition or a blatant — and certainly inappropriate — reassertion of the tradition of civic humanism. Medici patronage had always manifested its ideological concerns in a more sophisticated and multilayered manner. Certainly by Piero's time the Medici were populating their environment with images that had more traditionally been connected with public commissions fostering public awareness of civic *virtù*. In the process of this assimilation, the Medici transformed the images through allegory, such as the psychomachia tradition, to fit the new private role they had to play, and essentially moved the symbols of the republican state into a private family environment.[14]

The significance of this transformation becomes more cogent once we recall that, from about 1455, Cosimo no longer went to the Palazzo Vecchio to participate in city government; from that time on, the elected city officers came to him on matters of official business, which were transacted within the Medici enclave. Participating officials not only saw the Medici against the backdrop of the appropriated symbols of the

bronze *David* and the *Judith*, but eventually against such additional visual supports to their power as Pollaiuolo's series of the labors of Hercules.

Reinstating the *David* to the time of Piero di Cosimo raises questions concerning its relationship to the colossal *David* intended for the cathedral buttress commissioned for Agostino di Duccio in 1463. Although the bronze *David* has become a kind of paradigm for fifteenth-century Florentine art, I would like to suggest that it is really a cast from the 1463 modello for the buttress figure and that it may even have been made after Donatello's death. While the evidence is circumstantial, it is convincing in its range and weight. Such a supposition would explain the frontal pose of the bronze *David*, the close proximity of the form with Michelangelo's *David*, the downward-looking glance (as if meant to be seen from the street below the tribune buttress) and the curiously dry aspects of certain areas of the cast.

Seeing the *David* as a cast after the 1463 modello would also explain the rather crabbed aspect of the wreath at the base of the figure which, although providing a stand for the statue, is curiously detached from the figure itself. In fact, the helmet of Goliath is broken at the back of the figure, where the wreath interrupts what once must have been either a complete neck plate or some other meeting of the helmet with the ground (fig. 7.3). For the wreath to be completely undisturbed by the helmet as it is now, indicates some shift in concept between the design of the figure and the base that was ultimately provided for it. Only Goliath's beard and the ribbons coming from David's right foot move over the wreath in any attempt to fuse it to the figure. Yet even here a careful inspection of the beard reveals a slight change in the handling of the surface where it joins the wreath, as if the lower strands of the beard were an afterthought. The ribbons obviously could also easily have been added at the time of casting. The incised decorative work on the boots of David and the visor of Goliath's helmet is, furthermore, anomalous in Donatello's work; much of it was clearly tooled in during the chasing process and may have little to do with the original model.[15]

The posited relationship between Agostino's 1463 modello and the bronze *David* adds disturbing problems of attribution to the already vexed history of the *David*. Equation of those figures does, however, narrow the dating of the work to 1463–69. If Donatello's inventive genius really lay behind Agostino's hand in 1463, as Seymour suggested, then the statue rightfully remains within Donatello's oeuvre, despite the intervention of Agostino and especially of the later caster. Although Agostino's elusive artistic personality cannot be explicitly described in the *David*, the antiquarian classicism of the figure, although more epi-

cenely refined, accords with the spirit of classicism of the Tempio Malatestiano where Agostino had worked during the 1450s.[16]

The suggestion that the Medici appropriated an image which apparently originated as a commission for public sculpture need not seem surprising once we realize constant involvement of this family with the building program of the cathedral itself. Lorenzo's intervention in the façade design is well known. But as early as January 1468, the very time that is of concern in the history of the modello for the *David*, Lorenzo participated as a councilor in discussions about the *palla* atop the lantern of the cathedral dome.[17]

It is, consequently, tempting to see the fine hand of the Medici at work in the awarding of the contract for the *palla* in September 1468 to Andrea del Verocchio,[18] who was one of a stable of artists working for the Medici family. Piero di Cosimo, in fact, acted as a financial intermediary between the Opera and Verrocchio during 1469.[19] Even though Lorenzo acted as part of a large group and even though Piero's role seems to have been managerial, it is nonetheless clear that the completion and decoration of the cathedral was of concern to the Medici in the years immediately before the first documented appearance of the bronze *David* in the Medici collections in 1469. We might more accurately, perhaps, see the Medici influencing artistic activity at the cathedral, and ultimately appropriating the forms as their own.[20]

If the bronze *David* and the 1463 modello really represent the same figure, then Michelangelo's attack on the nodum on his block in 1501 must have been made with full cognizance of the history and Medician implications of the model for his own *David*. His actions not only declared his personal creativity but separated the new republican statue from the tradition of Medici iconography that had been attached to the modello through the bronze *David*.[21] For the renewed republic, Michelangelo provided a statue that reasserted the concept of civic *virtù* in its generalized pose, and thus emphasized a communal heroism rather than the more private aestheticism of the bronze *David*. Michelangelo's *David* and the bronze *David* thus stand as contrasting versions of a particularly Florentine symbol whose appropriation gave legitimacy to political power.

# NOTES

1. The document concerning the nodum, along with all other relevant documents concerning the commission and the placement of the *David* are collected by Charles Seymour, Jr., *Michelangelo's David: A Search For Identity* (Pittsburgh, 1967), pp. 107–55. Seymour relied on Giovanni Poggi's transcription of the documents, *Il Duomo di Firenze (Italienische Forschungen,* Vol. 2) (Berlin, 1909). For a more recent interpretation, see Saul Levine, *Tal Cosa: Michelangelo's David–Its Form, Site and Political Symbolism* (Ph.D. diss., Columbia University, 1969). Irving Lavin was the first to suggest that this nodum was a transfer point ("Bozzetti and Modelli. Notes on Sculptural Procedure from the Early Renaissance through Bernini," *Stil und Uberlieferung in der Kunst des Abendlandes* 3 Berlin, 1967): 98). My own comments on Seymour's book appeared in a review in *The Art Bulletin* 51 (1969): 294–97.

2. Seymour, *Michelangelo's David*, pp. 123–27.

3. Ibid, p. 122. Seymour makes an unexplained reference to the statue as terracotta on p. 37.

4. Ibid, pp. 35–38. Seymour also traces the early history of the sculpture for the north tribune of the Duomo, for which Michelangelo's *David* was also intended (pp. 27–35). For a discussion of Donatello's *David* and the buttress program, see also H. W. Janson, *The Sculpture of Donatello* (Princeton, 1963), pp. 3–7. For a divergent point of view concerning the roles of Donatello and Nanni di Banco in the 1408–09 commission, see Manfred Wundram, *Donatello und Nanni di Banco, Beiträge zur Kunstgeschichte,* vol. 3 (Berlin, 1970) and Volker Herzner, "Donatello und Nanni di Banco," *Mitteilungen des Kunsthistorischen Institutes in Florenz* 17 (1973): 1–28.

5. Agostino di Duccio is one of the more shadowy artistic personalities of the fifteenth century. Although a Florentine, he spent most of his life outside the city. Few works, save the "signed" 1442 antependium reliefs of San Gimignano now immured in the facade of the Modena cathedral, can be attributed with certainty to Agostino's hand, and no freestanding figures divorced from a larger architectural program are recorded in the documents. For a recent summary of Agostino's career, see H. W. Janson, "Die Stilistische Entwicklung des Agostino di Duccio mit besonderer Berücksichtigung des Hamburger Tondo," *Jahrbuch der Hamburger Kunstsammlungen* 14/15 (1970): 105–28.

Another possible reason for Agostino's release from his contract may have had to do with shifting priorities in the cathedral administration; in January 1467, work began on the *palla* of the lantern, and the Opera may have decided to concentrate its energies and monies on completing the dome of the cathedral (see Cesare Guasti, *La Cupola di Santa Maria del Fiore* [Florence, 1857], pp. 111–14, for the documents).

6. Verrocchio's bronze *David* of the early 1470s is the most notable example; but see Charles Seymour, Jr., *Sculpture in Italy 1400–1500* (Baltimore, 1966), p. 173, for an earlier dating to ca. 1465. The *Martelli David* at the National Gallery in Washington is yet another example of a David type, although its chronological relationship to the bronze *David* is not clear; the Washington figure has been attributed to Donatello (see Janson, *Donatello*, pp. 21–23, for a summary of opinions to 1957); to Bernardo Rossellino (Frederick Hartt, "New Light on the Rossellino Family," *The Burlington Magazine* 103 (1961): 387–92); and to Antonio Rossellino (John Pope-Hennessy, "The Martelli David," *The Burlington Magazine* 101 (1959): 134–39). Any future discussion of the *Martelli David* will depend upon the assimilation of John White's brilliantly detailed analysis of the technical aspects of the carving campaigns of the figure, now in typescript in the files of the National Gallery.

Ursula Schlegel discusses the bronze statuette in the Berlin museum after the *Martelli David* (which she accepts as being by Bernardo Rossellino), in "Problemi intorno al David Martelli," *Donatello e il suo tempo: Atti dell'VIII Convegno Internazionale di Studi sul Rinascimento, 1966* (Florence, 1968), pp. 245–58; the statuette is most likely a late copy

rather than an autograph work by Donatello, as she maintains. The bronze statuette in the Louvre that closely approximates the pose of the Bargello bronze *David* is attributed by Schlegel to Pollaiuolo; for a contrary view suggesting that the statuette is a *bozzetto* for Michelangelo's lost bronze *David* of 1501–08, see Charles de Tolnay, "Donatello e Michelangelo," in the same congress notes, pp. 259–75.

In addition to these well-known examples, there are numbers of terracotta figures of the victorious armored David by the Master of the David and St. John Statuettes (see John Pope-Hennessy, *Catalogues of Italian Sculpture in the Victoria and Albert Museum* (London, 1964), 1: 191–96); these statuettes conflate the attributes and the compositional forms of the Bargello *David* and of Verrocchio's *David*. A drawing of a nude David from late in the fifteenth century, perhaps deriving from the bronze *David* in the Bargello, once belonged to Vasari (see Licia Ragghianti Collobi, *Il Libro de' Disegni del Vasari* (Florence, 1974), 1: 78; 2, no. 210).

7. For the most complete summary of the history of this statue, see Janson, *Donatello*, pp. 77–86.

8. See ibid., pp. 77–80, for the pertinent references.

9. The circular wreath around the base of the figure is hardly a strong enough compositional force to warrant the viewpoint that the statue was conceived as a figure in the round.

10. Janson, *Donatello*, pp. 85–86.

11. See Leopold D. Ettlinger, "Hercules Fiorentinus," *Mitteilungen des Kunsthistorischen Institutes in Florenz* 16 (1972): 119–42. Saul Levine (*Tal Cosa*, pp. 110–11) believed that the bronze *David* was commissioned by Cosimo dei Medici "to symbolize his personal triumph in 1434."

12. Colin Eisler describes a specific tradition of the male nude to which the bronze *David* may be related: "The Athlete of Virtue: The Iconography of Asceticism," *De Artibus Opuscula XL* (New York, 1961), pp. 82–97.

13. REGNA CADUNT LUXU SURGENT VIRTUTIBUS URBES CAESA VIDES HUMILI COLLA SUPERBA MANU (Kingdoms fall through luxury, cities rise through virtues; behold the neck of pride severed by the hand of humility) and SALUS PUBLICA. PETRUS MEDICES COS. FI. LIBERTATI SIMUL ET FORTITUDINI HANC MULIERIS STATUAM QUO CIVES INVICTO CONSTANTIQUE ANIMO AD REM PUB. REDDERENT DEDICANT (Piero son of Cosimo dei Medici has dedicated the statue of this woman to that liberty and fortitude bestowed on the republic by the invincible and constant spirit of the citizens). See Janson *Donatello*, p. 198, for the sources of the inscriptions.

14. Saul Levine (*Tal Cosa*, pp. 30–33) suggests a conscious identification on the part of the Medici with traditional republican symbolism during the 1460s.

15. The punchwork of the relief on the visor of Goliath's helmet is unusual in Donatello's work; it appears, not as background but to give a sense of surface to costume, in such figures as the reliefs on the bronze doors for the Old Sacristy of San Lorenzo and the *Judith*, where it is limited to the decorative brocade around the sleeve of the left arm. The palmette motif on David's boots is also unusual in Donatello's work and seems to be one that only comes into use well after the 1430s.

16. The standard work on the Tempio Malatestiano and its sculptural program is still Corrado Ricci, *Il Tempio Malatestiano*, (Milan, 1925).

17. Cesare Guasti, *La Cupola di Santa Maria del Fiore* (Florence, 1857), pp. 111–13.

18. Ibid., pp. 113–14.

19. Ibid., p. 114.

20. The laurel on the hat of the bronze *David*, mentioned by Frederick Hartt, *Donatello* (New York, 1972), p. 210, as the plant of Saint Lawrence, a patron saint of the Medici and titular saint of their church, may refer more appropriately to Lorenzo (*lauro*), a standard poetic mode of reference to the Magnificent. The conjunction of the presence of this sym-

bol and the initial reference to the bronze *David* at Lorenzo's wedding festivities may be more than coincidental. Ettlinger, for example, points to the Pollaiuolo *Hercules* in the Frick Collection in New York City as the distinctive type of the young, beardless Hercules as opposed to the alternate, equally defined type of the mature and more sturdily built one (Ettlinger, "Hercules," pp. 131–32). The Frick *Hercules*, while not necessarily from Lorenzo's collection, nonetheless is indicative of the artistic and iconographic predilections of Laurentian Florence; it utilizes precisely the same classical pose as the bronze *David*.

21. It was at this very time (August 12, 1502) that Michelangelo was commissioned to make a copy of the bronze *David*, then in the Palazzo Vecchio, for Pierre de Rohan in France (Charles de Tolnay, *Michelangelo: I The Youth of Michelangelo*, (Princeton, 1969), pp. 205–09); this commission dragged on until 1508 and was eventually completed by Benedetto da Rovezzano. Even before this time, of course, Michelangelo would have known the bronze *David* when it had formed part of the Medici collections. The importance of the bronze *David* after 1495 as a public revision of a well-known Medici symbol can be measured, in part at least, by the fact that it was placed in the Palazzo Vecchio during the banner years of Savonarola's public life, despite its overt sensuousness.

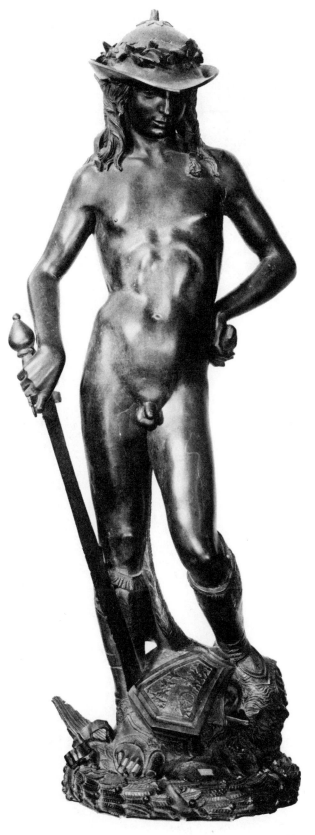

7.1 Donatello (?), *David*, Bargello, Florence.

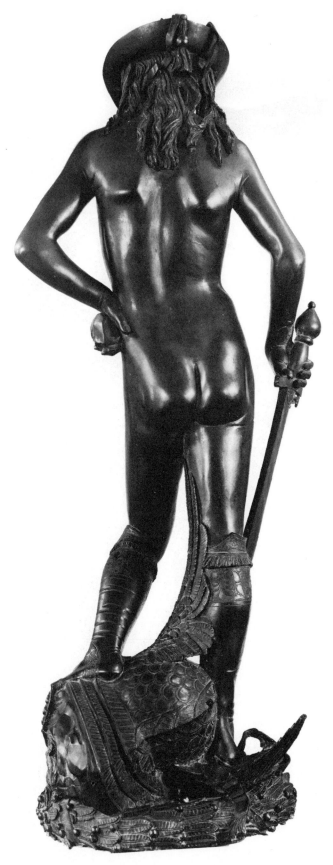

7.2 *David*, view from rear.

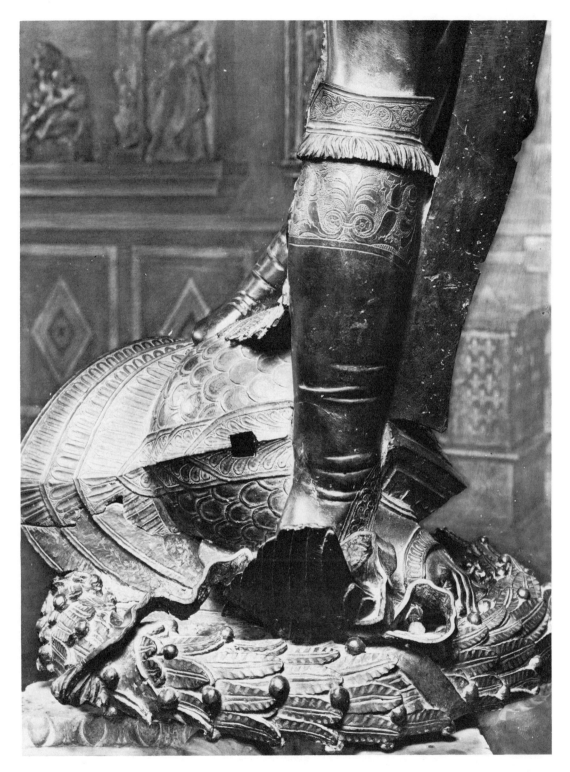

7.3 *David*, detail.

# 8. David's Scowl

*DAVID SUMMERS*

ACCORDING TO THE YOUNG NEAPOLITAN HUMANIST Pomponius Gauricus, whose *De Sculptura* was published in Florence late in 1504, some few months after Michelangelo's *David* had been set in place, physiognomy is "a certain manner of observation by which we recognize from the signs of the body the qualities of the soul.[1]" We recognize the invisible soul in the visible body, he continues by way of illustration, just as we recognize a craftsman by his tools or the character of a lord by his palace. This relationship is reversible—we might also deduce the tools of the craftsman from a knowledge of his craft or the appearance of his palace from the status and character of a lord. So, since the sculptor does more than merely duplicate appearances, the science of physiognomy is of great use to him, "and indeed to all mankind," for it makes it possible to resurrect the great men of antiquity, truly to envision the features of Catullus, Vitruvius, and Pliny from what we know of their natures.[2]

It was universally assumed in the Renaissance, as it had been for many centuries, that the human body is the agent (or tool) and the outward expression (or palace) of the intelligible soul, which both determines and governs it. Consistent with such an assumption, it had been one of the postulates of Renaissance art theory from Alberti's *Della pittura* onward that the painter (or sculptor) makes the invisible visible by showing the states of the soul in the actions of the body. Physiognomy carried the implications of this relation between body and soul to an extreme, proceeding from the premise that the nature of the soul is evident not only in the actions of the body but in its character, configuration, and resemblances.

Although its most conspicious theoretical development in art took place later, at the end of the sixteenth century and in the seventeenth,[3] the ancient tradition of physiognomy had been firmly reestablished in Renaissance letters by the time Gauricus wrote.[4] The pseudo-Aristotelian *Physiognomonica*, probably written in the third or fourth century

after Christ, was central to this tradition. This text was known in the Middle Ages, and the mid-thirteenth-century translation of Bartholomew of Messina enjoyed considerable popularity in the Renaissance, with thirteen editions between 1472, when it was first published in Cologne, and 1500.[5] The ideas set forth in the *Physiognomonica* must therefore have had some currency, and we may more generally surmise from its history that Pomponius Gauricus's chapter—bookish, pedantic, and dependent on sources other than the pseudo-Aristotle as it is—reflects a much broader contemporary interest in the science of physiognomy.[6]

The author (or compiler) of the *Physiognomonica*, although aware of the various pitfalls that lay along his path, held to one major assumption: that the relationship between soul and body is reciprocal and in its way proportional. "Mental character is not independent of and unaffected by bodily processes, but it is conditioned by the state of the body: and contrariwise the body is sympathetically influenced by the affections of the soul" (805a).[7] Since any soul was the "form" of its body, then the appearance of any animal should express its essence, and resemblances between animals and men, so it was argued, indicated a similarity in the character of the souls that formed them.

Speculation upon such resemblance was one of the prime methods of the physiognomist, together with the consideration of the relationship between the physical and mental characteristics of the different human races. What is now considered to constitute the whole province of physiognomy—namely, the investigation of the relation of the passion of the soul to facial expression—was only one aspect of the original science, as the face was only one part of the body that served the intelligible soul. The factors felt to be significant in physiognomical definition were "movements, gestures of the body, color, characteristic facial expression, the growth of the hair, the smoothness of the skin, the voice, condition of the flesh, the parts of the body, and the build of the body as a whole." (806a)

When the author of the *Physiognomonica* turned from theory to its application, he variously used all these kinds of data; but he returned again and again to the analogy with animals, by far the most frequently cited being the lion, which, as "king of beasts," is used repeatedly to exemplify the manly qualities of courage and daring, and in fact is said "to exhibit the male type (*forma* [idea] *maris*) in its perfect form." (809b). Just as the lion is mentioned often in the treatise, so is disproportionate attention given to the physical counterpart of the courageous soul, and a lengthy description of the appearance of courageous persons is provided.

> Signs of courage (*signa fortis*) are—coarse hair; an upright carriage of the body; size and strength of bones, sides and extremities; the belly broad and flat; shoulder

blades broad and set well apart, neither too closely nor too loosely knit; a sturdy neck, not very fleshy; a chest well covered with flesh and broad; flat hips; the thickness of the calf low down on the leg; gleaming eyes, neither wide and staring nor yet mere slits, and not glistening; the body of a brilliant hue; a forehead straight and lean, not large, and neither quite smooth nor yet a mass of wrinkles. [807a–b]

Much the same formula is repeated later in the *Physiognomonica,* and we are told again that "men of fierce temper (*iracundi*) bear themselves erect, are broad about the ribs and move with an easy gait ... their shoulder blades are set well apart, large and broad; their extremities large and powerful; they are smooth about the chest and groin" (808a).[8]

These descriptions not only agree with Michelangelo's *David* (fig. 8.1), but they correspond to some of its most outstanding characteristics: the broad shoulders, back, and chest; the relatively flat hips; the strong neck, large hands and feet. Although the final appearance of the *David* was determined to some unspecifiable extent by the state of the stone out of which it was carved when Michelangelo took it over in 1501, this can hardly account for all these correspondences, much less for such details as the coarse hair, which "gently curling at the ends will make for boldness of spirit, as is to be seen in lions." In view of his age, *David* does not have the great beard he might reasonably expect in his maturity, but the hair of his head "starts low down with a vigorous growth"; and "hair on the nape of the neck indicates liberality, as in lions" (812b).

It may be noted that the characterization of David as a lion which is implicit in such a representation was appropriate for other than physiognomic reasons: David was the "lion of Judah,"[9] and the lion was also an ancient symbol for the city of Florence, with much the same libertarian meanings that have been seen in Michelangelo's colossus.[10]

A major characteristic shared by the lion and the courageous man is a cloudy brow. "A square and well proportioned forehead," the pseudo-Aristotelian author wrote, "is a sign of a proud soul, as in the lion. A cloudy brow signifies self-will as in the lion and the bull" (quicunque autem obnebulosam, audaces vel iracundi, referuntur ad taurum et leonem) (811b) (fig. 8.2). The convention of the leonine scowl is well-known in both ancient and Renaissance portraiture of rulers, and Michelangelo exploited this convention when he carved his *Brutus.*[11] Outside this tradition, the scowl first appears in Michelangelo's art in the statuette of the warrior-saint Proculus for the Arca of San Domenico in Bologna, a subject to which, as to the *David,* a leonine scowl was appropriate.[12] And, as is often noted, this same cloudy brow deepened into a stormy brow in the *Moses* for the tomb of Julius II. If the *David's* famous scowl does indeed signify *audacia,* then it completes, animates, and directs the image of courage and boldness stated in the rest of the figure.

It is, of course, difficult conclusively to demonstrate the use of a source such as the *Physiognomonica*, but it should be repeated that the suggestion accounts for the characteristics that distinguish the *David* from comparable Renaissance or classical sculptures and from the rest of Michelangelo's works. It also explains the deviations from "ideal" proportions in what is clearly intended to be an ideal figure. Michelangelo's disciple, Vincenzo Danti, based his *Trattato delle perfette proporzioni* on just such a distinction between what he called "quantitative" proportion and "qualitative" proportion. By the first, he meant the kind of modular proportion set out by Vitruvius at the beginning of the third book of his *De architectura*. By *proportion* in the second sense, he meant the correspondence between the appearance of a thing and its "form" or "soul" or animating "qualities," the kind of relationship we have just seen exemplified by the relation of body and soul assumed by the physiognomist. In Danti's second, higher sense, proportion was a kind of decorum.[13] These two kinds of proportion could obviously contradict one another, and Danti meant that in such a case "qualitative" proportion was primary; it was more important to make visible the living soul which made the body what it was than to show the numerical relations of the parts of the material body. *Qualità* or *virtù* ought no more to be obscured by the inflexible laws of mathematics or music than by the accidents of the appearance of an individual.[14]

When Cesare Ripa described his allegory of *Audacia*, he mentioned the "clouded brow" as one of its attributes, referring to the pseudo-Aristotle. *Audacia*, Ripa wrote, "is the vice of those who little consider the difficulty of some great act, and presuming too much of their own powers, believe that they will easily attain their end. Therefore it is shown by a youth who tries by his strength, to knock a firmly set column to the ground."[15] On the sheet of studies for the bronze and marble *David*s, now in the Louvre,[16] Michelangelo quoted the opening lines of Petrarch's sonnet 229: "Rocte lalta colonna el verd" (Broken is the high column and the green [laurel]). The significance of this line for Michelangelo has been variously interpreted.[17] But if it means that he has overcome (or aspires to overcome) "the difficulty of some great act," and thus proclaims the triumph of *audacia*, then this line echoes the other jotted on the same sheet: "Davicte cholla fromba e io col larcho. Michelagniolo" (David with the sling and I with the bow. Michelangelo). The bow to which he refers, as Charles Seymour has argued, is the bow that is used as part of the sculptor's drill.[18] In other words, as David conquered Goliath with a sling, so Michelangelo will overcome seemingly insuperable difficulties with the tools of his art.

When Ripa defined *Audacia* allegorically, he called it a vice—specifically the vice of those who presume too much of their own powers. For the artist, however, *audacia* is a virtue, if paradoxically still a prideful one. As Michelangelo must have known, Pliny called the great colossi of antiquity, contructed only after the art of sculpture had been perfected, *audaciae*.[19] In the opening lines of his *Ars poetica*, Horace cited the *potestas audendi*, the exercise of which made the painter like the poet.[20] As Francisco de Hollanda represented him, Michelangelo emphatically affirmed this freedom which Horace had been at pains to circumscribe, saying that "poets and painters have license to dare to do, I say to dare, what they choose."[21] Some ten years later, Jacopo Pontormo praised the painter as *troppo ardito*—too bold.[22]

To return finally to physiognomy, we might expect, if *audacia* is the great virtue of the poet-artist, that the cloudy brow of the leonine nature would appear in images of artists as well as those of rulers and warriors, somewhat as, according to Petrarch, laurel could properly be worn only by poets and princes.[23] In fact it does. Mantegna's self-portrait (Fig. 8.3), as if in illustration of the poetic *potestas audendi* of the painter, wears a laurel wreath and a pronounced scowl. Giorgione's *Self-portrait as David* (Fig. 8.4) displays a similarly clouded brow, which in this case must signify both the daring of the biblical hero and the boldness of the painter.[24]

The scowl of Michelangelo's *David* thus has a double meaning: *audacia* is in the soul of the great warrior-king and psalmist—and it is also in the soul of Michelangelo. His colossus takes its place among the great *audaciae*, at once signaling the perfection of the arts and the overcoming of all difficulties, predecessors, and rivals, "all statues modern and ancient, Greek or Latin as they may be."[25] In his realization of the *David*, Michelangelo emerges the victor from his contest with antiquity and surpasses the artists of his own tradition. The scowl thus makes as visible as the soul of David the soul of the sculptor Michelangelo.

# NOTES

1. Pomponius Gauricus, *De Sculptura* (1504), ed. A. Chastel and R. Klein (Geneva, 1969), p. 129. "Physiognomonica . . . est certa quedam observatio, Qua ex iis que corpori insunt signis, animorum etiam qualitates denotamus."

2. He refers specifically to the statues crowning the late fifteenth-century Palazzo del Consiglio in Verona.

3. Giambattista della Porta's *De humana physiognomia* (1589) and the role of physiognomy in Renaissance art generally are discussed by Alessandro Parronchi, "Resti del presepe di Santa Maria Novella," *Antichità viva* 4 (1965): 9–28; see also Julius Schlosser Magnino, *La Letteratura artistica* (Florence, 1964), pp. 630th ff.; for the later history of physiognomy in the theory of the visual arts, see Ernst Kris, "Die Charakterköpfe des Franz Xaver Messerschmidt: Versuch einer historischen und psychologischen Deutung," *Jahrbuch der Kunsthistorischen Sammlungen in Wien*, n.f. 6, (1932): 169–228, esp. pp. 198th ff.

4. For the ancient physiognomical texts, see Richard Förster ed., *Scriptores physiognomici graeci et latini*, 2 vols. (Leipzig, 1893–94,).

5. Sybil Douglas Wingate, *The Medieval Latin Versions of the Aristotelian Corpus, with special reference to the biological Works* (London, 1931), pp. 93–94.

6. A good history of the literature of physiognomy, and an introduction to its uses in the art of the Renaissance, is provided by Chastel and Klein in their preface to Gauricus's chapter on physiognomy; Gauricus, De Sculptura, pp. 118–27.

7. I have used the translation of Thomas Loveday and Edward Seymour Forster in *The Works of Aristotle Translated into English*, ed. William David Ross (Oxford, 1913), Vol. 6, to which subsequent citations of the *Physiognomonica* will refer. Latin references are to Bartholomew of Messina's popular translation, given together with Richard Förster's edition of the Greek in his *Scriptores physiognomonici* 1: 4–91. Förster, like the Oxford translation, follows the standard numeration of Aristotle's works.

8. On the positive revaluation of *iracundia* and related vices in Quattrocento Florentine thought (including political thought) see Edgar Wind, *Pagan Mysteries in the Renaissance* Harmondsworth, 1967), pp. 68–69, with numerous references.

9. David was also the prefiguration of the Messiah, referred to in Revelations 5:5 as the lion of Judah.

10. On the lion as the symbol of Florence, see Leonold Ettlinger, "Hercules Florentinus," *Mitteilungen des kunsthistorischen Institutes in Florenz* 16 (1972): 119–42; and on the Marzocco, H. W. Janson, *The Sculpture of Donatello* (Princeton, 1957) 2: 42–43; and Alfredo Lensi, *Palazzo Vecchio* (Milan-Rome, 1929), passim. A Marzocco (not Donatello's) stood on the *ringhiera* of the Palazzo Vecchio from the Trecento onward; it was for a time crowned and bore a verse by Franco Sacchetti: "Corona porto per la patria degna, a ciò che libertà ciascun mantegna."

11. See Peter Meller, "Physiognomical Theory in Renaissance Heroic Portraits," *Studies in Western Art. Acts of the Twentieth International Congress of the History of Art* (Princeton, 1963), 2: 67–69. Clouded brows were also appropriate to warriors and are familiar in Donatello's *St. George* and Verrocchio's *Bartolommeo Colleoni*. See also a cuirassed *Warrior Guardian* in the left-hand niche of the Tomb of Doge Andrea Vendramin in the church of Santi Giovanni e Paolo, Venice; Wendy Stedman Sheard, "The Tomb of Doge Andrea Vendramin in Venice by Tullio Lombardo" (Ph.D. diss., Yale University, 1971), pp. 45–46, 48, 205–09.

12. On Saint Proculus, Charles de Tolnay, *The Youth of Michelangelo*, (Princeton, 1969), p. 140.

13. Vincenzo Danti, *Il Primo Libro del Trattato delle perfette proporzioni* (Florence, 1567), in Paola Barocchi, ed., *Trattati d'arte del Cinquecento fra Manierismo e Controriforma* (Bari, 1960), p. 243: "se bene io mi servo di questo nome 'proporzione' nella qualità,

il che forse altri chiamerebbe 'convenienza', io nondimeno intendo che per tale significato sia inteso." This is the same as Lomazzo's "proportion of prudence," already defined by Pomponius Gauricus (ed. Chastel and Klein, p. 55): "Prudentem etiam minimeque ineptum, Qui scilicet certam quandam in omnibus rebus rationem intelligat. . . . Alia enim in C. verbi gratia, Caesare Imperatore, Alia in Consule Alia in eodem ipso dictatore convenient, Nec Herculem ipsum semper eadem decebunt, vel cum Anthaco luctantem, vel coelum humeris substinentem, vel Deianirae amplexus petentem vel Hylam quaeritantem." Compare Francisco de Hollanda's definition of physiognomy. *De la pintura antigua por Francisco de Hollanda (1548) versión castellana de Manuel Denis (1563)*, ed. Elías Tormo y Monzó (Madrid, 1921), pp. 70-71: "Cúmplele finalmente entender de filosomía para dar a cada persona su propriedad y oficio y condicion y figura." And Lomazzo, *Trattato dell'Arte de la pittura* (Milan, 1584), pp. 30–31, where "moto, decoro, gratia, furia" are all used synonomously. Lomazzo associated "qualitative" proportion with movement (as did Vincenzo Danti). *Decoro* (which gives each thing its animating qualities, and is thus linked with movement) is achieved by the "method and order of prudence," aiding and supplementing the defects of nature with art. "Onde s'uno Imperatore è sproportionato, non deve il pittore esprimere quella sproportione nel ritratto . . . ma di tal modo, & con tal temperamento, che 'l ritratto non perda la similitudine, & che 'l difetto de la Natura si cuopra accortamente co'l velo de l'arte." This may constitute prudence in a slightly more commonplace sense, but the advice is still based on the notion that the portrait should first of all make visible the *virtù* of the emperor; and the wisdom of the painter consists in his knowledge and skill in embodying his knowledge.

14. The "method and order of prudence" corresponds to Vincenzo Danti's category of "imitare," "to make a thing as it would have to be in order to be of complete perfection" (*Trattato*, p. 241), probably again with the precedent of Pomponius Gauricus (pp. 204–07) who, like Lomazzo (see previous note) links *animatio* (or *psychike*) with *mimesis*, "hoc est imitacione." Animation is achieved by the treament of contours, by gestures and symmetry, all of which are governed by the highest principle of decorum (or *prudentia*). See Niccolò Martelli's letter of July 1544; Michelangelo, we are told, "did not take from Duke Lorenzo or Duke Giuliano for his model exactly what had been represented and composed by nature, rather he gave them a grandeur, a proportion, a decorum, a grace, a splendor which it seems to him bears them more praise, saying that a thousand years hence no one will be able to know that they were otherwise, such that, seeing them, people will be stupified by them" (Giorgio Vasari, *La Vita di Michelangelo nelle redazioni del 1550 e del 1568*, ed. Paola Barocchi (Milan, Naples, 1962), 3: 993. Danti (*Trattato*, p. 252) bases this in the Aristotelian distinction between poetry and history. *Imitare*, like poetry, "says things as they would have to be in complete perfection, and describing the life of an individual, poetry relates it as it would have been with all the *virtù* and perfection that pertain to him."

15. Cesare Ripa, *Iconologia* (Rome, 1603), p. 35.

16. See Frederick Hartt, *Michelangelo Drawings* (New York, 1970) no. 20.

17. Charles Seymour, Jr., *Michelangelo's David: A Search for Identity* (Pittsburgh, 1967), pp. 5–6, with notes, connects the line with the death some years earlier of Michelangelo's great patron, Lorenzo de' Medici. Ripa describes the column as unbroken (indeed as unbreakable); Michelangelo describes it as broken. The broken column relates allegories of fortitude, often exemplified by Hercules, to the Florentine political tradition to which the *David* is often related; see again Ettlinger, "Hercules Florentinus;" and for the theme of the broken column symbolic of *fortezza*, Edgar Wind, *Giorgione's 'Tempesta', with comments on Giorgione's Poetic Allegories* (London, 1969), pp. 2–3. Ripa *Iconologia*, p. 165) shows *fortezza* as a woman "per accommodare la figura al modo di parlare," but according to "la finosomia" describes her as having "il corpo largo, la statura dritta, l'ossa grandi," etc., a paraphrase of the description I have analyzed above. Following the scheme of Aristotle's *Nicomachaean Ethics, fortezza* is the mean (or virtue) between the vices of *audacia* and

*temidità*. See *Aristotelis Opera cum Averrois Commentariis* (Venice, 1562–74); 3: fols. 38v ff.

18. Seymour, *Michelangelo's David*, p. 9, with a review of interpretations in the notes.

19. Katherine Jex-Blake and Eugénie Sellers, eds., *The Elder Pliny's Chapters on the History of Art* (Chicago, 1968), pp. 30–33 (Pliny, *Natural History*, 34. 38–45: "evecta supra humanam fidem ars est successu, mox et audacia. . . . Audaciae innumera sunt exempla. moles quippe excogitatas videmus statuarum, quas colossaeas vocant, turribus pares." According to Petronius (*Satyricon* 2), it was also the *audacia* of the Egyptians which gave rise to the much-mooted "abbreviation" of painting. Petronius's critical attitude toward this development aside, it seems evident that the term is meant to apply to highly skilled artifice.

20. *Ars poetica*, 9–11: "pictoribus atque poetis /quidlibet audendi semper fuit aequa potestas scimus, et hanc veniam petimusque damusque vicissim." This text has a long and significant history in the Middle Ages and the Renaissance.

21. Francisco de Hollanda, ed. Joaquim de Vasconcellos, *Vier Gespräche über die Malerei geführt zu Rom 1538* (Vienna, 1899), p. 102: "os poetas e pintores teem poder para ousarem, digo ousarem o que lhes aprouver." Michelangelo's quotation of Horace may or may not mean that he was a student of the Roman poet, since the meaning of the phrase had long since been reversed and turned to the use of a Florentine painter. At about the time of Michelangelo's birth, after 1474, a follower of Benozzo Gozzoli modified the words slightly ("pictoribus atque poetis semper fuit et erit equa potestas") and used them as the motto for his sketchbook, together with the inscription in Hebrew, Greek, and Latin, IESUS NAZARENUS REX IUDAEORUM. See A. E. Popham, "A Book of Drawings of the School of Benozzo Gozzoli," *Old Master Drawings* 4 (1929–30): 53–58.

22. *Trattati d'arte del Cinquecento*, ed. Barocchi, 1: 68. It is no doubt because of the ambivalence of artistic *audacia* that Dante *(Purgatorio*, II) placed the painters and poets (himself perhaps included) in the circle of the proud.

23. See Ernest Hatch Wilkins, *Studies in the Life and Work of Petrarch* (Cambridge, 1955), p. 300–13 for Petrarch's coronation oration of 1341; and on the merging of the language of artistic and princely prerogative, Ernest Hartwig Kantorowicz, "The Sovereignty of the Artist. A Note on Legal Maxims and Renaissance Theories of Art," *De Artibus opuscula XL. Essays in Honor of Erwin Panofsky* (New York, 1961), pp. 267–79.

24. Edgar Wind, *Giorgione's Tempesta*,' pp. 10–11, n. 57, noting that the heads of David and Goliath are the same size in Giorgione's *Self-portrait as David*, suggests that Giorgione meant to depict himself as a giant and refers to Michelangelo's *David*. The painting would then constitute an audacious boast.

25. Giorgio Vasari, *La Vita di Michelangelo*, ed. Barocchi, 1: 22.

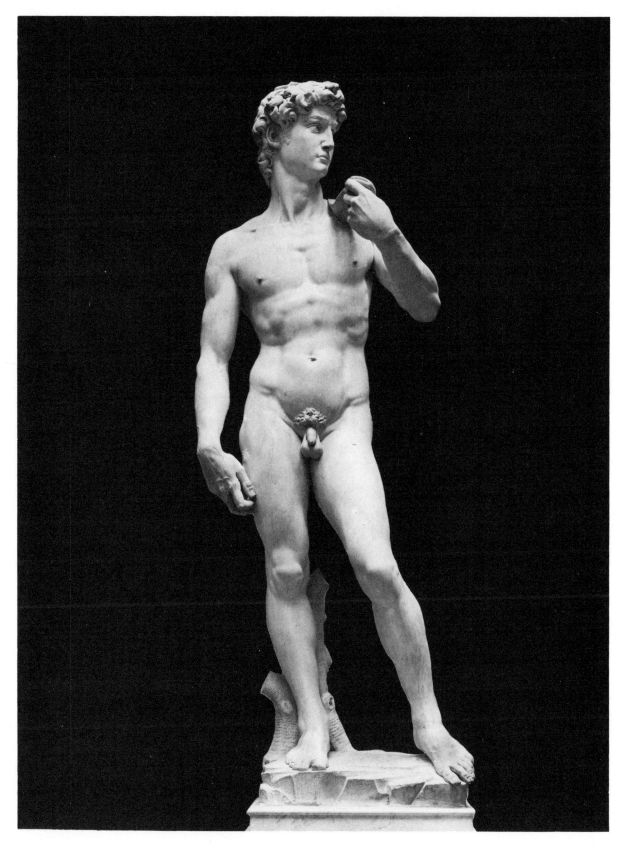

8.1  Michelangelo, *David*. Accademia, Florence.

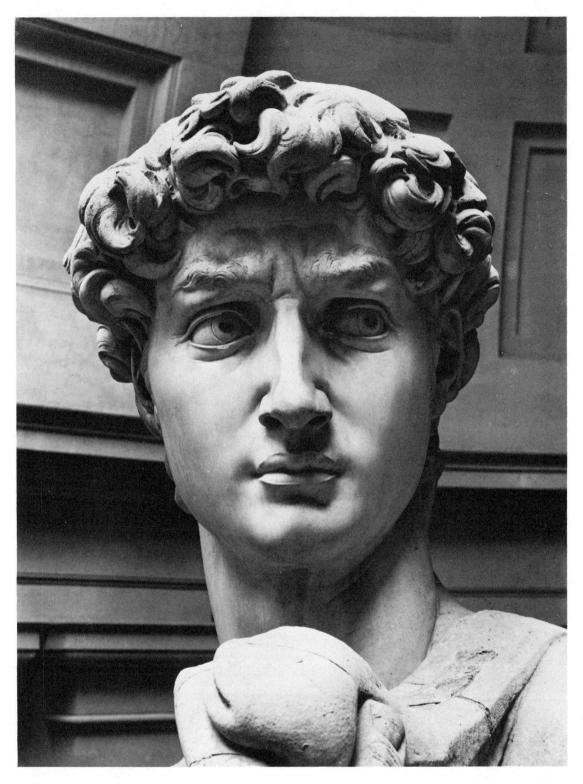

8.2 Detail of figure 8.1.

8.3  Andrea Mantegna (?), *Self-Portrait*. Sant'Andrea, Mantua.

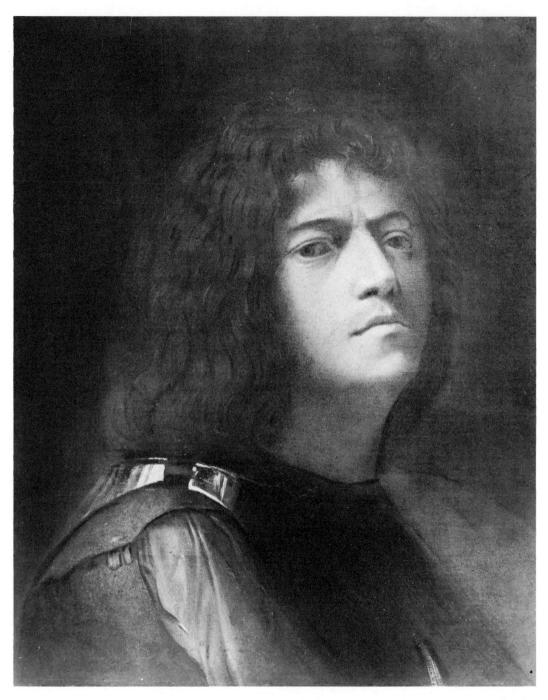

8.4 Attributed to Giorgione, *Self-Portrait as David*. Herzog Anton Ulrich-Museum, Braunschweig.

# 9.  Vasari's Staircase
# in the Palazzo Vecchio

*EDMUND P. PILLSBURY*

BEFORE GIORGIO VASARI (1511–74) renovated the Palazzo della Signoria in the late sixteenth century, the front part of the building possessed three different staircases. The oldest of these, built at the beginning of the fourteenth century, purportedly on the design of Arnolfo di Cambio (ca. 1240– ca. 1302) and refurbished in the fifteenth century by Michelozzo (1396– 1472), ascended along the north side of the first courtyard to a room beside the Sala dei Dugento; and from there, in the interior of the palace, to the Sala degli Gigli on the second floor.[1] A second set of stairs erected in the first decade of the sixteenth century led to the rear of the palace. Designed by Cronaca (1457– 1508), this stairway rose from a door on the far side of the main courtyard to the recently constructed Sala del Consiglio Maggiore, later known as the Salone dei Cinquecento or simply the Sala Grande.[2] A third public staircase occupied the area behind the first courtyard, next to the courtyard of the Dogana (Customs House). Installed toward the middle of the sixteenth century by Vasari's predecessor, Battista del Tasso (1500– 55), these stairs went directly from the ground level to the Guardaroba (Wardrobe) on the second floor.

When Vasari took over the remodeling of the palace in 1556, he designed a new system. His plan called for tearing out most of the existing steps and taking the space they had occupied to create a modern, more fully integrated network of stairs. The scheme he devised remains in use to this day (figs. 9.1, 5). It consists of a set of double ramps of three flights each, with plain white walls and simple *pietra serena* moldings, which encircle the courtyard of the Dogana to the center of the Sala Grande and branch, after the second ramp of the left-hand arm, to the Sala dei Dugento; from the vestibule outside the latter room the stairway ascends in six individual flights of steps, of varying lengths but also of ample width and simple design, to the top of the building (fig. 9.5).[3]

Although Vasari promoted the new staircase as an essential part of his modernization and conversion of the old municipal structure, its construction suffered delays. First, when Vasari presented the plan in 1560, Duke Cosimo de' Medici (1519–74) gave his consent to only part of the scheme—that connecting the first and second floors; then, before this section was done, he urged Vasari to devote himself to other projects in the palace.[4] Cosimo's concern about the high cost of the project further delayed the undertaking.[5] In fact, parts of the staircase remained unexecuted for nearly a decade.

Payments to the masons and other workers involved in the project allow us to follow its construction. These documents, which are preserved in the *Libri dello Scrittoio delle Fabbriche* in the state archives in Florence and which have never been fully published, show that a final completion of the new staircase occurred as late as 1570. Alfredo Lensi, the author of the only modern monograph on the Palazzo Vecchio, relying upon an incomplete series of payments, wrongly concluded that the stairway was finished by 1563; and his dating, although in conflict with other known facts, is accepted in all the recent writing on the building.[6] The payments overlooked by Lensi suggest, rather, that the parts of the new system rising to the center of the Salone dei Cinquecento—those, in fact, which gave the structure its distinctive feature of being a double stairway—belong to two subsequent building campaigns: the single flight of steps rising to the center of the Sala Grande from the north, to one in 1565; the three flights around the south side of the Dogana, to another in 1569–70.

These new facts are also of interest in other ways. They help to revise Lensi's dating of the dismantling of the Cronaca staircase and the construction of the sculpture niche in the main courtyard (fig. 9.2). And the latter event establishes a terminus post quem for the occupancy of the niche in the sixteenth century by various important pieces of sculpture, including the bronze *David* by Donatello, now in the Bargello, and the same master's *Judith and Holofernes*, now in the Piazza della Signoria in front of the palace.

The first part of the system to be built connected the apartments on the first floor of the building with those on the second (fig. 9.1); according to the payment to the head mason, Francesco Mechini, it ran from the Sala dei Dugento to the Sala degli Gigli, "la iscala nuova cecominicij alprimo piano dela sala de dugento e vane sune ala sala del oriuolo" (Doc. 1).[7] These five flights replaced the least serviceable segment of the old system. According to Vasari, the stairs serving this part of the building dated back to medieval times and were not only badly placed and poorly lit but were also made of wood, rather than of stone:

A una cosa sola non potette l'ingegno di Michelozzo rimediare: cioè alla scala

pubblica: perchè da principio fu male intesa, posta in mal luogo, e fatta malage-
vole, erta, e senza lumi, con gli scaglioni di legno dal primo piano in su.[8]

The construction of this part of Vasari's staircase went forward without
delay. After receiving Cosimo's approval to begin, probably in August of
1560, Vasari set four masons to work preparing the steps and ornaments
and tearing out the old ramps.[9] By the following January the vaults in
three of the four major branches were done, and workmen were ready to
install the door and window frames. At this moment a problem arose in
the fourth branch. Vasari wished to alter the small room outside the Sala
degli Gigli rather than making the last branch different from those
below.[10] Cosimo opposed major changes in the design but finally agreed
to Vasari's suggestions, allowing the staircase to be finished soon thereaf-
ter.[11] In a letter addressed to Cosimo the following April, Vasari relates
that he had begun to whitewash the stairs.[12]

Following the completion of the upper part of the staircase, work
came to a standstill. As early as January 1562, Vasari requested from
Cosimo permission to begin the lower extension of the stairway but the
duke refused, saying he should first build a *passo*, or passageway.[13] After
taking two months with this project—possibly identifiable as the wide
corridor connecting the Dogana with the third courtyard in the back of
the palace[14]—Vasari initiated construction in March 1562.[15] The payment
to the *scalpellino* Mechini neglects to mention the number of flights or
their location (Doc. 2). But these we can deduce from other sources. The
Cronaca staircase, which occupied the space where the right arm of the
double stairway would later be built, was still in use in 1565. Moreover,
subsequent payments to Mechini and the builder Bernardo di Monna
Mattea (Docs. 3, 5, and 7) account for the single ramp to the center of the
Sala Grande and the three flights of the right arm of the lower staircase,
and the 1564 payment to Mechini mentions the opening of a doorway in
the vestibule outside the Sala dei Dugento (Doc. 2). These facts would
suggest that the portion of the stairway undertaken in 1562 and finished
in late 1563 or in 1564 included only the three ramps connecting the far
side of the courtyard with the Sala dei Dugento.

The next part of the stairway was the single flight of steps joining
the second landing to the center of the Sala Grande, "la brancha della
iscala ce ariva nel mezo del salone del palazo ducale" (Doc. 3). Its con-
struction began in the spring of 1565 and lasted through the end of the
year (Doc. 4). In all likelihood, the stairs were in place for the wedding of
Cosimo's eldest son Francesco and Giovanna d'Austria in December
1565. For this occasion Vasari rushed to complete the ceiling and other
parts of the Sala Grande and decorated the courtyard with frescoes and
stuccoed ornaments (fig. 9.2); the added branch of the lower stairway pro-

vided the many guests direct access to the center of the Sala Grande, where the nuptial entertainment and banquets were to take place.

The construction of the final three ramps of the lower staircase—on the south side of the Dogana—began in late 1568 or early 1569. The mason Mechini received payments as early as October (Doc. 5), while Bernardo di Monna Mattea began work the following June (Doc. 7). They both served until the first months of 1570. Another payment entered in the accounts of the *Fabbriche Medicee* records the whitewashing of the stairway the following year (Doc. 6).

The completion of the Vasari staircase caused the demolition of the stairs built by Cronaca at the beginning of the century. These stairs, of which no trace survives, [16] ascended to the south end of the Sala Grande and hence became obsolete when Vasari installed the branch to the center of the Sala Grande. Although built on a large scale with steps measuring six *braccia* in width (more than twelve feet) and finely ornamented with pilasters, Corinthian capitals, and double cornices of blue-gray sandstone (*macigno*), this stairway doubled back on itself twice; as a result, its ascent to the Salone was relatively fast. Vasari considered this to be a serious deficiency, and in the 1568 edition of the *Vite* he contrasted the steepness of the Cronaca stairway to the more comfortable slope of his on the opposite side of the Dogana courtyard:

> Ed ancora che questa [the Cronaca stairs] fusse molto lodata, più sarebbe stata se questa scala non fusse riuscita malagevole e troppo ritta, essendo che si poteva far più dolce, come si sono fatte al tempo del duca Cosimo nel medesimo spazio di larghezza, e non più, le scale nuove fatte da Giorgio Vasari dirimpetto a questa del Cronaca, le quali sono tanto dolci ed agevoli, che è quasi il salirle come andare per piano. [17]

This comparison—in fact, juxtaposition—no doubt provided the justification for the subsequent removal of the stairway. None of the documents in the *Fabbriche Medicee* refers to its destruction. However, it is probably safe to assume that it occurred in late 1568 and early 1569 when Mechini was preparing to build the last part of the Vasari system (Doc. 5).

The installation of the final segment of the Vasari stairway also altered the appearance of the courtyard. It caused the conversion of the doorway leading to the Cronaca stairs into a sculpture niche (figs. 9.2, 4). This large portal stood beside the one constructed by Vasari and faced the main entrance from the piazza; it appears in Vincenzo Borghini's sketch for the wedding decorations in 1565 (fig. 9.3)[18] and is also mentioned by Mellini in the description of the wedding *Apparato* published in 1566.[19] Since the lowest ramp on the right arm of Vasari's double staircase rose along the back of the east wall of the courtyard, the completion of the system necessitated filling in the doorway. The building of a niche for

the display of sculpture had two advantages: it made use of the prominent site—opposite the entrance to the palace—and left undisturbed the cycle of frescoes with grotesque designs and views of the Austrian Empire painted on the walls of the courtyard in 1565. The whitewashing of the stairs in 1571—72, which also included parts of the courtyard, serves as a plausible terminus ante quem for the niche's existence (Doc. 6).

The date of the niche's construction clarifies the history of two pieces of Renaissance sculpture, Pierino da Vinci's *Samson and the Philistine*, which now occupies the niche (fig. 9.2), came into the courtyard only in 1592.[20] Prior to this date, according to Bocchi, the niche housed the Bargello's bronze *David* by Donatello.[21] This statue stood on a pedestal in the center of the courtyard until Francesco del Tadda's porphyry fountain supporting Verrocchio's *Putto and Dolphin* replaced it in the mid-1550s. Janson's monograph on Donatello suggests that the piece assumed its position in the niche soon thereafter.[22] The new evidence concerning the creation of the niche, however, suggests that the transfer took place after 1570. During the 1560s the statue probably remained in storage for subsequent placement, as Vasari suggests, in the courtyard Cosimo wanted to build in the rear of the palace.[23]

A second statue by Donatello has also been associated with the niche. According to Lensi, who does not give his source, the *Judith and Holofernes* came into the niche briefly during the first decade of the century—that is, from the time it left the *Ringhiera* (to make way for Michelangelo's *David*) in 1504, until it was installed under the westernmost bay of the Loggia dei Lanzi two years later.[24] The new dating of the niche demonstrates the fallacy of this assertion. Since Lensi believed the niche was in existence by the beginning of the sixteenth century, his conclusion may derive from the statement in Landucci's diary that the sculpture was put on the ground in the palace—"porre in Palagio in terra."[25] Simply on the basis of Landucci's remark, however, it is difficult to know where the statue may have rested, or even if it was placed in the courtyard at all.

The building of the new staircase by Vasari characterizes much of the work carried out in the Palazzo Vecchio for Cosimo de' Medici. In occupying the ancient seat of the Signoria, Cosimo strove to identify himself with Florence's past and thereby to enhance the legitimacy of his rule of the city. Cosimo's reluctance to approve more than a part of the scheme at any one time stemmed from his desire to preserve as much of the old building as possible: in Vasari's words, Cosimo "non ha mai voluta che nessuno architetto dia disegni che abbino a torgli la forma vecchia."[26] Since the new staircase involved the destruction of three existing structures—at least one of which (the Cronaca stairs) might have

been worth keeping for the sake of its rich ornamentation and ample scale—Cosimo had every reason to delay, or even prevent, the realization of the project. When Vasari proposed raising the ceiling of the Salone dei Cinquecento, Cosimo sent him to Rome to seek Michelangelo's counsel.[27]

Cosimo's conservatism may also have affected the design of the staircase. In contrast to the iconographic and formal cosmopolitanism of the decorated rooms, the principal stairs are distinctly Tuscan in character, with their simple *pietra serena* pilasters silhouetted against white walls. And the numerous ramps, while arranged in a novel way for the interior of a palace, conceal themselves behind the existing walls of the building: neither aesthetically nor physically do they impinge upon the older rooms they serve. In the staircase in the Palazzo Vecchio, Vasari demonstrated not only his ingenuity as an architect and engineer, but also his awareness of former architectural styles and his understanding of the building's political function.

In the introduction to the 1568 edition of the *Lives* of the Italian artists, Vasari speaks of the general requirements of a public staircase and some of the problems inherent in their fulfillment:

> The public staircase needs to be convenient and easy to ascend, of spacious width and ample height, but only in accordance with the proportion of the other parts. Besides all this, the staircases should be adorned or copiously furnished with lights, and, at least over every landing-place where there are turns, should have windows or other apertures. In short, the staircases demand an air of magnificence in every part, seeing that many people see the stairs and not the rest of the house ... This feature [the staircase] is most difficult to place in buildings, and notwithstanding that it is the most frequented and most common, it often appears that in order to save the rooms the stairs are spoiled.[28]

These ideas derive from Vasari's experience in the Palazzo Vecchio and demonstrate his conviction that the construction of a new principal staircase was of great importance in the overall scheme to convert the building into a suitable ducal residence and governmental seat.

# NOTES

1. Vasari took out the upper part of this stairway in 1560 and the lower part, in the courtyard, at the end of the following year (q.v. Alfredo Lensi, *Palazzo Vecchio*, [Milan and Rome, 1929] pp. 8, 184). Cosimo Conti, *La prima reggia di Cosimo I de' Medici nel Palazzo già della Signoria di Firenze* (Florence, 1893), p. 29, publishes an artist's rendering of the section of the staircase rising out of the courtyard. Conti's account of the history of the staircase wrongly states that the stairs were torn down at the beginning of the sixteenth century when those of Cronaca were installed, and that in the Life of Michelozzo (see n. 9 below) Vasari had confused the upper part of the stairway with the secret stairs constructed for the duke of Athens by Andrea Pisano.

2. According to Cambi (quoted by Lensi, *Palazzo Vecchio*, p. 105), this staircase entered the main courtyard in the southeast corner: "La schala nuova della Sala che riescie in Palazzo sotto la loggia di verso San Piero." Although no traces of this stairway have survived, Lensi (pp. 185, 271 n. 54) reports that a frontispiece belonging to one of the portals of the Cronaca stair was uncovered during the restoration of the Studiolo di Francesco I in 1910–11.

3. The principal, or public, staircase in the front of the Palazzo Vecchio should not be confused with those Vasari erected in other parts of the palace. These include the stairway leading from Tasso's doorway on the Via dei Leoni to the Terrace of Juno; the stuccoed and painted Scala Grande descending from the Sala degli Elementi to the Sala di Leone X, and from there to the courtyard of the Dogana on the ground level; and the various *scalette a chiocciola* and secret communications in the front of the palace connecting the ground with the private apartments in the upper part of the building. Most of these stairways were built in 1556–58. For an account of these, as well as the Tasso staircase in the courtyard of the Dogana, see Lensi (pp. 124, 156–57, 180).

4. See Cosimo's agent, Bartolommeo Concini, to Vasari on Jan. 14, 1561, and Cosimo to Vasari, Jan. 30, 1561 (Karl Frey, *Der literarische Nachlass Giorgio Vasaris* [Munich, 1923], 1: 592, 603–04).

5. See Cosimo to Vasari, Jan. 20, 1562: "Ma quel che voi vorresti metter' in la scala di dogana vogliamo lo mettiate in quel passo del cortile: Perche più Ci importa per hora tal, passo che le scale, ch è ve ne son, tante, che bastono" (ibid., p. 663).

6. Lensi, *Palazzo Vecchio*, pp. 184, 271 n. 51, followed by Paola Barocchi, "Il Vasari architetto," *Atti della Accademia Pontaniana*, n.s. 6 (1956–57): 131 n. 19, by Giulia Sinibaldi, *Il Palazzo Vecchio di Firenze*, 4th ed. (Rome, 1959), p. 7, and by the Touring Club Italiano, *Firenze e dintorni*, 5th ed. (Milan, 1964), p. 118. My essay serves to underscore the great need that exists for a monograph on the Palazzo Vecchio based upon an adequate standard of scholarship. Lensi's book (see n. 1) has the advantage of being based on records and chronicles; however, because of its broad scope and incomplete treatment of documentary sources, it has many omissions and factual errors. One of the important tasks will be to measure the building and examine it carefully.

7. Since the Sala degli Gigli housed the famous clock made for Lorenzo de' Medici by Lorenzo della Volpaia, it was common to refer to the room as the Sala dell' Oriuolo, or dell' Orologio.

8. Giorgio Vasari, *Le Vite de' più eccellenti pittori, scultori, ed architettori . . .*, ed. Gaetano Milanesi (Florence, 1878), 2: 437. Hereafter cited as Vasari-Milanesi.

9. Frey, *Nachlass*, 1: 577.

10. Ibid., pp. 599–601.

11. Cosimo's initial reluctance is evident from his comments to Vasari in a letter of Jan. 30, 1561 (ibid., pp. 603–04), but his subsequent acquiescence may be deduced from Vasari's letters of Feb. 3 and March 31, 1561 (ibid., pp. 604–05, 612).

12. Ibid., p. 626.

13. See n. 6 above.

14. Lensi, *Palazzo Vecchio,* p. 184.

15. Frey, *Nachlass,* 1: 672.

16. The stairway is mentioned by Vasari in the 1568 edition of *Le Vite* (Vasari-Milanesi, 4: 451).

17. Vasari-Milanesi, 4: 451.

18. This drawing belongs to the notebook in the Biblioteca Nazionale in Florence (Codice Magliabechianus, fil. II.X.100, c. 80r) which contains numerous drawings and notes relating to the decorations made in 1565 for the wedding of Francesco de' Medici and served as the basis for Ginori Conti's modern account of the *Apparato: L'Apparato per le nozze di Francesco de' Medici e di Giovanna d'Austria* (Florence, 1936). The present drawing is among those which Ginori failed to reproduce or discuss in his book.

19. Domenico Mellini, *Descrizione dell'entrata della Sereniss. Reina Giovanna d'Austria et dell'apparato fatto in Firenze nella venuta,* etc. [Florence, 1566], pp. 118 ff.

20. Lensi, *Palazzo Vecchio,* pp. 252–55.

21. Francesco Bocchi, *Le bellezze della città di Firenze* [Florence, 1591], p. 37: "In una Nicchia della Loggia, fatta nel muro semplicemente si vede un'altra statue di bronzo di un Davitte . . . di mano di Donatello."

22. H. W. Janson, *The Sculpture of Donatello,* (Princeton, 1957), 2: 80: "Soon after [1555], the David was put in the niche to the left of the doorway, near the stairs, where Donatello's Judith had stood between 1504 and 1506."

23. Vasari-Milanesi, 2: 406. After being removed from the niche, the *David* was put in the courtyard in the back of the palace which Buontalenti had recently finished (see Lensi, *Palazzo Vecchio,* pp. 252–55).

24. Lensi, p. 105: "Tolta di sulla ringhiera, la Giuditta fu collocata nella nicchia del cortile."

25. Luca Landucci, *Diario fiorentino dal 1450 al 1516,* ed. Todoro del Badia (Florence, 1883), p. 268.

26. Vasari-Milanesi, 8: 16.

27. Letter of Michelangelo to Cosimo, April 25, 1560 (Frey, *Nachlass,* 1: 561).

28. Quoted from *Vasari on Technique,* ed. G. Baldwin Brown, trans. Louisa S. Maclehose (New York, 1960), p. 97.

# DOCUMENTS*

1. Archivio di Stato, Firenze, Fabbriche Medicee, fil. 3, c. 61v:

dj 15 dagosto 1563

Spese della muraglia del palazo ducale Lire mileotocentosesantasette soldi tredicj piccioli si fano bonj afranc.° di gerdo mecinj jscapelino per la monta duno conto di più pietre lavoratte datoci per la iscala nuova cecomincja alprimo piano dela sala de dugento e vane sune ala sala del oriuolo per iscaglionj apogamanj cornice porte e per finestre come per uno contto si vede dj sua mano saldo e tazato detto conto per micele di gerdo jscapelino copiato detto conto a libro copia di liste e contj a libro D secondo da c. 164/166 saldo sotto dj 15 dj luglio 1563 ditratone Lire 447 soldi 10 per la taza

fiorini 266 Lire 5.13

2. ASF, Fab. Med., fil. 4, c. 32v:

dj 8 daprile 1564

Spese della muraglia del palazo ducale fiorini cinquecentosesantasej Lire cinque soldi sette piccioli si fano buonj afranº di gerdo iscapelino per la monta duno contto dj più pietre conce datocj per le scale nuove cesono sopra la dogana coè in pilastrj iscaglionj cornice supele scale apogamani e la entra duna porta ceriesce in fra le dua sala grande e finestre per supela scale e altre pietre come per il conto si vegono saldj e tazato dette pietre per simone deto del cotrice e micele di gerdo alesadro di Lᶻ° dj corbigniano tuti iscapelinj da adetto come per il conto saldo tazato copiato al quade[r] no deconti libro c.——108/109 particularmᵗᵉ

fiorini 566 Lire 5 soldi 7

3. ASF, Fab. Med., fil. 4, c. 47v:

MDLXV [1566 (st. c.)] dj 28 di fabrajo

Spese per conto della muraglia del palazo ducale fiorini secentootantadua denarj di monta Lire dua soldi dicanove picciolj si fano bonj a francº di gerado mecinj iscapelino per lamonta duno conto di più sorte pietre lavor-[a]te datocj per la brancha della iscala ce ariva nel mezo del salone del

---

*Although the seven payments transcribed here represent only a small fraction of those in the journals of the Fabbriche Medicee, they are the most important ones for establishing the principal stages of construction of the staircase.

palazo ducale e per più entrate di più porte per detto palazo e per lastronj del andito ce va dala porta diritto di detto palazo e per iscaglionj e lastronj murati in sul terazo iscoperto dello ilustrisimo principe e altro come distintamente apare per il conto det[r]atone fiorini novantatre Lire tre soldi otto piccioli per la taza di tale conto fatto e rivisto tutto per 4 amicj comunj come si vede alqu[a]de[r]no deconti c.——148.149

fiorina 682 Lire 2.19

4. ASF, Fab. Med., fil. 4, c. 48:

MDLXV [1566 (st. c.)] dj 28 di febrajo

Spese su dette fiorini setecentotrentotto dj moneta Lire tre soldi diecj picolj si fano bonj a santi dj fran⁰ del maiano muratore per magistero di più lavorj di muramentj fatti a sua ispese di muratorj manovalj e dj mazersie in murare e dare fine alopera del bandinello cenè sudetto salone e per fare la brancha di scala c[e] ariva in mezo a detto salone e per altrj muramenti fatti dadj 15 daprile 1565 a tutto dj 26 dj febrajo 1565 [1566 (st. c.)] come apare al quade[r]no deconttj libro c.——167 detratone fiorini 105 Lire 3.10 per la taza

fiorini 738 Lire 3.10

5. ASF, Fab. Med., fil. 5, c. 26v:

MDLxxj dj 28 daprile

Spese della muraglia su dette fiorini setecento trentasej di monetta si fano bonj [cancelled] e Lire quatro soldi dua denarj otto piccioli si fano bonj a fran⁰ di gerdo mecinj iscapelino e sono per lam[one]ta dj dua sua contj di più sorte pietre conce dette per detto palazo in lastronj per lastricare elbalatojo e per iscalionj apogamane cornice per le scale principale per le 3 branche e per altri aconcimj e muramentj del detto palazo tutto dotobre 1568 anzi datoci per tuto 24 dj marzo 1570 detratone la taza per quele partite ce non erono dacordo e tutto dettj contj visti per micele di gerado jscapeljno e simone dant⁰ del coltrice e riscontri per frn⁰ forsegli come distintame[n]te apare al qu[a]de[r]no de conti da c. 99/100 e da ca[r]te 123/125——

fiorini 736 Lire 4.2-8

6. ASF, Fab. Med., fil. 5, c. 30v:

MDLxxii dj 30 dj setebre

Spese di più sortte Lire otantadua soldi cinque piccioli si fano bonj adon[a]to dant⁰ maestri inbiachatorj per la monta dj uno loro conto davere inbiancato in palazo ducale più istanze e scale e su da alto dove istano le

damigele e per avere inpachato tutte le logie del cortile e inbia<sup>to</sup> dale dipinture in gune e inbia<sup>to</sup> le colone del cortile e quele 2 iscale ce comincono nel cortile per andare sune ala sala sala gra[n]de ispazate e inbiachate dale cornice in gune e per avere inbi[an]chato tute le camere cesono alpiano del cortile col salotto e per più altre istanze per il palazo dadì 5 di magio 1571 at[utt]o dì 8 di Luglio 1572 detratone di tale conto Lire dicanove soldi cinque per lataza di tale conto come particula[r]mente apare alqu[a]de[r]no decontj libro foglio 154.155

fiorini 11 Lire 5.5

7. ASF, Fab. Med., fil. 5, c. 32v:

MDLxxii [1573 (st. c.)] dj 28 dj febrajo

Spese su dette Lire dumilasetecentosesantasette soldi quatordicj si fano bonj a m° benado dimt° m<sup>a</sup> matea muratore per op'e 755 di muratorj et per op'e 1342 dimanovalj tenutj dadj 27 di gugnio 1569 alt° dj 22 dj Luglio 1570 afare le 3 branche dela iscala prjncjpale alentrata dela porta di marmo roso in sula maritta per salire in sul salone e di fato quela ce vi era e oniuta [?] deta porta e per sua faticha e per djmettj di tempi mes[s]i per tale conto come . . . aparta alqu[a]de[r]no de contj c. 351.352——

fiorini 395 Lire 2.14

9.1 Giorgio Vasari, A branch of the principal staircase between the first and second floors, Palazzo Vecchio, 1560-61.

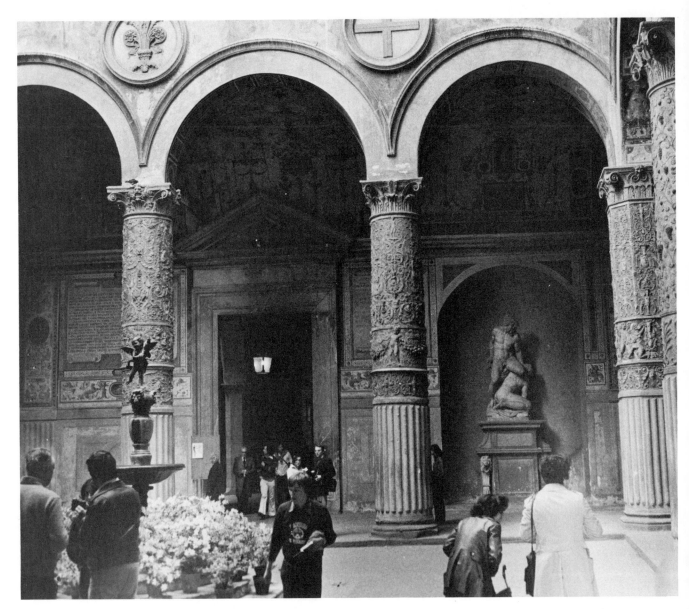

*Janet Smith*

9.2  View of the main courtyard of the Palazzo Vecchio, showing, through the arcade, the east wall with the sculpture niche and doorway to the Vasari double staircase.

9.3 Vincenzo Borghini, *Sketch of the Decorations on the Walls of the Main Courtyard in the Palazzo Vecchio*, 1565. Pen and brown ink, 213 mm. X 152 mm. Biblioteca Nazionale, Florence.

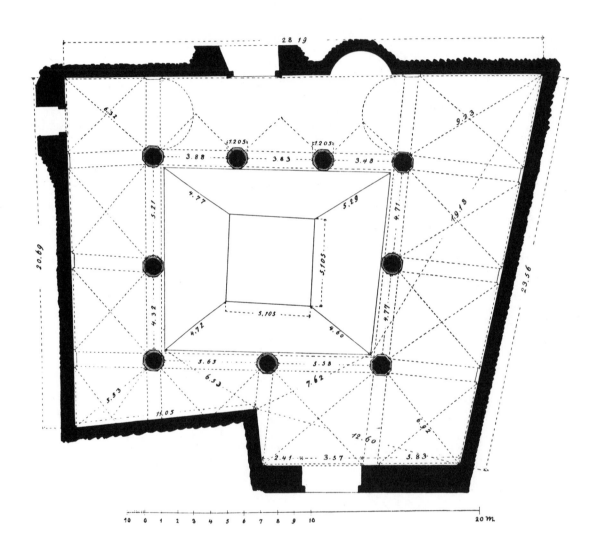

9.4  Ground plan of the main courtyard in the Palazzo Vecchio.

9.5 Plan of the ground floor of the Palazzo Vecchio, Florence, from an engraving of 1817.

# 10. Drawings by G. A. Montorsoli in Madrid

*GEORGE KUBLER*

IN THESE DAYS an architect's portfolio is a selection of illustrations showing the geographical scope of his work and the degree to which he has mastered a variety of problems, as well as his lineage in the profession. Older examples of such portfolios being uncommon, it was a surprise to find, in 1963, a large sixteenth-century Italian portfolio answering this description at the Biblioteca Nacional in Madrid.[1]

It is a collection of showpieces, assembled by Giovanni Vincenzo Casale of Florence, for his journey in 1586 to Spain and Portugal and amplified there until his death at Coimbra in 1593.[2]

Among other surprises in the larger surprise of the portfolio itself, are twelve drawings by Casale's teacher, who was Giovanni Angelo Montorsoli (1507–63). They are of interest both to Montorsoli's evolution as a designer of architecture and to the course of sixteenth-century artistic thought. They will here be discussed in chronological order and in relation to the commissions for which they were made.

### San Matteo, Genoa (1543–47)

The earliest drawings by Montorsoli in the Madrid album are those made after his return to Genoa from Naples in 1543, and before 1547, when he left for Rome. These designs are for the remodeling of the presbytery and crossing dome of the abbey church of San Matteo in Genoa (fig. 10.1), as commissioned by Andrea Doria.[3]

The rendering in perspective (no. 80) is a project which avoids the problem of the pointed crossing arches by cutting them off (fig. 10.2). A choice is offered: the right half of the apsidal vault suggests God with outspread arms, surrounded by cherubim. The remains of a twelfth-century mosaic were still visible here when Montorsoli redesigned the apse.[4] The left side of the apsidal vault offered an option of coffered rosettes, which, like those of the crossing arches, were executed in the nave

arcade soffits, after Montorsoli's departure, in 1557–61.[5] The triumphal arch spandrels also offer an option between a sibylline figure on the left and a diamond shape on the right. In execution, Montorsoli actually used torch-bearing angels.

Below the apsidal vault, an elaborate edicule was proposed, flanked by two doorways beneath niches. Preceding the triumphal arch, the walls of the choir are shown slightly recessed, with benches for the abbot and canons under a corbelled projection, and showing no trace of the polychrome stone revetments used in the actual design. The proportions, the structure, and the alternative proposals for the ornament identify this design as a preparatory scheme laid out for the client's approval.

Drawing no. 81 is also a project with options (fig. 10.3), but it is much closer to the final realization than no. 80. It shows the crossing dome from the north looking south, with the sanctuary to the left, and the nave arcades beginning on the right to the west. The dome itself was simplified in execution, but at the drum an option was offered between herms on the east and pairs of putti on the west. The giant putti were chosen for the drum, and the herms were used in the nave spandrels after Montorsoli's departure, alternating with single putti as garland-bearers.

Drawing no. 79 shows the north presbytery wall almost as executed (fig. 10.4). The colored stones in geometric panels extend the apsidal dome register, and below these panels the recess for the benches of the abbot and canons is structurally and proportionally identical to the one proposed in drawing no. 80.

Underneath the inked lines the same subject and design reappear in pencil and upside down. Below the sculptures, the benches are labeled as to the woods to be used—olive, cypress, and walnut in order toward the center of each panel. This portion of the design is today occupied by wooden choir-stalls.

Drawing no. 82 is Montorsoli's unrealized project for the exterior reform of the twelfth-century fabric, seen from the street on the south side (fig. 10.5). A gloss in Portuguese ("Toda esta fachada tem de largo setenta e quatro palmos g[enovese]s") confirms the impression that the entrance was to be shifted from west to south, and that Montorsoli's design transformed the flank into the main façade. If so, Montorsoli probably also made a missing project for the reform of the nave. In any case, this drawing of the exterior was unknown to recent scholarship, where the extent of the participation by Montorsoli in the whole reform of the abbey church has been debated.[6]

*Messina (1552–57)*

During his activity for Messina, first documented as being in 1550,[7] Montorsoli drew two designs that were preserved by his pupil. The first is

drawing no. 22 for the fountain of Neptune (fig. 10.6), begun in 1553[8] and dated 1557. Damaged in the earthquake of 1908, the fountain was rebuilt without the original platform, and its three statues, now in the Museo Nazionale at Messina, were replaced with replicas.

Montorsoli's drawing stresses the ornamental passages of the paving, the oval corner basins, and the reliefs and sculpture on the pedestal and on the octagonal basin. The figures of Neptune and Scylla are lightly drawn: the idea was complete at this date, but the purpose of the drawing was to isolate for separate consideration the secondary yet supporting enrichments.

Another drawing (fig. 10.7) for this fountain in the Uffizi[9] is more complete in showing all parts of the design for the pedestal from a higher point of view, yet in orthogonal elevation for the three main figures. The pedestal here bears the arms of Charles V. Montorsoli's drawing in Madrid is valuable for showing clearly the intended design of the plat-form pavement.

Drawing no. 89 (fig. 10.8) is described in Italian as being for the church of San Pietro in Messina ("Per la chiesa di S^to Pietro di Messina"), as well as with an enigmatic "Palmi 78 il tutto" in the same hand. The Portuguese index adds "fachada de S. Pedro de Messina, emvenção de frei João angelo." Neither of these descriptions corresponds to any known church in Messina,[10] but the mention of San Pietro may be a misunder-standing of Montorsoli's commission to remodel parts of the Duomo, which has had a chapel of San Pietro since 1552.[11] Vasari stated that after the fountains were done, the pleased people of Messina began the Duomo façade ("diedero, finite le fonti, principio alla facciata del duomo, tiran-dola alquanto inanzi"). Vasari implies that Montorsoli was in charge, being "un uomo secondo il gusto loro."

Drawing no. 89 may be a preliminary sketch for a proposed remodel-ing of the façade of the Duomo, of which the dimensions, like its iden-tity, were misunderstood when the sheets in the portfolio were labeled and rearranged.[12] The mention of *palmi* implies too small a building, but if the numbers written in another hand on the façade stand for *braccia*, the size would correspond better to the Duomo.

*Bologna (1558–61)*

Six drawings exist in Madrid for Montorsoli's work at Santa Maria dei Servi in Bologna. Three (figs. 10.9, 10.10, 10.12b) are finished designs for the main altar screen (nos. 73, 75, 78), which Montorsoli completed in twenty-eight months;[13] one (fig. 10.11) is a floor plan (no. 74), another (no. 77) shows the relation of the burial vault to the altar pavement (fig. 10.12a); the sixth (no. 95) is described as "Riscos do altar." This rapid

sketch (fig. 10.13) probably marks an early stage in the development of the design. Part of the altar screen was cut off at the right side, with the loss of the rear view of the sword-bearing figure atop the doorway. Between the candelabras are two, very tall, standing human figures. Eight predella reliefs appear; and the back of the altar at ground level has a central niche with capitals and keystone flanked by shields. This panel resembles the strap-work decoration of an alternate and earlier northern strap-work vocabulary which it is surprising to find in Montorsoli's ornament.

Drawings 73 and 74 are listed in the Portuguese index as "Desenho do altar da igreia dos frades dos servos da Cidade da Bolonha, emvenção e mão propia de frei João angelo Montorsoli, e planta do mesmo altar" (Design for the altar of the church of the Servite friars of the city of Bologna, invented and drawn by Fr. Giovanni Angelo Montorsoli).

Drawing No. 78 is the end elevation of the altar in Bologna, which the compiler of the index mistakenly listed as being for the Doria commission in Genoa. It displays a section and the south end of the free-standing upper story of the altar. The sculpture is carefully shown as executed: the *Cristo nudo*, a seated Moses at ground level, Saint Sebastian, and other figures—all rendered so accurately that the drawing may be dated near the end of the work in 1561.

Drawing no. 75 (fig. 10.9) is the nave elevation, or altar side facing west, showing the Madonna in the northern niche but no other fully drawn sculpture. No. 73 (fig. 10.10) shows the friars' side on the east. No. 74 (fig. 10.11) is the plan of the altar screen with ornamental flooring west of the altar table.

It was Giulio Bovio, the Master of the Servite Order, who commissioned from Montorsoli, not only the altar screen and its sculpture, but also his own burial vault beneath the ornate pavement. Vasari described the latter as "spartito con bell'ordine, e certi candelleri di marmo et alcune storiette e figurini."[14]

Drawing no. 77 (fig. 10.12, left) has two parts, the upper one showing a font next to a polygonal fourteenth-century column base, as well as a corner candelabra of marble marking the west end of the ornate pavement, as seen on the plan (no. 74). Between font and candelabra, the lower half shows a plan of the octagonal burial vault with four *candellieri* bases at the corners. Penciled lines faintly mark other forms of alternate arrangements for columns and niches on the cross-axis and at the corners.

*Florence (1562–63)*

The first drawing by Montorsoli listed in the Portuguese index is the latest, and it is missing. It is described as "Rasgunhos de mão propia de frei

João angelo pª o sello da academia de florenssa" (Sketches by his own hand from Fr. Giovanni Angelo for the seal of the academy of Florence). Like Vasari, we do not know whether these sketches were accepted,[15] but their date can be fixed somewhere in 1562–63, between the time of Montorsoli's work on the *cappella dei pittori* in the Annunziata church in 1562 and his death on the last day of August 1563.

Montorsoli donated a burial vault to the Annunziata cloister before May 24, 1562, for the funerals of eminent Florentine men of art. This vault was in the former chapel of the Benizi family, and having once been the chapter room, it was suitable for the meetings later held there by the Accademia del Disegno.[16]

Montorsoli may have patterned his gift on the Roman artists' club founded in 1543 as the society of the *Virtuosi al Pantheon*, which had its own chapel at the Pantheon for funerals of the members of the confraternity.[17] In Florence, Montorsoli's donation induced Vasari to organize the Accademia del Disegno with a regulation presented to the grand duke early in 1563.[18]

At this time, Montorsoli's pupil and assistant at the Annunziata was G. V. Casale, a Florentine then in his early twenties,[19] who eventually included his master's work[20] in his own portfolio and became a Servite friar like Montorsoli.

Montorsoli's drawings in Madrid reveal him more as an architectural designer than as a sculptor. He seems to have sought to please his clients rather than to impose his taste upon them. Thus, the austere drawing for San Matteo in Genoa, more reminiscent of Brunelleschi than of Michelangelo, was modified in the surcharged direction indicated by the perspective rendering of the crossing dome. The severe benches in the presbytery were enriched with polychrome effects in stone and wood.

During these two decades, Montorsoli's drafting habits changed markedly. In Genoa the perspective renderings are hesitant and timid, with different vanishing points competing for attention. This ambiguity persists in the drawing for the Marina fountain in Messina, where he was also anxious to meet the florid requirements of his patrons in Sicily. In Bologna, finally, architectural ornaments and sculptural poses are Michelangelesque, perhaps in deference to Giulio Bovio's taste, and in keeping with the program for an altar conjoined with a mortuary vault. Here, however, the orthogonal projections of the elevations display a fully developed system of architectural conventions far more professional than in the uneven drawings for Genoa and Messina.

The exterior projects for Genoa and Messina nevertheless retain more of Montorsoli's own architectural taste as of a generation earlier than his master's. The drawing for the façade of San Matteo shows no gravitation toward Michelangelesque models, nor does the façade for the

cathedral of Messina. Here a generalized Serlian diction precludes any close connection with the architecture of Michelangelo. Finally, the early sketch (fig. 10.13) for the altar in Bologna is less close to the Julius tomb than the design executed by 1561, with its recollections of that scheme.

# NOTES

1. Catalogued in the division of Bellas Artes as "Planos de arquitectura," with call numbers 16–49. Three index pages in Portuguese list 196 drawings, of which some 56 are missing today. The count is uncertain because of the tattered condition of the pages.

2. Eugenio Battisti, "Disegni cinquecenteschi per S. Giovanni dei Florentini," *Saggi . . . V. Fasolo* (1961), pp. 185 ff., called attention to the portfolio and to Casale.

3. Nos. 79–82 are explained in the index as being of the "capella de frei João angelo Montorsoli, mão propria" (the chapel of Giovanni Angelo Montorsoli, his own hand) and "fachada e emvenção de frei João angelo" (façade and invention by Fr. Giovanni Angelo). The compiler of the index was confused about nos. 77–78: he listed them as being for Andrea Doria, but they are of the altar in the Servite church at Bologna (see below).

4. Carla Manara, *Montorsoli e la sua opera genovese* (Genoa, 1959), p. 43, cites Varagine, Perasso, and Giustiniani on the mosaic. Only Varagine describes it as an "imago pulcherrima Christi." Giustiniani saw it before 1537, without naming the figure, of which remnants may subsist under Montorsoli's plain *cul de four*. This is adorned today only by the dove in low relief at the keystone, of which traces may appear over the head of God in Montorsoli's drawing.

5. Manara, *Montorsoli*, p. 62, n. 3.

6. Ibid., p. 61, n. 3, rejects Alizeri's attribution of the nave to Montorsoli, which argues that the nave might have been remodeled by other craftsmen, on his designs, after his departure in 1547.

7. Ibid., p. 90, n. 8.

8. The Portuguese index correctly states, "He a fonte da marinha da Cidade de mesina invenção de frei João angelo Montorsoli, Arquitetto, e iscultor exelente, mestre de frei João Visensio, e desipulo de miquael angelo bonaroti" (Here is the Marina fountain of the city of Messina, the invention of Fr. Giovanni Angelo Montorsoli, architect and excellent sculptor, teacher of Fr. Giovanni Vincenzo [Casale], and pupil of Michelangelo Buonarotti).

9. Pasquale Nerino Ferri, *Indice . . . dei disegni de architettura . . .* (Rome, 1885), pp. xxxiv, 93 (No. 943 Esp).

10. The most complete description of the sixteenth-century city, by G. Buonfiglio e Costanza, written in 1606, "Messanae urbis nobilissimae descriptio," 2d ed., in Johannes Georgius Graevius and Petrus Burmann, *Thesaurus antiquitatum et historiarum Siciliae* (Lyon, 1723), vol. 9, Bk. 4, col. 51C, named a *parochia S. Petri*, but no parochial church is mentioned or described.

11. Giorgio Vasari, *Le Vite de' più eccellenti pittori, scultori ed architettori . . .*, ed. Paola Della Pergola et al. (Novara: Istituto Geografico De Agostini, 1967), 6: 494. Cf. V. Saccà, "Studi critici sul Duomo di Messina," *Atti, R. Accademia Peloritana* 12 (1897–98): 393, citing payments for marble to be used by Montorsoli as *capo mastro* (head master) in 1552 of the Cappella di San Pietro. The question is not discussed by Stefano Bottari, "Montorsoli a Messina," *L'Arte* 31 (1928): 234–44.

12. Inscriptions in Italian on the drawings were probably written by G. V. Casale, The Portuguese inscriptions and index may be by Casale's nephew, Alexandro Massay, who accompanied him to Spain and Portugal and compiled in 1621 the *Descripção do Reino do Algarve*, preserved in Lisbon at the Gabinete de Estudos Olisiponenses (Palácio Galveias). Augusto Vieira da Silva, *Arqueologia e historia* 6 (1927–28): 178–79.

13. Vasari, *Le Vite*, ed. Della Pergola et al., p. 496: "l'altar maggiore tutto di mormo et isolato."

14. Ibid., p. 497.

15. Giorgio Vasari, *Le Vite de più eccellenti pittori, scultori ed architettori . . .*, ed. Gaetano Milanesi (Florence: G. C. Sansoni, 1906), 6: 659, n. 1, remarked that the *stemma*

of the Accademia was and remains "tre corone, una di lauro, l'altra d'ulivo e la terza di quercia, intrecciate insieme, le quali alludono alle tre arti del disegno, col motto: *Levan di terra al ciel nostro intelletto.*" The records of the Academy, which I have examined, are fragmentary (State Archives, Florence: Arti 27: A/V/3). *Entrate e uscita* span 1562–1602: the *Giornale* covers 1563–94. See Nikolaus Pevsner, "Einige Regesten und Akten der Florentiner Kunstakademie," *Mitteilungen des Kunsthistorischen Instituts* 4 (1933): 129–31.

16. Paola Barocchi et al., *Mostra di disegni dei fondatori dell'Accademia* (Florence, 1963), pp. 3–6; Manara, *Montorsoli,* p. 91, n. 13.

17. Nikolaus Pevsner, *Academies of Art, Past and Present* (Cambridge: The University Press, 1940), pp. 44, 56.

18. Vasari, *Le Vite,* ed. Della Pergola et al., p. 468, on the occasion of the removal of Pontormo's body to the newly founded *cappella dei pittori.*

19. Manara, *Montorsoli,* p. 91, n. 14, cities an attribution by Tonini of statues in the choir of the Annunziata church to Casale under Montorsoli's direction.

20. Barocchi et al., *Mostra di disegni,* p. 11, has noted the extreme rarity of graphic records of the activity of the Accademia.

10.1 Presbytery and crossing dome, San Matteo, Genoa.

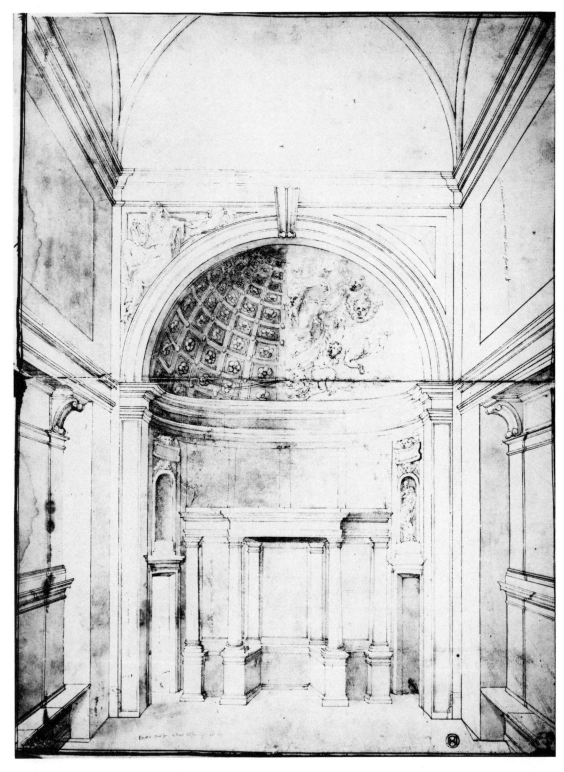

10.2 Study offering alternate but unexecuted solutions for presbytery of San Matteo. Ink and wash drawing. Biblioteca Nacional, Madrid.

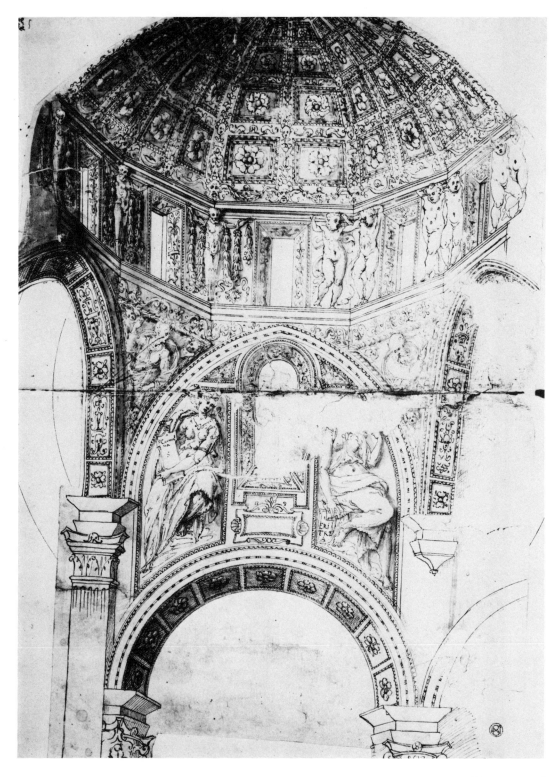

10.3 Design for the crossing dome, San Matteo. Ink and wash drawing. Biblioteca Nacional, Madrid.

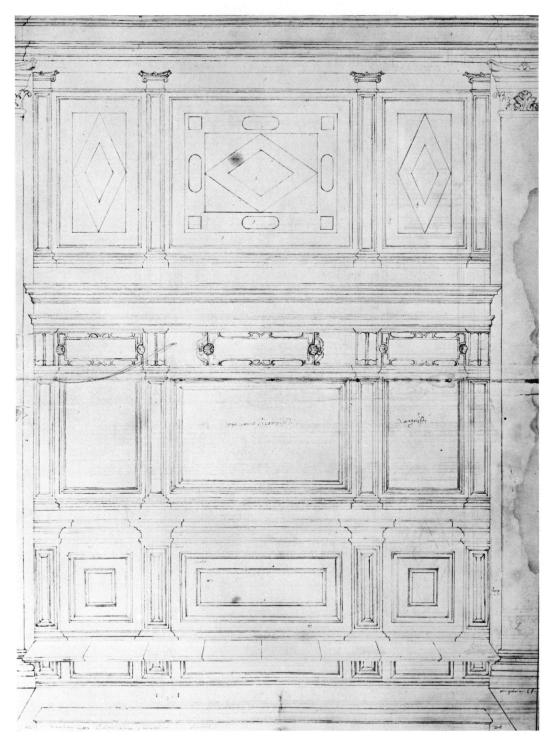

10.4 Perspective elevation of north presbytery wall, San Matteo. Pencil and ink drawing. Biblioteca Nacional, Madrid.

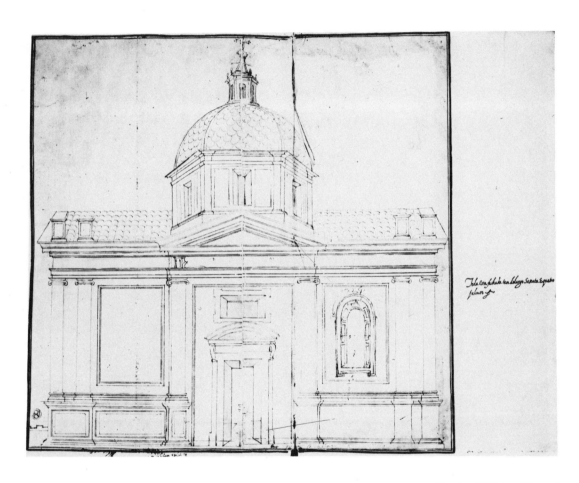

10.5  Unrealized project for exterior reform of south flank, San Matteo. Ink and wash draw-
ing. Biblioteca Nacional, Madrid.

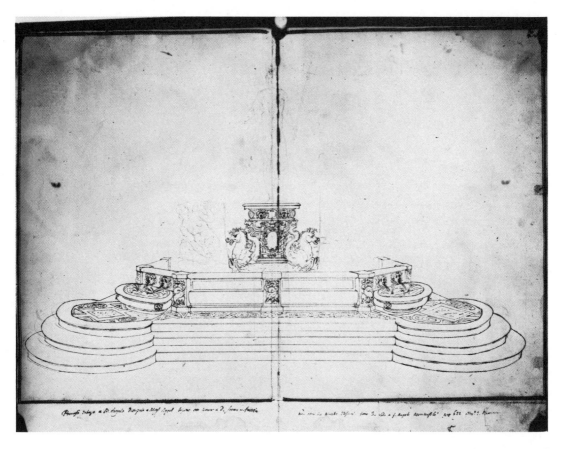

10.6 Study for the Fountain of Neptune, Messina. Ink and pencil drawing. Biblioteca Nacional, Madrid.

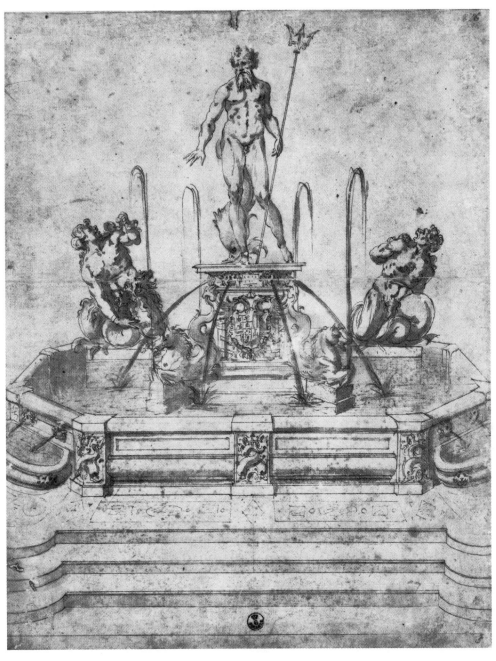

10.7 Study for the Fountain of Neptune, Messina. Ink and wash drawing. Uffizi, Florence, Gabinetto dei Disegni e delle Stampe 943E.

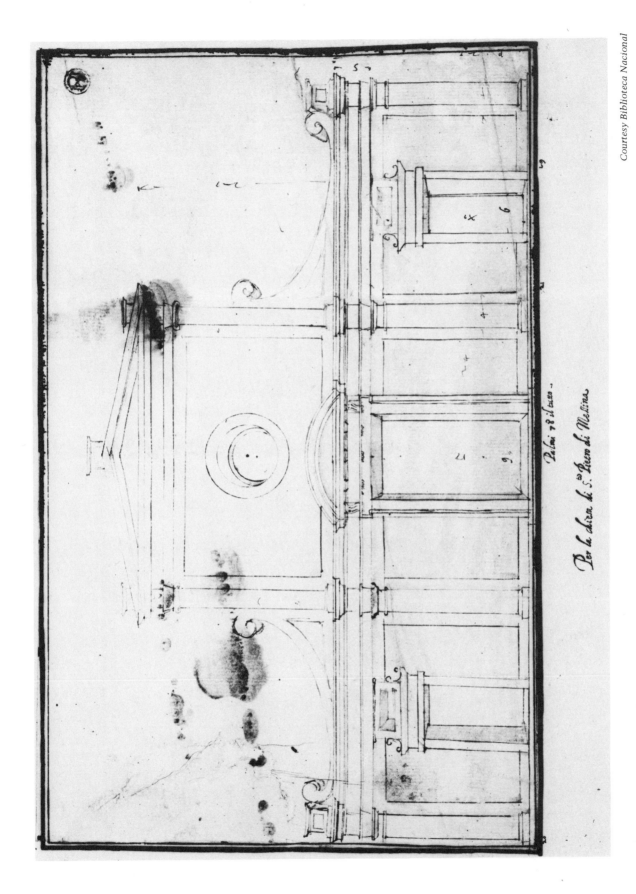

10.8 Drawing in perspective elevation of a project, possibly for the façade of the Cathedral of Messina. Pen and ink. Biblioteca Nacional, Madrid.

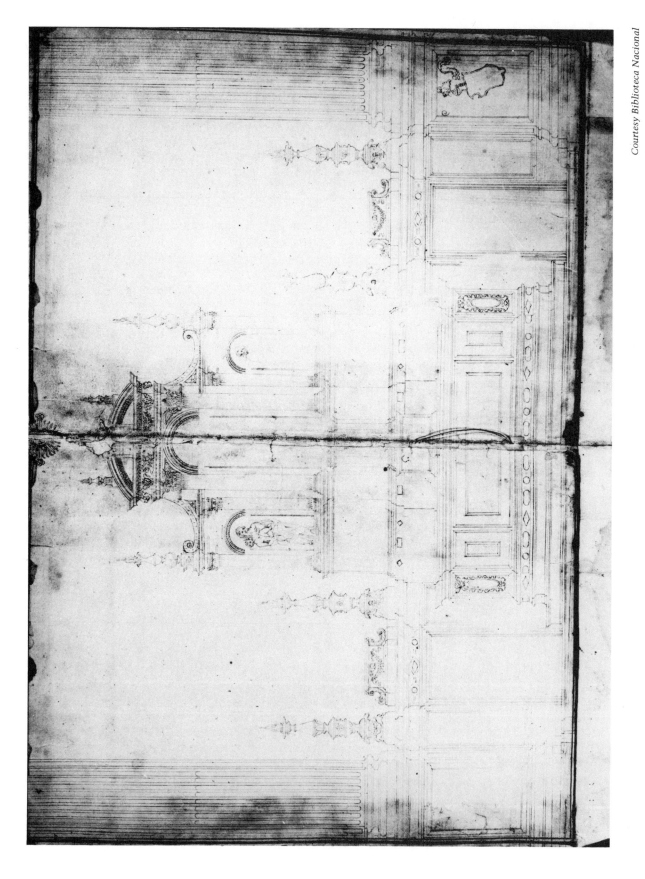

10.9 Drawing of the main altar screen, seen from the west, Santa Maria dei Servi, Bologna. Pen and ink. Biblioteca Nacional, Madrid.

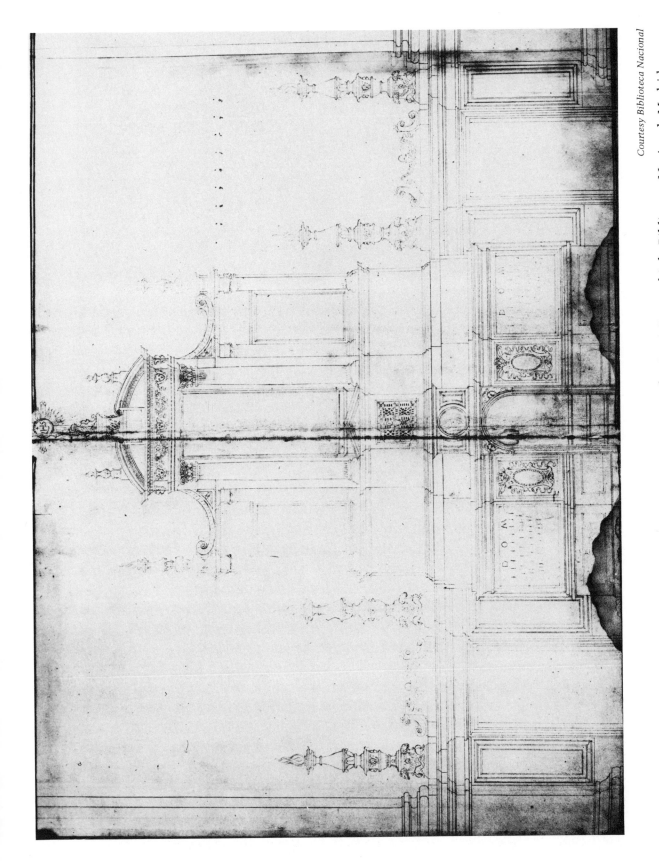

10.10  Drawing of the main altar screen, seen from the east, Santa Maria dei Servi. Pen and ink. Biblioteca Nacional, Madrid.

10.11  Plan of the altar screen flooring at west side, Santa Maria dei Servi. Pen and ink drawing. Biblioteca Nacional, Madrid.

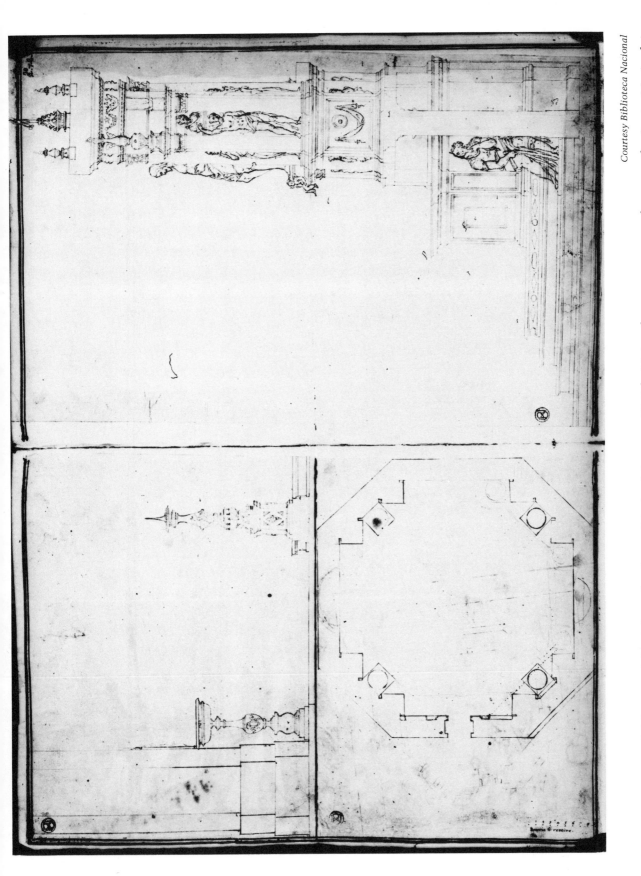

10.12b Main altar screen, seen from south, Santa Maria dei servi. Pen and ink drawing. Biblioteca Nacional, Madrid.

10.12a Font, candelabra, and burial vault, Santa Maria dei Servi. Pen and ink drawing. Biblioteca Nacional, Madrid.

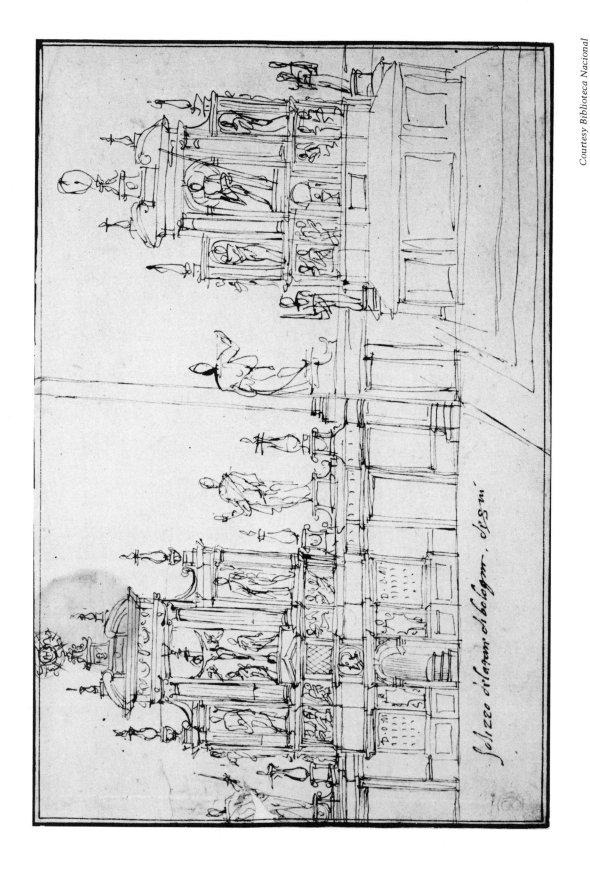

10.13 Preparatory sketches for main altar screen, Santa Maria dei Servi. Pen and ink. Biblioteca Nacional, Madrid.

*Milan*

# 11. The London *Madonna of the Rocks* in Light of Two Milanese Adaptations

*DAVID ALAN BROWN*

*Léonard de Vinci, miroir profond et sombre,*
*Où des anges charmants, avec un doux souris*
*Tout chargé de mystère, apparaissent à l'ombre*
*Des Glaciers et des pins qui ferment leur pays.*

Baudelaire, *Les Fleurs du Mal,* 1857

HIS CURIOSITY AROUSED, Charles Seymour once asked me about the problem of the two versions of the *Madonna of the Rocks*. Though I still cannot provide a final answer, I shall offer some visual evidence that may clarify matters left obscure by the documents.[1] No radically new theory of the relation between the paintings in Paris and London is here being proposed. What I have found tends rather to confirm the controversial hypothesis that the version in the National Gallery (fig. 11.1) was substituted, for some unknown reason, for that in the Louvre. Briefly stated, the substitution theory is as follows: according to the contract of 1483, Leonardo and the Predis brothers were to execute paintings for an altarpiece, the architectural structure of which—richly decorated with sculpture—was already finished. Depicting an apocryphal meeting between the young John the Baptist and the Christ Child on the return from Egypt, the Louvre picture would have formed the central part of the *ancona* for the chapel of the Confraternity of the Conception in the church of San Francesco Grande in Milan. This painting is then referred to as if finished in a legal appeal made by Leonardo and his assistant, Ambrogio de Predis, datable to the early 1490s. Yet the settlement of the dispute between the painters and the confraternity in 1506 states that the picture in question is incomplete. From this discrepancy one

may deduce that the settlement—and perhaps another appeal of 1503—must be connected with the London version, known to have come from San Francesco.

The proponents of this theory disagree among themselves, however, as to when the hypothetical substitution occurred. Giovanni Poggi claimed that the London picture was executed mostly by Predis between 1506 and 1508, when, after the final payment was made, it would have replaced the Louvre version.[2] Adolfo Venturi independently reached similar conclusions.[3] Giorgio Castelfranco added that Leonardo may have already begun to prepare the replica before leaving Milan in 1499.[4] The substitution took place, according to him, sometime between the second appeal and the settlement of 1506. He suggested, too, that Predis may have worked on the painting until the latter date, when Leonardo returned and completed it with assistance. In another *Festschrift* volume, Hermann Beenken further argued that the confraternity gave up the Louvre picture after the first appeal, in return for the London version, subsequently executed in large part by Predis.[5] L. H. Heydenreich approved of Beenken's thesis that the London painting was begun by Leonardo in the 1490s to replace the first one, which had by then been removed,[6] and John Shearman, agreeing, upheld the claim sometimes advanced for Leonardo's authorship.[7] Jack Wasserman has recently proposed that the London picture found a place in the confraternity's *ancona* as early as ca. 1490.[8] The replica, in his opinion, would have been designed by Leonardo and executed mostly by Predis in two stages, not in the 1490s, as others have suggested, but in the period ca. 1486–90, that is, before the first appeal, and then in 1506–08.

The theory outlined above has been rejected by officials of the National Gallery in London.[9] Indeed, Martin Davies's cautious but overingenious reading of the documents, referred to in the previous footnote, led two great Leonardo scholars to change their minds about the *Madonna of the Rocks*. Sir Kenneth Clark and A. E. Popham, both of whom had favored the substitution theory, came to agree with Davies that it must have been the London version that was ordered in 1483, that all the documents refer to that painting, worked on by Leonardo over a long period of time, and that the artist may have completed the Louvre picture in Florence before leaving for Milan.[10] Aside from contrary interpretations of the documents, objections to the view promoted by the National Gallery have been made on the basis of common sense and of style. It has been questioned whether the Milanese confraternity could have ordered an altarpiece to accommodate a panel so close in shape and dimensions to one that Leonardo had already painted in his native city.[11] Arguments from style have stressed the apparently late character of the London picture.

What is at stake here, it must be emphasized, is not simply a matter of dates. Involved is the important question of to what stage in Leonardo's development the London version belongs, whether or not it is entirely by the master. Those who believe with Davies that the commission of 1483 refers to that painting are forced to accept so early a date for its origin, while the proponents of the substitution theory disagree, as we have seen, about whether the picture was begun in the decade of the 1480s, the 1490s, or in the early sixteenth century.

During all the controversy one way out of the maze has hardly been explored. Not surprisingly, because of the focus on documents, little attention has been paid to those other records, the copies and adaptations of the *Madonna of the Rocks*. It is true that Francesco Malaguzzi-Valeri discussed and reproduced some of these,[12] and that others were listed by George Isarlo.[13] Davies mentions a few more.[14] But there has been no systematic study of the derivations, and I should now like to consider two of them to see what they can tell us about Leonardo's project.

An adaptation (fig. 11.2) by the Milanese painter known as Giampietrino, now in Lugano, provides us with a glimpse into how Leonardo's composition was understood by one of his contemporaries.[15] It is evident at once that the follower failed to appreciate what we consider the *sine qua non* of both versions of his prototype: the pyramidal figure grouping and the murky grotto that gives the work its name. Instead, Giampietrino focused on aspects of Leonardo's art that are now rather less admired—sweet facial types, curving draperies, and complex poses. To adapt the *Madonna of the Rocks* to the requirements of his theme, he adjusted the attitude of the Virgin. This left a gap to be filled by borrowing a musician angel from the left side of the altarpiece that included Leonardo's central panel.[16] Another figure awkwardly introduced is Saint Joseph, whose pose quite simply repeats that of Giampietrino's second angel on the right.

In formulating his conception of the attendant angel farthest to the right, Giampietrino seems to have consulted both versions—or, let us say, both traditions—of the *Madonna of the Rocks*. The outward glance and pointing gesture of the figure recall those of his counterpart in Leonardo's earlier formulation (fig. 11.3), while the robe and, even more, the particular tilt of the head and its relation to the prominent shoulder derive from the replica (fig. 11.4) in London.[17] The latter borrowing shows that Giampietrino, however inept, did grasp one important feature of the revision of the *Madonna of the Rocks*. For the change in characterizing the angel has been widely recognized as Leonardo's own. Clark, for instance, observed that the angel's head in the London painting "departs entirely from the Paris version ... [It] is a classic invention of great beauty; and no one who has looked at it closely can doubt who was

responsible for the mouth and chin, and the characteristic curves of the golden hair."[18]

In revising the angel, Leonardo evidently decided to suppress his outward glance and pointing gesture. The earlier figure, engaging and directing the viewer's attention, may be Albertian in origin.[19] The new characterization, however, seems to reflect the master's own recent achievement of a compelling psychological unity among depicted persons in the *Last Supper* in the refectory of Santa Maria delle Grazie. What intervenes between the two conceptions of the angel—one preoccupied with the spectator and the other absorbed in the event portrayed—is, in my opinion, Leonardo's effort to relate Christ and the apostles meaningfully in the great mural painting of ca. 1495–98.[20] At one level, Leonardo represented the spiritual communion of the Last Supper in human terms, which, nevertheless, he idealized from nature in order to conform to his notions of beauty and grace. The youthful apostle identified as Phillip, in his spiritualized yet sensuous bearing, might well be considered a prototype for the later version of the angel. Preparatory studies for the Saint Phillip, like that at Windsor (fig. 11.5), may even have served the purpose of revision.[21] Though Leonardo's fascination with mysterious beauty and his concern for dramatic propriety both appear to have prompted the reconception of the angel, it was the loveliness of the figure that attracted Giampietrino, who made it the focus of his involvement with the London *Madonna of the Rocks*.

If it is true that Leonardo's later rendering of the angel reflects the preparatory work for the *Last Supper*, then the design—or changes in design—that the painting incorporates cannot be dated before the mid-1490s. The connection posited here between the *Last Supper* and the *Madonna of the Rocks* tends to support the theory, based on the documents, that the second version originated in the 1490s or afterward. We know that the picture was brought to its present state by 1508, but when was it begun?—already in the 1490s, as some writers have claimed, or later? Various literary and visual references to the London version have been identified, but none of these, including Giampietrino's, is early enough to help in dating the painting. It is, for example, the London *Madonna of the Rocks* that Lomazzo describes in his *Trattato* of 1584.[22] And a partial derivation by another Milanese follower, Bernardino de' Conti, in which the Madonna's robe corresponds with the replica, is dated 1522.[23]

Of greater interest to us is a miniature of *Pentecost* (fig. 11.6) by Fra Antonio da Monza, now in the Albertina in Vienna.[24] Signed by the artist, it may have been made for Pope Alexander VI Borgia, who is portrayed in a medallion in the lunette beneath the inscription. Despite the ornamental character of the illumination, Fra Antonio's figures, it has

been noted, reveal the generic influence of Leonardo.[25] Venturi even claimed that the composition was based on some school work.[26] Davies went on to propose that the pair of kneeling putti in the richly decorated border may have been derived from the little Saint John in the *Madonna of the Rocks*.[27] To this convincing suggestion I would like to add that the apostles in the Pentecost scene resemble their counterparts in Leonardo's *Last Supper*. Among these figures, moreover, is one who has a source in the *Madonna of the Rocks*: the youthful apostle in the lower right of the miniature (fig. 11.7) recalls in pose and position the familiar figure of Leonardo's attendant angel. But the angel, we may ask, in which version?

Fra Antonio's youthful figure is appropriately included among apostles whose treatment was inspired by the *Last Supper*. Closely examined, he may be seen to incorporate, not only the draperies but also the changes, small but significant, that animate the angel in the London version, namely, the characteristic backward tilt of the head and its relation to the prominent shoulder. These same features, we have found, attracted Giampietrino to Leonardo's reconception of the angel. In this case, though, the derivation may be more precisely dated, for the miniature was presumably made during the pontificate of Alexander VI—that is, between 1492 and 1503. This means that Leonardo must have definitively formulated Fra Antonio's prototype, the figure of the angel, before leaving Milan late in 1499 and not after his return in 1506. If we assume that the original cartoon was used again, what Fra Antonio saw in Leonardo's studio was probably the London panel, completed perhaps to the stage of the *Adoration of the Magi* in the Uffizi Gallery or the *St. Jerome* in the Vatican. With the fall of Ludovico Sforza in 1499, Fra Antonio may have joined the exodus of artists and writers from Milan, and if he arrived in Rome about the same time as Bramante, he would have completed the *Pentecost* miniature early in the new century.[28] His illumination shows that he quickly became familiar with the kind of adaptations of antique *grottesche* found in the Borgia apartment in the Vatican. And reflecting works by Leonardo, as well as Bramante,[29] it would also have demonstrated something of the recent achievements of the Renaissance in Milan.

My observations about the reconception of the angel and its influence lend support, I think, to the hypothesis that Leonardo initiated the London painting in the 1490s, after he had begun planning the *Last Supper* and before he and Antonio da Monza left Milan. Just as he returned again and again to study his work in progress in the refectory of Santa Maria delle Grazie, so he must have pondered the first *Madonna of the Rocks* or its cartoon while making his revision. Though inferior in quality to its prototype, the London version nevertheless includes changes in pictorial treatment that Shearman has shown are proper to Leonardo

himself.[30] These changes in light and color amount to the achievement of tonal unity, which could have been sufficiently indicated to a follower, it seems to me, had Leonardo brought the picture to the stage of under-painting and supervised its further execution.[31]

There is evidence, in any case, that the later version was based on fresh studies by the master, like that at Windsor for the drapery of the angel (fig. 11.8).[32] As Clark noted, this brush drawing resembles in style another in black chalk at Windsor for the sleeve of Saint Peter in the *Last Supper*.[33] In both sketches the brush and chalk are used with the precision of metalpoint to define variations in planes. In comparable later studies, however—those for the Louvre *St. Anne*, for instance—the same media are employed in such a way as to lend an extraordinary softness to the drapery forms.[34] The change in Leonardo's style that I describe, involving *sfumato* or blurring of contours, first appears fully developed in drawings and paintings begun during his second Florentine period. The settlement of 1506, mentioned at the beginning of this essay, reveals that much remained to be done on the picture I take to be the London *Madonna of the Rocks*. Had Leonardo himself at that time taken any considerable share in its execution, we may be sure that it would more nearly resemble works like the *St. Anne*. It seems reasonable to suppose, then, that the task of completion was undertaken by an assistant, one who remained faithful to Leonardo's earlier, more familiar style, the master meanwhile having reached a new stage in his development. Though a workshop production, the London picture remains our best indication of Leonardo's aims as a painter in the 1490s. Prepared and begun by him and then executed under his supervision, it is the definitive edition of the *Madonna of the Rocks*.

# NOTES

1. The documentation (1483–1508) is presented in chronological order by Luca Beltrami in *Documenti e Memorie Riguardanti la Vita e le Opere di Leonardo da Vinci* (Milan, 1919). See also, with new transcriptions, Hannelore Glasser, "Artists' Contracts of the Early Renaissance" (Ph.D. diss., Columbia University, 1965), pp. 208–392.

2. Giovanni Poggi, *Leonardo da Vinci, La Vita di Giorgio Vasari* (Florence, 1919), pp. vi–xii. Numerous suggestions have been made about the disposition of the Louvre picture—that it was appropriated by King Louis XII, given by Ludovico Sforza to the emperor, or kept or sold by Leonardo, who claimed to have received offers for it; but with no evidence one way or the other, they remain speculative. It may be worth noting, however, that repercussions of the Louvre painting have not been detected in northern art, as we might expect had it been in France or Germany at an early date. The painting is first recorded as being at Fontainebleau in 1625.

3. Adolfo Venturi, "Per Leonardo da Vinci. La Vergina delle Rocce," *L'Arte* 23, no. 1 (1919), 1-7; idem, *Storia dell'Arta Italiana* 9, pt. 1 (Milan, 1925): 13-23.

4. Giorgio Castelfranco, "Momenti della Recente Critica Vinciana," in *Leonardo, Saggi e Richerche,* ed. Achille Marazza (Rome, 1954), pp. 451–53; idem, "Leonardo a Milano," *Storia di Milano* 8 (Milan, 1957): 491–92. Castelfranco's contributions are reprinted respectively in his collected *Studi Vinciani* (Rome, 1966), pp. 105–08, 210–13. The latter discussion also reappears in the *Raccolta Vinciana* 18 (1960): 185–87.

5. Hermann Beenken, "Zur Entstehungsgeschichte der Felsgrottenmadonna in der Londoner National Gallery," *Festschrift für Hans Jantzen* (Berlin, 1951), pp. 132–40.

6. Ludwig H. Heydenreich, *Leonardo da Vinci* (New York, 1954), 1: 32–36, 180, 188, and 2: v; idem, *Encyclopedia of World Art* 9 (New York, 1964), cols. 207, 212.

7. John Shearman, book review in *The Burlington Magazine* 103, no. 704 (November, 1961): 474–75, and letter in ibid. 104, no. 706, (January, 1962): 33–34; idem, "Leonardo's Colour and Chiaroscuro," *Zeitschrift für Kunstgeschichte* 25, no. 1 (1962); 26–27 and n. 33, p. 43. Sydney J. Freedberg (*Painting in Italy 1500 to 1600,* The Pelican History of Art Series [Harmondsworth, 1971] p. 467, n. 4) and Carlo Pedretti (*Leonardo, A Study in Chronology and Style* [Berkeley, Los Angeles, 1973] pp. 55–59) accept the substitution theory, the latter dating the revision 1506–08.

8. Jack Wasserman, *Leonardo da Vinci* (New York, 1975), pp. 21, 110–22.

9. See: Martin Davies, *Leonardo da Vinci, The Virgin of the Rocks in the National Gallery* (London, 1947); idem, *The Earlier Italian Schools,* National Gallery Catalogues (London, 1951), no. 1093, pp. 205–19, and in particular the 2d rev. ed. (London, 1961), pp. 261–81; Cecil Gould, "Leonardo's Virgin of the Rocks," *The Burlington Magazine* 90, no. 548 (November, 1948), 328–29; Michael Levey. "Leonardo's Madonna of the Rocks," ibid. 100, no. 663 (June, 1958); 218; and Gould, "Leonardo's 'Virgin of the Rocks,' " ibid., 104, no. 706 (January, 1962): 33. In fairness to Gould, it must be stated that he changed his mind (see n. 11 below).

10. For Clark's original opinion, see *The Drawings of Leonardo da Vinci . . . at Windsor Castle* (Cambridge, 1935) Vol. 1, nos. 12519–21, pp. 78–79, and his *Leonardo da Vinci* (Cambridge, 1939), pp. 43–48, 140–43. His later view appears in subsequent editions of the Leonardo monograph, beginning with that of 1952 (pp. 41–46, 138–41). The entries in the drawings catalogue remain unchanged, however, in the revised edition of 1968 (pp. 92–93), about which see n. 32 below. For A. E. Popham's first interpretation, see *The Drawings of Leonardo da Vinci* (London, 1946), p. 69, and for his reconsidered judgment, *The Burlington Magazine* 90, no. 544 (July 1948): 212; and 94, no. 590 (May 1952): 127–32. Both writers also came to feel that Leonardo had a larger share in the execution of the London panel than they had formerly believed.

Yet another interpretation has been advanced by Hannelore Glasser in the dissertation cited in n. 1 (pp. 264 ff.). Her view is compatible with mine in so far as we both think that the London picture was begun in the 1490s. However, she adds that it may have been the

Franciscans of San Gottardo in Milan who commissioned the London picture from Leonardo as a replica of the earlier version in San Francesco. The author is thus obliged to claim that the published documents, relating to San Francesco, all refer to the Louvre picture, including the settlement of 1506. This hypothesis seems untenable to me, for it is difficult to believe that Leonardo, given his working habits, would have agreed to repeat himself unless circumstances necessitated it, as they seem to have done at San Francesco. And the numerous copies of the London painting prove its status as a Leonardo composition. Furthermore, the document of 1506 indicates clearly that much still remained to be done, over a two-year period, on the painting to which it refers. Yet the Lourve version is entirely painted in an earlier style.

11. Shearman, *The Burlington Magazine* (1962), p. 34. After writing this article, I had the opportunity to consult Cecil Gould's *Leonardo the Artist and the Non-Artist* (Boston, London, 1975), in which the author comes around to the substitution theory (pp. 80–90). Moreover, he changes his mind about the attribution and also offers an elaborate hypothesis to explain how and why the substitution occurred.

12. See the list compiled by Francesco Malaguzzi-Valeri in *Pagine d'Arte* 2, no. 2 (Jan. 30, 1914): 27, and for a more comprehensive account, his *La Corte di Lodovico il Moro* (Milan, 1915). vol. 2, *Bramante e Leonardo*, pp. 416–25.

13. George Isarlo, "Leonard de Vinci," *Le Combat*, May 26, 1952, p. 7.

14. Davies claims that "nothing definite can be deduced from the existence or nature of these copies concerning the origin" of the pictures (*Italian Schools*, pp. 268–69). He adds that the matter of whether various derivations are specifically after the London *Virgin of the Rocks* is too complicated for his catalogue.

15. The painting, once in the Cook Collection at Richmond and now in the Museo di Belle Arti in Lugano, was ascribed, correctly in my opinion, to Giampietrino by Berenson (most recently in *Italian Pictures of the Renaissance. Central Italian and North Italian Schools* [London, 1968], 1: 168) and by Wilhelm Suida (*Leonardo und sein Kreis* [Munich, 1929], p. 301). An altarpiece by the artist, about whom virtually nothing is known, is dated 1521 (Berenson, *Italian Pictures* 1: 169, and 3: pl. 1524). This work compares in style, and possibly in date, to the painting in Lugano.

16. About the two side panels with music-making angels, see Davies, *Italian Schools*, no. 1661, p. 262, and *Earlier Italian Schools, Plates* vol. 2, National Gallery Catalogues (London, 1953), pl. 217. Giampietrino's angel is also modeled partly on Leonardo's Madonna.

17. Note how, as in the London picture, Giampietrino's angel is posed so that the contours of the head, tilted back, and of the shoulder, brightly lit and jutting forward, come together around a V-shaped area of shadow on the neck. Risking nothing, Giampietrino even relied on Leonardo's Madonna for the position of the angel's pointing hand.

18. Clark, *Leonardo*, (1952), p. 139. Earlier he had written that the angel's head "achieves real beauty of the kind made familiar in the work of the Milanese school, but certainly deriving from Leonardo himself" (1939, p. 142). Compare Castelfranco, *Studi Vinciani*, p. 108; "nella testa dell'angelo è una riscrittura che porta a tutta una nuova bellezza, più distante, nella sua ferma idealizzazione, dal disegno giovanile di Leonardo; sviluppo di ispirazione, non imitazione di allievi." Castelfranco considered the London picture an "opera di alta qualità con parti, come la testa dell'angelo, di grande bellezza" (p. 211). This figure had already been singled out for praise by Giulio Carotti, for whom it displayed "un atteggiamento del corpo ed una leggiera inclinazione della testa di ben maggiore naturalizza e spontaneità. Non discorriamo poi della espressione ideale, della bellezza incomparabile e della stupenda esecuzione di questa testa; non c'è che la Gioconda che le passi innanzi per espressione" (*Le Opere di Leonardo, Bramante e Raffaello*[Milan, 1905], p. 34). Like the above writers, Beenken assumed that Leonardo himself executed, as well as designed, the head of the angel (*Festschrift*, p. 136.) After praising the angel's hair, he wrote "Auch der Hals und gewisse Lichter im Antlitz, vor allem der schöne Glanz in den Augen des Engels zeigen m.E. die Malerei Lionardos."

19. See Leon Battista Alberti, *Treatise on Painting,* ed. Cecil Grayson (London, 1972), p. 83, par. 42: "I like there to be someone in the 'historia' who tells the spectators what is going on, and either beckons them with his hand to look, or . . . points to some danger or remarkable thing in the picture, or by his gestures invites you to laugh or weep with them." Leonardo was familiar with Alberti's treatise, we know, though precedents for his mediating angel can, of course, also be found in painting. Michael Baxandall (*Painting and Experience in Fifteenth Century Italy* [Oxford, 1972], p. 72) posits a connection between painting and theater, where plays "were introduced by a choric figure, the festaiuolo, often in the character of an angel, who remained on the stage during the action of the play as a mediator between the beholder and the events portrayed: similar choric figures, catching our eyes and pointing to the central action, are often used by the painters."

20. The most recent study of the painting is Ludwig H. Heydenreich, *Leonardo. The Last Supper*, Art in Context Series (New York, 1974). Bringing to bear his understanding of modern art, Leo Steinberg has also published an essay on the *Last Supper* in *The Art Quarterly* 36, no. 4 (1973): 297–410. While it may give pause to some *Leonardisti,* Steinberg's interpretation does justice to the depth of meaning in a great work of art about which there seemed to be little or nothing left to say.

21. Clark, *Drawings,* 2d ed., revised with the assistance of Carlo Pedretti (London, 1968) 1: no. 12551, p. 102. See also Popham, *Drawings,* no. 165, p. 150. The Madonna in the London version possibly reflects the conception of the now damaged figure of Saint John in the mural painting. Compare especially the cartoon copy after the Saint John sold at Sotheby's (June 28, 1962, no. 74; March 28, 1968, no. 5). The expressive intensity of the two apostles cited may perhaps be better imagined from their echoes in the *Madonna of the Rocks* than from what remains of the figures in the ruined mural.

22. Giovanni Paolo Lomazzo, *Trattato dell'Arte della Pittura* (Milan, 1584), p. 171.

23. The picture is reproduced in Berenson, *Italian Pictures,* vol. 3 pl. 1398. Malaguzzi-Valeri *(Corte,* p. 422) cites a copy of the London version dated 1526. An even earlier reflection of it appears in a Burgundian triptych of 1520 (Michel Laclotte, "Quelques tableaux bourguignons du XVIe siècle," in *Studies in Renaissance and Baroque Art presented to Anthony Blunt* [London, 1967] pp. 83–85 and pl. XVII–7).

24. The miniature is in the Staatliche Graphische Sammlung der Albertina, Vienna (Inv. no. 17644). See Alfred Stix and Anna Spitzmüller, *Beschreibender Katalog der Handzeichnungen* (Vienna, 1941), vol. 6, no. 386, p. 36. It is on vellum and is relatively large in scale, the central scene measuring 33.6 X 26 cm. A color reproduction appears in Walter Koschatzky and Alice Strobl, *Die Albertina in Wien* (Salzburg, 1969), p. 316. This is the only signed work by the artist, to whom were once attributed a number of miniatures and engravings (Malaguzzi-Valeri, "Sul miniatore Frate Antonio da Monza," *Rassegna d'Arte* 3, no. 2 [1916]: 28–37). Possibly related to the Albertina miniature are four others with large initials and figure compositions. These were in the Klinkosch Collection in Vienna until April 1889, when they were sold. One of them, depicting the Visitation, was acquired for Berlin, but the fate of the others is unknown (Paul Wescher, *Beschreibendes Verzeichnis der Miniaturen, Handschriften und Einzelblätter des Kupferstichabinetts der Staatlichen Museen Berlin* [Leipzig, 1931], no. 1799, p. 136, and fig. 132; and *Arte Lombarda dai Visconti agli Sforza* [Milan, 1958], no. 501, p. 160). This group of miniatures, not entirely homogeneous in style, has been attributed to Antonio da Monza by Wescher in *Jahrbuch der Berliner Museen* 2 (1960): 75–77. Wescher also refers to a smaller illumination of the Nativity sold from the Czezcowitzka Collection in Vienna (C. G. Boerner, Leipzig, May 12; 1930, pt. 2, no. 17, pl. 6), as belonging to this group (*Miniaturen* p. 136; and *Jahrbuch,* p. 75). One of the miniatures, depicting the Resurrection, formerly in the Klinkosch Collection, is a variant of a splendid illumination by Antonio da Monza in an antiphonal with H. P. Kraus (*Monumenta Codicum Manu Scriptorum* [New York, 1974], no. 42, p. 107, and illus. pp. 106 [color], 165–66). It is suggested in the catalogue that this may be the manuscript to which the *Pentecost* belonged.

25. About the Leonardo influence, see: Gerolamo D'Adda and G. Mongeri, "L'Arte del

Minio nel Ducato di Milano dal secolo XIII al XVI," *Archivio Storico Lombardo* 12, no. 4 (1885): 771–72 (759–96); Malaguzzi-Valeri, *Corte* (1917), 3: 154; Mario Salmi, *La Miniatura Italiana* (Milan, 1955), p. 48; and *Arte Lombarda*, no. 500, pp. 159–60.

26. Venturi, "Il Pontificale di Antonio da Monza nella Biblioteca Vaticana," *L'Arte* 1 (1898): 164.

27. I find no evidence for Davies's further proposal that the hands of these putti correspond better with the Louvre picture (*Leonardo*, p. 8, n. 26), a point not repeated in his catalogue (*Italian Schools*, p. 269). If anything, the face of the putto on the left suggests the London version. Compare also the nearly identical putti in the Kraus miniature, cited in n. 24 above. The connection with the *Madonna of the Rocks* made by Davies is taken up by Angela Ottino Della Chiesa in *L'Opera Completa di Leonardo Pittore* (Milan, 1967), p. 95. And it might be further observed that the small female figure making music in the lower right part of the border of the Albertina miniature appears to recall the pair of similar figures of angels from the altarpiece in San Francesco. (About these see n. 16.)

If we assume that Fra Antonio is responsible for the other miniatures attributed to him, it is relevant to note that the rocky and watery landscape settings in the *Nativity*, the Kraus miniature, and the *Resurrection* formerly in the Klinkosch Collection (Wescher, *Jahrbuch*, fig. 2, p. 77) all show, it seems to me, the influence of the *Madonna of the Rocks*. The Kraus miniature and a preparatory study for it in the Berlin-Dahlem Museum (Wescher, *Jahrbuch*, fig. 1, p. 76) include the motif of a horse in the upper right-hand corner that appears to derive from some Leonardo prototype (compare Popham, *Drawings*, nos. 63B and 65). About this study, see also Wescher, *Miniaturen*, no. 612, p. 100, and fig. 89.

28. It is worth noting here that Ambrogio de Predis, Leonardo's documented associate, is recorded as an illuminator in Rome in 1491 (*Journal of the Warburg and Courtauld Institutes* 21 [1958]: 297).

29. D'Adda and Mongeri, "L'Arte del Minio," p. 771; Malaguzzi-Valeri, "Antonio da Monza," p. 29; and Malaguzzi-Valeri, *Corte* (1917), 3: 153–54. Fernanda Wittgens (*Storia di Milano* 7 [1956]: 187) related the style of the illumination to Bramantino.

30. See the article in the *Zeitschrift für Kunstgeschichte* cited in n. 7. I do not believe that Leonardo's reworking of the theme was motivated primarily by iconographic considerations, as Mirella Levi D'Ancona tries to prove ("La 'Vergine delle Rocce' di Leonardo. Studio Iconografico delle Due Versioni di Parigi e di Londra," *Arte Lombarda* 1 [1955]: 98–104).

31. By Leonardo's "supervision," I mean to imply that he may also have been partly responsible for the execution of the London painting. His own participation in the completion of the work at this stage, aside from guiding an assistant, is likely to have been the kind described in contemporary accounts. We are informed, for example, by Fra Pietro da Novellara in 1501 that "two of Leonardo's pupils were doing some portraits and he from time to time put a touch on them" (Beltrami, *Documenti*, no. 107, p. 65). Vasari as well mentions certain works in Milan that were said to be by Salai but retouched by the master (*Vite*, ed. Milanesi [Florence, 1879], 4: 38). Concrete evidence of Leonardo's correcting pupils' work is provided by a drawing at Windsor (Clark, *Drawings* 1 [1968], no. 12328, pp. 27–28). In the altarpiece there is a palpable difference in quality between the head of the music-making angel on the left and that of the Madonna. Can this difference be explained by assuming that Leonardo had a considerable role in executing as well as designing the central panel? Or does it point to the intervention of a third hand less competent than Predis, such as Francesco Napoletano?

32. If we believe that Leonardo prepared the London painting in the 1490s, then the drapery study for the angel at Windsor (no. 12521) would date from that time. Clark, who identified the purpose of the sheet, dates it, correctly in my opinion, ca. 1496 (*Drawings*, 1935, pp. 78–79; 1968, pp. 92–93). Popham, who at first agreed about the identification, dated the drawing, however, ca. 1506 (*Drawings*, no. 158, p. 69, and p. 149). Later, in accordance with his reinterpretation, he claimed there were no drawings which could be con-

nected with the London painting (*The Burlington Magazine* [1952], p. 128). Though the studies of a child's bust also at Windsor (nos. 12519–20), dated by Clark ca. 1497, may have served for a work of sculpture, their close resemblance in type to the Christ Child in the London painting again suggests that Leonardo himself undertook the revision. The artist may have used the drawings for the sculpture project in modifying the children in the *Madonna of the Rocks*, just as he appears to have employed the *Last Supper* studies in revising the Virgin and the angel (see n. 21).

33. See: Clark, *Drawings* (1968), 1: 93, and no. 12546, p. 101, and 2, pl. 12546; and Popham, *Drawings* (1946), no. 169, p. 151, and pl. 169.

34. Compare Clark, *Drawings* (1968), vol. 1, nos. 12526–32, pp. 94–96. The problem of dating these studies and of the painting for which they were made is too complicated to discuss in detail here. It is enough to say that I believe they are related to the lost cartoon described by Fra Pietro da Novellara in a letter of April 3, 1501 (Beltrami, *Documenti*, no. 107, p. 65), and less accurately by Vasari (*Vite* [1879], 4: 38–39). The cartoon in the eye-witness account of Fra Pietro—allowing for some understandable confusion in deciphering and recalling what he saw—agrees in essentials with the Louvre painting. Though the execution of the picture may have been prolonged over a long time, the design at least was available to Raphael during his Florentine period.

The present tendency to retard the dates of this and other of Leonardo's works is contradicted by the influence they patently exerted on contemporary art. For instance, the valuable contribution of Jack Wasserman in a recent study (*The Art Bulletin* 103, no. 3 [Sept. 1971]: 312–23) is to have shown that motifs in the London National Gallery cartoon are echoed in Filippino Lippi's decoration of the Strozzi Chapel in Santa Maria Novella, Florence, completed, according to an inscription, in 1502. This rules out the late dates of ca. 1505–06 proposed by Clark (*Drawings* [1968], no. 12526, pp. 94–95), of 1507–08 advanced by Gould (*Leonardo*, pp. 152–62), and of ca. 1508–10 by Pedretti (*The Burlington Magazine* 110, no. 778 [January, 1968]: 22–28). For the proper interpretation, see Heydenreich. "La Sainte Anne de Léonard de Vinci," *Gazette des Beaux-Arts* 10 (1933): 205–19; and Popham, *Drawings*, pp. 72–74. The cartoon, which dates from the end of Leonardo's first Milanese period, represents a radically new treatment of the theme of the *Madonna of the Rocks*, based, as is the London replica but more comprehensively, on the immense conceptual effort behind the *Last Supper*.

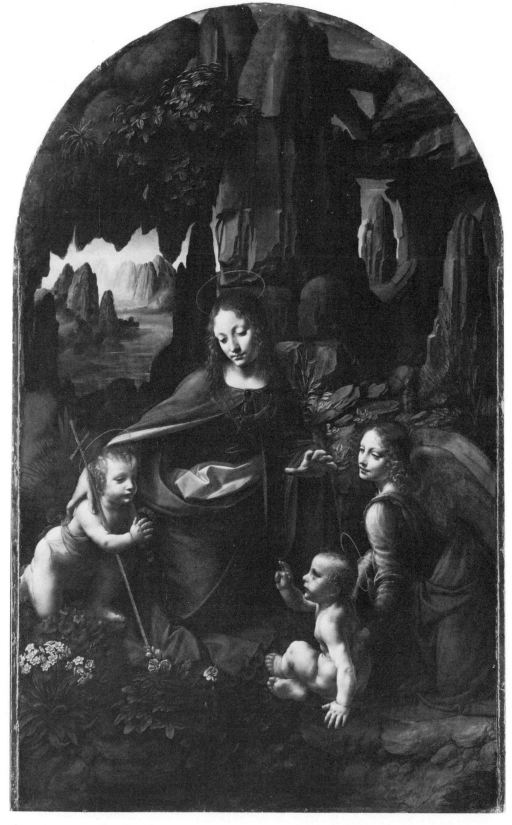

11.1 Leonardo da Vinci (with assistance), *Madonna of the Rocks*. National Gallery, London.

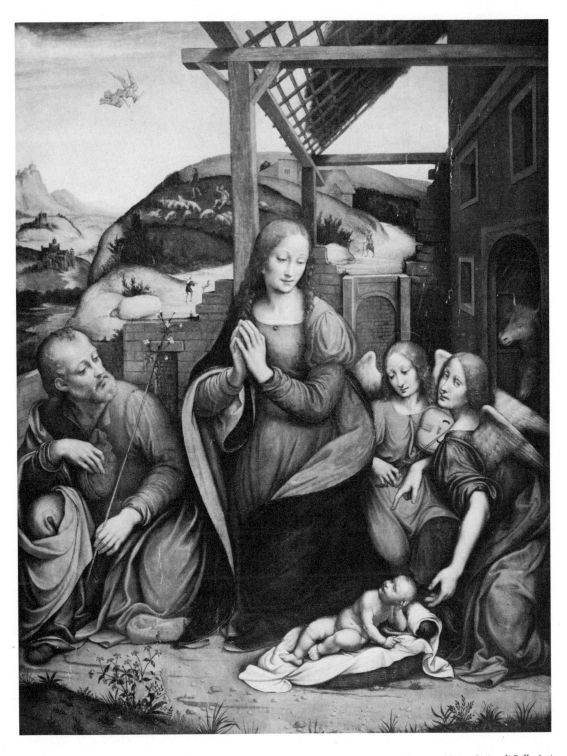

11.2 Giampietrino, *Nativity*. Museo Civico di Belle Arti, Lugano.

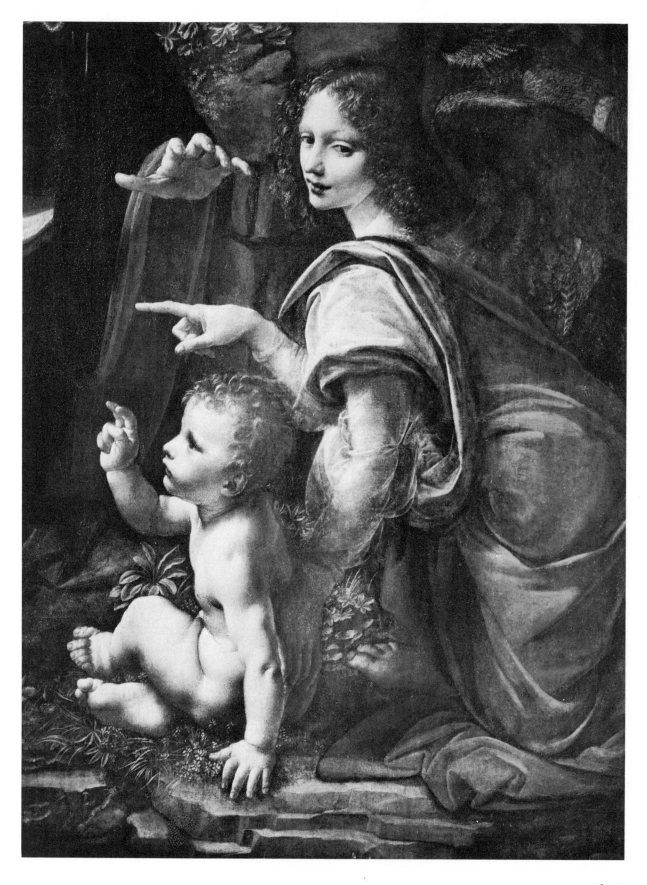

11.3 Leonardo da Vinci, detail of the *Madonna of the Rocks*. Musée du Louvre, Paris.

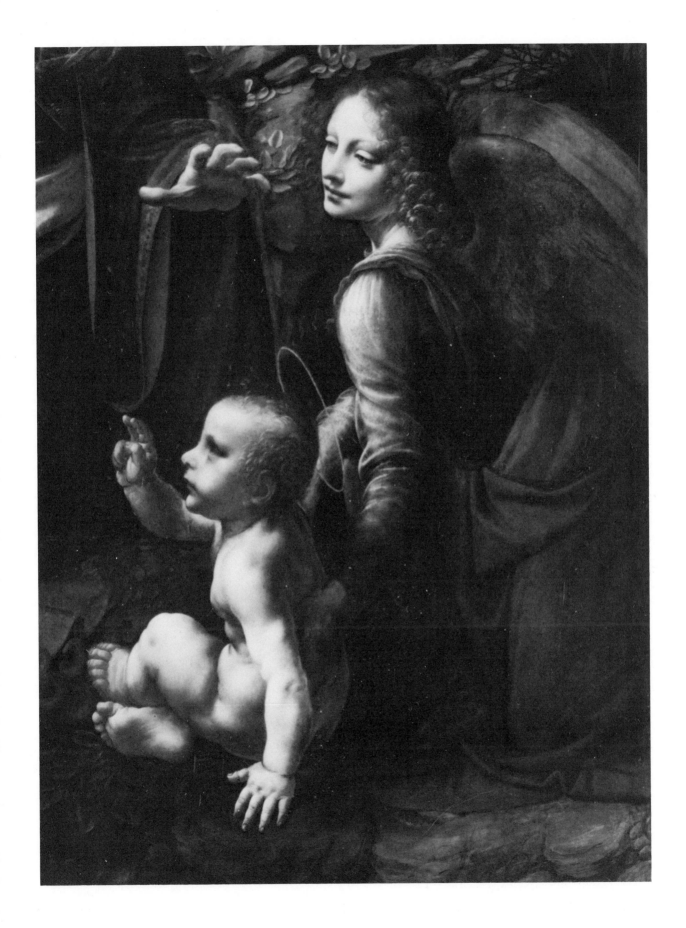

11.4 Detail of figure 11.1.

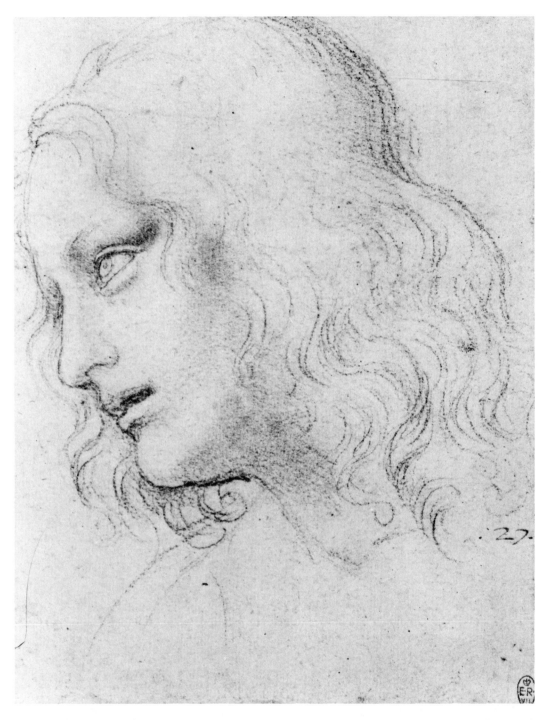

11.5 Leonardo da Vinci, Study of an Apostle for the *Last Supper*. Royal Collection, Windsor Castle.

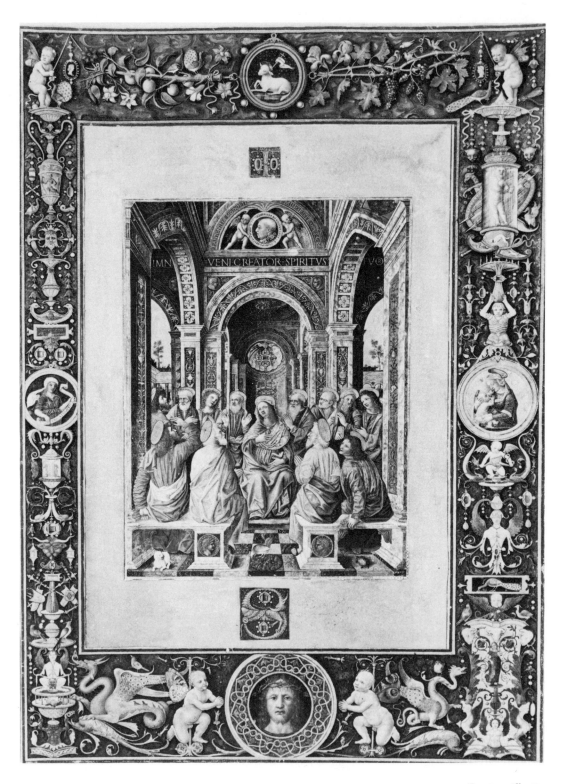

11.6 Antonio da Monza, *Pentecost*. Albertina, Vienna.

11.7 Detail of figure 11.6

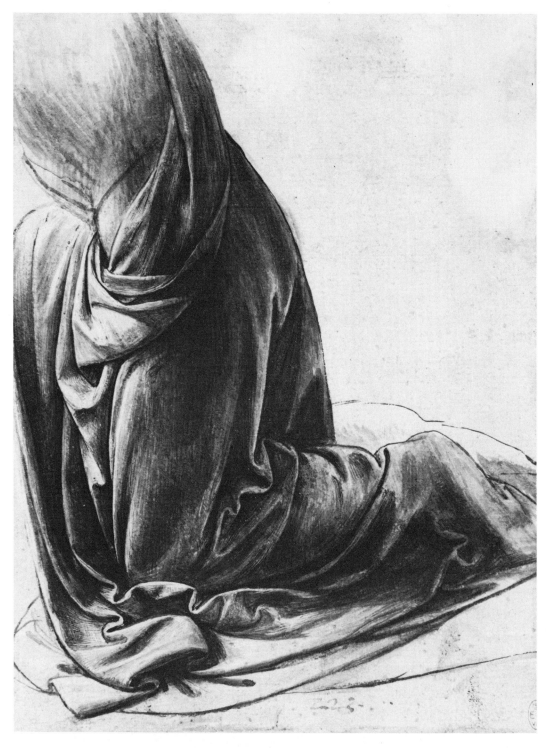

11.8  Leonardo da Vinci, Drapery Study for a Kneeling Figure. Royal Collection, Windsor
Castle.

# Venice and the Veneto

# 12. The Widener *Orpheus:* Attribution, Type, Invention

*WENDY STEDMAN SHEARD*

THE *ORPHEUS* in the Widener Collection of the National Gallery of Art[1] has long presented an iconographic puzzle.[2] Since it was removed from the canon of autograph Bellini works in the 1930s nothing very conclusive has been said about its attribution. Yet so august an authority as Bernard Berenson once termed the picture "one of the most enchanting works of art of the Italian Renaissance."[3] This small but intense and glowing painting (figs. 12.1, 3–5) clearly deserves a second look.

Two groups of figures are disposed diagonally in a lighted central area against a background of woods separated off by a stream. In the fore- and middle-grounds there are five birds. These have been identified as, from left to right, a bantam, a guinea hen, and three peacocks or peahens.[4] In the woods are a panther, three deer, and a swine. That the painting, at some point transferred from panel to canvas, was once cut down, is shown by the truncated human form at the right-hand edge, where only the torso and outstretched right arm of a bearded man who peers intently into the forest are now visible, immediately to the right of the swine and the deer behind it (fig. 12.4). A bird and a deer on the left edge were likewise mutilated. The identification of the young man playing the fiddle as Orpheus has never been in dispute, despite the fact that in antiquity Orpheus was always depicted with a lyre. There has been general agreement, too, that the nude seen from behind, wielding a long wand in the direction of the forest, is Circe, and that the myths of Orpheus and Circe are mingled here in an unusual manner. I shall briefly defer taking up the more vexing question of the foreground couple's identity.

Scholarly consensus that the *Orpheus* is not by Giovanni Bellini's own hand emerges from the traditional exclusive concentration on attribution. Technical factors, such as the somewhat confused drawing of

Orpheus's drapery (fig. 12.3) and the even more disturbing stream separating the lighted glade from the deep wood, whose uniform surface lacks any attempt to mimic the texture of flowing water (fig. 12.4), led Dussler to remove it from Bellini's oeuvre.[5] A different notion of connoisseurship, however, might rather focus on a particular artist's way of thinking as expressed through the structure of his imagery, both formal and intellectual. Such an approach has not heretofore been brought to bear on this picture, despite the fact that George Martin Richter long ago separated the *invention* of the *Orpheus* from its *execution*, maintaining that its invention ought to be attributed to Giorgione while still in Bellini's studio.[6] I would like to demonstrate the great probability of Richter's hypothesis by looking closely at the structure of this painting. I believe that the understanding which results may, moreover, offer several clues to the evolution of Giorgione's approach to subject matter.

Apart from technical weaknesses, stylistic discrepancies and several features that are uncharacteristic of Bellini's compositions and lighting methods support the removal of this painting from his oeuvre. Instead, a collaboration between at least two painters seems feasible to postulate, given numerous differences in the proportions, extremities, and modeling employed in the two figure groups, and from the use of tempera for the figures but not for the landscape background, which is painted using an oil base, thinly applied with moderate impasto in certain details, over a thin white ground.[7] Orpheus (fig. 12.3) was painted with a looseness and rapidity of execution quite unlike the deliberate modeling employed for the left-hand couple, where individual brushstrokes are submerged in a homogeneous surface texture (fig. 12.5).

When Bellini shop productions of the period are scanned for parallels, one is found when Orpheus's unusually broad face, round head, and somewhat coarse facial features, combined with long hands and tapering fingers, are compared to some of the figures in the Accademia *Allegories*. The nude in figure 12.7 serves as an example; one might recall many of the heads in the illustrations to the *Hypnerotomachia Poliphili* as well.[8] The body type of the foreground nude in our picture, however, while similar in some ways to the northern-derived shape of the allegorical panel, is much more smoothly rounded and graceful, with a sloping shoulder that foretells Giorgione's future ideal form for nudes (compare figs. 12.5 and 7)—think of the nude in the *Tempesta*. The X-ray (fig. 12.6) is interesting in this connection, since it shows that the background nude, Circe, once had a more voluptuous figure—note the contour of the breast and more fully rounded hips—that was later chastened. Thus, in her original form this nude, too, suggested female types associated with Giorgione. Yet the nudes' scale and rather tentative air suggest a date analogous to that of the Accademia *Allegories*, well before the appear-

ance of grandly-scaled nudes became a matter of course in Venice following the decoration of the *Fondaco dei Tedeschi*.[9]

The foreground nude's head and the satyr's are shaped quite differently from Orpheus's. They are closer to idealized ovoids, and their hands, small, broad and limp, are more typically Giorgionesque (fig. 12.5). Somewhat differently conceived, the rather angular contour describing Circe (fig. 12.3) may depend on a figure from antique relief sculpture, probably a nereid.[10] Though perhaps somewhat awkwardly rendered, the extreme nature of this figure's torsion is remarkable, and indicates that the interest in poses in which an animated balance is attained in part by contrasts in the positioning of limbs, so evident in the *Fondaco dei Tedeschi* frescoes, stemmed from the very earliest phases of Giorgione's brief career, when the *Orpheus* was designed.

Despite weaknesses in execution already mentioned, the picture's overall visual conception reaches a high level. It is tempting to believe that Giorgione designed and began painting the panel while he and the other painter involved both belonged to Giovanni Bellini's shop. Though Andrea Previtali has been proposed as the author of the *Orpheus*,[11] Previtali's mature style seems too imperfectly known to allow any such presumption about an early manner. Thus the identity of Giorgione's collaborator remains, for the time being at least, a mystery.[12] While Giorgione's contribution was mainly the conception or invention, in my view, the possibility that he himself painted the nude and satyr in the foreground should not be excluded. The lack of textural differentiation in the group—for example, in the satyr's legs (fig. 12.5)—could be explained either by the unfinished state in which the painting was apparently left or by a desire to deemphasize the figure's animal-like quality.

Before taking up the question of subject matter, I want to examine the composition and other pictorial devices, since in this typically Venetian case the invention is not restricted to the intellectual content but includes its fusion with formal elements. Almost immediately the viewer notices the ingenious combination of particular forms—the figures, their placement, gestures, and expression—bathed in the warm light of the glade contrasted to the darkness of the woods (fig. 12.1, 3–5), which creates the painting's mood of mysterious thrall and lends it such power to enchant. We are struck by the idea that the action of the picture on the viewer has been made to mirror its subject matter. Inevitably the notion suggests itself that a new concept of pictorial functioning is at work here, one that recalls the late Quattrocento matrix in Venice out of which so many new inventions were soon to flow. The handling of light, moreover, also brings Giorgione to mind. It is conceived as color: it glows in the delicate flesh tones and their juxtaposition with warm, earthy hues in the satyr's skin and the wood and stone seats supporting

the figures. These colors, high-keyed in the nudes' flesh and Orpheus's bright cloak, more subdued in the satyr's skin, harmonize unobtrusively with what was once more obviously the prevalent hue of the picture: green, in several shades—a color emphasis characteristic of Giorgione.

Also, much of the picture's effect stems from the un-Bellinesque use of chiaroscural contrast. In fact, contrast or contraposition is an important aspect of the picture's conceit, as will shortly be demonstrated. The contrast between the light-filled greensward and the darkness of the forest beyond, against which the illumined silhouettes of the nudes, especially the contour of Circe, tell so clearly, is visually highly effective (fig. 12.3). The juxtaposition of such luminous figures with so much encroaching darkness recalls Leonardo's pictorial methods more than Bellini's. The contrast is carried further by the repoussoir element at the lower right, consisting of the nearly bare tree, bushes, and shadowed forest floor, which extends almost exactly to the mid-point of the lower edge of the painting.

The contrast of light and dark is thus one of the major determinants of the composition. The other is the diagonal direction of its spatial recession, an element that would be equally unexpected in a painting designed by Bellini. The diagonal spatial construction begins with the bare branch at lower left (fig. 12.1) and leads through the supports of the figure groups to the panther and deer beyond (figs. 12.3, 4). It points up the opposition between the two groups of figures, a structural equivalent to the contradictory forces being expounded by the picture's conceit. This arrangement is coherent and complete, echoed by the edge of the repoussoir and parallel felled branch just above it, with Circe's wand wittily pointing to its major axis (fig. 12.3). Another, secondary diagonal crosses it, leading from the foot of the large tree at right through Orpheus and the rock against which he leans, to the single lighted area behind the trees which, by accentuating the head of the satyr, brings the eye back again to its point of departure (figs. 12.1, 5). The two diagonals cross in the figure of Orpheus, suggesting his importance to the overall meaning of the picture. So tightly integrated a composition is almost impossible to imagine as an accidentally detached part of a larger whole, which would have to be the case if we were to conclude that the area of the picture has been substantially cut down, as the Tietzes maintained. This impression of completeness is borne out by the interpretation of the painting's invention I shall shortly propose.

Tietze and Tietze-Conrat argued that the *Orpheus* must have been drastically reduced in size, partly because, in the Renaissance, the center of the composition could not have been occupied by a figure seen from behind.[13] Although this deduction might be warranted for a composition by Bellini, it would not necessarily hold true for one by Giorgione, three

of whose new painting types featured figures seen from behind, two of them nudes.[14] To me this focus on the motif of a nude seen from behind can even be read as a Giorgionesque signature on the composition. I interpret the unusual stress on diagonal recession in the same way.[15]

The immersion of the light-filled central scene in a sea of darkness that even penetrates the front plane in the form of the unusually large repoussoir, serves several functions, then. Visually intelligible space—which need not be rationally constructed, as the Venetians were discovering—results from it, and the small dimensions of the painting are overcome. What is even more unusual in a Venetian painting of the 1490s, this bold chiaroscural structure sets up a precise psychological position of the viewer vis-à-vis the painting: he is drawn up short at the edge of the clearing by the unexpected woodland scene. The repoussoir effectively excludes him from the charmed circle of radiant space and at the same time allows him the protection of darkness, while beckoning him closer.

The picture belongs to a compositional type characterized by placement of the scene in front of or within a thick screen of trees. In Venice the type was given new vigor by the engraving from the *Hypnerotomachia* showing Poliphilo lost in the woods (fol. a iii v), but seems to have ended temporarily with Bellini's *Feast of the Gods*, before Titian changed the landscape background. Close to the *Orpheus* in the series of its compositional type is the *Death of St. Peter Martyr* in London (fig. 12.2) now not generally attributed to Bellini's hand, despite widespread acceptance of his authorship of the composition.[16] The way the trees are indicated in the London picture is more complicated than the convention adopted for the *Orpheus* (compare figs. 12.1 and 2), in which the trees are fewer in number and less schematic, rendered with a characteristic curve and diminution of volume toward the top, and drawn to avoid the true vertical. At the same time, the opacity of the background has been intensified; the accents of light glimpsed through Bellini's trees, which serve to bring out the character of the woods as a copse standing just outside a city (fig. 12.2), have given way to a green forest gloom pierced only by an opening behind the satyr's head whose function in the composition has already been noted. The character of these woods is thereby revealed as wild and removed from civilization, perhaps in deliberate contrast to the *Death of St. Peter Martyr* where, as Giles Robertson has indicated, Bellini is purposely setting his figures in a context of nature visually linked with human activity.

In the *Death of St. Peter Martyr*, the main groups of figures and their space are organized in a straight line, parallel to the picture plane (fig. 12.2). Diagonal recession is absent. There is a felled branch placed at lower right as a support for the *cartellino*. In the *Orpheus*, this element

was dramatically expanded (fig. 12.1). The space occupied by the two couples, moreover, is much greater in relation to the available field. The narrow ledge of space in the London picture resembles a stage on which the scenes of violence are enacted, echoed ironically by the postures of the woodsmen, with the trees as a scenic backdrop brought forward on purpose to underscore the claustrophobic violence.[17]

When the *Orpheus* is viewed beside it, the intense stillness of its figures, which have been depicted as if in suspended animation, is evident. The woodland scene has been endowed with a timeless quality alien to the idea of storytelling or narration. This quality of being outside time is familiar to us from Giorgione's *Tempesta* and *Three Philosophers.* Comparison of the *Orpheus* with Bellini's narration of a scene from the life of a saint thus brings out its antitemporal, antinarrative, symbolic nature. Hence when the Tietzes argued that because the *Orpheus* tells a story—even though just which one had not been deciphered—it is unlike Giorgione,[18] their contention, while stressing Giorgione's distaste for illustration, yet betrays a too hasty assumption that the Widener panel is a narrative picture.[19]

Most attempts to identify the *Orpheus*'s subject have in fact been vitiated by the underlying assumption, never critically examined, that the picture illustrates a mythological episode. Yet when placed beside straightforward illustrations such as Cima's mythologies in Parma (figs. 12.9, 10), the picture reveals itself as belonging to another category entirely, a "new category of invention" just then coming into being.[20] Analyzing the strategies employed by the designer of the *Orpheus* will help us to define what this "new category" entailed and why the study of it is important.

As with traditional iconographic method, any investigation of subject must first identify the iconological elements. Here one difficulty has been lack of agreement as to what the satyr is holding, the object at which he and his companion are raptly gazing (fig. 12.5). Robert Eisler saw it as a skein of white wool or fleece, and thus connected with the episode in which Pan seduces Luna.[21] Even to entertain an identification of that kind involved a denial of the deeply antinarrative stance of this painting.[22] As Mather long ago pointed out, what is transpiring between the two figures is not erotic.[23] Hartlaub thought the satyr held up a mirror, and that the foreground pair symbolized the power of prophecy.[24] Shapiro recently interpreted the object as a sponge.[25] Although the outlines of the object are not sharply drawn, there is no question in my mind that it represents a conch shell.[26] Compare the conch shown on a much larger scale, apparently drawn from nature, in one of the Accademia *Allegories* from the series offering suggestive comparisons to the style of the *Orpheus* (fig. 12.8).[27] The shell's position in the composition and its pro-

found effect on the two figures who seem to be meditating on it alert us to its importance in the iconographic scheme.

The presence of several varieties of birds in scenes of Orpheus enchanting wild animals with his music was traditional. There seems to be no reason to dispute Friedmann's identification of the birds in the foreground of this picture as guinea fowl and peacocks. A major literary source, Philostratus, stressed the presence of birds with cacaphonous cries, for which honor the cry of the peacock certainly qualifies. Philostratus specifically mentions daws, crows, and Zeus's eagle,[28] which may be what is represented perched in the tree in a drawing once attributed to Cima (fig. 12.11).[29] In this drawing, as with our painting, ancient visual sources are ignored and Orpheus is shown playing a fiddle whose features are not rendered precisely enough to identify it as a *lira da braccio*. Yet the likelihood that it was so intended is suggested by the contemporary identification of the Greek and Latin *lyra* referred to in the literary sources with the *lira da braccio*.[30] A boar and a deer are also mentioned by Philostratus. Thus their presence in the right background (fig. 12.4) might, though not necessarily, be associated with Orpheus imagery.[31] Yet the role played by these animals appears to be at least a double one, since they could also represent men who have been turned into animals by Circe; the presence of the swine in particular can be related to the Circe episode in the Odyssey.[32] The truncated figure at the right edge appears to have shown a man being turned into an animal (fig. 12.4), suggesting the theme of transformation that pervades the picture in other ways as well.

Turning to the painting's figural elements, it is evident both from the substance of their actions and the pictorial strategy of their situation that Orpheus and Circe are intended as contraries. They have their backs to one another, Orpheus facing the viewer and the birds, Circe the dark forest (fig. 12.3). In this unusual presentation of figures from separate myths, both make magic that has power to transform nature. Orpheus, through the power of his art, affects animals and even inanimate nature with an upward metamorphosis on the great chain of being, to nobler possibilities. Circe, turning humans into swine, drags conscious matter downward with a black or left-handed magic—note that she wields the wand in her left hand (fig. 12.3). Her possibly fearful visage is hidden. Pointing at the ravenous panther, the direction of her wand underscores the potential ferocity in human nature thus elicited.[33] Orpheus's magical instrument, held in his right hand, is his bow.[34]

The theme of transformation or metamorphosis thus dominates the picture.[35] The image of human nature sinking (implied by the cut-off torso if not by the panther and swine, fig. 12.4) juxtaposed to that of animal nature rising (the attentive, humanly listening birds, fig. 12.1) recalls

Pico della Mirandola's *Oration on the Dignity of Man*.[36] Pico's famous passage on the plasticity, moldability, and capacity to exercise free will that are typical of human nature, indeed the constituents of its greatness, comes to mind.[37] That parts of Pico's essay can be read as a gloss on the *Odyssey* strengthens the hypothesis of a connection to the unusual configuration of images in the *Orpheus*.[38]

As for the couple in the foreground (fig. 12.5), their postures and gestures are so serenely balanced and symmetrical that the author's intention to contrast them with Orpheus and Circe is obvious. Since the more distant couple represents contraries, the nearer must be complementaries. The picture's basic structure of contradiction and counterpositioning thus manifests itself strongly in the visual contrasts between the two couples. Also opposed are the relationships—or lack thereof—operating in each pair (figs. 12.1, 3, 5).

The usual identification of the satyr as Pan, based on his cloven hooves and goatlike legs, is no doubt correct. Here the artist has drawn upon an ancient classical tradition in which Pan, conceived as a hybrid combining human and animal form, was depicted with the heavily bearded face of an older man, a body human from the waist up, and goatlike legs and hooves. Sometimes he wore an animal skin or drapery.[39] This type antedated the humanization of Pan, associated with the Polykleitan type portraying the god as a completely human figure on which the tiny horns signaling his identity were almost totally disguised, which appeared, close to the time of the Widener picture, in several small bronzes attributed to Andrea Riccio and his followers.[40]

The gesture of the female nude is that of Venus *pudica*, calling attention to Venus's role as a procreative force. In the absence of any other attribute, the gesture alone serves to identify this nude as Venus. The conch shell held up by Pan at which they both gaze, wrapped in a veil of contemplation, is a symbol of Venus, the sea, and rebirth.[41] This Pan is not the lecherous satyr of Ovid's and Lucian's tales;[42] rather, he appears in his symbolic aspect, as the principle of animation in nature. As such, he is the All, the Universal, the One, which his name means.[43] The Venus with him is his mirror image, the sacred force of living nature, Venus *physizoa*, Earth, the life-giver, the Venus of the *Hypnerotomachia Poliphili* and the Giorgionesque *Venus Resting after the Hunt* recorded in a seventeenth-century inventory.[44] In a gesture analogous to that of Venus, Pan, too, directs the viewer's attention to the genital area, the source of his generative capacities. Thus the pair represents the male and female principles of nature, the dichotomy of their sexual difference—a primal one, after all, in the human perception of the world and indeed of the cosmos—now fused by union in a shared rapturous experience which is a visual equivalent of their essential primordial unity beneath the

world of appearances. In this way the theme of *discordia concors*, or harmony, is sounded.[45] Their rapture arises out of contemplation of the perpetual rebirth and renewal that flows from *their* powers of transformation, embodied in the symbol of the shell.

The goddess's left hand lightly caresses Pan's shoulder, the part, or gesture, mirroring the whole, or loving essence, in contrast to the left-handed action of Circe in the background. As gestural motif, this small hand creeping unobtrusively into view is another Giorgionesque hallmark, familiar from the Berlin *Portrait of a Young Man*.[46]

The shell functions not only to unite male and female in contemplation of its meaning, but to sum up the idea of the One inherent in the Many through the repetition of its structure in every part. The waves heard endlessly reverberating in the conch are a kind of music of nature which articulates the rhythmic ground of being, like the sound of breathing.

As Edgar Wind noted, Pico della Mirandola's *Orphic Conclusions* included the admonition "He who cannot attract Pan approaches Proteus in vain," in reference to this Neoplatonic doctrine of the One inherent in the Many. Beneath the appearance of diversity ("the ever-changing Proteus") the underlying identity of all things in Nature (the hidden Pan) must be sought.[47] The *Orpheus* reflects the intellectual climate of Venice in the 1490s, when a sharp influx of Florentine ideas culminated in the Venetian publication not only of works by Pico, but by Ficino and Poliziano, continuing a process already begun during the previous decade.[48]

The Washington painting does not illustrate ideas as an allegory would, however, with one-to-one correspondences between image and idea. Instead it exemplifies the new kind of invention in which, unlike allegory, the artist combined ideas with visual forms in ways that were not rigidly determined, allowing fantasy a greater role. This does not mean, though, that the resulting art has no subject matter, or that the artist's fantasies are ultimately indecipherable.[49] With Pico's aphorism in mind, it is possible to see that the *Orpheus* may include among its dense texture of associations the Protean principle of transformation as an explanation for the world of manifold appearances, represented in two diametrically opposed aspects by Orpheus and Circe yet subsumed under the engulfing cosmic principle of unity embodied by Pan-Venus. The obvious psychic alienation of Orpheus and Circe from one another, despite their physical proximity, may signify that, unlike the male and female principles of nature portrayed nearby in so harmonious a state, the good and evil, upward and downward, right and left dichotomies, particularly as apprehended in the opposing potentialities of black magic and beneficent magic, cannot be blended in the *concordia discors* of experiential unity but must always appear as separated contraries, even if

the ultimate One is always felt as underlying the appearances of the Many. But, to return to the painter's strategy: by instilling a mood of contemplation in the viewer analogous to the one it depicts, the picture functions as a means to gain experience of the One, and is thus an instrument of self-exploration and self-knowledge. The act of viewing the painting now becomes an aid or inducement to meditation comparable to Ficino's singing of the Orphic hymns.[50]

Predictably, the *Orpheus* permits a Christian level of meaning to coexist with its pagan-inspired, philosophical one. Pan can also be seen as a symbol of Christ who holds up to *ante legem* Nature the promise of Resurrection (the shell) at the end of cyclically revolving time (thus at the end of everything Protean and transitory) on the Day of Judgment, when human spiritual and physical perfection will be united in a new and final form, the Resurrection of the Body.[51]

Turning to the painting itself once more, one's eye is again arrested by the compositional and chromatic focusing on Orpheus that insists on the figure's importance even among such awesome cosmic representations as Pan and Venus.[52] It is easy to see why Orpheus would have been a compelling figure of self-identification for an artist, since it was precisely in his role as an artist that Orpheus practiced the good or "natural" magic Pico called "the science of the Divine."[53] The type of the philosopher-artist-magus created by Pico in the *Oration on the Dignity of Man*, who achieves an understanding of his own transformational power that makes him the ruler, rather than the slave, of his brutish potentialities, was incarnate in Orpheus, whether conceived as a divinely inspired poetic teacher or as one of the most ancient theologians. Like Pan and Apollo, Orpheus exercised and proclaimed the sovereign power of music. Unlike them, however, he was human, yet still possessed of godlike powers; the perfect figure of the magus. The focus on Orpheus (figs. 12.1, 3) leads inevitably to the twin themes of the power of music and the power of the artist at the heart of the invention. Juxtaposition with Circe on the one hand, and the united Pan and Venus on the other, suggests the artist's responsibility to treat his power as a sacred trust, to reject the temptation to misuse it (as, for example, by the arousal of those dark and uncontrollable passions Plato deplored).[54] He should rather strive to create a harmony in the human soul consonant with the divine harmony of the spheres of which music itself is an emanation, represented in the picture by the union of Pan and Venus.

By the end of the Quattrocento, the transformational powers of music had become increasingly evident. Its ability to transcend fixed boundaries of genre differentiated it from the then-existing situation in the arts of poetry and painting. The frequent use of an identical melody for sacred and secular (even for obscene) contexts was noteworthy in this

regard.[55] Such flexibility must have struck an artist like Giorgione, especially if, as seems likely, he thought of himself as musician first and painter second.[56] The perfect correspondence of music to the mathematical formulas of cosmic harmony worked out by Pythagoras, so widely known in the period under discussion, lent music a unique philosophical status that had been celebrated continuously from antiquity down through the Middle Ages and into the Renaissance.[57]

At the same time, music has a freedom from words and specific images that mirrors, as well as appeals to, feelings, sensations, and the stream of consciousness. It is this capacity of music immediately and sensuously to correspond with and thus to generate an inner state that the stance of this new type of painting imitates. In striving to approach more closely the nonillustrative, nonconceptual auditory immediacy of music, perhaps even to attain a kind of musical structure, painting reaches a new inclusiveness coupled with an intensified power to condense associations and allusions that discourages and renders inadequate a method of interpretation that relies on one-to-one correspondences.[58] Paintings which can be considered as belonging to this "new category of invention," such as Bellini's *Sacred Allegory* in the Uffizi, begin to appear in the Venetian milieu for the first time during the 1490s, when the Florentine Neoplatonists' ideas, together with Leonardo's, about the parallels between painting and music, were spreading throughout northern Italy.[59]

The *Orpheus* casts a spell of enchantment, like Orpheus's music. It beckons the viewer into itself, into the stillness and luminosity of its timeless glade, and into himself, where an equivalent state of his own mind may at last be reached, whose profound openness to the harmony— and for some the oneness—of human and cosmic nature, is expressed in the alpha rhythm pulses made by the brain waves during meditation.[60]

The shared contemplation of Pan and Venus brings to mind an image strikingly like it in the Benson *Holy Family* (figs. 12.12, 13, 14),[61] in which Mary and Joseph, a similar combination of old age and youth paired under extraordinary circumstances, are depicted in much the same way, enabling us to witness the breakdown of traditional boundaries between sacred and secular art in Giorgione's early work. Many standard references to narrative aspects of the scene, such as the manger, the ox, and the ass, have been omitted. The Virgin is shown in a state of trance-like introspection (fig. 12.13). She does not gaze directly at the infant, but inward, and is seen as if through a veil. Joseph appears to gaze directly down at the child, while his left hand rests lightly on the infant's arm in a manner resembling Venus's caress of Pan.

The infant looks and points heavenward to communicate the essential significance of the Nativity scene—that He is the Incarnation of God

made flesh. This wondrous and miraculous mystery is what the two figures who nurture and protect the child are contemplating so reverently. "A Meditation on the Incarnation" would be a more accurate title for this picture. The landscape seen through the arch, its forms repeating those of the figures (fig. 12.14), replaces the Orpheus and Circe group in the scheme of diagonal disposition of space with which Giorgione is experimenting (compare fig. 12.1). The view through the arch, brought insistently to our attention by the very framing function of the arch itself, is connected to the shapes of the figures in innumerable subtle ways. Parallels between the arrangement of landscape forms and the holy figures express the idea that the earth itself is also an Incarnation—or "in-terration"—and that its sacred character should inspire similar enraptured contemplation.[62]

By removing the possibility of a commonplace appreciation of the narrative details of the Nativity scene, Giorgione turns the beholder's attention to the fundamental significance of the event, which was sometimes overshadowed by its treatment as genre. Through its massive, engulfing shape of pyramidal stability, painted with enamel-like colors which sing clearly against the earthy browns of the surroundings, Giorgione leads the eye back again and again to the figure of the Virgin, monumental despite the painting's small scale. After a few moments, the figure seems to float suspended in midair, detached from the geometric anchorage of the picture's careful construction, almost forcing the viewer to enter into the same state of introspection that is depicted.

Here again the painting's action on the beholder leads him to imitate and thus to become united with the subject of the painting: a mystery and its contemplation, in this case a Christian Mystery. A much more rigorous intellectual and spiritual commitment is demanded of the observer than when he is encouraged to imagine himself a spectator at a holy event in the past, as if attending a theatrical performance or mystery play. In the situation created by the Benson *Holy Family*, analogous to that of the *Orpheus*, whoever draws near to this intimate, intense event becomes an invisible participant in it. The pictorial forms and the intellectual forms of content combine to induce in the viewer a mood or state of mind which converges on what is depicted. The boundaries between the art object and the spectator are purposefully blurred, even denied.

This relatively new functioning of imagery in the Widener and Benson pictures can be seen as a logical result of the fifteenth-century history of the devotional image in northern Italy, in which its efficacy was continually heightened by artists' discoveries, mainly Mantegna's and Bellini's. The viewer's relationship to the religious image, which was gradually becoming the catalyst for a spiritual event in the present rather than an iconic embodiment of divinity, underwent a complex history which

obviously cannot be entered into here.[63] It was at first, evidently, a release from the bonds of convention that allowed the observer the status of a supposed witness rather than that of a recipient of power or grace through the instrumentality of an icon.[64] Yet as the century progressed, Bellini seems to have reconsidered the nature of the icon, whose presence was felt so vividly in Venice, and to have begun reincorporating some of its magical means into contemporary imagery.[65] His was a conscious attempt to manipulate the mood or state of mind of the beholder, to make him more accessible to certain categories of religious experience—an attempt resembling artistic aims often expressed in styles of later eras but as yet insufficiently detected and described at this early date.

Giorgione appeared on the scene just when this new awareness of efficacy had fully ripened. He took it over, explored, extended, and deepened it. He enlarged the scope of engendered contemplation to include philosophical, aesthetic, and poetic objects — and perhaps even the mood or state of meditation itself as an object. In due course the traditional boundaries between sacred and secular art gave way in his work, with the result that paintings such as the *Tempesta* and the London *Sunset Landscape* are able to inhabit both worlds, and constrictive, narrowly exclusive explanations of their subjects will suffice no longer.[66] We are fortunate to have, in these two small paintings in the National Gallery, two superb, unique records of the beginning of this process in Giorgione's art (figs. 12.1, 3–5, 12–14).

# NOTES

1. The opportunity to join fellow students and friends of Charles Seymour, Jr., in honoring his memory in appreciation of the unique intelligence and humor that enriched all our lives, and is now sorely missed, is a welcome one.

My interest in the Widener *Orpheus* developed during two seminars on Giorgione which I taught at Yale University in 1972 and 1973. They focused on the question of Giorgione's approach to subject matter, and on methods of defining his inventions. I would like to thank the students in those seminars for their role in stimulating the thoughts that find expression in this paper. I am especially grateful to C. Triphyllius Farley, who first perceived the remarkable nature of the invention in this painting. Some of this material was delivered as a brief talk at the symposium on Venetian art held at Johns Hopkins University on March 22, 1974. A second version was presented at the National Gallery on October 20, 1974. The article was submitted for publication in this volume in March, 1975. In January 1976, volume 6 of the National Gallery's *Studies in the History of Art*, dated 1974, appeared, in which Maurice L. Shapiro's "The Widener *Orpheus*" treats some of the same issues considered here, although reaching mostly quite different conclusions. In a subsequent revision of these notes, I noted Shapiro's observations and positions.

An obvious debt to Edgar Wind's *Pagan Mysteries of the Renaissance* is hereby acknowledged, without, of course, my laying claim to the sort of erudition that aided his original discoveries.

2. The painting, NGA Widener 598, measures 18⅝'' × 32''. Some sections are in tempera, others in oil. Its condition is only fair, with extensive inpainting. Yet the X-rays show that the essential elements of the composition have not been altered in such a way as to hinder analysis of the picture's style and iconography (see fig. 12. 6)

The *Orpheus* was bought by Joseph E. Widener in 1925 ("The Perfect Collection," *Fortune Magazine* 6, no. 3 [September 1932]: 62–72) and so was not included in the catalogue by Joseph Widener (with W. R. Valentiner?), *Paintings in the Collection of Joseph Widener at Lynnewood Hall* (Elkins Park, Pa. 1923). It was published in the first edition of the catalogue of paintings form the Widener collection in the National Gallery of Art, John Walker, *Paintings and Sculpture from the Widener Collection* (Washington, D. C., 1948), and repeated in the 2d ed. (1959), p. 15, No. 598, titled *Orpheus*, with dimensions but no provenance. The provenance given by Fritz Heinemann, *Giovanni Bellini e i Belliniani*, 2 vols. (Venice, [1959]) 1:144, #S. 364, is as follows: Bardini coll., Florence [coll. of Hugo Bardini]; Agnew, London: Joseph Widener, Philadelphia. Otto Kurz suggested that the painting could be identified with the "Orpheus & a woman & a Paes., naked figures. Bellini's manner" seen by Richard Symond "at one Harrison's ye King's Embroyderer" in December 1652 ("Holbein and Others in a Seventeenth Century Collection," *Burlington Magazine* 82–83 (1943): 279-82). C. Douglas Lewis, Jr., Curator of Sculpture at the National Gallery, was especially helpful to me in sketching the *Orpheus's* history.

3. Letter, 1925 (National Gallery's file on the painting). Berenson and Hendy still believed the *Orpheus* was by Bellini (*Italian Pictures of the Renaissance, Venetian School*, 2 vols., [London, (1957)], 1:36; Philip Hendy and Ludwig Goldscheider, *Giovanni Bellini* [London, 1945], fig. 116), despite the fact that Luitpold Dussler had demoted it on account of technical weaknesses: *Giovanni Bellini* (Frankfurt on the Main, 1935) pp. 147, 151 (called "Orpheus and the Nymphs" and dated 1500–10).

4. Herbert Friedmann, "Cornaro's Gazelle and Bellini's Orpheus," *Gazette des Beaux Arts*, ser. 6, 32 (1947): 21–22. The first two birds on the left, with red combs, blue heads, white hackles, and gray bodies with white spots, may both be guinea fowl (according to the National Gallery's file on the painting, compiled by Ann Watson, May 30–June 5, 1966). The bird on the right, if intended to represent a peahen or female peacock like the plump and attractive pair in the center of the picture, is curiously clumsy, possibly one of the weaknesses Dussler noticed. Maurice L. Shapiro identifies the paired birds in the center as "molting peacocks" ("Widener *Orpheus*," p. 29) and sees a sixth bird, an owl, in the shadow

behind the bearded satyr's right leg, invisible to me except as a slight blurring of forms on the surface of the painting itself; so far as I can see, it is absent from the X-ray (fig. 12. 6). The article by Friedmann, a zoologist, was apparently unknown to Shapiro since he did not cite it and terms the first two birds on the left incapable of identification.

5. *Bellini*, p. 147. See Appendix 1.

6. Johns Hopkins University, *Giorgione and His Circle*, exhibition catalog (Baltimore, 1942), p. 15: "it seems inconceivable that this . . . composition . . . as well as the type of figures could be attributed to [Bellini]. This painting is full of the spirit of Giorgione . . . . The invention seems to be Giorgione's. The question still remains open whether the picture was executed by Giorgione himself or a close collaborator."

Strangely, the painting has been consigned to a kind of limbo in recent years. It is altogether absent from Teresio Pignatti's *Giorgione*, trans. Clovis Whitfield (London, 1971) and from the original Italian edition (Venice, 1969); also from Giles Robertson, *Giovanni Bellini* (Oxford, 1968). A student could glean no inkling from these books that, as Richter implied, the *Orpheus* deserves to be considered one of Giorgione's earliest surviving pictorial inventions. Cf. George Martin Richter, *Giorgio da Castelfranco* (Chicago, 1937), pp. 73–74, 234–35.

7. Report of Kay Silberfeld, Conservator of Painting, National Gallery of Art, December 1972. Some uncertainty as to binding media noted in the report remains necessary lacking data possible only after exhaustive chemical analysis.

8. For the Accademia panels, consult Sandra Moschini Marconi, *Gallerie dell'Accademia di Venezia. Opere d'Arte dei Secoli XIV e XV* (Rome [1955]), pp. 71–73, No. 72 A–E.

9. The Accademia *Allegories* are usually dated to the late 1480s or 1490s. See, apart from entry in Moschini Marconi, *Gallerie*, Edgar Wind, *Bellini's Feast of the Gods* (Cambridge, Mass., 1948), pp. 48 ff., and Robertson, *Bellini*, pp. 103–06. Lifesize nude figures in various attitudes were being frescoed on the façade of the *Fondaco dei Tedeschi* by Giorgione in the summer of 1508, as may be inferred from documents and Sanudo's eyewitness reports (evidence brought together by Richter, *Giorgio da Castelfranco*, p. 303, followed by Pignatti, *Giorgione*, p. 165).

10. Richter singled out a relief from the Grimani collection in the Museo Archeologico, Venice, as the source for Circe (*Giorgio da Castelfranco*, p. 234). The antiquities in the Grimani Collection, however, were located in the family palace in Rome until 1523. Rodolfo Gallo, "Le Donazioni alla Serenissima di Domenico e Giovanni Grimani," *Archivio Veneto*, ser. 5, 50, pt. 1 (1952): 34–77. Fragments of Roman architectural friezes were abundant in the Veneto, as elsewhere in northern Italy. One featuring nereids is walled into an interior courtyard of the Museo Archeologico, Venice. Illustration in Wendy Stedman Sheard, "The Tomb of Doge Andrea Vendramin in Venice by Tullio Lombardo" (Ph.D. diss., Yale University, 1971), vol. 2, pt. 1, pl. 82b. See the sketchbooks of Jacopo Bellini and associates, Victor Golubew, *Die Skizzenbücher Jacopo Bellinis*, 2 vol. facsimile ed., (Brussels, 1912).

If one were to seek further afield, the closeness of Circe's pose to that of Psyche in the antique relief called the *Letto di Policleto* once owned by Lorenzo Ghiberti and often used as a source in the Renaissance, pointed out to me by David Alan Brown, should be considered. See Kenneth Clark, *The Nude: A Study in Ideal Form* (New York, 1959), p. 516, note to p. 384. An illustration of a rough seventeenth-century copy of this relief appears in Ernest H. Gombrich, *Norm and Form*, (London, 1966), fig. 173.

11. Heinemann, *Bellini e i Belliniani*, 1:144.

12. The Tietzes proposed Giulio Campagnola ("L'Orfeo' attribuito al Bellini della National Gallery di Washington," *Arte Veneta* 3 (1949): 90–95, p. 94). Here again, while Campagnola is conceivable as Giorgione's collaborator, and although Giorgione's influence on his engraving technique is assured, so little is known of Campagnola's painting that the Tietzes's hypothesis can be neither corroborated nor disproved.

13. " 'L'Orfeo,' " p. 92.

14. The portrait of a man seen from behind with his head turned (Marc' Antonio Michiel, *Notizia d'Opere del Disegno*, ed. Theodor Frimmel [Vienna, 1888], p. 88); the reclining female nude seen from behind (ibid., p. 114, also known from Giulio Campagnola's engraving, illustration in Jay Levenson, Konrad Oberhuber, and Jacquelyn Sheehan, *Early Italian Engravings from the National Gallery of Art* (Washington, D.C., 1973], fig. 19.10); and the reclining male nude seen from behind, with three different reflections of his body and head seen in a pool, a burnished cuirass, and a mirror; Giorgio Vasari, *Le Vite de' più eccellenti pittori, scultori ed architetti,* trans. Gaston D. DeVere as *Lives of the Most Eminent Painters, Sculptors and Architects,* 10 vols. (London 1912–14), 4:113. Giorgione's version of the motif of the sleeping nymph disclosed by a satyr further demonstrates his interest in the nude or partially clad figure seen from behind. This painting, known from its illustration in the 1627 catalog of pictures owned by one Andrea Vendramin (so far unidentified with any particular individual of that name) in the British Museum, Tancred Borenius, *The Picture Gallery of Andrea Vendramin* (London, 1923), p. 2, seems to have anticipated Bellini's integration of the formal content of this image (as seen, for example in the *Hypnerotomachia Poliphili* engraving, fol. e, discussed in Appendix 5) with the myth of Priapus and Lotis portrayed in the *Feast of the Gods.* The ass braying at the extreme left of the painting attributed to Giorgione in Vendramin's collection suggests this (illustration in Borenius, p. 29).

15. Cf., for Giorgione's experiments with diagonal recession, the *Castelfranco Madonna* (landscape behind wall), the *Tempesta,* the *Three Philosophers,* the *Sleeping Venus,* the *Sunset Landscape,* the Benson *Holy Family* (fig. 12. 12), the *Rape of Europa,* and *Aggression* (a painting which may have represented Emperor Frederick's sexual assault upon Antonia de Bergamo, which Carlo Ridolfi, in 1648, said was painted in fresco by Giorgione on the façade of his (Giorgione's) own house (both paintings known from copies by David Teniers) and the *Nymph and Faun* (or *Priapus and Lotis,* the painting referred to in in n. 14). Illustrations of these can be found in Pignatti, *Giorgione.* These compositions often, like the Widener *Orpheus,* feature opposing crossed diagonals. Sometimes, instead, a number of short diagonal lines zigzag rapidly back in space — for example, the outlines of the body of water in the *Allendale Nativity.* This type of zigzagging recession, called by Konrad Oberhuber "bays and curves leading into space" characterizes Giorgione's landscape space, as Oberhuber's discussion of Giulio Campagnola's engravings based on Giorgione's compositions makes clear. That Campagnola did use Giorgione's compositions in this manner lends support to the hypothesis that he was Giorgione's collaborator on the Widener *Orpheus.* See *Early Italian Engravings from the National Gallery,* pp. 397–99, figs. 19.7 and No. 149, facing p. 402.

Another Giorgionesque feature of the *Orpheus* is the light-flecked foliage rising above the panther (fig. 12. 4). The distinctive technique and importance to the general effect of the painting is clear even in the X-ray detail of this passage (not published). Cf. Giorgione's handling of foliage in the *Tempesta* and *Three Philosophers.* Shapiro pointed out the importance of this "shining, vibrational" foliage ("Widener *Orpheus,*" p. 35).

16. National Gallery of Art 812; Martin Davies, *The Earlier Italian Schools,* 2d ed. rev. (London, 1961), pp. 65–67. The picture is falsely (?) signed on the *cartellino,* which is genuine, but not dated.

17. Cf. the remarks of Robertson, *Giovanni Bellini,* pp. 125–27. The relationship between the National Gallery's *Death of St. Peter Martyr* and the version in the Courtauld Institute (Lee of Fareham Collection), which is said to have once borne the date 1509 on its back and is surely later than the National Gallery version, remains unresolved.

18. Tietze and Tietze-Conrat, " 'L'Orfeo,' " p. 93.

19. The anonymous author of "The Perfect Collection" in *Fortune Magazine* 6, no. 3 (September 1932): 72, perhaps advised by Berenson, betrayed awareness of the painting's potentially symbolic and non-narrative nature: "The 'Little Bellini,' which is called *Orpheus* because a man is playing a musical instrument while various beasts listen . . .

may well be about something entirely different. It has an unearthly charm and is strangely *surréaliste* in feeling and technique."

20. Jayne L. Anderson (Jayne Anderson Pau), "The Imagery of Giorgione" (Ph.D. diss., Bryn Mawr College, 1972), defines it as "a new category of invention, whereby compositions are made up from composite literary and visual sources and presented with a poetic brevity of style" (p. 11). Anderson has constructed a carefully reasoned and well-documented argument to illuminate her definition, pointing out parallel instances in the work of Dürer and Jacopo de' Barbari and discussing later reflections, in the writings of theorists, of changes in the most advanced artists' practice (as in Paolo Pino).

Although the implications for understanding the shifts in conceptualization then in progress have not been spelled out in Nancy Thomson de Grummond's "Giorgione's 'Tempest': the Legend of St. Theodore," *L'Arte* 18–19/20 (1972): 5–53, her analysis of the *Tempesta*, heretofore almost universally interpreted either as a "non-soggetto" or as secular allegory, as depicting telescoped incidents from a saint's life, is important in the unfolding discussion of new painting types at the end of the Quattrocento and beginning of the Cinquecento. Whether Giorgione painted the *Tempesta* with this subject in mind, and further, whether it was expressly a "hidden genre," are related questions of utmost importance.

By way of contrast, Cima da Conegliano's tondo showing the contest between Apollo and Marsyas before King Midas (Parma, *Galleria Nazionale* No. 373) attempts no more than to illustrate the scene (fig. 12. 9). The same may be said of the *Endymion Asleep*, with Selene in moon form hovering overhead (Parma, *Galleria Nazionale* No. 370, fig. 12. 10). See Armando O. Quintavalle, *La Regia Galleria di Parma* (Rome, 1939), pp. 149–50.

21. Mentioned by Vergil in the context of how to assure pure white fleece in a flock of sheep; *Georgics* 3. 391 ff. and Servius's *Commentary*, ed. George Thilo and Hermann Hagen (Leipzig, 1902), p. 383. Eisler's opinion was cited by Richter without source; *Giorgio da Castelfranco*, p. 234.

22. Cf. the relatively straightforward rendering of Pan's seduction of Luna in Agostino Carracci's Farnese ceiling, illustrated and discussed by John R. Martin, *The Farnese Gallery* (Princeton, 1965), p. 114, fig. 65.

23. Frank Mather, *Venetian Painters* (New York 1936), p. 129.

24. Gustav F. Hartlaub, *Zauber des Spiegels* (Munich, 1951), pp. 130–131.

25. "Widener *Orpheus*, pp. 26–27.

26. Richter, *Giorgio da Castelfranco*, p. 234, also saw it as a conch.

27. Moschini Marconi, *Gallerie dell'Accademia di Venezia*, pp. 71–73, No. 72D.

28. Philostratus the Younger, *Imagines*, ed. A. Fairbanks (New York, 1931), pp. 309–13.

29. Uffizi 1680, "Orpheus," pen and wash, 250mm. x 200 mm., outline pricked. Old inscription, apparently unconnected with the drawing, is canceled. Attributed to Cima by Carlo Gamba, *I disegni della R. Galleria degli Uffizi* (Florence, 1912–21), vol. 3, pt. 1, No. 10. Cf Hans Tietze and Erica Tietze-Conrat, *The Drawings of the Venetian Painters of the 15th and 16th Centuries* (New York, 1944), p. 160, No. 655.

30. Emanuel Winternitz, "A Lira da Braccio in Giovanni Bellini's *The Feast of the Gods,*" *Art Bulletin* 28 (1946): 114–15; and idem, "Lira da braccio," in Friedrich Blume, *Die Musik im Geschichte und Gegenwart*, many vols. (Basel, etc., 1960), 8: 935–54.

31. The Tietzes thought that the freely moving deer in the *Orpheus* could not be integrated satisfactorily with literary accounts of Orpheus's enchantments, in which the animals' enthralled stillness (see fig. 12.11) plays an important part (" 'L'Orfeo,' " p. 92). There is a relief in Knole Castle, Kent, however, depicting a scene which, in the Renaissance, would have been understood as Orpheus among the animals, where "a lion or panther mangling a horse and so evidently not fully tamed by the art of the musician" is shown (Adolf Theodor Michaelis, *Ancient Marbles in Great Britain*, trans., C. A. M. Fennell [Cambridge, 1882], p. 422, illustrated in Robert Eisler, *Orpheus the Fisher* [London, 1921], pl. VII). Surely the evident disparity between the image as painted and any text

drawn from mythological narrative should lead us to explore the possibility of a different conceptual basis for the picture, rather than to continue searching for a still more obscure myth or literary passage which the painting is presumed to illustrate.

32. *Odyssey* 10. 230–45.

33. Circe's ominous wielding of the wand, in conjunction with the implication that men have been turned into beasts, suggests a connection between the downward movement into lower spheres and black magic. This was implied by Pico della Mirandola: "magic has two forms, one of which depends entirely on the work and authority of demons, a thing to be abhorred . . . and a monstrous thing. The other, when it is rightly pursued, is nothing else than the utter perfection of natural philosophy"; *On the Dignity of Man*, trans. E. L. Forbes, in Paul Oskar Kristeller, Ernst Cassirer, John Herman Randall, eds., *The Renaissance Philosophy of Man* (Chicago: The University of Chicago Press, Phoenix Books, 1956), pp. 246–47. That the black, or downward-tending, magic was performed with the left hand (in which Circe holds her wand) may be found in Apuleius's *Metamorphoses*, editio princeps, (Rome, 1469), where the theme of humans being condemned to assume animal form as a punishment for transgression also appears (see Appendix 3). Apuleius's *Metamorphoses*, much in vogue in the last third of the Quattrocento, was a major source for Francesco Colonna in writing the *Hypnerotomachia Poliphili* (ed. Giovanni Pozzi and Lucia Ciapponi, 2 vols. [Padua, 1964], 2: 11–12 and s.v. "Apuleius" in index). For magic in the later fifteenth and sixteenth centuries in relation to the total intellectual context, see D. P. Walker, *Spiritual and Demonic Magic from Ficino to Campanella* (London, 1958).

Maurice Shapiro thought Circe's wand was pointing at the figure subsequently cut off at the right, viz. that her gesture with the wand is one of specific transformation directed at this victim, who raises an arm to ward it off. Shapiro refers to the man's left—weaker—arm being raised, whereas if the figure had been intended to be seen frontally, the gesturing limb would have been the right arm.

34. See Appendix 2.

35. This theme received widespread circulation in Venice with the April 1497 publication there of Ovid's *Metamorphoses* in Bonsignore's Italian translation, illustrated with fifty-two woodcuts; published by Johannes Rubeus (Zoan Rosso Vercellese) for Lucantonio Giunta, see Max Sander, *Le Livre à Figures Italien depuis 1467 jusqu'à 1530*, 6 vols. in 5 (Milan, 1942), 5: 2, p. 911, no. 5330; entry provides description and bibliographical references. It is worth mentioning that the theme also pervades the *Hypnerotomachia Poliphili* which, it is now thought, Francesco Colonna worked on at various times between the early 1470s and its publication in 1499. See ed. cit., vol. 2, pp. 4–9, with previous literature. The general outlines of the *Hypnerotomachia's* story would no doubt have been familiar, during the 1490's, to the circle of artists which frequented Giovanni Bellini's studio, one of whom may, of course, have been the book's illustrator. See the essay by George D. Painter in his facsimile ed. (London, 1963), pp. 12–16.

36. Published in Bologna with the first edition of Pico's collected works in 1495–96, and again in Venice in 1498 (*Opera*, published by Bernardinus Venetus between 14 August and 9 October; British Museum, *Catalogue of Books Printed in the XVth Century*, vol. 5 [London, 1924], p. 548).

37. Kristeller et al., *Renaissance Philosophy of Man*, pp. 224–25. Shapiro also recognized the pertinence of this passage to the interpretation of the Widener *Orpheus*, but via a somewhat different line of reasoning ("Widener *Orpheus*," pp. 31–32).

38. See Appendix 3.

39. Cf. Dorothy Kent Hill, "Some Representations of the Greek Pan," *The Journal of the Walters Art Gallery* 17 (1954): 61–69.

40. The later, humanized type of Pan is illustrated in Hill's article by a figure of Pan with syrinx on a fourth-century B.C. (?) agate gem (Hill, fig. 2). Riccio's small bronze Pan in the Ashmolean Museum, and one in the Louvre, are illustrated in Leo Planiscig,

*Andrea Riccio* (Vienna, 1927), figs. 507 and 510.

41. See Waldemar Déonna, "Aphrodite à la coquille," *Revue archéologique,* ser. 5, 6 (1917): 392–416; M. Brickoff (Bratschkova), "Afrodite nella conchiglia," *Bollettino d'arte* 9 (1929): 563 ff.; A. A. Barb, "Diva Matrix," *Journal of the Warburg and Courtauld Institutes* 16 (1953): 193–238. The shell also has the added religious (not only Christian) connotation of Resurrection; Déonna, pp. 408–16; Mircea Eliade, *Images et Symboles* (Paris, 1952), chap. 4, "Remarques sur le symbolisme des coquillages," pp. 164–98, especially p. 173. There is a stucco figure of Venus holding up a conch shell in the intrados of one of the arches of the loggia of the Villa Madama, illustrated in Renato Lefevre, *Villa Madama* (Rome, 1973), unnumbered plate opposite p. 41 and color plate 4. My thanks to Carolyn Kolb Lewis for calling my attention to this example.

Pan is shown in Correggio's *Camera di San Paolo* (1518), the artist following the more ancient Silenus-like type with the head of an old man and goatish lower extremities, blowing an outsized conch shell to instill "panic" terror in hostile armies. Erwin Panofsky, *The Iconography of Correggio's Camera di San Paolo,* Studies of the Warburg Institute, 26 (London, 1961), p. 26; excellent illustrations in Roberto Longhi, *Il Correggio nella Camera di S. Paolo* (Milan, [1973]), pp. 74–75. Panofsky interpreted this figure as "a war-like demon striking terror into the hearts of mortals and immortals" by the unexpected loudness and disturbing quality of his trumpeting with the conch, with reference to "an astro-mythological fantasy recorded only in a text as recondite as the pseudo-Theonian '*Commentary on Aratus*'" (*Iconography of Camera di San Paolo,* p. 45; see pp. 39–45).

42. Pan's bestiality has been almost totally suppressed in the Widener painting. Cf. representations of Pan on the Farnese ceiling: Martin, *Farnese Gallery,* figs. 48, 51. In contrast to the lecherous, goatish creature of the Carracci medallions, this earlier Pan seems, apart from his vaguely rendered goat-like legs, almost to belong to the type of the "melancholy sage" (Julius Held, *Rembrandt's Aristotle and Other Rembrandt Studies* [Princeton, 1969], pp. 29–32). Maurice Shapiro's interpretation of the appearance of Pan is similar in many respects to my own ("Widener *Orpheus,*" pp. 25–26), yet I cannot agree with his conclusion that the Pan here portrayed stands for sexual purity, an interpretation which does not seem to fit the complexity of the image.

43. See Appendix 4.

44. See Appendix 5.

45. "Harmonia est discordia concors" is pictured on a scroll issuing cartoon-style from the mouth of Francesco Gafurio in the woodcut frontispiece to the 1518 edition of his *De harmonia musicorum instrumentorum* (Milan: G. Pontanum). However, *De harmonia musicorum instrumentorum* was finished by 1500—written between 1480 and 1500, according to Irwin Young, trans, and ed., *The Practica Musicae of Franchinus Gafurius* (Madison, Wis., etc., 1969), p. xix. In the introduction to *Angelicum ac divinum opus misicae,* editio princeps (Milan, 1508), Gafurio himself says that the *Instrumentorum Harmonia,* as he then called it, had already been published in a Latin version. Thus it appears that the woodcut with the motto "Harmonia est discordia concors" might easily have dated back to the 1490s or even earlier. The classical formulation is "discordia concors;" Wind, *Pagan Mysteries* (New York: W. W. Norton & Co., 1968), p. 86, n. 15.

46. Pignatti, *Giorgione,* p. 100, no. 11, pl. 46.

47. Wind's discussion, *Pagan Mysteries in the Renaissance,* pp. 191 ff., is important to an understanding of the symbolism of Pan in the *Orpheus.* The Neoplatonic law that the contraries coincide in the One applies to the theme of universal harmony the illusory quality of the apparent (to the senses) *discordia* of its components, represented in this picture through the overt dichotomies displayed by both pairs of figures, but especially by Orpheus and Circe.

48. The first Venetian publication of Ficino was his *Epistolae* (1495) (see Appendix 5). His *De voluptate* was published, together with his translations of Pythagoras's *Aurea*

*Verba et symbola*, Iamblichus's *De Mysteriis Aegyptiorum, Chaldaeorum, Assyriorum*, Proclus's *De Anima et Daemone* and *De Sacrificio et Magia*, Prophyry's *De occasionibus sive causis ad intelligibilia nos ducentibus, De Solutione animae, De abstinentia*, Synesius's *De Somniis*, Psellus's *De Daemonibus*, and other Neoplatonic writings, by Aldus in September 1497.

The influence of Poliziano could have been felt through his *Miscellanea (centuria prima)*, published as early as 1489 (and, in Venice, ca. 1497), which announced his intention, never carried out, to revise Aristotle's corpus and to found a humanists' encyclopedia of Greek and Latin. The Aldine edition of his works (*Opera*, July 1498) included his letters and provided a fund of information about the lives and conversations, as well as the thought, of the Florentine humanists. Already, eighteen years earlier, Poliziano had visited Venice (first visit between December 1479 and early 1480), where he had become acquainted with Gerolamo Donato, Ermolao Barbaro, and Pietro Contarini; in fact, these men formed an exclusive circle nicknamed by Poliziano the "quadrumviri litterarii." Ida Maïer, *Ange Politien. La Formation d'un Poète Humaniste (1469–1480)*, *Travaux d'Humanisme et Renaissance* (Geneva, 1966), 81: 355–57; and Vittore Branca, "Ermolao Barbaro and late quattrocento Venetian humanism," in J. R. Hale, ed., *Renaissance Venice* (London, 1973), pp. 221–25, with many references in notes.

The friendship and exchange of ideas between Pico della Mirandola and Ermolao Barbaro has been well documented (Branca, article cited above and "Ermolao Barbaro e l'Umanesimo Veneziano," in *Umanesimo Europeo e Umanesimo Veneziano* [Venice, 1963], pp. 193–212). For translations of the key documents, see Quirinus Breen, "Giovanni Pico della Mirandola on the Conflict of Philosophy and Rhetoric," *Journal of the History of Ideas*, 13 (1952): 384–422. The original edition of Pico's *Opera* by his nephew, Gian Francesco Pico, was published in Bologna in 1495–96. A Venetian edition of 1498 (see n. 36 above) encouraged interest in and awareness of Pico's thought in that city.

It is clear that the deep-rooted traditions of Byzantine thought and esthetics in Venice, renewed in the Quattrocento by the influx of Greek scholars and literati documented by Deno J. Geanakoplos, *Greek Scholars in Venice* (Cambridge, Mass., 1962), prepared the way for an enthusiastic reception of the Florentine Neoplatonists' ideas. The relationship of the latter to the dominant themes in Byzantine art and culture—as outlined, for example, by Gervase Mathew, *Byzantine Esthetics* (New York: Harper and Row, Icon editions, 1971)—has not as yet received the investigation in depth so obviously warranted by this important subject.

49. To the thesis put forward by Creighton Gilbert in "On Subject and Not-Subject in Italian Renaissance Pictures," *Art Bulletin* 34 (1952): 206–16, compare the arguments of Eugenio Battisti, "Un Antica interpretazione della 'Tempesta,' " *Rinascimento e Barocco* (Turin, 1960), pp. 146–56, summed up and elaborated in connection with the *Tempesta* by Jayne Anderson Pau, "The Imagery of Giorgione," pp. 108–11; and the detailed refutation by Nancy Thomson de Grummond, "Giorgione's 'Tempest': the Legend of St. Theodore," *L'Arte* 18–19/20 (1973): 36–41, with additional information in footnotes.

50. Ficino used and discussed music chiefly for medical, magical, or theurgic purposes. These three ultimately converge to one: the purifying of the body, *spiritus*, and soul, in order to achieve a life of contemplation leading to knowledge of and union with God (D. P. Walker, "Ficino's *Spiritus* and Music," *Annales Musicologiques* 1 [1953]: 132). According to Gustaf Fredén, *Orpheus and the Goddess of Nature*, (See Appendix 5), after attending Ficino's series of lectures on Plato's *Philebus* delivered in Florence in 1465, Poliziano called him "an extraordinary man who with his music had succeeded far better than the Thracian Orpheus in calling back the true Eurydice, the Platonic wisdom, from the kingdom of the dead," p. 47; cf. also pp. 14–15, 33 ff. The most complete discussion of Ficino's singing of Orphic hymns is found in D. P. Walker, *Spiritual and Demonic Magic from Ficino to Campanella*, cited in note 33 above, of which chapter 1 is "Ficino's *Spiritus* and Music," reprinted from *Annales Musicologiques* with minor

changes; cf. also Frances Yates, *Giordano Bruno and the Hermetic Tradition* (New York: Vintage Books, 1964), pp. 78–80.

51. A fundamentally religious interpretation of the picture as an allegory of the mystical progress or ascent of the soul is proposed by Shapiro in "The Widener *Orpheus.*"

52. See p. 192 above.

53. Pico della Mirandola, *On the Dignity of Man*, p. 248.

54. *Republic* 399D–E, which gave rise to a persistent tradition that downgraded wind instruments as being of dubious moral influence while upholding the superiority of stringed instruments; Emanuel Winternitz, "The Curse of Pallas Athena," in *Studies in the History of Art Dedicated to William E. Suida* (New York, 1959), pp. 185–95. Patricia Egan pointed out the popularity of scenes from myths illustrating this subject, notably Athena and Marsyas, Apollo and Marsyas, and the related episode of the contest between Apollo and Pan (see fig. 12.9), in Venetian and northern Italian painting of the late fifteenth and early sixteenth centuries: "*Poesia* and the *Fête Champêtre*," *Art Bulletin* 41 (1959): 309, n. 28. Many other aspects of the issue are discussed by Egan as well; see pp. 309–12.

The power to break a spell cast by the *goeteia*, evil magic (represented by Circe), is suggested by the presence of the rue plant (perhaps Homer's *moly*) in the right foreground, if Shapiro's identification of the diagonal row of bushes is correct ("Widener *Orpheus*," p. 27). Shapiro called attention to the prominence of this plant in the picture's lower right segment. Because rue both suppresses sexuality and drives away malignant spirits, Shapiro connected it to Pan (seen in his interpretation as a symbol of sexual purity). On the other hand, it is perhaps even more relevant to an interpretation of the picture that *moly* was the plant given by Hermes to Odysseus to enable him to break Circe's spell and remetamorphose his men from animal to human form, a point Shapiro does not mention (*Odyssey* 10.280–329).

55. Alfred Einstein, *The Italian Madrigal*, 3 vols. (Princeton, 1971; 1st ed., 1949), passim.

56. George M. Richter, *Giorgio da Castlefranco*, p. 11; Teresio Pignatti, *Giorgione*, p. 8. Particular conditions of patronage and musical performance in northern Italy and the Veneto at the end of the Quattrocento ushered in a period of rapid change in which preexisting melodies, rhythms, and forms were abandoned in favor of a new tonal structure that was to be unified harmonically while diversified rhythmically and metrically—in short, a new simultaneous conception of harmony and polyphony which replaced the older, successive techniques of composition. Giorgione, a performing musician, could not have helped but be aware of this atmosphere of ferment in the art that allowed greatest social access to the houses of aristocrats from whom commissions for decorations were no doubt forthcoming.

For a detailed exposition of the kinds of revolutionary changes occurring in music and how they arose, see Edward E. Lowinsky, "Music in the Culture of the Renaissance," in Paul Oskar Kristeller and Philip Wiener, eds., *Renaissance Essays* (New York: Harper Torchbooks, 1968), pp. 337–81 (reprinted from *Journal of the History of Ideas* 15 [1954]). For details of social context and changes in the status of musicians at, for example, the Gonzaga court; an account of formal and stylistic changes; relationships between music theory and poetic theory; and the role of poets like Bembo; see Einstein, *Italian Madrigal*, 1: 34–65, 75–88, 104–19, 152–53, 228, etc.

57. Charles de Tolnay, "The Music of the Universe," *Journal of the Walters Art Gallery* 5 (1942): 83–104, is a readable and reasonably complete account of this phenomenon as expressed in the visual arts, with a wealth of bibliographical references in the footnotes. Tolnay suggested that the subject matter of all pictures featuring Orpheus and his lyre is "the harmony of the spheres" (p. 87).

58. For a scholarly method of investigation and interpretation that well suits the new approaches to "subject" evolved by Leonardo in Milan and Bellini and Giorgione in

Venice at roughly the same moment, see Leo Steinberg, "Leonardo's Last Supper," *Art Quarterly* 36/4 (1973): 297–410.

59.  See note 48 above. Ficino's theories about music and the *spiritus* appeared in *De Triplici Vita* first published in 1489. Another influential locus for the discussion was his commentary on Plato's *Symposium*, its Italian version available in manuscript from at least 1474 (S. R. Jayne, "Ficino's Commentary on Plato's Symposium," *University of Missouri Studies*, vol. 19, pt. 1 [1944], in which he observed that "the heavenly harmony of the music of the spheres was imitated on earth by various instruments and songs" (Jayne, p. 181). Ficino's ideas about the theurgic use of music, referred to in note 50 above, would have been of especial interest in Venice.

There was also, of course, the context of *paragone*, especially the argument about the visual versus the acoustic sense as the best mode of apprehending beauty. For Ficino's claims for the superiority of the acoustic sense, see Walker, *Spiritual and Demonic Magic*, pp. 6–11, with a translated excerpt from Ficino's commentary on Plato's *Timaeus*, one of the major locations of his argument on the subject. For Leonardo's *Paragone*, see Irma I. Richter, *Leonardo's Paragone* (Oxford, 1949), and Jean Paul Richter, *The Literary Works of Leonardo da Vinci*, 3d ed. (New York, 1970), 1: 14–101. If we are to believe the evidence of Vasari, Leonardo's topos of the *paragone* was introduced into artists' discussions in Venice as early as the 1480s, "when Andrea Verrocchio was making his bronze horse." When Verrocchio's *Colleoni*, cast by the Venetian bronze sculptor Alessandro Leopardi, was erected on its imposing pedestal in 1492, the event seems to have rekindled arguments between painters and sculptors about the relative merits of their arts. This was the context (still following Vasari's reconstruction, though it errs in telescoping Verrocchio's and Giorgione's roles into a single decade) in which Giorgione was inspired to seize upon the witty stratagem of arguing for the superiority of painting by making the *paragone* itself the subject of a painting (*Lives of the Most Excellent Painters, Sculptors and Architects*, ed. and trans. Gaston DeVere [London, 1912–14], 4: 112–13).

60.  Charles T. Tart, ed., *Altered States of Consciousness* (New York, 1969), sect. 8, "The Psychophysiology of Some Altered States of Consciousness"; A. Kasamatsu and T. Hirai, "An Electroencephalographic Study on the Zen Meditation (ZaZen)"; B. K. Anand et al., "Some Aspects of Electroencephalographic Studies in Yogis"; J. Kamiya, "Operant Control of the EEG Alpha Rhythm and some of its Reported Effects on Consciousness."

61.  Pignatti, *Giorgione*, pp. 95–96, no. 3.

62.  Somewhat the same conceptual structure generates the composition and mood of Lorenzo Costa's *Nativity* at Lyons, a painting of great loveliness and expressive significance that single-handedly should boost Costa's somewhat faded reputation.

63.  Among recent attempts to give a coherent account of changing pictorial strategies with respect to the later Trecento and Quattrocento viewer is Sixten Ringbom, *Icon to Narrative. The Rise of the Dramatic Close-up in Fifteenth Century Devotional Painting*, Acta Academiae Åboensis, ser. A, 31/2 (Åbo, 1965). Ringbom's account, learned and filled with priceless nuggets of iconological information though it is, tends to overly dichotomize the iconic and narrative modes, at least in the last quarter of the Quattrocento.

64.  For the function of an icon as a magic counterpart to its prototype, see Otto Demus, "The Methods of the Byzantine Artist," *The Mint* 2 (1948): 64–77.

65.  Rona Goffen, "Icon and Vision: Giovanni Bellini's Half-Length Madonnas," *Art Bulletin* 57 (1975): 487–518, enumerates some of the more salient aspects of Bellini's adoption of the icon.

66.  The identification of the subject matter of the *Sunset Landscape* as Saint Anthony Abbot in the act of healing a young man afflicted with Saint Anthony's fire has recently been confirmed and extended by Anderson ("Imagery of Giorgione," pp. 87–92). The painting's significance as demonstrating a type (narrative of events from a saint's life) which Giorgione altered beyond all recognition, becomes even clearer when its subject

is compared to that proposed for *The Tempest* by Nancy Thomson de Grummond, "Giorgione's 'Tempest'" (see note 49 above).

# APPENDIX 1

*Alfonso d'Este's Aborted Gazelle Portrait*

The *Orpheus* has been linked with a letter of 1520 to Alfonso d'Este from Tebaldi, his agent in Venice, describing a visit he and Titian paid to Girolamo Corner so that Titian could paint a portrait for Alfonso of a gazelle Corner owned "dal naturale e come è proprio vivo . . . in tela tutta integra," as the duke had ordered. Fern Rusk Shapley, "Giovanni Bellini and Cornaro's Gazelle," *Gazette des Beaux Arts*, ser. 6, 28 (1945): 27–30; the letter from Duke Alfonso commissioning the painting was quoted by Giuseppe Campori, "Tiziano e gli Estensi," *Nuova Antologia* 27 (1874): 590. The letter from Tebaldi (reported, but not cited, by Campori) went on to describe how Corner showed the visitors a picture which included a gazelle, apparently by way of apologizing for the nonexistence of the real thing (it had died): "Gliela fece vedere ritratta [i.e. the gazelle] in piccola proporzione con altre cose da la mano di Giovanni Bellini in un quadro che si teneva in casa." Based on the identification of the deerlike animals in the *Orpheus* as gazelles, Shapley identified the Widener picture as the painting in the Corner palace attributed to Bellini and referred to in the letter quoted, concluding that the *Orpheus*'s attribution to Giovanni Bellini thereby remained firm and that the picture was datable approximately to the last year of his life, 1516.

Granting that the animals in question can be identified with certainty as gazelles (based on the shape of the horns visible on the animal whose neck rises from behind a bush just to the right of the panther's tail, see fig. 12.4), how could Titian have gained, merely from observing them, an idea of the appearance of this (to Alfonso) zoological curiosity accurate enough to satisfy his precise demands for naturalism (that the gazelle should be painted "from life, as if actually alive, and all there on the canvas")? Yet we deduce from Campori's summary that Titian was indeed willing to base a portrait of a gazelle on Corner's picture! ("Alla veduta del quale Tiziano si offrì di buon grado a ridurla in forma del naturale, quando ne ricevasse l'ordine.") Despite this fascinating account of what Titian had to go through to assure himself of Duke Alfonso's patronage, it strains the imagination to conclude from it that the presence of gazelles in the Widener *Orpheus* warrants the attribution to Bellini and date of 1516 claimed by Shapley. It is unlikely, in any case, that Girolamo Corner's Bellini survived the disastrous fire of 1532 that destroyed the Corner palace at San Maurizio, described by Marin Sanudo; Rinaldo Fulin, Federico Stefani, Nicolò Barozzi, Guglielmo Berchet, Marco Allegri, eds., *I Diarii* (Venice, 1879–1903), 56: cols. 751–54.

*Orpheus in the Renaissance*

The interpretation of the Widener *Orpheus* proposed here depends crucially on the identification of the music-making figure as Orpheus. As far as I know, the lone dissenter from the consensus that this is indeed the correct identification is Emanuel Winternitz. He feels that "a few fowl are not sufficient to represent an audience of the teaching and domesticating Orpheus" and objects that the stags and leopard are not listening (letter of 16 September 1974).

These objections may, I think, be answered by considering the following points: (1) the unusual conflation of the Orpheus and Circe myths forces the animals to play double roles; (2) in the painting's Neoplatonic symbolism the animals are seen as the bestial part of the human soul being released from bondage by the transforming power of art (recalling Ficino's theory of music as "soul therapy," see n. 50 above); and (3) the animals can also be taken as referring to the Orphic doctrine of the transmigration of souls (discussed in Appendix 3). As further evidence for the likelihood that the music-making figure must be Orpheus, we should recall the important notice by Otto Kurz, cited in note 2, in which he demonstrated the popularity of scenes from the Orpheus myth in Giorgione's circle.

The figure of Orpheus was open to at least four interpretations by the later fifteenth century. As Walker pointed out, the various aspects of Orpheus were mutually reinforcing and lent him a multifaceted richness of meaning. His traditional role as "the type of the ethically influential, effect producing singer, charming the rocks, trees and wild animals" with his lyre, a divinely inspired poetic teacher who reformed and civilized barbarous contemporaries, was defined by Horace and Quintilian (D. P. Walker, "Orpheus the Theologian and Renaissance Platonists," *Journal of the Warburg and Courtauld Institues* 16 [1953]:100, and was brought up to date by Pietro Bembo in *Gli Asolani*, begun ca. 1495, a date very close to the invention of the Widener *Orpheus*, in the view here presented (trans. Rudolf B. Gottfried [Bloomington: Indiana University Press, 1954]—see the speech of Perottino, pp. 27—28). A century ago this aspect of Orpheus was well summarized by John Addington Symonds: "Orpheus was the proper hero of Renaissance Italy—the civilizer of a barbarous world by art and poetry, the lover of beauty, who dared invade Hell and moved the iron heart of Pluto with a song. . . . In the myth of Orpheus the humanism of the revival became conscious of itself. This fable was the Mystery of the new age, the allegory of the work appointed for the nation" *(The Renaissance in Italy, Italian Literature* [London, 1927]:2, pt. 1:358). I owe knowledge of this passage to Elizabeth Welles. Poliziano's metaphor placing Ficino in the role of Orpheus to the Eurydice of theretofore "dead" Platonic wisdom (see n. 50) bears witness to the accuracy of Symonds's insight.

Poliziano's *Orfeo*, the first Renaissance pastoral drama in the vernacular, is now considered to have been written in 1480. It is an excellent source, obviously, for Quattrocento conceptions about Orpheus. There he is presented as a poet/lover, bereft of his morally efficacious role as teacher and seer and driven to his ghastly end by an excess of *furor amatorius*. In Poliziano's drama, for which the ancient models were Vergil's *Georgics* and Ovid's *Metamorphoses*, it is only for the purpose of his own love that Orpheus uses his power as a poet; Poliziano, *Orfeo*, trans. Elizabeth Welles as "Angelo Poliziano's Tale of Orpheus" (unpublished typescript), introduction, pp. 5—6.

The third aspect under which Orpheus could have been apprehended was as one of the *prisci theologi*, the triad revered as the most ancient theologians, whose hidden unfolding to the initiated of approaches to a unified truth was discussed in the writings of Ficino and Pico della Mirandola (Walker, "Orpheus the Theologian," pp. 103—07, and Frances Yates, *Giordano Bruno and the Hermetic Tradition*, index, s.v. *prisca theologia*).

Fourth, Orpheus was the type of the spell-binding musician, an artist-magus whose power to instill harmony and enlightenment is achieved through divinely endowed inspiration and consequent inventive energy. This aspect of Orpheus is differentiated from the first because it refers more specifically to Orpheus as an incarnation of the power of music (see discussion in text, pp. 198–99). Then, too, a broader interpretation of the scenes showing Orpheus taming animals with the sounds of his lyre, not necessarily confined to the Renaissance, sees them as images of cosmic harmony or the harmony of the spheres, deriving from Pythagoras's theories of the fixed orbits of the planets and their majestic sounds, music on a scale so colossal that it surpasses human hearing; Charles de Tolnay, "The Music of the Universe," *Journal of the Walters Art Gallery*, 6 (1943): 83–104. Fritz Saxl interpreted the Widener *Orpheus* in this sense, as depicting "the harmony of music," followed by George Richter: "the chief subject of the picture seems to be an allegory of music" *(Giorgio da Castelfranco*, p. 234). Richter quoted Saxl's view without source (pp. 73–74).

Various examples of Orpheus in art are treated by Konrat Ziegler, "Orpheus in Renaissance und Neuzeit," in Hans Wentzel, ed., *Form und Inhalt, Kunstgeschichtliche Studien; Otto Schmidt ... dargebracht von seinen Freunden* (Stuttgart, 1950), pp. 239–56.

# APPENDIX 3

*Human Souls in Animal Form*

Attention should be called especially to the following passage: "The Pythagoreans degrade impious men into brutes . . . Mohammed, in imitation, often had this saying on his tongue: 'They who have deviated from divine law become beasts. . . . For it is not the bark that makes the plant but its senseless and insentient nature; neither is it the hide that makes the beast of burden but rather its irrational, sensitive soul; neither is it the orbed form that makes the heavens, but their undeviating order; nor is it the sundering from body but his spiritual intelligence that makes the angel. For if you see one . . . blinded by the vain illusions of imagery, as it were of Calypso, and, softened by their gnawing allurement, delivered over to his senses, it is a beast and not a man you see" (*On the Dignity of Man*, p. 226). In fact, Pico adds a little later that Homer had "concealed this philosophy [i.e. μαγεία, the good magic, a science of the Divine] beneath the wanderings of his Ulysses" (p. 248).

Pico's antithesis of *mageia* (the way of Orpheus) and *goeteia*, evil witchcraft (the way of Circe) is seen by Shapiro as underlying the Orpheus/Circe pair in the Widener picture ("Widener *Orpheus*," p. 33).

Another aspect of the relevance of *On the Dignity of Man* to our picture is the appearance in it of bird symbolism. Pico equated the cock with the highest part of the human soul, recalling Pythagoras (pp. 235–36). The birds thus represent both animal natures drawn upward by the "good magic" of Orpheus, and the highest, divine, nature of the fully realized human soul.

Pico's ideas aside, deer—and specifically stags—commonly symbolized the human soul. In Carpaccio's *Meditation on the Passion*, Metropolitan Museum 11.118 (Federico Zeri, *Italian Paintings, Venetian School* [Greenwich, Conn., Vicenza, 1973, paperbound] pp. 14–16, with literature), very possibly dating from about the same time as the *Orpheus*, a panther attacks a stag which Zeri identified as probably a symbol of a human soul on the left, or unredeemed, side of the picture. On the right, another stag successfully eludes a leopard.

There is yet another tradition in which human souls assume animal form. It descends, in its Western version, from Plato's *Republic*. In the Vision of Er the Armenian, a mythic tale of a soldier whose return from the afterworld forms the climax of the book, souls assume animal form in subsequent states of transmigration, on the way to ultimate release from their bondage to matter. Er witnessed the transformation of human souls into a swan, a nightingale, a lion, an eagle and an ape, "the unjust changing into the wild creatures, the just into the tame" (*Republic* 10.620, trans. and ed. Francis MacDonald Cornford [Oxford, 1951]). Interestingly for the Orpheus connection, Cornford points out that the vision of Er shares certain features with Empedocles' religious poems, Orphic amulets found in graves, and Vergil's sixth *Aeneid*, suggesting a common source in an Orphic apocalypse, a Descent of Orpheus to Hades. These included the divine origin of the soul, its Fall to be incarnated in a cycle of births as a penalty for former sins; the guardian genius; the judgment after death; the torments of the unjust and the happiness of the just in the millennial intervals between incarnations; the hope of final deliverance for the purified; and certain topographical features of the afterlife. Kristeller has connected Pico's theory of human nature to a central feature of ancient Orphic tradition: "In the mutability of man's essence lies the true meaning of the old doctrine of the transmigration of souls." *The Philosophy of Marsilio Ficino*, trans. Virginia Conant (New York, 1943), p. 408.

The vision of Er was accessible in Venice, not only in Ficino's translation of the complete works of Plato, published in Florence in 1484 (by a Venetian publisher, Lorenzo Veneto; see Ficino, *Supplementum Ficinianum*, ed. Paul Oskar Kristeller

[Florence, 1937], 1: lx–lxi), but also in a form which possibly received even greater circulation: Cicero's *Dream of Scipio* preserved in Macrobius's Commentary, published twice in Venice quite soon after the *editio princeps* (Jensen, 1472), by Johannes Rubeus in 1492; and by Philippus Pincius, 29 October 1500.

# APPENDIX 4

*Pan in the Renaissance*

Pan (πάν), the deity of everything connected with pastoral life but especially of flocks' fruitful increase and thus a fertility god, the inventor of the syrinx (the "pan-pipe"), who haunts the woods and wild mountainsides and can inspire terror (panic) in the unwary, was also conceived as πᾶν, the "all," by Hellenistic times, possibly because of the semantic coincidence, which, however, ignored the more likely etymology of his name from *pa-on*, "grazer"; *Oxford Classical Dictionary*, 2d ed. (Oxford, 1970), p. 773.

The several literary traditions available in the Renaissance reflected a multiplicity of roles for Pan. In Apuleius, he appears as a kindly old shepherd who comforts Psyche after she has attempted suicide. In some ways, Pan in the Widener *Orpheus* resembles Apuleius's word picture (for Apuleius's *Metamorphoses* in the fifteenth century, see n. 33 above and E. H. Haight, *Apuleius and his Influence* [London, 1927]). Another Pan, in the *Orphic Hymn*,

> I call strong Pan, the substance of the whole,
> Ethereal, marine, earthly, general soul,
> Immortal fire; for all the world is thine,
> And all are parts of thee, O pow'r divine.

[lines 1−4]

combines two distinct notions of the god. The symbolic Pan, portrayed as a cosmic mover of unimaginable power ("All nature's change thro' thy protecting care"), the supreme governor or soul of the universe, is here fused with remnants of the popular pastoral goat-god ("Come blessed Pan, whom rural haunts delight,/ Come, leaping, agile, wand'ring, starry light"). For the availability of the Orphic hymns, see Appendix 5.

Macrobius, also influential with the Neoplatonists and others during the fifteenth century, referred to Pan as "not the lord of the woods but the ruler of universal material substance." Medieval and Renaissance encyclopedists described a more schematic, allegorical Pan, with "horns in the shape of the rays of the sun and the moon . . . skin marked with spots, because of the stars of the sky . . . [a face which is] red, in the likeness of the upper air. He carries a pipe with seven reeds, because of the harmony of heaven in which there are seven notes and seven distinctions of tones. . . . He has goat hoofs, to show forth the solidity of the earth, he whom they desire as the god of things and of all nature: whence they call him Pan," as Isidore of Seville, following Servius's commentary on Vergil's *Eclogues* 2.31 and *Georgics* 1.17 almost verbatim, put it (Servius, *Commentary*, ed. George Thilo and Hermann Hagen [Leipzig, 1902], pp. 38−39, 204).

Ca. 1482, Paulus Marsus, in his commentary on Ovid's *Fasti* 1.397, introduced what was to become a significant equation of Pan with Christ to explain the strange story in Plutarch's *Moralia* in which a mysterious voice called out to a Roman ship passing the island of Paxi to announce that the Great God Pan was dead. Marsus placed the time of this incident in the nineteenth year of Tiberius's reign, at the hour of the Crucifixion. For this account of the literary sources, I am greatly indebted to Patricia Merivale, *Pan the Goat-God* (Cambridge, Mass., 1969), pp. 1−16, where many valuable references in footnotes, translations of the key Greek and Latin passages, and Thomas Taylor's translation of the Orphic hymn to Pan (p. 233−34), quoted here, simplify the task of recapitulating a long and complex process of image morphology.

The reader is urged to compare with our figure the double guise of Pan in Annibale Carracci's *Cupid Overcoming Pan* in a medallion from the Farnese Gallery ceiling (Martin, *Farnese Gallery*, pp. 95−96). Another medallion, showing Pan and Syrinx, corre-

sponds allegorically to the scene of *Orpheus and Eurydice* that faces it across the vault, in signifying heavenly love thwarted by human frailty. "Is it conceivable that in one medallion Pan can signify the lower nature of man subjugated by divine love [*Cupid Overcoming Pan*] and in another the love of Christ for a human soul? It is conceivable only if we bear in mind . . . that meanings are not fixed in an absolute way but that it is context that determines which of several meanings shall apply in a given instance" (Martin, *Farnese Gallery*, p. 99). Martin further links the Pan-Syrinx, Orpheus-Eurydice scenes, manifestly alike in their depiction of a woman cruelly snatched from the arms of her pursuer, through musical symbolism. Pan also appears in a medallion, mostly hidden by the "frame" of the huge *Polyphemus and Acis*, whose subject Martin interprets as *The Contest of Pan and Apollo before Marsyas* (figs. 58, 62).

The most complete assemblage of pictorial and sculptural representations of Pan from antiquity through the nineteenth century can be found in Reinhard Herbig, *Pan, der Griechische Bocksgott, Versuch einer Monographie* (Frankfurt on the Main, 1949; does not include Pan in the Widener *Orpheus*). Herbig noted the difficulty of visually formulating the Orphic conception of Pan (pp. 63–69), which we are now in a position to see solved by Giorgione with such ingenuity in this painting.

# APPENDIX 5

*Venus Physizoa*

This is the Venus to whose temple Poliphilo makes a sacred-erotic pilgrimage in the *Hypnerotomachia Poliphili: Venus Physizoa,* Venus of Living Nature; Francesco Colonna, *Hypnerotomachia Poliphili,* 1: 191 and 156. Pozzi has interpreted the sleeping nymph in the *Hypnerotomachia* engraving (fol. e) inscribed ΠΑΝΤΩΝΤΟΚΑΔΙ ("to the all-bearing") as this very goddess, Venus in her capacity of symbolizing the female generative force of nature. Pozzi rejects the identification of this figure as Ariadne, Lotis, Vesta or any of the other names formerly put forward (*Hypnerotomachia,* 2: 93; and see Maria Teresa Casella and Giovanni Pozzi, *Francesco Colonna,* 2 vols. (Padua, 1959), 2: 68–70). This image of a recumbent nude female approached by an ithyphallic satyr who draws a curtain to reveal the sleeping form, so recently interpreted as symbolizing the approach to one another of the male and female principles of nature, has important connections with the Widener *Orpheus.* See also Linda Fierz-David, *The Dream of Poliphilo* (New York, 1950), pp. 106–09, 131 ff., 222.

Edgar Wind, referring to the definition of Higham and Bowra in their introduction to *The Oxford Book of Greek Verse in Translation,* noted that *physizoos,* an adjective steeped in primitive mysticism, was an extremely rare word in Greek poetry. It occurs only five times, of which the two most famour instances refer to the Dioscuri (*Illiad* 3.243, used with aîa—Earth, the life-giver; and *Odyssey* 11.301), while a third appears in the Homeric *Hymn to Aphrodite; Pagan Mysteries in the Renaissance,* 2d ed., rev. (New York, 1968, paperbound), p. 168, n. 62). From Wind's observation, the inference might be drawn that Poliziano's translation into Latin of the third book of Homer's *Illiad* (1472), for which see Ida Maïer, *Politien,* pp. 88–89, 419, was one avenue by which this rare adjective achieved diffusion in the fifteenth century.

Michael Liebmann, tracking down the sources for the sleeping nymph motif in Cranach's *Nymph of the Fountain* (Leipzig, variants elsewhere) took note of the rhymed seventeenth-century inventory of the collection of Franz von Imstenraedt (Otto Kurz, "Holbein and others in a Seventeenth Century Collection," *Burlington Magazine,* 82–83 [1943]: 279–82), in which a painting of Venus "vitam exprimens"—resting after the hunt, with a herd of deer in the background—is ascribed to Giorgione ("On the Iconography of the Nymph of the Fountain," *Journal of the Warburg and Courtauld Institutes,* 31 [1968]: 434–37). This Venus, who plainly personified life and energy, seems to have inspired Cranach's nymphs of similar type. Liebmann correctly connected this image and type of Venus *Vitam Exprimens* with the epithet "all-bearing" in the inscription below the *Hypnerotomachia* engraving (fol. e). The deer in Cranach's picture, moreover, can be interpreted as symbols of Venus and luxuria; Guy de Tervarent, *Attributs et symboles dans l'art profane* (Geneva, 1958), pp. 66–67.

Cranach's picture and its variants thus combined two motifs, the Nymph of the Spring and Venus *luxuria* (not *luxuria* in the sense of "voluptuousness," but rather "luxuriant growth," "powerful increase"). Both personifications played important roles in Giorgione's imagery, but Giorgione's use of the Nymph of the Spring has been more generally recognized than his depiction of *Venus Physizoa.* For a corrective, see now Jayne Anderson Pau, "The Imagery of Giorgione," pp. 113–17, where the *Sleeping Venus* is interpreted as a *Venus Genetrix,* portrayed in her capacity as ancestress of the Marcello family, and brought into connection with the epithet "to the all-bearing," or "parent of all." Anderson presented this material in a talk delivered to the conference on Titian and Venice sponsored by the University of Venice (Sept. 27–Oct. 1, 1976), which will appear in the publication of that conference's papers. For Giorgione's overt use of the motif of the sleeping nymph disclosed, as opposed to its transformed appearance in the *Sleeping Venus,* see note 14 above. In Rome, where the Sleeping Nymph as a

visual type attained great popularity, it was never understood as a Venus, perhaps because of a closer association in that city with the false antique epigram "Huius nympha loci. . . ." The Roman examples are most recently and fully discussed by Elizabeth MacDougall, "The Sleeping Nymph: Origins of a Humanist Fountain Type," *Art Bulletin*, 57 (1975): 357–65, where the source of the epigram is also traced.

I do not think that Colonna's and Giorgione's *Venus physizoa* ought to be identified with Ficino's and Pico's *Venere Volgare* (see Erwin Panofsky, "The Neoplatonic Movement in Florence and North Italy," *Studies in Iconology* [New York, Evanston, 1962, paperbound], pp. 141–55), though the latter did symbolize a generative force. The peculiarly Venetian concept seems to have arisen independently of Florentine Neoplatonic humanism, and to have stemmed instead from antique literary sources such as Homer's epics and hymns (as well as those cited by Anderson, *loc. cit.*). These, though in many cases only accessible in translations by Poliziano, Ficino, and other Florentines, were being interpreted differently in Venice, where humanists' ambitions were often less philosophical than philological; Vittore Branca, "Ermolao Barbaro and Late Quattrocento Venetian Humanism"; J. R. Hale, ed., *Renaissance Venice* (London, 1973), pp. 218–43.

Another antique literary source—perhaps the one most likely to have inspired the concept of Venus as the cosmic source of life in its female manifestation, a fitting complement to Pan—was Lucretius, whose "Thou alone dost govern the nature of things, since without thee nothing comes forth into the shining borders of light, nothing joyous and lovely is made" (*De rerum natura* 1. 21 ff.; editio princeps, 1493; Venetian eds. 1495, 1500) is quoted, with many references that are germane to my argument, by Phyllis Williams Lehmann, "The Sources and Meaning of Mantegna's Parnassus," *Samothracian Reflections, Aspects of the Revival of the Antique*, Bollingen Series, 92 (Princeton, 1973), pp. 159–60. See also Lucretius's figuring of Venus as a source of artistic inspiration, a "super-Muse"; Lehmann, p. 160, n. 207.

A poetic image of *Venus physizoa* as the female generative aspect of nature—highly resplendent and potent—was no doubt an effective stimulus in promoting awareness of this Venusian persona in fifteenth-century Venice. It pervades *O Physi*, the Orphic hymn to Nature from that body of *Orphica* which Ficino, as early as 1462, made the first focus of his ambitious program of translations, putting it ahead even of the works of Plato; D. P. Walker, "Orpheus," article cited in Appendix 2, pp. 102–64; Frances Yates, *Giordano Bruno*, pp. 12–19, 78 ff. Fredén provides an English translation of *O Physi* and suggests much about the Orphic hymns and their influence in the Renaissance; *Orpheus and the Goddess of Nature*, Acta Universitatis Gothoburgensis, Göteborgs Universitets Årsskrift 64 (1958): 15 and passim. In Venice in the 1490s, Ficino's *Commentary* on the hymn in a letter to Germain de Ganay could be consulted in the first edition of his collected letters (Venice, 1495; description of the edition in Kristeller, *Supplementum*, 1: lxvii); Kristeller reprinted the letter in "The Scholastic Background of Marsilio Ficino," *Traditio*, 2 (1944): 257–318.

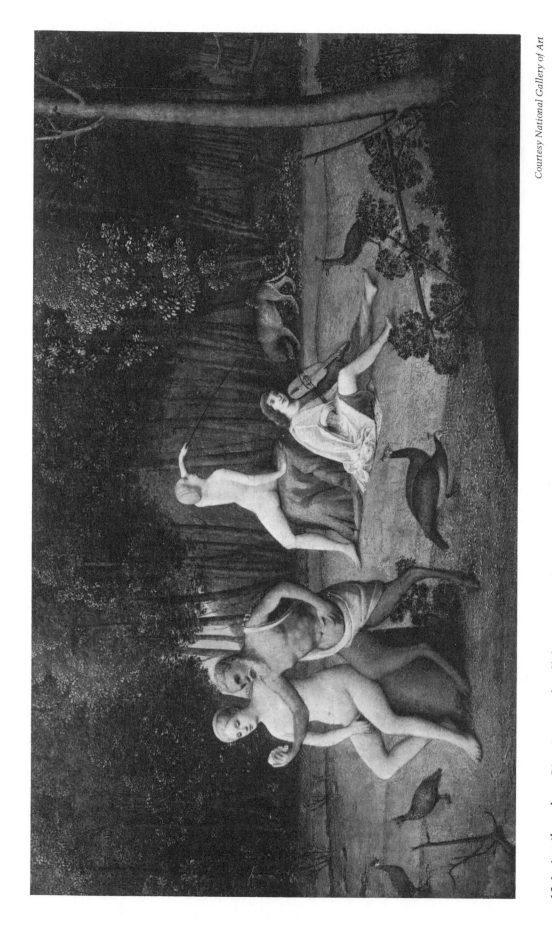

12.1 Attributed to Giorgione and collaborator, *Orpheus*. Mixed media transferred from panel to canvas. National Gallery of Art, Washington, D.C., Widener Collection.

12.2  Giovanni Bellini or follower, *Death of Saint Peter Martyr*. Tempera (?) on panel. National Gallery, London.

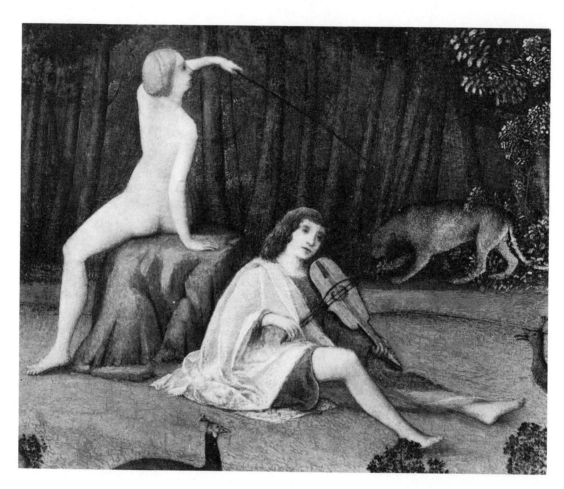

12.3  Detail of figure 12.1, Circe and panther.

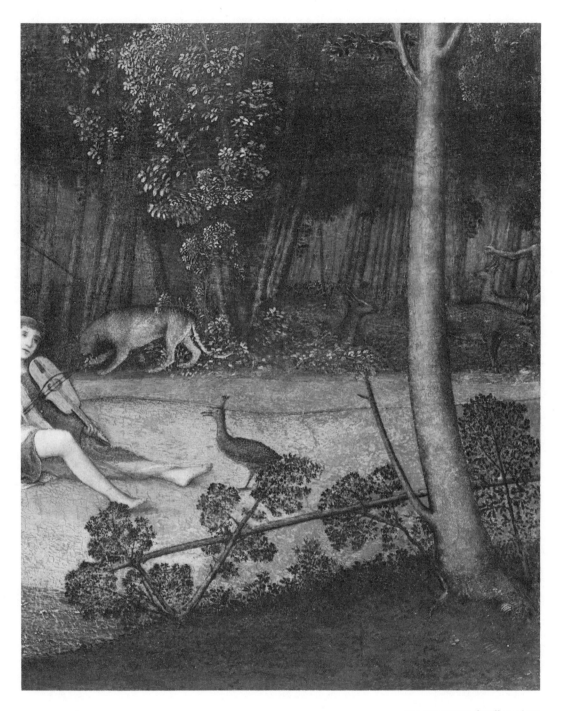

12.4 Detail of figure 12.1, Orpheus, panther, peacock, deer or gazelles; human form cut
off at right edge.

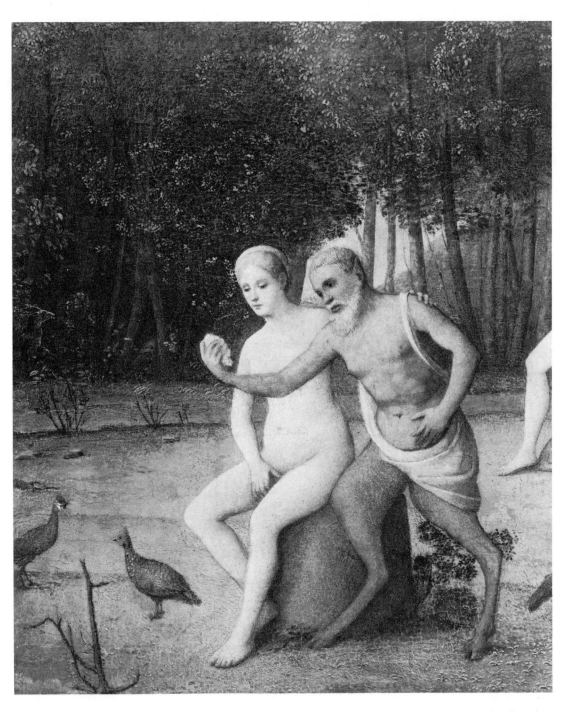

12.5  Detail of figure 12.1, figures in left foreground (Venus and Pan).

12.6 **X-ray photograph showing figures in left foreground of figure 12.1 and original contour of Circe.**

*Böhm*

12.7 Giovanni Bellini or follower, *Allegory*. Tempera on panel. Gallerie dell'Accademia, Venice.

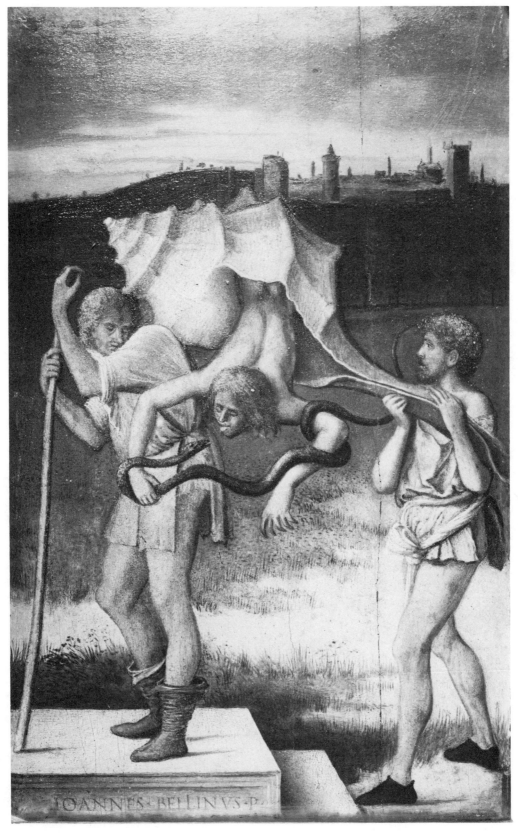

IOANNES·BELLINVS·P·

12.8 Giovanni Bellini or follower, *Allegory*. Tempera on panel. Gallerie dell'Accademia, Venice.

*Vaghi, Parma*

12.9 Cima de Conegliano, *Contest between Apollo and Marsyas before King Midas*. Oil on panel. Galleria Nazionale, Parma.

*Vaghi, Parma*

12.10 Cima da Conegliano, *Endymion*. Oil on panel. Galleria Nazionale, Parma.

12.11 Follower of Cima da Conegliano, *Orpheus*. Pen and wash on paper. Uffizi, Florence, Gabinetto dei Disegni e delle Stampe 1680.

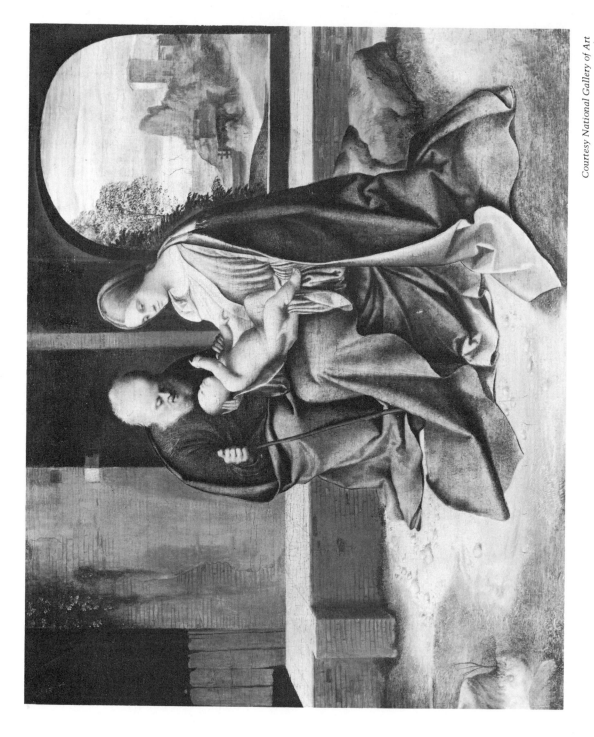

12.12 Giorgione, *Holy Family*. Oil on panel transferred to masonite. National Gallery of Art, Washington, D.C., The Samuel H. Kress Collection.

12.14 Detail of figure 12.12, landscape.

12.13 Detail of figure 12.12, Virgin, Christ Child, and Saint Joseph.

# 13. The Washington Relief of *Peace* and Its Pendant

A Commission of Alfonso d'Este to Antonio Lombardo in 1512

*DOUGLAS LEWIS*

A BRONZE RELIEF purchased on the Paris art market in 1970 was acquired from the New York firm of Michael Hall Fine Arts in 1972 by the National Gallery of Art in Washington, with the aid of the Ailsa Mellon Bruce Fund (inv. no. A-1750; fig. 13.2). It measures 40.6 cm. X 33.9 cm. X 7.6 cm. (16″ X 13⅜″ X 3″) and is apparently a unique cast of this subject, to be dated on technical grounds to the first half of the sixteenth century in northern Italy. The task of its accurate historical placement is rendered more intensely challenging by its very quality: its provenance and history have yet to be established, its artist has not been satisfactorily identified, it is unpublished, and its subject has remained unspecified. Yet it clearly ranks as one of the finest Italian Renaissance bronzes to be discovered in many years, and its beauty provides the unimpeachable justification for a detailed study.

The Washington relief is here identified as *Peace Establishing her Reign: An Allegory of the Victory of Ravenna*, proposed as the pendant to a known marble relief of *Mars Divesting the Armor of War* (fig. 13.1), and both assigned, as works of 1512, to the late style of Antonio Lombardo (ca. 1456–March [?] 1516). The discovery of the spectacular relief of *Peace* offers an appropriate subject with which to celebrate the memory of my long-time teacher and also my predecessor as curator of sculpture in Washington; this reconstruction of its origin is thus dedicated both to the deferentially esteemed "Professor Seymour" of undergraduate and graduate days at Yale, as well as to the affectionately remembered "C. S., Jr." who set an example of generous scholarship for all his successors in charge of the nation's collection of old master sculptures in Washington.

The contentual presentation of the National Gallery bronze seems straightforward enough: a partially draped female figure rests lightly on an empty cuirass, a corner of her loosely held drapery fluttering back over one shoulder as if implying a recently arrested forward movement. This almost hovering quality in her stance is heightened by the fleetingly held positions of her limbs, with her head still directed forward as if in con-

centration on some element or quality beyond the fictive space. Behind her a type of secular "cloth of honor" hangs in a broad arc from a screen suspended before the beribboned trunk of a palm tree. But in a curious gesture, almost without seeming to take notice, she points downward a staff or wand around which two serpents dramatically twine their tails, as they glide in apparent subservience toward her feet.

Armor, staff, subjugated serpents, and decorated palm all bespeak the presence of a symbolic allegory, as do the idealized facial type and generalized forms of the figure itself. That the image has to do with military matters is established by the cuirass and baton of command; that these are to be interpreted as successful or even triumphant is signalized by the confident demeanor of the figure, the honorific, celebratory, and almost throne-like quality of the hanging behind her seat, and by the palm's inevitable connotations of victory. Indeed, as Cesare Ripa recorded in his description of *"VICTORY and how it was depicted in Antiquity"*,[1] "The Ancients very often represented victory seated on the spoils of the enemy ... with a palm," and there exist many Renaissance redactions of the type. But the illustration (through the castigated serpents) of the beneficent effect of her wand marks our figure as a related personification, that to which Ripa refers in his description of *Peace on a Medal of Claudius*: the ancient coin, he said, depicted "A woman, who points a Caduceus down toward the ground where there is a serpent with intense entwinements."[2]

The source of this motif as an attribute of Peace is explained by Cartari: the Caduceus began simply as a golden wand Mercury had been given by Apollo in exchange for the lyre; its principal properties were the bestowal of joy and riches. "To it were afterwards added the serpents, ... since we read that having once found two of them struggling together, Mercury threw it between them, and straightway they were pacified. ... The Latins called it *Caduceus*, because its appearance caused all discords to cease [*cadere*], and for this reason it became the emblem ... adopted for Peace."[3] From its prototypes on ancient coins[4] it joined the repertory of Renaissance medallic art, in conjunction with which, to my knowledge, this relief constitutes one of its first large-scale examples.[5] Thus in a twofold sense we actually see here an image in the process of formation, as Peace borrows Mercury's wand to pacify the serpents of discord, and thereby exemplifies the introduction of the nascent Caduceus into Renaissance art as a symbol of "concord, union, and peace."[6]

The locus within which this emerging allegory should be placed—for it seems clearly to symbolize some particularly hazardous peace, achieved after a difficult (in this case almost occluded) victory—is fortunately easy to establish, since the figure type, relief composition, and size all relate the image directly to a double series of Venetian figurated reliefs, of which the present example is the first to be discovered in

bronze. The earliest of these relief cycles is the famous group of marbles in the Hermitage that the Venetian sculptor Antonio Lombardo carved for Alfonso I d'Este immediately upon his arrival at the court of Ferrara, between 1506 and 1508.[7] Formerly connected with the "Alabaster Chambers" in a wing of the Ferrara castle (and especially with that celebrated "Camerino d'alabastro" which, as the duke's study, contained Titian's *Bacchanals* and the National Gallery of Art's *Feast of the Gods* by Bellini),[8] the Lombardo reliefs have recently been documented instead to the "Camerino di marmo," the duke's older study inside the block of the castle itself.[9] This room, moreover, in which they were being installed on 6 March 1507 as the principal elements of an entirely sculptural decoration (representing an earlier phase of duke Alfonso's personal taste), by at least 1517 contained bronzes as well—"small figures both ancient and modern in marble and in bronze."[10]

A second series of reliefs connected with the style of Antonio Lombardo (though only partially with the Ferrarese court)[11] provides the immediate nexus for the Washington composition, for among its twenty-odd versions of subjects apparently after Lombardo designs—mostly of single heroes and heroines from antiquity—there is in fact a marble *Portia* directly adapted by Antonio's follower Zuan Maria Padovano, called Mosca, from the model of the present figure[12] (fig. 13.3). The marble reliefs of this second series have traditionally been divided between Mosca and Antonio himself, and can at least partially be differentiated through the criteria of size, iconography, and sculptural quality.[13] From such an analysis the striking fact emerges that the three best compositions—constituting, indeed, the only ones which can confidently be ascribed to Antonio's own hand—are very closely comparable to the present bronze in relief size, figure type, and quality of handling.[14]

Through these associations and the accepted attribution to Mosca of its derivative *Portia*, the bronze *Peace* now in Washington thus gains a highly defensible ascription to Antonio Lombardo.[15] Moreover, its size and allegorical subject matter (which is unshared by any of the marble "hero or heroine" series) bring it intriguingly close to the similar scales and iconographies of two of Antonio's reliefs of 1507, showing *A female figure with two marine deities* and *Hercules in a Chariot drawn by Sea-Horses*, for the "marble study" of Alfonso d'Este at Ferrara.[16] Finally, its own iconography and its probable connection with that soldierly prince are both supported by its almost certain pairing, as the second element in a pendant group of *War* and *Peace*, with a splendid marble relief of *Mars divesting the Armor of War*, of dimensions nearly identical with the Washington bronze (44 cm. X 37 cm.), which is still preserved in the Galleria Estense at Modena (inv. no. 2054; fig. 13.1).

Though not included in any of the cited discussions of Antonio's

relief cycles in Ferrara or their echoes (by Mosca and others) in the Veneto, with regard to them the *Mars* exhibits such a manifest superiority of composition and technique as to make it a touchstone of quality, against which the plethora of reliefs claiming some relationship to the "hero and heroine" series, mostly deriving from designs by Antonio, must all be measured.[17] The National Gallery bronze is a work on the same exalted level: whether conceived in a deliberately contrasting medium, or originally as a second marble (of which the Washington bronze would be a contemporary replica predictably reduced in the shrinkage of casting by a uniform 3 cm. in height and width), it would now be difficult to determine categorically—except, of course, through the possible future discovery of a cognate marble *Peace* of exceptional quality.

At the middle of the composition in the Washington relief of *Peace* is a palm trunk, mysteriously veiled behind the billowing drapery and hanging banner. When we consider that this tree may be present in its character as a standard Este *impresa*,[18] and that the motif of subjugated twin serpents had also been associated with the reigning Alfonso since its use on the medal commemorating his birth (as an infant Hercules),[19] then the possibility emerges of connecting our *War* and *Peace* reliefs with the "small figures ... in marble and in bronze" which were observed in Alfonso's study in 1517. And, in fact, a highly celebrated event in the duke's life, exactly halfway between the dates of commencement and finished description of his *camerino di marmo*, offers a convincing key to every aspect of the curious *concetto* for this dual commission.

On 11 April 1512, Alfonso personally directed the famous Ferrarese mobile artillery in his brilliant assault, with the French army under Gaston de Foix, against the combined Papal and Spanish forces in the Battle of Ravenna. A decisive though costly victory was won, for Gaston de Foix was killed, and the city of Ravenna subjected to the worst pillage of its history in a riotous sack by the leaderless French soldiery. But Alfonso energetically strove to restrain and placate these discordant forces, and conspicuously promoted the succeeding peace by rescuing (and hospitalizing in his own castle) the wounded Papal commander Fabrizio Colonna—who subsequently, released by Alfonso without ransom, was the principal agent in arranging his reconciliation with Pope Julius II on 9 July 1512.[20]

Alfonso himself was exceptionally accomplished in bronze casting, and in fact personally founded some of the pieces of his renowned artillery. Since it has been maintained that in his command at the Battle of Ravenna "mobile artillery was for the first time a decisive factor,"[21] it is thus eminently comprehensible, for iconographic as well as for personal reasons, that bronze should have been chosen as one of the media for a

sculptural commemoration of his military prowess. Indeed, the image of the Washington *Peace*, when seen in association with the Modena *Mars*, strikingly bears out all the particularized characteristics of this specific triumph: the victorious symbols of captured armor and the (Este) palm take second place behind an honorific banner transforming them into a battlefield throne, which Peace arrives to occupy as she acts (through Alfonso) to quell the excesses of the discordant foreign soldiery in their sack of Ravenna. Mars has thus been induced to lay aside his arms, and to renounce the accoutrements appropriate to war—as we are informed by the motto (*Non bene Mars bellum posita nisi veste ministro*) inscribed beneath the bellicose deity on the marble relief in the Galleria Estense (fig. 13.1).

In the reconstruction offered here, the circumstances of the commission for these reliefs evidently restrict their date to 1512 or soon thereafter.[22] It is consequently admissible to suggest that both offer important evidence for the development of Venetian and North Italian art in the first decades of the sixteenth century. The *Peace* is especially up-to-date, for it exemplifies a compositional pose apparently developed in the Bellini-Giorgione-Titian orbit around 1505–08[23] (it will be remembered that Antonio Lombardo was in Venice until after 4 May 1506, and presumably in close touch with his native metropolis thereafter);[24] and it seems also to demonstrate an influence (through drawings, or possibly even through Marcantonio's engraving, itself of ca. 1512?) from the same antique *Ariadne/"Cleopatra"* figure, owned by Girolamo Maffei in 1508, which inspired the Muse *Euterpe* in Raphael's fresco of *Parnassus* for the Stanza della Segnatura in the Vatican.[25] As a sculptural form it is exceptionally close to Antonio Lombardo's Venetian works in bronze (as in the Cappella Zen at San Marco)[26] and marble, among which, for the close similarity of the two heads, the figure of *Charity* on the tomb of Doge Giovanni Mocenigo might particularly be mentioned.[27] We have noted its own importance as a model for Mosca's *Portia* of perhaps a decade later,[28] and an apparent resonance of its composition in Ferrara may even be seen in Dosso's painting of *Melissa* of ca. 1523, now in the Borghese Gallery in Rome.[29]

Above all, the newly located reliefs of *Mars* and particularly of *Peace* provide a unique testimony to the character of Antonio's late style, otherwise undocumented for almost the whole final decade of his life. With their more expressionistic development of an ideal figural type, first adumbrated by his elder brother Tullio,[30] in their bold yet sensitive modeling, and withal through their passionate projection of antiquity, by 1512 they represent Antonio Lombardo at a moment of classical balance which is yet hauntingly suggestive of the first intimations of the *Maniera*.

# NOTES

1. *Iconologia*, Padua, MDCXI [1611], p. 547. Among the published Renaissance examples, which tend, like the present relief, to conflate the types of Victory and Peace here under discussion, Jennifer Montagu (who first suggested the identity of the present figure as Peace) has cited a Laurana medal of 1463 (for the single cuirass; Graham Pollard, *Renaissance Medals from the Samuel H. Kress Collection at the National Gallery of Art* [London, 1967], p. 11, no. 24); a type such as a Medici medal of 1534 (for a very similar gesture, though burning the arms; Pollard, p. 60, no. 317); and Tintoretto's painting for the Anticollegio of the Palazzo Ducale, Venice, with Peace sitting on a pile of arms (private communication, 16 August 1971). See also Jacopo dei Barbari's engraving of *Victory Reclining amid Trophies* of ca. 1500–03, which may well have influenced the present compositions: Jay A. Levenson et al., *Early Italian Engravings from the National Gallery of Art*, (Washington, 1973), pp. 362–63, no. 138.

2. Ripa, *Iconologia*, p. 402; the figure type may be seen in a sixteenth-century bronze plaquette, in which, however, the wand has again become a torch for the burning of arms, although the figure's drapery arrangement over the bust may depend on the present or a related example: John Pope-Hennessy, *Renaissance Bronzes from the Samuel H. Kress Collection*, (London, 1965), p. 110, no. 406, fig. 411.

3. Vincenzo Cartari, *Le imagini degli Dei degli Antichi*, (Padua, 1608), pp. 290–91, 293.

4. Guy de Tervarent, *Attributs et symboles dans l'art profane, 1450–1600*, (Geneva, 1958), col. 57, no. 2, with previous literature.

5. One earlier appearance was on the reverse of a medal of 1468 by Cristoforo di Geremia, often copied: George Francis Hill, *A Corpus of Italian Medals of the Renaissance before Cellini*, 2 vols. (London, 1930), 1: 197, no. 755 rev., and 2: pl. 127, nos. 753, 755. For other instances at larger scale, see Tervarent, *Attributs*, cols. 57–58; an important Venetian example, apparently unpublished except in a passing reference by Ridolfi (*Le vite de' pittori* [Venice, 1648], p. 290) is the beautiful fresco by Veronese in the vault of the garden nymphaeum at the Villa Barbaro, Maser.

6. Cartari, *Le imagini*, p. 289.

7. Pope-Hennessy, *Catalogue of Italian Sculpture in the Victoria and Albert Museum*, 3 vols. (London, 1964), 1: 355–56, no. 380 H., with full literature. Reproduced in Leo Planiscig, *Venezianische Bildhauer der Renaissance*, (Vienna, 1921), p. 223, fig. 231.

8. See especially John Walker, *Bellini and Titian at Ferrara*, (New York, 1956), p. 35, n. 50, with previous literature.

9. Charles Hope, "The 'Camerini d'Alabastro' of Alfonso d'Este—I." *Burlington Magazine*, 113, no. 824 (1971): 641–50, esp. p. 649 and no. 50. Professor Hope kindly informs me that new material, shortly to be published, further confirms this point about the location of the sculpture-decorated *Camerino di Marmo* (conversation of 20 May and letter of 9 June 1977).

10. Hope, "The 'Camerini d'Alabastro,'" p. 649 and n. 49, quoting letter of 1 June 1517 from Stazio Gadio to Isabella d'Este: "uno bellissimo camerino fatto tutto di marmoro da carrara et di meschi [*sic*] con figure et fogliamenti molto belli excellentemente lavorati, adornato de vassetti et figurine antiqua et moderne i di marmor i di mettal."

11. Julius von Schlosser, "Aus der Bildnerwerkstatt der Renaissance, III—Eine Reliefserie des Antonio Lombardo," *Jahrbuch der Kunsthistorischen Sammlungen in Wein* 31 (1913–14): 87–100, pls. 19–20; Wolfgang Stechow, "The authorship of the Walters 'Lucretia,'" *Journal of the Walters Art Gallery* 23 (1960): 72–85; Pope-Hennessy, *Catalogue*, pp. 355–56, no. 380, text, and especially item J (an *Apollo* inscribed "AL. D. III," thus presumably involving also [at least] its pendant *Venus*). This inscription, frequent on the Lombardo marbles for Ferrara, might perhaps refer equally well to the third year of Alfonso's reign (1508) as to his succession as third duke—possibly with intentional ambiguity.

12. Museo Correr, Venice; Pope-Hennessy, *Catalogue*, p. 355, no. 380 C., with previous literature. The principal noniconographic change introduced by Mosca is in the greater torsion of the back-turned head, which, as in all his works, is far too large for the figure's body; these form two of the clearest means, indeed, of distinguishing his style from the much more subtly posed and classically proportioned works of Antonio Lombardo, points made immediately clear by a comparison of his *Portia* with the present relief.

13. A first group of three pieces (the *Apollo* and *Venus* mentioned in note 11 above, plus a *Cleopatra* in Berlin—Pope-Hennessy, *Catalogue*, p. 355, no. 380, A. iii) average about 25 cm X 17 cm. and are rather weakly derivative: the two former are perhaps poor Lombardo workshop pieces, while the latter is a German variant dated 1532. A middle group of eight reliefs (a *Philoctetes* in Mantua, the *Eurydice* in the Metropolitan Museum, a *Lucretia* in the Walters Art Gallery, a *Mucius Scaevola* and an *Achilles/Mars* relief in the Bargello, a *Helle with the Ram* in Munich, and two *Anthony and Cleopatra* panels—Pope-Hennessy, *Catalogue*, pp. 354–55, no. 380, ii, A. i, B. i, D., E., F. i and ii, and G.) averages around 35 cm. X 24 cm. (apart from the two-figure panels, which are wider), and can mostly be assigned to lesser hands in Antonio Lombardo's studio, or perhaps at a slightly later date to Mosca (as can certainly the *Portia*, note 12 above, which is idiosyncratic in its substantially larger size [49 cm X 32 cm.] than any of these reliefs, and in its derivation from the present bronze). A further *Psyche* (?) "du même style e de la même époque" apparently as this second series, but neither measured nor photographed, is mentioned as being in the Musée de Rennes by Marguerite DeVigne, "Le sculpteur . . . Guglielmo Fiammingo," *Oud-Holland*, 56 (1939): 89, n. 5.

14. These include the Victoria and Albert *Philoctetes*, the Naples *Eurydice*, and the *Venus Anadyomene* recently acquired for the Victoria and Albert Museum as well (Pope-Hennessy, *Catalogue*, pp. 353–57, no. 380, A. ii, and "Sculpture for the Victoria and Albert Museum," *Apollo*, 80 [December 1964]: 463–65, fig. 9): at 41.3 cm. X 24.8 cm., 40 cm. X 28 cm., and 41.9 cm. high, respectively, they are all very close to the slightly broader measurements of 40.6 cm. X 33.9 cm. for the present relief—close enough, in fact, to imply that uniform modelli at approximately this scale may well have represented Antonio Lombardo's *invenzioni* for these designs, one of which is here proposed as being recorded in bronze by the present relief. (We know that Mosca, at the beginning of his career, made terracotta modelli for marble reliefs [see following note], a practice he may have learned from his association with this series of Antonio's.)

15. Actually, the only alternative attribution would be to Mosca, but see notes 12 and 14 above; Antonio is, after all, thoroughly documented for his involvement in elaborate bronze-casting projects (Pietro Paoletti, *L'architettura e la scultura del Rinascimento in Venezia*, 3 vols, [Venice, 1893], 1: 244–52), including even Alfonso d'Este's Ferrarese artillery (Paoletti, p. 250 n. 2); while Mosca is known to have produced only the modello for one small bronze, cast not by him but by the Paduan foundryman Guido Minio, called Lizzaro, in whose house Marcantonio Michiel saw five other Mosca terracottas, apparently all modelli for marbles (Jacopo Morelli, *Notizia d'opere di disegno nella prima metà del secolo XVI . . . scritta da un anonimo di quel tempo* [Bassano, 1800], pp. 26–27, 29), of which the "Nuda de terra cotta in piedi appoggiata ad una tavola" has already been associated with the Walters *Lucretia* (Planiscig, *Venezianische Bildhauer*, p. 264; Stechow, ["Walters 'Lucretia'"] pp. 78–79, 85).

Is it possible, perhaps, that "la Venere de terra cotta che esce dalla cappa," in the same description, could be a version by Mosca of the Lombardo *Venus Anadyomene* wringing out her hair, with her foot on a shell? If so, a marble executed by Mosca after this modello—or *aide-mémoire*—would thus stand in precisely the same relation to a presumed autograph work by Antonio (see n. 14 above) as does Mosca's marble *Portia* to the present relief. Wendy Stedman Sheard, "The Tomb of Doge Andrea Vendramin in Venice by Tullio Lombardo," (Ph.D. diss., Yale University, 1971), p. 418, n. 82, was the first to connect the Victoria and Albert's marble *Venus* to the terracotta seen by Michiel in the collection of Guido Lizzaro in 1520.

16. Of 42 cm. and 45 cm. height, respectively (Pope-Hennessy, *Catalogue*, 356, no. 380 H.); the Hercules also prefigures some aspects of the pose of our figure, which might have made their juxtaposition stylistically plausible as well. For the iconography of one of the marble reliefs, see Edgar Wind, *Bellini's Feast of the Gods* (Cambridge, 1948), pp. 36–38 and n. 9; a second, the famous *Forge of Vulcan*, with its visual quotation from the lately discovered Laocoön figure, would provide a close analogy to the present relief in its reference to Alfonso's activity as a bronze founder and its up-to-date reflection of Roman antiquities.

With these connections in mind, one might profitably review Giacomo De Nicola's comment on the history of the Este collections: ". . . when Clement VIII drove the Este out of Ferrara in 1598, they had carried with them to Modena all that they could, and among the rest the marbles of the little cabinets ["camerini di marmo," see n. 7]. Of these marbles a part passed later into the Belvedere of the neighboring Este castle of Sassuolo and were sold by its ultimate proprietors, the Finzi, to the Comte d'Espagnac, who exported them to France." "Notes on the Museo Nazionale of Florence—IV," *Burlington Magazine* 31 (1917): 177. The Washington relief's reported modern provenance from a French provincial collection accords well with these circumstances.

17. Augusta Ghidiglia Quintavalle, *La Galleria Estense di Modena* (Genoa, 1956), pp. 52–53, pl. 17. I wish to thank Richard Stone for calling the Modena *Mars* to my attention, and Giorgio Bonsanti for providing its photograph (fig. 13.1). In my view, the uniform 3-cm. shrinkage of the Washington bronze, with respect to the exactly comparable but slightly greater dimensions of the Modena marble, proves clearly that both compositions originally existed as congruent marble pendants—or at least as congruent terracotta modelli.

18. Tervarent, *Attributs*, col. 297, no. 5; it appears in this same central background position, and with the same part of its trunk showing, behind the Este unicorn in Marescotti's medal of 1460 of Borso d'Este, the first duke: Hill, *Corpus*, 1: 23, no. 82, and 2: pl. 19, no. 82.

19. I.e. strangling the two serpents sent by Hera (here—perhaps significantly—entwined in one group in his right hand), in a pun on his father's name (*Ercole* I d'Este, second duke) and on his own quality—at the same age of one year reported for Hercules' mythic feat—as a worthy successor: Pollard, *Renaissance Medals*, p. 128, no. 41. It is perhaps also worth recalling that Pietro Bembo dedicated a poem to Alfonso's bride in the year of their marriage (1502), entitled *"De serpente aurea Lucretia Borgiae Ferr[arie] Duc[issa]."* Marco Pecoraro, *Per la storia dei Carmi del Bembo* (Venice, n.d.), p. 160.

20. Romolo Quazza, "Alfonso I d'Este," *Dizionario biografico degli Italiani* (1960), 2: 335; Touring Club Italiano, *Emilia e Romagna* (Milan, 1957), p. 666.

21. Quazza, "Alfonso I d'Este," p. 333; Jean Charles Léonard Simonde de Sismondi, *A History of the Italian Republics* (London, 1931), p. 682 (quoted by Arthur M. Hind in *Early Italian Engraving*, 7 vols. [London, 1938-48], 5: 267–68, no. 3, for "The Two Armies at the Battle of Ravenna" by the Roman engraver "Master NA-DAT with the Mousetrap").

22. That the summer of 1512 is the most likely time in which Alfonso would have commissioned such an image is confirmed by his increasingly strained relations with Julius II after his enforced flight from Rome (14 October 1512). Since the battle's anniversary date of 11 April took on a new significance with Alfonso's reappointment as *gonfaloniere della Chiesa* for Leo X's coronation procession in the very next year (1513—Quazza, 335), it thus seems probable that so specific a commemoration of peace after the battle responsible for the sack of Ravenna must immediately postdate the victory itself—a conclusion perhaps supported by Antonio Lombardo's collaboration with Alfonso on the Este cannon (n. 15 above).

23. The pose may have been invented by Giorgione, for Giulio Campagnola's engraving of ca. 1509 of the *Young Shepherd* (H. 10) shows a closely analogous disposition of the figure, "based quite clearly on motifs from Giorgione's *Tramonto*" (Konrad Oberhuber, in Jay Levenson et al., *Early Italian Engravings*, p. 400)—a picture, however, now given by

Charles Hope to Giulio himself (conversation of 20 May 1977). The *"Judith"/Justice* figure from the Fondaco dei Tedeschi, presumably executed ca. 1508–09 by Titian in collaboration with Giorgione, is another extremely specific source, as is, for the Modena *Mars*, Giorgione's *Seated Man* for the same program. Titian's own *Adulteress before Christ/"Daniel and Susanna"* in Glasgow, of ca. 1509–10 (Sydney J. Freedberg, *Painting in Italy 1500–1600* [Harmondsworth, 1971], pp. 88–89, p. 478, n. 40, pl. 52), as pointed out by Francis Haskell (conversation of September 1971), is probably the most immediate and compelling prototype for the figure style.

A sculptural precedent close to Antonio may perhaps be seen in the pose of the Christ Child in his father Pietro's *Loredan Madonna* of ca. 1501–06 for the Palazzo Ducale (Planiscig, *Venezianische Bildhauer*, p. 180 pl. 193), and a compositional analogy (in fact closer to Mosca's *Portia* derivation) with Giovanni Bellini's (?) *Infant Bacchus* in the National Gallery of Art (no. 1362, ca. 1505–10 ?) should perhaps not be overlooked. The latter, finally, has a sculptural parallel in a figure from a contemporary (?) North Italian marble relief in the North Carolina Museum of Art, Raleigh (Guy de Tervarent, "Sur deux frises d'inspiration antique," *Gazette des Beaux-Arts* 55 (1960): 312–14, figs. 8–9), which displays motifs of drapery in a pattern almost precisely identical to the present composition. For this device, see also the Este marble relief of Saint Jerome in Vienna, ascribed to Tullio Lombardo: Planiscig, p. 229, fig. 239.

24. Paoletti, *L'architettura e la scultura*, p. 250.

25. Pope-Hennessy, *Raphael* (New York, 1970), pp. 95–96, 140, 142–43, 280 n. 32, figs. 82–84, 126–28; Hans Henrik Brummer, *The statue court in the Vatican Belvedere* (Stockholm, 1970) pp. 153–84, with extensive documentary and visual material.

26. Of which Antonio was probably responsible for the general design, as well as unquestionably for the columns of the baldacchino with their capitals, their pilaster responds, the marble architrave, bronze frieze, pediment rosette, the ceiling relief of *God the Father*, the central image of the *Madonna and Child* (the *"Madonna della Scarpa"*), and especially the two pendentive figures of *Fame*, of which the one on the right has a gesture and drapery pattern identical to the present composition (Paoletti, p. 246).

27. As pointed out by Wendy Stedman Sheard (private communication, 19 August 1971); see Franca Zava Boccazzi, *La basilica dei Santi Giovanni e Paolo in Venezia* (Padua, 1965), pp. 140–41, figs. 74–75. The close similarity of the billowing drapery end with that on the left lateral pedestal relief of the Vendramin monument, carved ca. 1493 by Tullio and Antonio Lombardo, should be emphasized (Planiscig, p. 241, fig. 254), as should also the identical form of the background hanging in Antonio's relief of the *Miracle of the Child* in the Santo at Padua, for which he was paid in 1505 (Planiscig, p. 217, fig. 228).

28. The "second series" of reliefs traditionally divided between Antonio and Mosca (n. 11 above) has usually been dated to ca. 1515–16 (Stechow, "Walters 'Lucretia' ", p. 82) in order to place them within Antonio's life-span (he was dead, but probably very recently, by March of 1516—Paoletti, p. 250). Since only two or three of the twenty or more versions of these reliefs can satisfactorily be ascribed to Antonio himself, however (n. 14 above), and since Mosca's documented career begins only with a contract advance on 28 April 1520 (Planiscig, p. 259—he supposedly lived until 1573), it thus seems far more likely that his *Portia* after the present relief, as well as his other versions in this "second series" after Antonio's Ferrarese inventions, should probably be dated to the years following 1520—that is to the same period in which Michiel saw Mosca's possibly related *modelli* in Guido Lizzaro's house (n. 15 above).

29. Freedberg, *Painting in Italy 1500–1600*, p. 210, pl. 135.

30. Sheard, "The Tomb of Doge Andrea Vendramin" (esp. chap. 5); private communication, 19 August 1971.

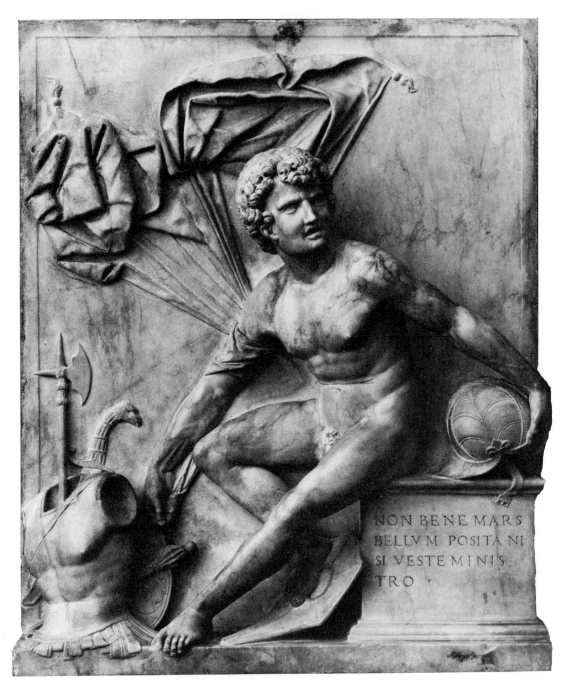

13.1 Antonio Lombardo, *Mars divesting the Armor of War: An Allegory of the Victory of Ravenna, 1512*. Marble relief. Gallerie Estense, Modena.

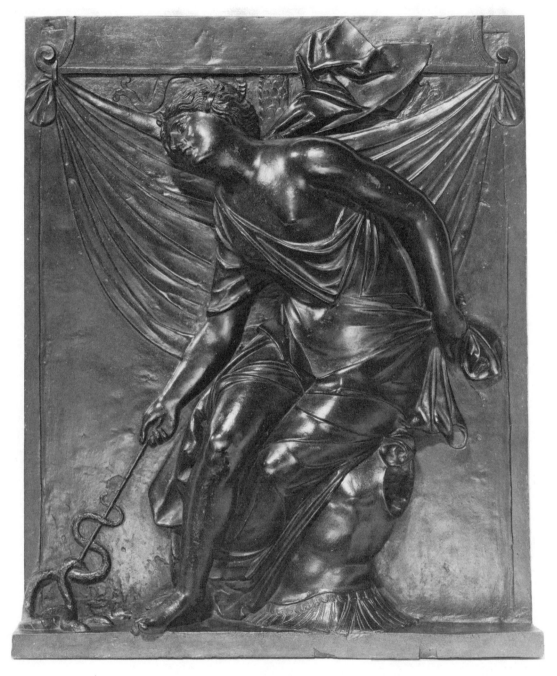

13.2  Antonio Lombardo (here attributed to), *Peace Establishing her Reign: An Allegory of the Victory of Ravenna, 1512*. Bronze relief. National Gallery of Art, Washington, D.C.

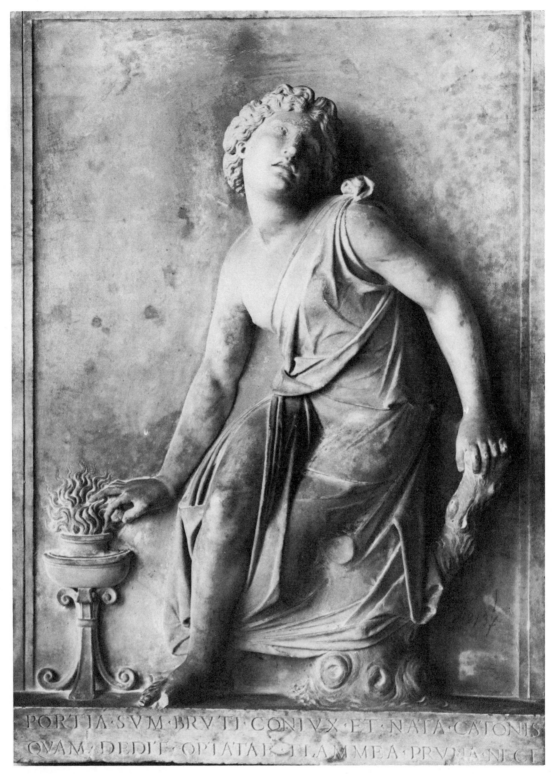

PORTIA SVM BRVTI CONIVX ET NATA CATONIS
QVAM DEDIT OPTATAE FLAMMEA PRVNA NECI

13.3 Attributed to Zuan Maria Padovano, called Mosca, *Portia*. Marble relief. Ga d'Oro, Venice.

# 14. Titian and Michelangelo: The *Danae* of 1545–1546

*PAUL F. WATSON*

When Michelangelo and Vasari went one day to see Titian at the Belvedere, they saw in a painting which he had then completed, a nude woman representing Danae who had in her lap Jove transformed into a shower of gold. And greatly did they praise it to him, as one does in company. After they had left him and were discussing the art of Titian, Buonarroti commended him highly, saying that his *colorito* and his *maniera* pleased him greatly, but that it was a sin that at Venice he did not learn from the outset to draw well, and that those painters did not have a better method of study. For, said he, if this man had been aided as much by art and *disegno* as he is by nature (and especially in counterfeiting the living model) then he could not have been better, because he has a fine spirit and a beautiful and lively *maniera*.[1]

WHAT PROVOKED MICHELANGELO'S CRITICISM of Titian was the splendid version of the myth of Danae that is now in Naples (fig. 14.1). As Vasari indicates, the canvas was executed in Rome, where Titian resided from October of 1545 to March of 1546 as the honored guest of Michelangelo's chief patron, Pope Paul III. It was probably commissioned by the pope's grandson, Ottavio Farnese, lord of Camerino and Castro and soon to be duke of Parma and Piacenza. Like Vasari, we see a nude princess who reposes at ease on her bed, languidly gazing upward at the miraculous explosion of gold that Jupiter has become. At her feet Cupid, armed with his bow, turns away as if startled by this sudden apparition. Danae's couch, shaded by a canopy, is shielded from a distant light-filled landscape by a great dark column whose base profile provides a gracious echo of the contours of Danae's body. Though the *Danae* is an obvious compliment to the art of sculpture, both in the plasticity of the nude and the friezelike ordering of the composition, it also embodies a breadth and freedom typical of the art of painting as practised in Venice.[2]

Vasari's anecdote was probably intended as a broadside in the quarrel between *disegno* and *colorito* that erupted in the late Cinquecento.[3] Few modern historians, however, can resist telling the story once more, because it epitomizes the rivalry between Venice and Rome and dramatizes a confrontation between the two aging chieftains of Renaissance art. Thanks in part to Vasari, the current consensus is that Titian from the outset directed his *Danae* at Michelangelo, either as a graceful exercise in his manner or as a deliberate challenge to it.

This polemical interpretation rests on the question of figural sources. Nearly a century ago Crowe and Cavalcaselle proposed, with some diffidence, that the *Danae* was inspired by Michelangelo's composition of *Leda with the Swan*. Despite some scholarly reservations and outright dissent, time has hardened their suggestion into a certainty, as two important recent publications, Panofsky's posthumous study of Titian's imagery and Wethey's continuing catalogue of the paintings, attest.[4] The *Danae* has thus become a prime instance of competition between a painter and a sculptor, or more precisely, between a painter fascinated by the carver's art and a sculptor who from time to time deigned to paint.

Certain it is that Titian could scarcely have avoided Michelangelo's *Leda* even before his journey to Rome. In July of 1529 his patron, Alfonso d'Este, duke of Ferrara, commissioned a painting of that subject from Michelangelo, who had fled to northern Italy from besieged Florence. Though the duke's *Leda*, finished in 1530, does not survive, its appearance is well known from contemporary copies. One attributed to Rosso is in the National Gallery (fig. 14.3).[5] Another copy, now lost, was brought to Venice in 1541 by none other than Giorgio Vasari, who attempted to sell it and a second erotic mythology also copied from Michelangelo, *Venus Reclining with Cupid*, to another of Titian's patrons, the duke of Urbino. Both were eventually purchased by Don Diego Hurtado de Mendoza, the imperial ambassador to Venice, a client of Titian's and a member of his circle.[6] Vasari's compatriot and Titian's great friend Pietro Aretino also promoted his copies after Michelangelo, forcefully describing them in a letter of 1542:

> One of the two pictures is a Leda, but in a tender manner of flesh, elegant of limb and slender of figure, and so sweet, soft, and gentle of attitude, and with so much naked grace from all parts of the nude that one cannot look on without envying the swan who takes pleasure in it with a tenderness so much like life that it seems, as he extends his neck to kiss her that he wishes to exhale into her mouth the spirit of his divinity. The other is Venus, delineated with a marvellous rotundity of line.[7]

What we see in Michelangelo's *Leda with the Swan* is a complicated figural invention that must have served as an envoy of the *Maniera* in

Venice. It also represented Michelangelo's mature consideration of a compositional type derived from antique sculpture, a figure reclining with the leg closer to the viewer dramatically flexed as the other is relaxed. Its earliest appearance is in subsidiary parts of the Sistine Chapel ceiling, where Michelangelo explored it as an alternative to the type developed in the *Drunkeness of Noah* and the *Creation of Adam*.[8] The type also intrigued Raphael and Titian's friend, Jacopo Sansovino.[9]

The pose and proportions of the *Leda*, however, more immediately paraphrase the tortuous figure of *Night* in the Medici Chapel. Indeed, the painting aped marble in its drawing, scale, and compressed mode of composition. That point is proven by its effortless retranslation back into sculpture, as demonstrated by Ammanati's elegant relief after the *Leda* and by Vincenzo de' Rossi's adaptation of it in the *Dying Adonis*.[10] If Michelangelo's *Leda* inspired the *Danae*, then Titian must have competed with the Florentine on his own terms, as an inventor of sculptural figures.

A fresh comparison between the *Danae* and the *Leda*, together with the *Night*, rapidly quenches any sense of confrontation. Michelangelo's figures embody a governing principle of Mannerist design, the convoluted flexing of all parts of the body that results only in its imprisonment in a compacted plane. His nudes recline in attitudes best described as tensed, articulate, acutely uncomfortable, and masterfully deployed to show the figure "contornata con maravigliosa rotondità di linee," as Aretino put it. Formal concerns outweigh narrative plausibility.

Titian's heroine, on the other hand, is langorous, static, and convincingly conceived. The shadowed glance of her head, easy disposition of her arm, and receptive deployment of her legs, one upraised, one relaxing, concede little to the *Maniera*. In fact, the figure demonstrates rather well what Vasari meant when he praised Titian for skill in imitation, "nel contrafare il vivo." The chief point of similarity remains the emphasis given the long contours of back, buttock, and upthrust leg. But Michelangelo and his Florentine amanuenses define contours with lapidary precision, making them control the major rhythms of the composition. Titian softens contours with shadow. The accent of upraised thigh, potentially dramatic, is here muted by the drapery placed across Danae's right leg. *Muted* is perhaps too gentle a word; Vasari must have read that obscuring cloth as a stylistic solecism. Titian's nude owes surprisingly little to Michelangelo.[11]

Danae's bedfellow further complicates the problem of competition between Michelangelo and Titian. Panofsky suggested that Titian derived the putto's stance from Michelangelo's *Christ* of 1519–20 in Santa Maria sopra Minerva in Rome (fig. 14.5). If the statue is reversed, then the Cupid resembles it in stance, particularly in the disposition of

the legs.[12] Once more, however, a direct comparison raises more questions than it answers. The painter sets aside the sculptor's concerns: he suppresses the forward thrust of a shoulder; he glosses over the torsion of the pelvis; he counters the direction of the contrapposto with a splendid accent of colored wings and a bright note of baldric. Titian's lively putto, moving in rhythms not easily controlled, seems now remote from the serenely disciplined *figura serpentinata* that Michelangelo carved.[13]

Titian's Cupid has its sources in the art of relief, not in statuary, as its design indicates. Perhaps what the painter remembered in Rome was a series of reliefs in Venice: the marine deities adorning the plinths of the Loggetta in the Piazza di San Marco. These were carved early in the 1540s by Gerolamo Lombardo and Tiziano Minio under the general supervision of Jacopo Sansovino. Several of the figures are cousins to Danae's Cupid. A putto astride two dolphins anticipates him in pudgy proportions and slightly knock-kneed stance. Another marine deity, attributed to Minio, is a first draft for the Cupid; he is winged, holds a staff in much the same way that Cupid bears his bow, draws his other arm across his chest, and poses in a restrained, serpentine fashion. This Venetian relief is in many ways a more satisfying source for the Cupid than Michelangelo's Roman statue, from which it was perhaps derived.[14]

Danae's companion ultimately clarifies the problem of Danae herself. The sources of that reclining figure lie north of the Apennines. We remember that the *Danae* enriches a beautiful Venetian tradition, that of the recumbent (and sometimes somnolent) female nude. The princess descends from Titian's own Venus done for the duke of Urbino in 1538 and from the remarkably abandoned nude in the foreground of the *Bacchanal of the Andrians* painted for the duke of Ferrara around 1519. From a Venetian vantage point, the ultimate source of the *Danae* is Giorgione's *Venus* in Dresden, completed by the youthful Titian and in the Cinquecento embellished by a putto crouching at the goddess's feet. Yet the Venetian argument proves as elusive as the Roman one, for the tradition fails to account for the specific character of Titian's Danae.[15]

Overlooked in the search for sources is a painting that Titian knew well: the *Feast of the Gods*. The painting was finished in 1514 by Giovanni Bellini for the duke of Ferrara, whom, we recall, commissioned Michelangelo's *Leda*, and was revised a least twice by Titian. Prominent among the drowsy gods of that wry narrative is Mercury, so identified by a caduceus (fig. 14.2). His back propped up by a wine cask, he sprawls on the ground, gazing dreamily at another supine deity, the sleeping nymph about to be attacked by Priapus. X-ray photography indicates that originally both of Mercury's legs were drawn up close to his body. In the final version his left leg relaxes. Whether Bellini himself in 1514 or Titian in the 1520s revised the Mercury cannot be considered here.[16] Whoever

changed that figure, however, substituted for an observed naturalism a more artful pose whose understated rhythms stress the god's total enervation. The revision recalls the art of Giorgione and his circle in Venice, and beyond Giorgione, the art of the ancients.[17]

The Mercury of 1514 and thereafter is the source of the Danae of 1545–46. The drunken god anticipates the enamoured princess in his general pose and in such crucial details as the disposition of the legs—one flexed, the other flaccid—the limp deployment of right hand and wrist, and even the dreamy face shrouded in shadow. Despite its heroic proportions, Titian's nude retains the essential flavor of Bellini's figure: loose-jointed, easy, natural, "massimamente nel contrafare dal vivo", as Vasari was to say.[18]

Between Bellini's Mercury and Titian's Danae intervened changes that can be reconstructed with some precision. Sometime after 1531 Titian may well have studied frescoes by Giulio Romano of river-gods in the Palazzo de Te at Mantua. Though the paintings have disappeared, Giulio's preliminary drawings survive; one of these is a god who reposes, amusingly enough, with a swan (fig. 14.4). The figure looks as if Bellini's Mercury had been revised by a master thoroughly steeped in the art of Raphael and of ancient Rome.[19] It also anticipates, to a degree, Titian's Danae in the turning of the relaxed leg, the angle of the back, and the rendering of the torso. Giulio Romano must have contributed a classicizing link to a chain of figural invention connecting Bellini and Titian.[20]

We can now assess more accurately the significance of the *Danae* painted for Ottavio Farnese. The conventional notion of the painting as a challenge to Michelangelo is misleading if we assume that Titian appropriated his *Leda with the Swan* and emulated his statuary. The sources of the painting, rather, are Venetian. Venetian too is the superb realization of Titian's design, as all have agreed. The drapery thrown over Danae's leg, for example, is not only a memory of Mercury's kilt in the *Feast of the Gods*, it is a way of emphasizing the nude's soft flesh that only a colorist would devise. That the *Danae* was an alien visitation in the Belvedere is proven also by Vasari's anecdote and by the homily he extracts from it: "whoever has not drawn a great deal and studied selected specimens of ancient and modern art, cannot acquire good methods nor aid the things of nature that are drawn from life."[21] If Titian really intended to offer a challenge in Rome in the winter of 1545–46, perhaps it was simply to champion the fullness of painting.

Yet the air of rivalry remains. Perhaps a more pointed competition existed, not between sculpture and painting but between painting and literature, not with Vasari's copy of Michelangelo's *Leda* but with Aretino's ekphrasis based on it. Pietro's voluptuous description so perfectly suits the *Danae* of 1545—"a tender manner of flesh, elegant of limb and

slender of figure, and so sweet, soft, and gentle of attitude, and with so much naked grace from all parts of the nude"—that one cannot look upon her without envying Jove himself.[22]

# NOTES

1. Giorgio Vasari, *Le vite de' più eccellenti pittori, scultori, ed architettori*, ed. Gaetano Milanesi (Florence, 1881), 7: 447: "Andando un giorno Michelagnolo ed il Vasari a vedere Tiziano in Belvedere, videro in un quadro, che allora avea condotto, una femina ignuda, figurata per una Danae, che aveva in grembo Giove transformato in pioggia d'oro, e molto (come si fa in presenza) gliele lodarono. Dopo partiti che furono da lui, ragionandosi del fare di Tiziano, il Buonarroto lo comendò assai, dicendo che molto gli piaceva il colorito suo e la maniera; ma che era un peccato che a Vinezia non s'imparasse da principio a disegnare bene, e che non avessono que' pittori miglior modo nello studio. Con ciò sia (diss' egli) che se quest'uomo fusse punto aiutato dall'arte e dal disegno, come è dalla natura, e massimamente nel contrafare il vivo, non si potrebbe far più nè meglio, avendo egli bellissimo spirito ed una molto vaga e vivace maniera." An earlier version of this paper was presented at the Symposium of Venetian Art Sponsored by Johns Hopkins University in Baltimore on 22 March 1974.

2. Consult the useful summaries of fact and opinion in Ordenberg Bock von Wülfingen, *Tiziano Vecellio: Danae* (Stuttgart, 1958); Francesco Valcanover, *Tutta la pittura di Tiziano* (Milan, 1960), 2: 31; and Sidney J. Freedberg, *Painting in Italy 1500–1600* (Harmondsworth, 1971), p. 347.

3. At the Hopkins Symposium, Mark Roskill pointed out that Vasari's report of Michelangelo's criticism may well have been a fabrication crafted to suit the climate of the late 1560s. It is worth remembering, however, that as early as 1542 Pietro Aretino compared Michelangelo's draughtsmanship with Titian's coloring; his letter is cited in E. Tietze-Conrat, "Titian as a Letter Writer," *Art Bulletin* 26 (1944): 117. The *Danae* is analyzed as an example of *disegno* versus *colorito* by Hans Tietze, *Titian: The Paintings and Drawings*, 2d ed. (New York, 1950), p. 36, "a Venetian plea against Rome," and by Freedberg, *Painting in Italy*, p. 347.

4. J. A. Crowe and G. B. Cavalcaselle, *The Life and Times of Titian*, 2d ed. (London, 1881), 2: 121–22, imply a competition with the *Leda*. Their view is seconded by Erwin Panofsky, *Problems in Titian, Mostly Iconographic* (New York, 1969), pp. 146–47 and Harold E. Wethey, *The Painting of Titian: I, The Religious Paintings* (London, 1969), p. 30. Consult also the *Mostra di Tiziano* (Venice, 1935), p. 131; no. 64 and Bock von Wülfingen, *Danae*, p. 19.

5. Rosso's copy of the *Leda* is thoroughly treated by Cecil Gould, *The Sixteenth Century Italian Schools (Excluding the Venetian)* (London, 1962), pp. 97–99. Other copies are assembled in Charles de Tolnay, *Michelangelo* (Princeton, 1948), 3: 106–07, 190–93. Consult further the exhaustive discussion in Giorgio Vasari, *La vita di Michelangelo*, ed. Paola Barocchi (Milan and Naples, 1962), 3: 1101–22, and the excellent analysis of J. Wilde, "Notes of the Genesis of Michelangelo's Leda," in *Fritz Saxl 1890–1948: A Volume of Memorial Essays From His Friends in England*, ed. D. J. Gordon (London, 1957), pp. 270–80.

6. Vasari discussed his copy of the *Leda* in *Le vite*, 7: 670; see further Panofsky, *Problems in Titian*, pp. 146 and 122, n. 34. For Mendoza and Titian, consult Harold E. Wethey, *The Paintings of Titian: II, The Portraits* (London, 1971), pp. 199–200 and David Rosand, "*Ut Pictor Poeta*: Meaning in Titian's *Poesie*," *New Literary History* 3 (1972): 543–44.

7. Pietro Aretino, *Lettere: il primo e il secondo libro*, ed. Francesco Flora (Turin, 1960), 1: 963: "L'una de le due imagini è Leda, ma in modo morbida di carne, vaga di membra e svelta di persona, e talmente dolce, piana e soave d'attitudine, e con tanta grazia ignuda da tutte le parti de lo ignudo, che non si può mirar senza invidiare il cigno, che ne gode con affetto tanto simile al vero che pare, mentre stende il collo per basciarla, che le voglia essalare in bocca lo spirito de la sua divinità. L'altra mo è Venere, contornata con maravigliosa rotondità di linee." A copy by Pontormo after Michelangelo's *Venus* is in the Uffizi. For the Venus, see de Tolnay, *Michelangelo* 3: 108–09, 194–95; Vasari's copy is discussed on p. 195.

Panofsky argues that Michelangelo's *Venus* influenced Titian's *Venus with Cupid* in the Uffizi of 1545–48, in *Problems in Titian*, p. 121, n. 34. The relationship seems remote. I agree with Panofsky, however, that Primaticcio's *Leda* was derived from Michelangelo's painting of the same subject, and that it is unlikely that Titian knew it. See *Problems in Titian*, p. 146, refuting Hans Tietze, "An Early Version of Titian's *Danae*: An Analysis of Titian's Replicas," *Arte Veneta* 8 (1954): 207–08.

8. Reclining figures of the "Leda" type appear in the spandrel above the throne of Ezekiel, illustrated in de Tolnay, *Michelangelo*, Vol. 2; figs. 206–07, and in the spandrel above the *Brazen Serpent*, illustrated in Charles Seymour, Jr., *Michelangelo: The Sistine Chapel Ceiling* (New York, 1972), pl. 81, as well as the medallion representing the *Death of Uriah*, illustrated in Seymour, *Ceiling*, pl. 57. Michelangelo probably derived the type from an antique relief depicting Leda with the swan, now lost but known from sixteenth-century drawings, that was probably the source of his own *Leda*: see de Tolnay, *Michelangelo*, Vol. 3; p. 192, pl. 281.

9. Raphael developed the figure-type discussed above in the *Council of the Gods* in the Sala di Psiche of the Farnesina, illustrated in Luitpold Dussler, *Raphael: A Critical Catalogue of his Pictures, Wall-Paintings and Tapestries*, trans. Sebastian Cruft (London and New York, 1971), pl. 159. Raphael's figure is, in turn, the source of a river-god designed by Sansovino for the Loggetta in the Piazza di San Marco, Venice, illustrated in John Pope-Hennessy, *Italian High Renaissance and Baroque Sculpture*, 2d ed. (London and New York, 1970), fig. 103. Also in Raphael's orbit is a figure of Jupiter by Peruzzi in the Sala delle Prospettive of the Farnesina, illustrated in C. L. Frommel, *Baldassare Peruzzi als Maler und Zeichner* (Vienna and Munich, 1967–68), Tafel 37ᵈ. Fully Michelangelesque are the reclining figures designed by Perino del Vaga for the Castel Sant' Angelo in 1545–47 and by Vasari in the Palazzo della Cancelleria in 1546, illustrated in Freedberg, *Painting in Italy*, pls. 108 and 191.

10. Ammanati's relief is illustrated in Adolfo Venturi, *Storia dell'arte italiana* (Milan, 1936) Vol. 10, pt. 2, p. 404, fig. 336, and Vincenzo's figure appears on p. 303, fig. 261. The relationship between the *Leda* and the *Adonis* is unexplored by Hildegard Utz, "The *Labors of Hercules* and Other Works by Vincenzo de' Rossi," *Art Bulletin* 53 (1971): 344, 347. Several students of Titian have asserted that he was influenced directly by Michelangelo's figures from the Medici Chapel. Tietze, *Titian*, p. 36, suggests that the Danae's source was one of Michelangelo's river-gods, while Cecil Gould, "The *Perseus and Andromeda* and Titian's *Poesie*," *Burlington Magazine* 105 (1963): 114 and n. 8, argues that the pose of the Danae is like that of the Medici Chapel nudes, which Titian may have known from drawings or casts.

11. Those who advocate the *Leda* as Titian's source have often noted that the differences outweigh the similarities: see Panofsky, *Problems in Titian*, pp. 146–47, and the conscientious analysis of Bock von Wülfingen, *Danae*, p. 19. The influence is abruptly denied by Thedor Hetzer, "Studien über Tizians Stil," *Jahrbuch für Kunstwissenschaft* 1 (1923): 230.

12. Panofsky, *Probelms in Titian*, p. 147. For the *Christ*, consult de Tolnay, *Michelangelo*, 3: 89–95, and Pope-Hennessy, *High Renaissance Sculpture*, pp. 20 and 325–27. Panofsky's observation is somewhat more convincing than the conventional view that Titian's figure reflects an antique statue of Cupid stringing his bow, now in the Vatican Museum. See Crowe and Cavalcaselle, *Titian*, 2: 121; *Mostra di Tiziano*, p. 131; Tietze, *Titian* p. 36; and especially Otto J. Brendel, "Borrowings from Ancient Art in Titian," *Art Bulletin* 37 (1955); 121.

An antique relief that Titian probably knew very well seems closer to the mark than the Vatican *Eros*; it is a neo-attic relief showing two putti at play, formerly in Santa Maria dei Miracoli, Venice, where it was recorded in 1369, and now in the Museo Archaeologico; see Bruna Forlatti Tamaro, *I1 museo archaeologico del Palazzo Reale di Venezia* (Rome, 1953), p. 24; illustrated p. 68. See Wethey, *Titian: Religious Paintings*, pl. 20.

13. Titian's borrowings from Michelangelo tend to be more explicit that the pre-

sumed usage of the *Danae* indicates. For example, Titian's Saint Sebastian of 1522 clearly reflects Michelangelo's *Rebellious Slave,* while the *Christ* of the Minerva is remembered in Titian's last painting, the *Pietà* in the Accademia. For the Saint Sebastian, see Brendel, "Borrowings," p. 118 and n. 17; Wethey, *Titian: Religious Paintings,* pp. 18, 126–27 and Panofsky, *Problems in Titian,* p. 20 and n. 27.

14. The reliefs are illustrated in Giulio Lorenzetti, "La loggetta al Campanile di San Marco, note storico-artistiche," *L'Arte* 13 (1910), fig. 13 and p. 128. See further Pope-Hennessy, *High Renaissance Sculpture,* pp. 404–07 and fig. 102, a sixteenth-century view of the Loggetta with the reliefs in situ. Sansovino's winged god may derive from Michelangelo's *Christ,* as indicated in the text; all of the plinth figures, however, indicate a study of the antique relief discussed in note 12 above.

15. Tietze, "An Early Version of Titian's *Danae,*" p. 206; Bock von Wülfingen, *Danae,* pp. 5–9.

16. The X-ray photographs are in John Walker, *Bellini and Titian at Ferrara* (London, 1956). The most astute and judicious discussion of the revisions is in Giles Robertson, *Giovanni Bellini* (Oxford, 1968), pp. 133–52; Robertson tends generally to credit most of the alterations in the Mercury to Bellini himself. The dating of Titian's revisions has been pushed forward to the late 1520s by Charles Hope, "The 'Camerini d'Alabastro' of Alfonso d'Este—II," *Burlington Magazine* 113 (1971): 717.

17. Robertson, *Bellini,* p. 151, likens the revised Mercury to the so-called surveyor of Giorgione's *Three Philosophers.* His pose has a more exact counterpart in a Giorgionesque work, the reclining figure of Callisto in a drawing currently attributed to Sebastiano del Piombo and datable around 1511, now in the Louvre; see Terisio Pignatti, *Giorgione,* trans. Clovis Whitfield (London and New York, 1971), pp. 133–34 and pl. 192. An antique source for the Mercury was proposed by Theodor Hetzer, "Studien urber Tizians Stil," p. 226 and n. 3. A central Italian painting then available at Mantua may have been the ultimate source of Bellini's Mercury; this is Perugino's *Conflict of Chastity and Love* of 1505, now in the Louvre, where a reclining figure appears in the right foreground. The painting is illustrated in Egon Verheyen, *The Paintings in the Studiolo of Isbella d'Este at Mantua* (New York, 1971), pl. 24.

18. Hetzer, "Studien über Tizians Stil," pp. 229–30, briefly noted the resemblance between Titian's Danae and Bellini's Mercury. Hetzer assumed, however, that the *Danae* was itself derived from an antique sarcophagus relief (C. Robert, *Die antiken Sarcophagreliefs* [Berlin, 1909], vol. 2, Tafel 2: 6) which was also the source for Bellini and for a bronze by Riccio. Hetzer therefore assumes that the *Feast of the Gods* served chiefly as a serendipitous route to the antique. Titian, however, never forgot the art of Giovanni Bellini throughout his long career, as demonstrated by borrowings from Bellini in the Pesaro Altarpiece in the Frari, and in the Pietà of 1576 intended for the same church. See Millard Meiss, *Giovanni Bellini's St. Francis in the Frick Collection* (Princeton, 1964), p. 13, for the first example, and for the second, David Rosand, "Titian in the Frari," Art Bulletin 53 (1971): 210–11. I am indebted to my friend Wendy Sheard, who at the Hopkins Symposium on Venetian Art directed my attention to Hetzer's superb studies, too much neglected, of Titian's art.

19. I am indebted to Egon Verheyen for information on the dating and purpose of Giulio's river-god. The drawing is British Museum, Ff. 1-44 and was first given to Giulio by Frederick Hartt, *Giulio Romano* (New Haven, 1958), 1: 102, 295, who believed that it was a modello for a stucco relief in the Palazzo del Te and dated it late in the 1520s. Hartt's attribution was accepted by P. Pouncey and J. A. Gere, *Italian Drawings in the Department of Prints and Drawings in the British Museum* (London, 1962), Vol. 3, pt. 1, p. 64, no. 84. Giulio's figure derives from the figure-types discussed in notes 8–9 above. He could well have studied Perugino's variant, then in Mantua, cited in note 17.

20. Titian visited Mantua in 1532, 1536, and 1538; see John Shearman, "Titian's Portrait of Giulio Romano," *Burlington Magazine* 107 (1965): 174. Titian's borrowings from Giulio have been studied by Hetzer, "Studien über Tizians Stil," pp. 243–48, and more

recently by Madlyn Kahr, "Titian's Old Testament Cycle," *Journal of the Warburg and Courtauld Institues* 29 (1966): 201–02.

21. Vasari, *Le vite,* 7: 447–48: "chi non ha disegnato assai e studiato cose scelte antiche o moderne, non può fare bene di pratica da sè nè aiutare le cose che si ritranno dal vivo."

22. A case can be made for borrowings in the *Danae* from both Michelangelo and the antique of a selective and poetic sort. Danae's hand touches her bed-linen in an elegant fashion not previously known in Titian's work (compare the *Venus of Urbino);* the motif closely resembles the hand of Christ interlaced with the folds of the Virgin's robe in Michelangelo's *Pietà,* of 1499, which Titian could have seen at the Vatican in 1545–46. On borrowings of this sort, see Rosand, *"Ut Pictor Poeta,"* p. 539. Another response to statuary is the unusually complicated configuration of bolster and sheets, again not anticipated by the Urbino *Venus,* which suggests a painter's response to the conventions of the river-god in ancient art, as represented by Giulio's drawing (pl. 5); or by the antique figures Titian could have studied on the Capitoline Hill, where the painter was made a Roman citizen in March of 1546; or by the river-gods displayed in the garden of the Belvedere, where he lodged, and so splendidly reconstructed by Hans Henrik Brummer, *The Statue Court in the Vatican Belvedere* (Stockholm, 1970).

14.1 Titian, *Danae*. Museo di Capodimonte, Naples.

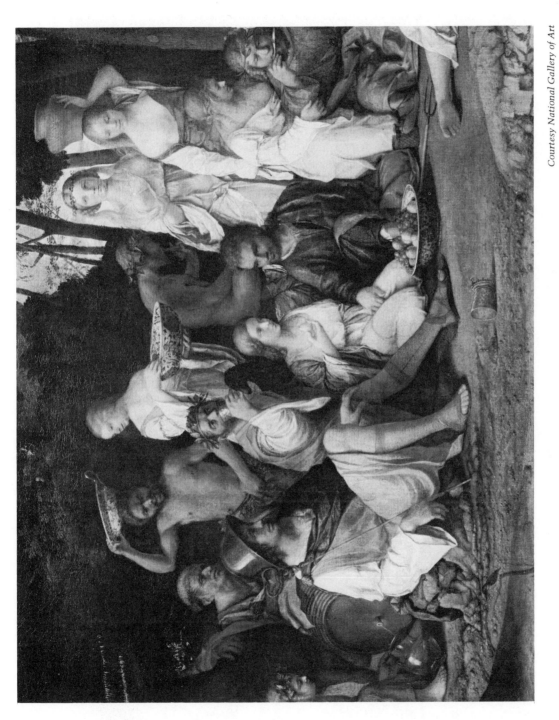

14.2 Giovanni Bellini, *Feast of the Gods*, detail. National Gallery of Art, Washington, D.C., Widener Collection.

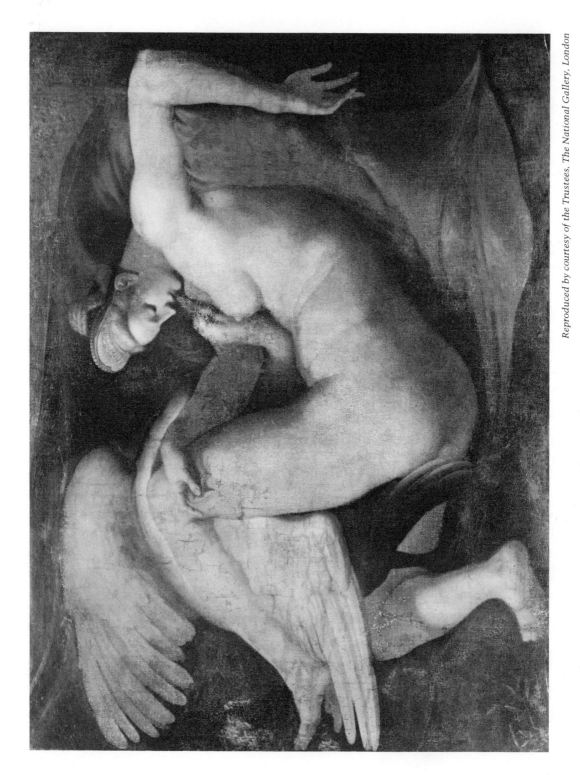

14.3 Rosso Fiorentino, after Michelangelo, *Leda and the Swan*. National Gallery, London.

14.4  Giulio Romano, *River god*. British Museum, London.

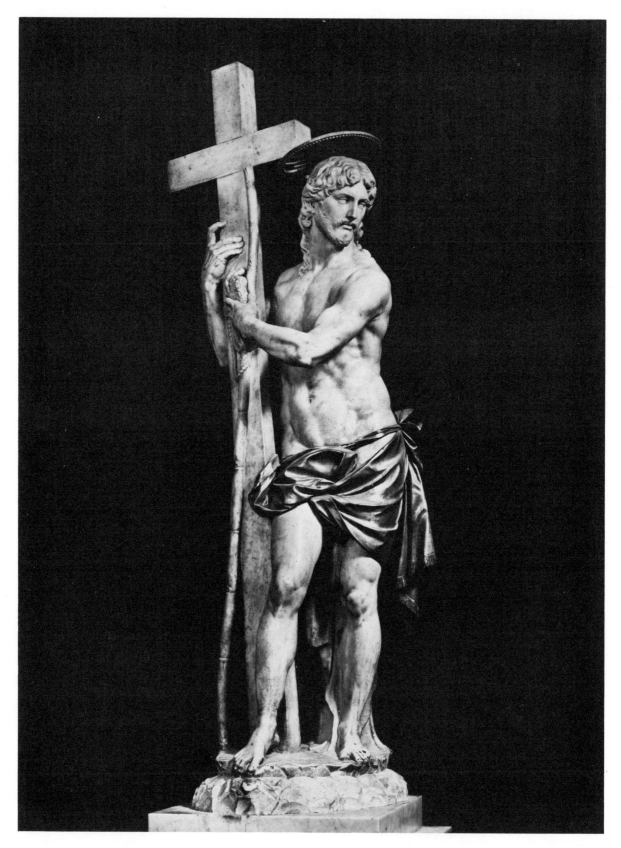

14.5 Michelangelo, with assistance, *Christ*. Santa Maria sopra Minerva, Rome.

# Index